Social Work and the Arts

Social Work and the Arts

Expanding Horizons

Edited by
Shelley Cohen Konrad

and

Michal Sela-Amit

OXFORD
UNIVERSITY PRESS

Oxford University Press is a department of the University of Oxford. It furthers the University's objective of excellence in research, scholarship, and education by publishing worldwide. Oxford is a registered trade mark of Oxford University Press in the UK and certain other countries.

Published in the United States of America by Oxford University Press
198 Madison Avenue, New York, NY 10016, United States of America.

© Oxford University Press 2024

All rights reserved. No part of this publication may be reproduced, stored in a retrieval system, or transmitted, in any form or by any means, without the prior permission in writing of Oxford University Press, or as expressly permitted by law, by license, or under terms agreed with the appropriate reproduction rights organization. Inquiries concerning reproduction outside the scope of the above should be sent to the Rights Department, Oxford University Press, at the address above.

You must not circulate this work in any other form
and you must impose this same condition on any acquirer.

Library of Congress Cataloging-in-Publication Data
Names: Cohen Konrad, Shelley, editor.
Title: Social work and the arts : expanding horizons /
[edited by] Shelley Cohen Konrad, Michal Sela-Amit.
Description: New York : Oxford University Press, [2024] |
Includes bibliographical references and index. |
Identifiers: LCCN 2023041162 (print) | LCCN 2023041163 (ebook) |
ISBN 9780197579541 (paperback) | ISBN 9780197579565 (epub) |
ISBN 9780197579572
Subjects: LCSH: Social service. | Arts in social service. |
Social work education. | Social change.
Classification: LCC HV40 .S61772 2024 (print) | LCC HV40 (ebook) |
DDC 344.03—dc23/eng/20230907
LC record available at https://lccn.loc.gov/2023041162
LC ebook record available at https://lccn.loc.gov/2023041163

DOI: 10.1093/oso/9780197579541.001.0001

Printed by Marquis Book Printing, Canada

Dedicated with love and gratitude to my mother, Rachel Sela, and my late father, Itzik Sela, whose love of singing and dance taught me that art can and should be part of everyday life.

<div style="text-align: right">Michal Sela-Amit</div>

Dedicated to the memory of Marie Roy (1965–2022), a remarkably artful social worker and friend.

CONTENTS

List of Figures ix
Preface xi
Our Authors xv

Introduction 1

PART I. Art and Education: Its Many Forms

1. Worth a Thousand Words: A Bio-Cognitive-Spiritual Framework for Arts in Social Work Education 9
 Peter Szto
2. Art in Translation: Addressing Challenging Emotions From Classroom to Practice 28
 Shelley Cohen Konrad and Michal Sela-Amit
3. Expressive Arts Within a Liberation Psychology Framework in Field Education 43
 Rafael C. Angulo
4. Creative Arts in Social Work Education: "Good Ideas," Domains, and Activities 57
 Lori Power
5. Social Work and the Arts: Through the Student Lens 72
 Emily Frumkin, Brianna Lear, Jennifer Schoch, Sydney Siegel, Shefali Dutt, and Max Deeb

PART II. Arts and Research: Learning With and From Each Other

6. A Vision for Arts-Based Social Work Research 91
 Rogério M. Pinto, Ephrat Huss, and Mimi V. Chapman
7. Affinity Between the Aims of Social Work and the Mechanisms of Arts-Based Research 107
 Ephrat Huss

8. Conducting Online Research in the Era of COVID: Theater-Based Methods to Study HIV Stigma 121
 Marc Arthur and Rogério M. Pinto

PART III. Practice in Community: The Arts and Social Work
9. Creating Comics on the Curb 145
 Katy Finch
10. Coming Fully Into the Present: How the Arts Have Shaped My Social Work Practice 173
 Clay Graybeal
11. A Vision for Engaging the Arts in Social Work Practice 189
 Brian L. Kelly, Carrie Lanza, Raphael Travis, and Taylor Ellis
12. Building and Repairing Through the Arts 211
 Nesrien Abu Ghazaleh, Osvaldo Heredia, and Eltje Bos
13. "When I Hold the Door for You" 228
 Maya Williams

PART IV. Foresightful Epilogue
14. Four Ways the Arts Can Help Social Work Be More Future Ready and Future Engaged 247
 Laura Nissen

Continuing the Conversation: An Epilogue 261
 Shelley Cohen Konrad and Michal Sela-Amit

Addendum 1: Expressive Work: Realm of the Dead: An Installation Performance 267
 Rogério M. Pinto
Addendum 2: The Calling Commentary and Script 269
 Clay Graybeal
Index 275

LIST OF FIGURES

1.1 Terracotta Warrior statutes, Xian, China. 11
1.2 Depiction of how navigators imagined China. 12
1.3 Hooverville. 16
1.4 Race relations in Guangzhou, China. 20
1.5 White mannequins in Guangzhou, China. 21
1.6 Dance partners, Guangzhou, China. 22
1.7 Female patients, Guangzhou Psychiatric Hospital, China. 23
1.8 Cloth restraints, Guangzhou Psychiatric Hospital, China. 24
3.1 Graphic with speech balloons. 53
5.1 Healing Through the Arts SWAC Event (2019). 77
5.2 "Untitled" by Shefali Dutt (2020). 78
5.3 Dancing Through Parkinson's Performance at Art Rx Symposium. 81
5.4 Breaking Boundaries (Carbajal, Anthony, 2019). 84
7.1 Bedouin Woman's Artwork. 115
9 *Making Comics on the Curb* comic. 151
10.1 Scene from "The Calling." 183
11.1 Vision for engaging the arts in social work practice with individuals, groups, and communities. 199
13.1 Drawing by Artist Katy Finch: When I Hold the Door Open. 229
A1 The "Mother" suitcase from Realm of the Dead (by Rogério M. Pinto). 268
A2 Scene from "The Calling." 270

PREFACE

Imagine a spectacular tree in a majestic rolling green meadow. Hints of its massive roots appear in the grass-covered soil beneath it. Its sturdy trunk and strong, upward-reaching branches hold a rich canopy of leaves dotted with small white flowers glittering in the sun's rays. Take in its reviving beauty, vibrance, and all the promises it holds and feel your spirit soaring.

That spirit-lifting energy was buzzing at the University of Southern California's (USC's) Suzanne Dworak-Peck School of Social Work when conversations first began around the prospect of reintegrating the arts into the social work profession. Inspired by Hull House's history and the pioneer integration of the arts in settlement communities fostered by Jane Addams and Ellen Gates Starr, a small cadre of faculty broke ground to bring the arts and social work into education. We sought to cultivate a new way of thinking about art in social work beyond its use as a therapeutic activity and more so as a fully integrated, innovative method to use across all aspects of practice.

The group collectively brainstormed about how the arts might fit with education, theory, research, advocacy, and community-based practice methodologies. We agreed that the field had regrettably lost something of its zeal and soul in its efforts to become professionally "credible." Privileging scientific rather than human aspects of evidence-based practice had, we thought, distracted social work from its origins to empower, advocate, obtain justice, and preserve the dignity of diverse people and communities. We wanted to recalibrate and return to social work's mission and rekindle the natural and inherent connection between the expressive arts and the social work profession.

The first step we took was to introduce and infuse the arts, creativity, and expression into our teaching and writing. We encouraged their use as a strengths-based and relational practice approach, especially when teaching students and working with marginalized populations. We believed that the arts are not only relevant for the social work practices of today but also vitally important to the social work of the future.

Our passion and conviction fortunately received strong and enthusiastic support from our then-dean, Dr. Marilyn Flynn, who was a firm believer in innovation and who urged us to experiment and develop our ideas. In September 2015, she provided a small budget "for coffee," which supported regular meetings of what came to be known as "the incubator," a time for lively discourse about how we could advance social work and the arts. Initially co-led by Maryalice Jordon-Marsh and Michal Sela-Amit, the group was open to the entire school and also to faculty from other USC departments as well as the USC museums. The incubator promoted ingenuity and inclusivity and sought to spread ideas about arts' utility beyond the USC community. The chapters in this book and the epilogue that follows affirm the work of this inventive team of faculty who couldn't imagine how broad their passion for social work and the arts would go and how far it would reach. This book attests that these faculty members weren't alone in this journey—the stories embedded in the chapters tell of others who believed in the value of arts for social work education, practice, research, and community change.

In its first year, to break isolation, the group sponsored conference presentations and articles on the use of the arts in social work education as well as a large-scale photography exhibit highlighting the challenges of aging in U.S. prisons as a way to educate the school community through the powerful images of inmates and their narratives. Students' passions were also ignited, and they established an enduring social work and the arts caucus. The group had clearly hit on a need that moved beyond reintegrating social work roots to actively cultivating fertile ground for a new and meaningful brand of the profession.

The responses of students and community partners encouraged further conversations on what needs to be done to create a lasting dent in the direction of the profession. We agreed that we had to bring forward a sound theoretical foundation and rationale for integrating the arts and social work, and that to achieve this end, we needed to engage with like-minded colleagues from social work and related fields outside USC to shape and expand ideas.

In June 2017, with a generous donation from an anonymous, arts-loving donor, the USC Suzanne Dworak-Peck School of Social Work held the first of three round tables focused on the arts and social work; these were held at the Islandwood retreat center on Bainbridge Island in Washington State. The purpose of the gatherings was to rigorously examine if and how the arts are helpful to progressing the mission of the social work profession and to explain and articulate the understanding of the relationship between the arts and social work theory, research, education, and practice.

To identify scholars that would be conducive to the mission at hand, Dr. Sela-Amit conducted a national and international search and then invited scholars from social work and the fields of philosophy and sociology; several socially engaged artists; and a few art-enthusiast social work students. The invitees presented position papers that were the basis for vigorous discussions in the group.

Bainbridge Island was the perfect setting for the group's conversations. Participants gathered at Islandwood, a beautiful and secluded retreat facility rich with lush hiking trails, ocean views, and wildlife, including a snowy owl who became somewhat of a mascot. Our hosts were masterful cooks, so we enjoyed thought-provoking, as well as lighthearted conversations, seasoned with laughter, over delicious meals. For three consecutive years, the core group with some newly identified scholars and artists who were deemed needed, gathered for 2 days in the summer to engage in intensive discussion and debate. Each time, the round tables concluded with new understandings, goals, and directions, and importantly, with new and enduring relationships that ameliorated the isolation many of us had felt before learning that others also believed in the interconnection of arts and social work. We're proud that several articles were published by attendees, first in 2019 in a special issue of *Research on Social Work Practice* journal. Further, and perhaps most relevant to this volume, at the last round table, the group felt compelled to share the knowledge gained and decided to collaborate on a book that would reflect Islandwood round tables' findings, foresight, and future aspirations.

This is the story of how this book, *Social Work and the Arts: Expanding Horizons*, came to be. It began with the imagination, dedication, and passion of a small community of committed scholars, artists, and thought leaders. Its pages showcase the contributions of many, some whose writings are within and others whose ideas influenced the shared words and ideas expressed. The book is the fruit of our labor and carries the seeds for new growth. Like the majestic tree, this new domain's directions, like branches, are growing and roots deepening. We invite you to engage with the ideas, to be inspired by the arts projects presented, and to forge new and unforeseen pathways that further expand the social work horizon.

We would like to warmly thank the Arts Incubator's pioneers, including professors Rafael C. Angulo, Murali Nair, Anne Katz, Terence Fitzgerald, Helen Land, and Estela Andujo, among others, for their enthusiasm, inspirational discussions, and many contributions to the development of the arts at the USC Suzanne Dworak-Peck School of Social Work. We would also like to wholeheartedly thank the former dean Marilyn Flynn for both her generous

support and her inspiring scholarly contributions in conceptualizing the arts in social work (Flynn, 2019). Special thanks also go to the wonderful assistants that provided administrative support to the round tables, including Michele Clark, Hilary Chisum, Nils de mol Van Otterloo, and Breanna Lear.

With gratitude,
Michal Sela-Amit
Shelley Cohen Konrad

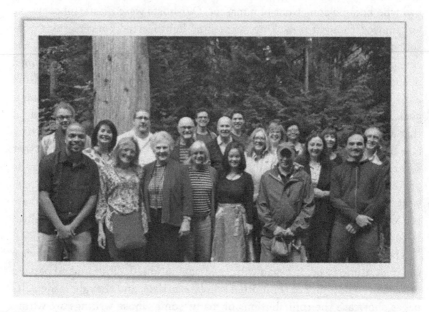

Authors and friends gathered at the arts and social work roundtable on Bainbridge Island.

OUR AUTHORS

Rafael C. Angulo, MSW, LCSW: Rafael is a clinical professor at the University of Southern California (USC) Suzanne Dworak Peck School of Social Work following 11 years of investigative work and clinical practice with Child Protective Services. Fascinated by the beauty and grandeur of cultures, Angulo conducted ethnographic research in Bali, Indonesia, exploring the Balinese parental methods of discipline and perceptions of child abuse. His clinical and policy interests include fatherhood's impact on child development, clinical practice with Latino clients, media literacy, spiritual dimensions of clinical work, transforming the power of art in undervalued communities and relational attributes in psychotherapy. Trained as a filmmaker, Angulo produced and directed documentaries and public service announcements and used video technology to conduct oral histories, digital storytelling, and ethnographic recordings. Rafael teaches integrative field seminars and an elective, Media in Social Work: Documentary Filmmaking. Outside the university, he facilitates group therapy for Spanish-speaking fathers and immigrants, provides psychodynamic therapy, and is working on numerous documentary projects for national distribution.

Marc Arthur, MA, PhD: Marc (he/him/his) completed a postdoctoral fellow in arts-based social justice research and practice at the University of Michigan while writing his chapter. He holds a PhD and MA in performance studies from New York University. He studies the role of directing, devised theater, dramatic writing, and performance in achieving diversity, equity, and inclusion in education and social work practice. Marc's research focuses on artists who use performance to restage the AIDS crisis by enacting dramaturgies of transformation and new forms of biomedical embodiment. As an artist, he develops international performances at theaters and galleries.

Eltje Bos, PhD: Eltje is professor emerita of cultural and social dynamics at the University of Applied Sciences Amsterdam. Also trained as a drama teacher, she focuses her work on the use of arts and creativity in social work as well as on strategies of collaboration to increase personal empowerment and livability in the city.

Mimi V. Chapman: Mimi (she/her/hers) is the Frank J. Daniels Chair and Professor and Associate Dean for Doctoral Education at the University of North Caroline (UNC) Chapel Hill School of Social Work. Her research interests span child and adolescent well-being, particularly among new immigrant families. She's developed arts-based interventions aimed at decreasing implicit and explicit bias among "high-intensity professionals" such as public school teachers, healthcare providers, and essential workers of color, work that has garnered media attention in outlets such as National Public Radio and the *New York Times*. Her extensive global work includes projects in China and the Galapagos Islands. Dr. Chapman is a fellow of the Society for Social Work Research and a Thorpe Engaged Scholar; she is a graduate of the Academic Leadership Program sponsored by the Institute for the Arts and Humanities at UNC Chapel Hill. In 2016, Dr. Chapman received the Edward Kidder Graham Award, one of UNC's highest honors. Her blog, Sympathetic Ink, spans both personal and professional topics (https://sympathetic-ink.blog).

Max Deeb is a student of social work, an elementary school teacher, a musician, and an artist. Deeb was born and raised in Pasadena, Ca where he continues to push for arts within education as well as in the social work field.

Shefali Dutt, MSW: Shefali received her BA in psychology and social welfare from the University of California–Berkeley and her MSW from the University of Southern California, where she was co-president of the Social Work and the Arts Caucus. She currently works with families impacted by the child welfare system. Shefali is passionate about integrating artistic modes of healing in therapy with trauma-impacted youth. Shefali finds solace in her own artistic practices of mixed-media collage and guitar.

Taylor Ellis is an assistant professor of social work at Jacksonville State University. He obtained his Master of Social Work (MSW) and PhD in Social Work from the University of Alabama, and a bachelor's degree in Human Services from Kennesaw State University. Outside of education, Dr. Ellis' primary role in social work practice has been as a program evaluator. Currently, he partners with the Embrace Alabama Kids to provide independent consulting on the evaluation of their Higher Education

scholarship program. Dr. Ellis is a poet, partner, parent, and member of the Social Work and the Arts Roundtable.

Katy Finch, **LCSW:** Portland-based social worker and artist Katy Finch has been making comics and "zines" for over two decades while working at myriad nonprofits, including as the program director for the "Made in NY" Production Assistant Training Program in partnership with Mayor Bloomberg's Office of Film and Television from 2006 to 2017. Originally a filmmaker, Katy is interested in looking for ways to combine her interest in visual storytelling with her work with vulnerable and underrepresented populations. She currently works as a social work clinician with people experiencing homelessness in Maine and continues to make comics with her collaborator Robert Bergeron. She's thrilled to be included in this collection and hopes that she can make social work comics forever.

Emily Frumkin, **LCSW:** Emily (she/her) is a licensed clinical social worker in the state of California. After graduating from the University of Southern California Suzanne-Dworak-Peck School of Social Work in 2018, Emily worked at both Children's Hospital Los Angeles and OUR HOUSE Grief Support Center. Emily now works in a private practice and encourages clients to use diverse forms of artistic expression and somatic awareness to process pain, grief, and trauma. In daily life, Emily enjoys practicing the embodied arts of yoga and qigong.

Nesrien Abu Ghazaleh, **PhD:** Nesrien (she/her) has a degree in social psychology and a PhD from the University of Amsterdam Business School. Her PhD research focused on perceptions of discrimination experienced by both applicants during the selection procedure and employees within an organization. Nesrien has built a broad knowledge base, having gained experience in both commercial and noncommercial sectors. Currently, she's working as a researcher with the University of Amsterdam Applied Sciences. Her research focuses on young people in need of help (e.g., future plans, preventing loneliness, or coaching); social and work integration (e.g., refugee and minority groups); impact measurement; and the use of art-based research methods and interventions. Nesrien also teaches at the University of Amsterdam Applied Sciences and the University of Amsterdam.

Clay Graybeal, **MSW, PhD:** Clay is professor emeritus at the University of New England School of Social Work. He serves as president of the board of York County Shelter Programs in Alfred, Maine. He began his career as a social worker in a private psychiatric hospital. His scholarship has focused on strengths-based assessment and evidence-based practice. Clay is a playwright, landscape gardener, and avid golfer.

Osvaldo Heredia, PhD: Osvaldo is a clinical psychologist and psychotherapist with almost 40 years of experience in many fields, including child, forensic, and mental healthcare. He began as a social worker in the field of child protection, followed by 5 years as a social worker for youth experiencing severe behavioral disorders detained in juvenile detention centers. Osvaldo studied clinical psychology at the Vrije Universiteit in Amsterdam and has worked as a clinical psychologist with a range of client populations, including those experiencing psychosis, autism and/or attention disorders, severe mental illness, personality disorders, and complex trauma. During his time as Directeur Behandelzaken in Amsterdam South/New West and Amstelveen, Osvaldo's passion and specialty was working with civil society organizations and building community networks.

Ephrat Huss, PhD: Ephrat is a professor of social work and art therapy with a background in fine arts at Ben-Gurion University of the Negev in Israel. She heads an innovative master in social work specialization that integrates arts in social practice. Dr. Huss's areas of research include the interface between arts and social practice and arts-based research as a method for accessing the voices of marginalized populations. Dr. Huss has received multiple competitive grants and published extensively on arts-based research with Indigenous Bedouin women and youth in unrecognized villages in the south of Israel. She's forged collaborations with social arts projects in Israel and abroad. Dr. Huss's current research is focused on the use of arts with refugees in Greece and also with an Arab–Jewish youth group using the arts as communication. She is active in the Women for Peace movement where she also introduced quilt making as a method to gain media attention.

Brian L. Kelly, PHD, MSW, CADC: Brian's (he/him/his) research explores current and historical uses of recreational, art, and music-based activities in social work and related fields as sites and opportunities for strengths-based social work practice. He holds an associate degree in audio engineering and incorporates audio documentary and other audio-based ethnographic methodologies in his work as a means to increase strengths-based, participatory research practices. Findings from his work have been presented at national and international conferences and published in peer-reviewed journals and edited texts. He brings over three decades of experience as a musician, song writer, producer, DJ, label owner, and event curator to his work as a social work educator and scholar. Currently, he co-runs Harlem & Irving, an independent music label established in 2020. The label is co-located in Chicago and New York City and focuses on music that is contextually specific, locally grounded, and ever interesting.

Shelley Cohen Konrad, PhD, LCSW, FNAP: Shelley (she/her/hers) is professor in the University of New England School of Social Work and founding director of the Center for Excellence in Collaborative Education, an initiative that promotes cross-disciplinary learning, research, collaborative practice, and service. She graduated from Boston University in developmental psychology and received an MSW and PhD from Simmons University in Boston. In 2014, she was inducted as a Distinguished Scholar and Fellow in the National Academies of Practice and the Social Work Academy. Shelley's writing and presentations focus on experiential learning, arts and social work, power dynamics in health education and care, and relational practices. Shelley is passionate about supporting artists' work in any way she can. She lives on the coast of Maine, where she enjoys gardening, reading, baking, British mysteries, hiking, and time with family, friends, and her beloved dog, Hank.

Carrie Lanza, PhD, LSWAIC: Carrie (she/her/hers) is an assistant teaching professor at the University of Washington (UW) School of Social Work. She received her PhD in social welfare at UW, her MSW from the University of Michigan, and a BA in cultural anthropology from Ohio University. Her research explores the integration of media and the arts with social work research, practice, and pedagogy. Her social work career and scholarship work in tandem with a career in cultural production that spans film and digital media production and curation; visual research methods and socially conscious design; museum curation; and education/event production with the Seattle Fandango Project and Women Who Rock: Making Scenes, Building Communities Collective. Carrie's work is driven by questions about how communities use cultural practices to build strong social bonds, pass on traditional knowledge, buffer the effects of historical and intergenerational trauma, and heal and build foundations for resilience and political resistance. She collaboratively works with arts faculty to develop integrative, multidisciplinary curriculum and study abroad programs.

Brianna Lear, MSW: Brie (she/her/hers) is a licensed independent clinical social worker in Massachusetts, USA. She has an MSW from the University of Southern California (USC) Suzanne Dworak-Peck School of Social Work and a bachelor's degree in psychological science from Vassar College. While at USC, Brie co-led the student interest group Art Rx, which produced multidisciplinary, arts-based workshops to explore how art engagement enhances empathy, clinician self-care, and clinical practice. Currently, she works in community mental health as an outpatient clinician serving children, youth, families, and adults. With a background in the performing arts, Brie has particular interest in using expressive methods to support

culturally sensitive and trauma-informed mental healthcare and psychosocial development. She plans to continue exploring the power of creativity and the natural world to enhance individual and community connection and positive health outcomes.

Laura Nissen is with the Portland State University School of Social Work. With a commitment to innovative and equity-centered systems change, Laura has worked with futures practice and lenses throughout her career. Laura is a foresight practitioner and a Research Fellow with the *Institute for the Future*. She is the PI and Director of the national *Social Work Health Futures Lab* funded by the Robert Wood Johnson Foundation.

Rogério M. Pinto, LCSW, PhD: Born in Belo Horizonte, Brazil, Rogério (he, him/his) is a professor and associate dean for research and innovation at the University of Michigan (UM) School of Social Work. Pinto focuses on finding academic, sociopolitical, and cultural venues for broadcasting voices of oppressed individuals and groups. Funded by the National Institute of Mental Health, his community-engaged, art-based research highlights the impact of interprofessional collaboration on the delivery of evidence-based services (HIV and drug use prevention and care) to marginalized racial/ethnic and sexual minorities in the United States and Brazil. Rogério's one-act play Marília, which explores the tragic death of his 3-year-old sister and how it haunts and inspires the family, has been performed globally. Rogério's art installation, Realm of the Dead (see Addendum 1), funded by UM's Office of Research, among other sources, investigates his own marginalization as a gender nonconfirming, mixed-race, and Latinx immigrant. Both works were performed in 2021 at UM School of Social Work's centennial celebration.

Lori Power, MSW, EdD: Lori (she/her/hers) is an assistant teaching professor at the University of New England in Portland, Maine, and founding coordinator of the Applied Arts and Social Justice Certificate in the School of Social Work. She's inspired by artists and disruptors of all stripes. She's published on the value of arts and social work education and presented at professional conferences. Lori is proudest, however, of connecting students to their creativity.

Jennifer Schoch, MSW: Jennifer has a BFA in theater, received a master's degree in social work from the University of Southern California, and is a trained trauma-informed yoga instructor. Jennifer merged her creative and mindfulness background into her educational experience as a student leader of Art Rx and through her clinical internships and work with the Los Angeles Unified School District and the Simms/Mann UCLA Center for Integrative Oncology and USC's Keck School of Medicine. She's developed

arts-based interventions and programming for clinicians utilizing theatrical tools to enhance professionalism. Jennifer currently is engaged in her most creative and challenging role as a mother.

Michal Sela-Amit, MSW: Michal is an associate teaching professor at the USC Suzanne Dworak-Peck School of Social Work, where she teaches graduate-level courses on theory, advanced clinical practice, diversity, social justice, and culturally humble practice. She also leads global immersion courses to Israel. She integrates humanistic, relational approaches and equity-based practices in her teaching and mentoring. She's served on the CSWE-China collaborative project, where she worked with Chinese counterparts in Nanjing University and the Jiangsu region agencies to develop the social work profession and child welfare.

Prior to relocating to California, Sela-Amit served as a therapist at residential settings with abused and neglected youth and as a research practitioner at the City of Haifa Domestic Violence Unit in Israel. Passionate about the integration of the arts in social work, Sela-Amit, among others, developed the domain at USC and then designed and served as chair of a 3-year summer consortium of national and international scholars focusing on advancing the arts in the profession. She continues to lead the Social Work and the Arts think tank and the associated student caucus at USC, as well as advises nonprofit agencies serving youth in using the arts in practice. Sela-Amit enjoys using creativity and expressive practices in her everyday life and work.

Sydney Siegel, MSW: Before her career in social work, Sydney (she/her/hers) received her bachelor's degree in cinematic arts and business at the University of Southern California. She went on to work as a documentary/film producer, and her projects premiered at festivals, including the Tribeca Film Festival and DOC NYC. She's collaborated with nonprofits and hospitals to bring filmmaking and other creative coping strategies to vulnerable populations. These experiences ultimately inspired her to return to USC to pursue an MSW. Sydney is currently working as a licensed clinical social worker at the Simms/Mann UCLA Center for Integrative Oncology, where she provides psychosocial services to patients and families facing the stressors that accompany a cancer diagnosis. Utilizing the expressive arts, she's created multiple evidence-based programs to better assist patients struggling with questions of legacy and meaning. She's presented her arts-based programs at conferences, and her work has been featured in the *Los Angeles Times* (https://www.simmsmanncenter.ucla.edu/wp-content/uploads/Simms-Mann-UCLA-Center-for-Integrative-Oncology-LA-Times-February-16-2021.pdf).

Peter Szto: Peter (he/his) was born and raised in New York City. His parents immigrated from China, and at an early age his dual interests in

photography and helping others were encouraged. Visualizing his social world was an avocation until he realized the potential of using photography as a tool for social research. In addition to writing about visual epistemology and social work, Peter has produced documentary photography work on China's mass internal migration and psychiatric care and mental health stigma in Iowa. In 2022, Peter's Fulbright Scholarship brought him to Singapore to conduct a visual study of mental health stigma and spirituality. His current photography project is "Cows of Color"—a visual satire and commentary on race relations. Peter has degrees from Calvin University, Michigan State, Westminster Theological Seminary, and the University of Pennsylvania. He's a professor at the Grace Abbott School of Social Work, University of Nebraska at Omaha, where he lives with his wife and two dogs.

Raphael Travis, PhD, MSW: Raphael is a professor and MSW program director at the Texas State University School of Social Work. His research, practice, and consultancy work emphasizes healthy development over the life course, resilience, and civic engagement. Raphael uses the creative arts to investigate hip-hop culture as a source of health and well-being for individuals and communities and authored the book *The Healing Power of Hip Hop*. His latest research, linking arts engagement and well-being, appears in a variety of academic journals and book chapters. The *Collaborative Research for Education, Art, and Therapeutic Engagement (CREATE) Lab* at Texas State University (San Marcos, TX, USA) is led by Raphael and is complete with professional-quality music technology, hardware, and software and makes constructing, recording, remixing, and other ways of engaging music possible. There, he partners with researchers, educators, artists, and community-based organizations to better understand the educational, health, and therapeutic benefits of music and art engagement. Raphael is founder and director of FlowStory, PLLC, which promotes the empowering aspects of hip-hop culture as a critical tool for learning, growth, and well-being across all ages, especially with youth.

Maya Williams, MSW: Maya Williams (ey/they/she) is a nonbinary, Black, multiracial suicide survivor. Ey was named the seventh poet laureate of Portland, Maine, in 2021. They have contributed poems to spaces such as Bosque Press, Black Table Arts, *Indianapolis Review*, *Portland Press Herald*, *FreezeRay*, and more. Her first full-length poetry book is forthcoming through Game Over Books and may be available when this book is published. You can find Maya as one of the three artists of color selected to represent Maine in the Kennedy Center's Arts Across America series (https://www.mayawilliamspoet.com/).

Introduction

This collection of writings on social work and the arts was born during extraordinary and uncertain times. The 2020 COVID-19 pandemic had brought the world to a standstill—most of us were hunkered down, if lucky, able to work from home yet feeling isolated and collectively lonely; others lost their jobs, and yet others were on the front lines fighting a heretofore unknown yet perniciously contagious disease. At the same time, precipitated by sequential killings of several Black men and women at the hands of law enforcement, racial tensions in the United States erupted. Fueled by a culture more politically divided than ever, people defied the virus, taking to the streets demanding racial equity, justice, and inspiring hope that social change was (is?) possible.

Amidst tragedy, fear, and fury, as has been the case throughout history, art brought voice to the frenzy that swirled around us. It bolstered resilience, made sense of the senseless, fostered belonging, and illuminated social justice advocacy. Art flourished during the pandemic: Child-inspired rainbows were taped to windows everywhere; kaleidoscopic murals depicting the faces of George Floyd and Breonna Taylor, among others, made sure their lives were memorialized. Artists from around the globe drew, wrote, performed, and offered tributes to those taken by the virus. And people who never thought of themselves as "artists" joined in refusing to allow the capricious virus (O'Toole, 2020) or societal unrest to rob them of art's capacity to engender connectivity and comfort.

Some of the chapters contained in *Social Work and the Arts: Expanding Horizons* reflect the complexity, ferocity, and raw beauty of this unprecedented time in modern history. Others speak of the historical and timeless powers of the arts in healing and transforming society. In combination, they speak to the creative arts as a mechanism to better understand diverse perspectives, human behavior, loss, and the challenges that lie ahead (Leavy, 2017). Collectively, they offer a compelling case for integrating the arts in

social work as a strategy for understanding human struggles, building agency, gaining new knowledge, promoting social justice, and envisioning "ways to maximize collective imagination and creativity—as well as ways to intentionally co-create the futures we want" (see Chapter 14 by Laura Nissen).

The book's chapters capture multiple voices and manners of expression, posing the question: "What do the arts and social work offer each other?" (Chapter 11). This query is woven into four sections, the first describing myriad ways the arts are used in social work education. Educators expound on theories that support and justify the synergistic relevance of the arts to social work and explore approaches to implementing expressive methodologies in pedagogy. This exploration is told by both teachers and students, their roles as learners being bidirectional and equally influential.

In Chapter 1, Peter Szto uses his brilliant photography to examine the role of "seeing" in social work education. Seeing, he proposes, involves more than the biomechanics of the eye; it engages a multiperspective, bio-cognitive-spiritual process without which we're at risk for rendering clients' problems invisible and muting social problems across communities. Dr. Szto takes a reflexive and holistic approach to understanding human behavior using the art of photography as a visual epistemology for social work education.

Chapter 2 offers both theory and practical applications of the expressive arts to address difficult conversations that inevitably emerge in the social work classroom. Shelley Cohen Konrad and Michal Sela-Amit propose that the void created by not addressing fraught emotions contradicts social work ethics and has the potential to undermine students' future role of being fully present with suffering and pain. The authors provide an array of expressive methodologies to prepare students for managing the exigencies of clients' distress, including willingness and readiness to recognize their own.

In Chapter 3, Rafael C. Angulo provides a powerful rationale for integrating the expressive arts into social work practicum education. Angulo views the historic loss of connectivity between social work and the arts as a "tragedy," one that has separated "the social worker from the poet, the dancer, the musician, the painter, the dramatist, the hip-hop rapper, the filmmaker." Angulo describes how he uses expressive methods in his courses to reframe fieldwork and promote advocacy and social justice.

In Chapter 4, Lori Power begins with a brief history of the ways in which art amplifies social justice advocacy. This is followed by examples of expressive methods, what she calls "four good ideas," to establish an optimal environment for arts-based learning. Readers will find Dr. Power's examples readily accessible and enjoyably implementable in their classrooms.

Chapter 5 elevates the voices of students Emily Frumkin, Brianna Lear, Jennifer Schoch, Sydney Siegel, Shefali Dutt, and Max Deeb, who have benefited and grown from the use of arts in their social work program. Each offers

a glimpse into their experiences while enrolled in the University of Southern California's master of social work (MSW) program highlighting the unique opportunities for personal growth, enhanced well-being, integration of learning experiences, and development of communication, organization, and leadership skills that engagement with expressive practices afforded them. It further illustrates the creative and innovative possibilities that collaborations between social work and medicine can produce to promote the healing powers of arts for people living with illnesses and their professional teams.

The second section of the book focuses on the value of art-based social work research. Consummate researchers Rogério M. Pinto, Ephrat Huss, and Mimi Chapman offer examples of how artworks inform lived realities in ways that traditional, data-based research does not necessarily capture (Huss & Sela-Amit, 2019). Collectively, they speak of the power of art to bring forth silenced narratives, surface faces of oppression, and raise taboo subjects in ways that both empower participants' authorship and protect them from undue harm.

In the following solo chapter, Ephrat Huss, a trailblazer in the use of arts-based research, takes readers through the process of designing and implementing expressive inquiry. To illustrate, she invites us into the cultural world of Bedouin women, learning with and from them about their situational realities, hopes, and dreams. Huss concludes the chapter by describing inherent opportunities when using art in research and acknowledging the multitude of ways it can be applied.

Chapter 8 concludes the research section with the introduction of a framework for online theatrical social work research. Authors Marc Arthur and Rogério M. Pinto describe the roots of theatrical methods as a tool to unearth hidden bias and raise awareness of institutionalized stigma (a description of Dr. Pinto's play, *Realm of the Dead*, can be found in Addendum 1). The authors also share insights about the adaptability and accessibility of virtual modalities that readers may find applicable to their work across settings and populations.

In Part III, Practice in Community: The Arts and Social Work, we compiled the work of social workers who are artists in their own right. Chapter formats range from traditional scholarly works to one comprising mostly graphics, and yet another rich with poetry. This delightful collection of writings presents thought-provoking alternatives that lead to deeper understanding of social problems and their possible creative solutions.

Chapter 9 by Katy Finch, a social worker and comic illustrator, highlights an expressive collaboration between Finch and Bob Bergeron, an artist who spent much of his life unhoused. She asks readers to reconsider traditional social work assessment methods toward a fuller, more holistic view that offers clients opportunities to author their life stories. Katy and Bob's comics depict the intricacies of living life on the streets that will enlighten and broaden

readers' understanding of homelessness. Katy continues to infuse art into her professional practice and mentors others to do the same.

Chapter 10 gives an insider's narrative on the value of arts-based social work. Clay Graybeal, an emeritus social work artist/educator and practitioner reflects on his years in the field concluding: "Social work without art, like life without art, is limited, restrained, and incomplete." Dr. Graybeal's story captures professional quandaries, personal discoveries, and choices. He invites readers to explore the diversity of ways social workers can build meaningful relationships with clients in their practices by combining evidence for the art of social work (Graybeal, 1998). Excerpts of Dr. Graybeal's play, *The Calling*, can be found in Addendum 2.

In Chapter 11, coauthors Brian L. Kelly, Carrie Lanza, Raphael Travis, and Taylor Ellis offer a vision for integrating the arts into social work practice, one that guides readers to consider a richer palette of possibilities for culturally responsive, antiracist, and trauma-informed, micro, macro, and mezzo client- and community-centered practice. Each author offers an introductory statement highlighting their intersectional identities as worker/artists—artists/workers, situating their commentary in a disruptive yet grounded challenge to the field's privileging of depersonalizing, outcome-oriented practices. While acknowledging hurdles to needed change, the authors point toward hope—that art potentializes possibilities for workers, clients, artists, and communities to "work within this unrest" and lead us to a more united and better world.

The theme of hopefulness continues into Chapter 12, wherein writers Nesrien Abu Ghazaleh, Osvaldo Heredia, and Eltje Bos explore the interrelationship between the arts and theories of positive psychology, approaches that can be equally applied as preventive and life-enhancing methodologies, ones that strengthen resilience and avert unnecessary distress. Their positivity/expressive interconnection is especially salient in the postpandemic world where burnout, secondary trauma, and compassion fatigue are global public health problems.

The section finishes with the powerful and critical work of Maya Williams. Maya actualizes the intersectional nature of social workers/artists through poetry, practice, and performance. Their work calls us to consider the ways in which the social work profession has fallen short of its ethics and, more importantly, its promises by de-individualizing the client/worker relationship and erasing their truths. The chapter departs from the traditional: It is blunt, bold, and rich with Maya's merging of the personal with the political, a remarkable sharing of writings about complex and controversial topics at the heart of social work and life challenges.

Section IV considers the future of the social work profession and its relationship to the arts. Composed of two chapters, it's a vision and an epilogue that invites contemplation rather than conclusions. The essence of Laura

Nissen's Chapter 14 brings to mind the words of English poet William Blake (1757–1827) when he wrote: "What is now proved was once only imagined" (Blake, 1975). Dr. Nissen reminds readers that social work is implicitly future oriented, engaged in co-creating a better, more equitable world.

Given our vision of the expansion of arts since it is a practice, research, and education methodology as well as an area for theory development, Shelley see the word *methodology* as limiting rather than expanding horizons in social work. Because of this, we chose to end this book with an open invitation rather than a closing. We thought it germane to conclude it with a conversation bringing together our contributing authors to ask them for their visions and insights since they submitted their work. The epilogue resonates with Dr. Nissen's vision to think and act with foresight and imagination, and it taps into the visions of the future possibilities of this growing field.

This collection offers diversity in topic and format, yet each chapter illustrates just how the arts engage the deepest emotional, spiritual, social, and neurocognitive aspects of experience, hence is vital in its offering of possibilities to social work. The chapters in this book are designed to tap into your imagination and to inspire your use of the arts in the arts in social work.

<div style="text-align: right;">Shelley Cohen Konrad
Michal Sela-Amit</div>

REFERENCES

Blake, W. (1975). *The marriage of heaven and hell*. Oxford University Press.
Graybeal, C. (1998). The Calling (unpublished).
Huss, E., & Sela-Amit, M. (2019). Art in social work: Do we really need it? *Research on Social Work Practice*, 29(6), 721–726. https://doi.org/10.1177/1049731517745995
Leavy, P. (2017). *Research design: Quantitative, qualitative, mixed methods, arts-based, and community-based participatory research approaches*. Guilford Press.
O'Toole, F. (2020, March 31). We can't help giving meaning to this absurd virus. *Irish Times*. https://www.irishtimes.com/opinion/fintan-o-toole-we-can-t-help-giving-meaning-to-this-absurd-virus-1.4216018

PART I
Art and Education
Its Many Forms

1

Worth a Thousand Words

A Bio-Cognitive-Spiritual Framework for Arts in Social Work Education

PETER SZTO

INTRODUCTION

Lecturing can be unnerving. It requires public speaking skills and the ability to neatly craft words and ideas for students to grasp. For most social work educators, teaching became an acquired responsibility born of necessity after completing their doctorates. The profession has traditionally relied on words to communicate often nebulous emotions, complex diagnoses, and knotty social situations. Words are important, but are they always necessary?

The adage "a picture is worth a thousand words" is a well-worn phrase on the unique allure of photography. The photograph enhances our seeing. Why use words when a photograph enables us to see things just as well? When humans see a photograph, they intuitively grasp that it represents reality and thus saves having to use words at all to describe the same reality. How do photographs do that? More importantly, how does the human mind perceive photographic meaning? Developmental psychobiologists assert that as early as within the womb humans begin to see (Rones, 2013). The multiple and developmental benefits of seeing become clearer as vision sharpens and the newborn navigates and explores the world. Seeing allows for experiencing the social world, appreciation of the arts, and perceptual acuity.

This chapter critically examines the role of seeing in social work education. Seeing is essential to how social workers observe, process information, and understand the social world. An advantage of a keen observer is effectively

Peter Szto, *Worth a Thousand Words* In: *Social Work and the Arts*. Edited by: Shelley Cohen Konrad and Michal Sela-Amit, Oxford University Press. © Oxford University Press 2024. DOI: 10.1093/oso/9780197579541.003.0002

advancing social work practice (O'Loughlin & O'Loughlin, 2015). Without clear-eyed observations, clients, communities, and social problems are difficult to see and thus prone to invisibility. Seeing, however, involves more than just the biomechanics of the eye. Seeing involves how the mind perceives and interprets the social world while grasping the spiritual dimension of the human experience. Human spirituality is viewed as integral to comprehending meaning, creativity, and engaging personhood (Dunn, 2019; Profitt & Baskin, 2019).

In this chapter, a bio-cognitive-spiritual conception of personhood is examined in relation to seeing. More specifically, a reflexive approach to the art form of photography is taken to demonstrate a holistic approach to personhood and development of a visual epistemology for social work education. A function of social work education is to communicate knowledge about the social world to enhance well-being. According to Klinke (2014), visual epistemology refers to knowledge of the world mediated through images. The next section unpacks what visual epistemology is and its benefits to social work.

WORDS AND IMAGES

Language and learning are universal cognitive processes with distinct local expressions. In Western languages, such as English, French, and German, words are the basic building blocks for articulating ideas. Words are formed by arranging letters from an alphabet system; these letters in turn form sounds to convey meaning and ideas. Words function to mediate ideas. In Eastern languages, such as Chinese, Korean, and Japanese, pictographs are the basic building blocks for articulating ideas. Pictographs are mental images or highly symbolic forms that directly convey meaning and ideas to the mind. They are also known as ideograms, which undergo less decoding for the mind as in the Western alphabet system. These differing sociolinguistic and cognitive frames are significant for social work education.

Social work educators stand to gain from cognitive science insights on how students learn. For example, human cognition relies on language to mediate between the external world and the internal world of the mind (Klinke, 2014). Harald Klinke is a German digital art history scholar interested in how the mind processes information. His interdisciplinary approach yields insights into how humans know the world. For example, cognitive science explores questions about how humans think and know. Do humans think in words or images? What is the relationship between words and pictures as mental images? Are pictures mental representations of words? How does language shape human thought?

The linguistic shaping of thought is an important dynamic that has been debated since antiquity. Linguists explain that languages are complex symbol

systems comprising sociocultural elements that humans have constructed for communication. Pictures and words are part of this symbol system. The relationship between pictures and words is significant in how thoughts are conveyed between educator and student.

One relevant perspective on the relationship between thought and language is from the French film critic André Bazin (1918–1958). Bazin (1960) argued that the arts meet a deep-seated psychological need for representation through image making. For example, ancient societies made terracotta statutes and mummies to memorialize the deceased. These evidentiary artifacts were designed to preserve images of the dead for future generations. The Chinese built almost 8,000 Terracotta Warrior statutes (Figure 1.1) to stand guard over Emperor Qin's (259–210 BC) tomb. Seeing these warrior statutes today is totally breathtaking: They are a raw display of his power and ego. Each warrior statute was individually crafted with distinct facial features and personalized military equipment. Qin wanted history to see his greatness as embodied in the statutes. Bazin believed the ancients, like the Chinese, used art for the "creation of an ideal world in the likeness of the real" (p. 6).

The ancient Egyptians also represented the dead through mummification. Like the terracotta statutes, the mummies satisfied an innate need to visually represent the deceased. The basic psychological desire for representation through image making—or the arts—has remained constant throughout history.

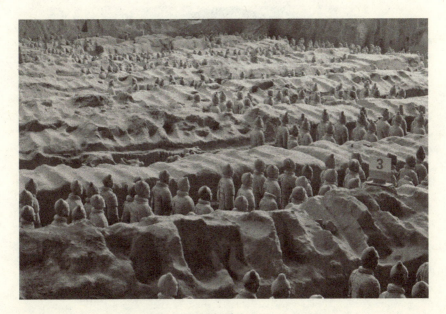

Figure 1.1 Terracotta Warrior statutes, Xian, China.

Civilizations have continued to produce human likenesses through various plastic arts, that is, illustration, painting, sculpture, and more. Visualizing human likeness traditionally viewed the person as whole, meaning neither fragmented nor compartmentalized in the modern sense (Janson, 1970). Paintings were also understood as visual representations intended to project the appearance of reality, but not actual reality. Maps, as well, represented spatial locations and geographic relationships how cartographers imagined the land. Ancient maps, even though they grossly distorted the land, provided enough visual information for travelers to reliably navigate. Figure 1.2 illustrates how navigators imagined China—a fair depiction of what China actually looks like.

As mapmaking improved with more reliable technology, the refined maps depicted geography more accurately but never with complete 1:1 correspondence with reality. An implicit understanding between cartographers and navigators was that what they were looking at was not reality, but the "proclivity of the mind towards magic" (Bazin, 1960, p. 6). This mutual agreement held sway until technological innovations achieved higher precision and thus increased reliability. For artists, the ability to create exact representation of persons made portraiture work also of high social value. "The artist was now in a position to create the illusion of three-dimensional space within which things appeared to exist as our eyes in reality see them" (p. 6).

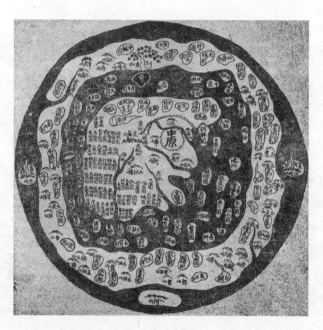

Figure 1.2 Depiction of how navigators imagined China.

SCIENCE AND THE PROGRESSIVE ERA: THE EMERGENCE OF SOCIAL WORK

The desire to accurately represent human likeness also influenced how social work educators understood reality. Students and professors alike both see the social world through a particular cultural-historical lens. They do not see in a cultural vacuum detached from context and values. Socioeconomic and religio-cultural factors shape how social workers interpret and make visual sense of the world. Wenocur and Reisch (1989) pointed to how Enlightenment ideas of the 17th and 18th centuries influenced social work education. The Enlightenment was an intellectual movement that argued for a new way of seeing. The modern ethos elevated science over traditional ways of knowing by displacing religion and spirituality as inferior epistemologies. Science guaranteed certainty and greater reliability over a value-based and subjective perspective. The social impact of science was significant, as manifested in the movement known as the Progressive Era (1890s–1920s). The Progressive Era occasioned the ecclesiastical office of the diaconate to evolve into scientific philanthropy.

The scientific method relied on reducing phenomena into constituent parts to yield knowledge. Mathematician-philosopher Rene Descartes (1596–1650) advocated this method in his 1641 *Discourse on Method and the Meditations* to see the natural world free of subjective bias. When the scientific method was applied to humans, personhood was also reduced into separate and distinct parts. A consequence of the scientific method was less emphasis on the whole than on the parts. A clear example of this is in medicine, where reduction allowed for the rise of specialization by way of dissecting human anatomy and physiology. Human spirituality was likewise separated from the whole person and deemed not objective, nonmaterial, not quantifiable, and therefore not reliable. The reductive method would also yield the construct *bio-psycho-social* to describe persons. This way of describing persons emphasized the distinct parts rather than an integrated whole. The risk of separating the whole into parts is whether the parts can be put back together again into a functioning whole. Recent trends embracing holistic health and mindfulness demonstrate a yearning for wholeness. The popular British nursery rhyme "Humpty Dumpty" also helps to illustrate the risk of full restoration once the whole is broken.

TRENDING FROM SPIRITUAL TO SECULAR

The life and work of Jane Addams (1860–1935) offers a revealing case study on the cultural shift away from the spiritual and toward the secular. Her life story parallels as well the impact of Enlightenment ideals on America's social

welfare system. Addams's formative years were spent in a religious household, but over time her personal views shifted toward a secular faith. Addams's father wanted her to have an elite college education at a prestigious Christian institution close to home. He enrolled her at nearby Rockford Female Seminary, in Illinois, where she graduated as the valedictorian in 1881. The Christian college was founded in 1847 to educate women to become leaders in society. Jane was a stellar student with an inquisitive mind. At Rockford, she began to question the intellectual precepts that her family held so dear. An avid reader willing to explore her moral options, at 19 she wrote: "Every time I talk about religion, I vow a great vow never to do it again. I find myself growing indignant and sensitive when people speak of it lightly as if they had no right to, you see I am so unsettled, as I resettle so often, but my creed is ever be sincere and don't fuss" (Addams, 1879/2003, p. 286). After graduating, Jane knew that someday she would somehow help the poor. It was her spiritual destiny. She believed in social responsibility and caring for others, values that her devout father had instilled in her. Addams apparently developed spiritual eyes for seeing the poor, and this led her to seeing the Hull House become a reality in 1889.

Besides Jane Addams, the Progressive Era and Social Gospel movement responded to social problems due to industrialization, mass immigration, and rapid urbanization. Notable social reform responses included establishment of the Salvation Army, Young Men's Christian Association (YMCA), and Charitable Organization Societies (COS). Yet, these faith-based and private-sector charitable initiatives would later prove inadequate to handle the demands of the Great Depression. Without a centralized government-controlled relief effort, the antebellum private sector needed something more than charitable relief alone (Bremner, 1956).

A closer look at the COS movement is necessary to appreciate its links to scientific philanthropy. The COS model of care began in England in 1869 and was imported to America in 1877. The goal was to create a nationwide network of charitable relief agencies in order to share evidence and advice through journals and periodicals. Words and statistical analysis were the primary means to communicate ideas about social work. The New York COS founded the journal *Charities Review* in 1891. Respected welfare writer Edward T. Devine launched *Charities* a few years later in 1897 and subsumed *Charities Review* in 1901. In 1902, two brothers from Michigan, Paul and Arthur Kellogg, joined *Charities* and would turn it into the leading journal for social work practice. Under Paul Kellogg's leadership, the journal began to emphasize measurement and evaluation and changed its name to the *Survey* in 1907 to reflect this. Realizing the power of illustrations, photography, and charts to analyze social problems, the *Survey Graphic* was launched in 1921 as a companion publication. Its statement of purpose explicitly embraced visualization:

> We chronicle developments ... pool experiment and experience ... afford a forum for free discussion ... carry forward swift first hand investigations with a procedure comparable to that of scientific research ... interpret the findings of others ... employ photographs, maps, charts, the arts in gaining a hearing from two to twenty times that of formal books and experts.

Survey Graphic demonstrated the persuasive power of intertextual dialogue by juxtaposing words and images They also sought to humanize "the other" through visualization.

PHOTOGRAPHY AND SOCIAL WORK

Photography was simultaneously discovered in 1839 in France and England. It literally means *to write with light*. Soon after its discovery, people the world over started taking pictures. Photography permitted new ways of seeing portraits, landscapes, cities, war, medicine, and psychiatry. Recording with uncanny accuracy made truth-telling about reality exciting. Advertising, pamphleteers, and newspapers also benefitted from the camera's capacity to record so persuasively. Intuitively, people knew they were looking at a very high depiction of reality. Photography created a novel way of seeing unlike anything before. Matthew Brady (1822–1896), Lewis Hine (1874–1940), and Jacob Riis (1849–1914) were the earliest practitioners of photography to focus the camera on social issues—Brady on the Civil War, Hine on child labor, and Riis on immigrant tenement housing. In 1933, America's newly elected president Franklin D. Roosevelt (FDR) sought major legislation to respond to the Great Depression of 1929. Roosevelt campaigned to institute a new deal with the American people, where the government would provide social security because the old deal of family, church, and local communities could no longer do so. Mass unemployment, bank closures, makeshift homeless enclaves called Hoovervilles, needs of the disabled, and retired workers were all in need of significant interventions.

Franklin D. Roosevelt understood the importance of galvanizing to support his New Deal and for the nation to see afresh the depth of poverty in America. He also grasped the persuasive power of photography to visualize poverty. FDR thus established the Farm Security Administration (FSA) in 1937 and appointed Rexford Tugwell as its head. Tugwell hired Roy Stryker of Columbia University to lead the historical section with the singular mission of documenting poverty exclusively with photography (see Figure 1.3). Stryker hired 11 highly regarded photographers, who produced over 250,000 images of everyday life in America—with a special focus on the rural poor. The photographs are a powerful visual record of the effect of economic disaster on people's lives. But most importantly, photography allowed America's urban elites to see for themselves the

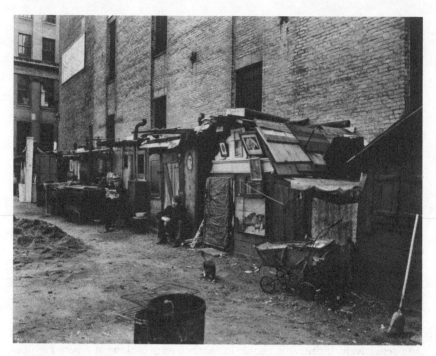

Figure 1.3 Hooverville.

devastating impact of the Great Depression on their fellow countrymen (Szto, 2008). Photography enabled lucidity of social problems and aroused an ethical response. It also challenged the presumed "cognitive authority granted to linguistic representation" (Braigrie, 1996, xviii). The New Deal benefitted from the fact that certain phenomena are better represented and communicated visually.

PRESERVING PERSONHOOD

Even though social work began as a helping profession focused on people, historically its view on persons has been philosophically uneven. Judeo-Christian views on the person held sway for the early practitioners of social work. The person was understood as an integrated whole: mind, body, and spirit. Jane Addams, the Progressive Era, and the Social Gospel movement held to this holistic view. The last movement involved Protestant leaders arguing for a more holistic message with direct impact on the poor and disenfranchised (Rauschenbusch, 1917). Goldstein (1990) observed that as early as the 1930s: "Among others, Bertha Reynolds was troubled that the profession was losing sight of its commitments to the whole person" (p. 34). Alternatively, a dualistic conception viewed personhood as two ontologically distinct

entities: mind and body. This reductionist frame was known as Cartesian dualism and is credited to the 17th-century French mathematician-philosopher, Rene Descartes. For Descartes, the mind was immaterial "thought life," such as memory, language, and visual and spatial perception. The body was material and housed the physical organs and contained the mind.

Descartes's mind-body dualism had a profound influence on medical science, psychiatry, and social work in two significant ways. First, Cartesian dualism privileges thinking over other aspects of the person such as the affections. Feelings were deemed too subjective and inferior to the intellect. In the case of social work, it was perceived as less academic, less intellectually rigorous, and prone to anecdotal solutions (Goldstein, 1990). Second, the Cartesian worldview embraced science as the means to deduce the laws of nature. Descartes believed the world was a machine and explainable in mechanical terms. Likewise, persons also, once reduced into component parts and without a soul, could be mechanically explained. Reductionism permitted an understanding of the mechanics of the eye, but at the expense of less focus on spiritual perception and relational affective states.

How does social work education define the person? This is an important question for a profession committed to helping people. In the National Association of Social Workers' (NASW's) Code of Ethics, the word *person* appears frequently throughout the code, yet nowhere is it explicitly defined. The concept *person-centered care* is also a common phrase used in social work but without clear meaning about what a person is. More recently, the construct "biopsychosocial" appears in the social work literature to describe the person or personhood (Howard, 2007; Kitwood, 1997). This last descriptor is more commonly used in mental health and the older adult literature to assess clients (Parker, 2001; Smebye & Kirkevold, 2013). It presumes a static and/or universal view of personhood without influence from cultural variability or contextual diversity. These constructs of personhood presume that social workers somehow intuitively know what a person is where a clear definition is unnecessary. To the contrary, a full-orbed philosophical anthropology on personhood is essential for social work (Green, 1978). Yet, the presumption that everyone knows what constitutes a person leaves much to the imagination. There are, however, profoundly differing views on personhood that animate racism, sexism, bigotry, and other systems of oppression (Blevins, 2005; McTighe, 2015).

The good news is that the social work literature shows promising signs of reclaiming personhood. For example, discourse on a strengths-based perspective (Saleebey, 1996), spiritual-sensitive practice (Canda & Furman, 2010), human rights (Mapp et al., 2019), and the bio-cognitive-spiritual construct (Senreich, 2013) are hopeful indicators of a turn toward a holistic view of the person—and a turn away from Cartesian dualism. The bio-cognitive-spiritual

construct is a humanistic and holistic perspective on personhood that embraces the inner unity of the person.

BIO-COGNITIVE-SPIRITUAL CONCEPT AND SEEING

Among the five human senses, the eye is perhaps the most valued. Seeing is vital to everyday survival (Bower, 1977). The retina is a major structure of the eye that performs critical optical functions for seeing. Its primary function is to receive and convert electromagnetic radiation, that is, light, into neural signals for the mind to decode into mental images (Seltman, 2019). The human retina receives light to illuminate physical objects, which is then transmitted to the brain and received as perception. This bioneural information transfer is called transduction (Griffiths et al., 2000). Light functions to illuminate objects and then for the retina to transform and transmit these received light patterns into visual sensory information. The visual sensory information is experienced in the mind as perception. Thus, perception is a subjective cognitive event where the viewer culls meaning from these experiences with light (McLeod, 2018). Meaning involves sensory operations but is more than the sum of biochemical processes and optical parts. For example, visually impaired individuals, despite their loss of biomechanical optics, can still "see" and perceive the world. Ableism understands that human perception goes beyond the functionality of the eye. Perception is an epiphenomenon not reducible to the mechanics of visual sensory processing. Human spirituality plays a key role for the mind's eye to grasp meaning (Szto, 2020).

The construct bio-cognitive-spiritual is a holistic view of personhood. It is a realistic view that affirms both the external and internal experiences of the person. It acknowledges the person-in-environment scheme familiar to social work education. Most importantly, it avoids the extreme cognitive position of solipsism, where knowledge only exists in the mind of the social worker. For the solipsist, self-awareness is merely cognitive, as when Descartes suggested: "I think, therefore I am." As a practice profession, the implications for social work are significant. Social work education that trains students to see the social world holistically improves the next generation of practitioners to discern more clearly social injustices, systems of oppression, and inequalities. To believe that anything external to the mind is indeterminate makes seeing unreliable, an epistemic position that is problematic for social work education. Instead, social work aspires toward a holistic way of seeing that views both internal and external phenomena as real. This view historically has not always been the practice.

The arts offer social work educators a way to uphold bio-cognitive-spirituality. In particular, a reflexive approach enables social workers an attitude to see the world more clearly. Reflexivity self-consciously attends to the bidirectional

nature of the person-in-environment relationship. The relationship is circular between cause and effect, exposing how each affects the other. This is in contrast to a linear way of thinking and shift away from didactic learning. It is also sensitive to underlying dynamics and unobservable social structures that give rise to observable events. The seeing takes in surface events and deep structures. It sees by seeking to reveal presuppositions that generate social phenomena, even when camouflaged and difficult to see. The fruit of reflexive eyes is sharper seeing, heightened visual acuity, perceptual lucidity, and a deeper understanding of the social world. Reflexivity liberates spirituality from a worldview that only sees the world in material and empirical terms. Criticality deepens how social work educators can see in the pursuit of social justice (Gray & Webb, 2013; Fook, 2003). In relation to social work education, Phillips and Bellinger (2010) asserted photography is a reliable mode and method for "deep relationality and compassion."

ART IN SOCIAL WORK EDUCATION: REFLEXIVE PHOTOGRAPHY

The chapter concludes with a demonstration of art in social work education. The art form of photography and a reflexive stance are combined to see social issues in more depth (D'Cruz et al., 2007; Leung et al., 2011). When used as a tool of social research, photography is more than not only an aesthetic add-on, but also a way for the eyes to penetrate beyond surface appearances. It is generative and seeks to "challenge guiding assumptions of our culture, raise fundamental questions about social life, and generate fresh alternatives for personal and social action" (Goldstein, 1990, p. 39). The location for the photography was the southern port city of Guangzhou, China. Guangzhou is a densely populated urban hub of about 8–10 million Chinese. The city was chosen as a transitional social welfare example—moving from one level of development to another. Guangzhou today is very cosmopolitan, with surrounding areas boasting international manufacturing, finance, and trade.

International social work education is a growing curriculum area in need of relevant pedagogical resources. A challenge for students is the prohibitive cost of overseas studies and lack of cultural sensitivity for global understanding (Healy & Link, 2012; Szto, 2017). Visualizing social issues, however, is a way for students to practice and gain reflexive understanding of social phenomena they may not directly see themselves. In 2020–2021, the COVID-19 pandemic also significantly restricted global travel and access.

Photography challenges these obstacles with visual evidence of social issues. Five select photographs are shared as credible visual evidence. The images represent three different social welfare issues students might be sensitive to in an American cultural context, but may not readily grasp their meaning in China. The three issues are race relations, gender relations, and

mental health. The photographs also represent reflexivity in that they were intentionally taken as evidence of a bio-cognitive-spiritual attitude toward personhood. The images are displayed as stand-alone photographs accompanied with brief reflexive comments.

RACE RELATIONS

Race relations are worldwide phenomena not unique to the United States alone. The American experience with race, however, is historically fraught with misunderstanding, violence, and deep-seated suspicion. Figure 1.4 is a Guangzhou street scene taken in China on June 14, 2014. The image shows five people seemingly doing everyday activities, that is, buying groceries, walking home carrying vegetables, hanging out with friends with soft drinks, and chatting on a mobile phone. There's nothing out-of-the-ordinary except that three of the five individuals are black. The phenotypic dissimilarity is clearly visible in the photograph. One would assume that only ethnic Han

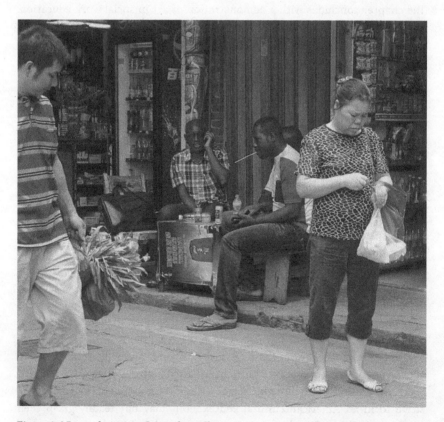

Figure 1.4 Race relations in Guangzhou, China.

Chinese are in China. The photograph begs the questions: Why are these Black men in Guangzhou, and why do they appear to fit in? This reflexive query caught my eye to take this photo. The image challenges the U.S.-centric perspective on race relations and allows for the possibility of alternative views. Several questions come to mind to promote a reflexive, bio-cognitive-spiritual exchange in the classroom. Does racism exist in China? If so, how might it be manifested? Where are the Black men from? Are there others? What do they do in China? Are Chinese racists?

In the 1980s, China embarked on an unprecedented journey of economic reforms. The reforms involved opening up trade with Western countries after a long period of stagnation and self-imposed global isolation. Western foreigners poured into China seeking cheap labor and access to the world's largest market. An unintended consequence of the foreigners' arrival was the permeation of "White privilege" into Chinese society. The foreigners brought not only their capital investments but also their global White supremacy. What's the evidence of this? As I was strolling about Guangzhou on June 5, 2005, I came across these three mannequins and a woman with her bike (Figure 1.5). Her Chinese gaze was striking. Was she struck by the otherness of the White mannequins or what? Mannequins do play a functional role in marketing, for sure, but one would imagine that Chinese mannequins would be the norm rather than whiteness. However, I saw White mannequins in other major Chinese cities. How does their ubiquity inform the perception of foreigners and of Chinese self-image?

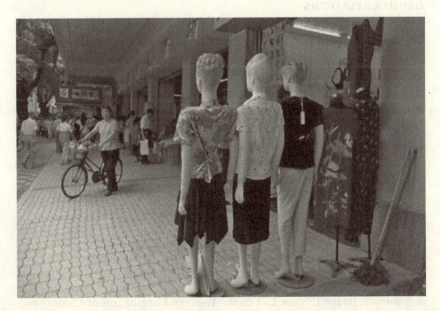

Figure 1.5 White mannequins in Guangzhou, China.

BIO-COGNITIVE-SPIRITUAL FRAMEWORK [21]

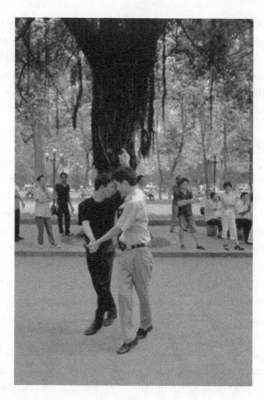

Figure 1.6 Dance partners, Guangzhou, China.

GENDER RELATIONS

Traditional Chinese culture accepts public displays of same-gender affection. The acceptance has nothing to do with sexual orientation but rather a simple gesture of friendship. I photographed two men dancing (Figure 1.6) because they appeared visually elegant. At first, the booming sound appeared faint. It was hard to tell exactly what it was. As I walked faster and came closer it sounded like big band music. But in China? The day was June 5, 2005, and as I was in earshot it was clearly Glenn Miller blaring from loudspeakers in a big city park. Scores of people were ballroom dancing! Swinging and swaying is what I saw in Guangzhou. The dancers were also in different gender and age combinations. The photograph is perhaps suggestive and ambiguous about sexuality, depending on whose cultural lens is doing the interpretation.

MENTAL HEALTH

A dominant image (Figure 1.7) in the Western imagination of Chinese psychiatry is state control for political ends. Human rights abuse also comes to

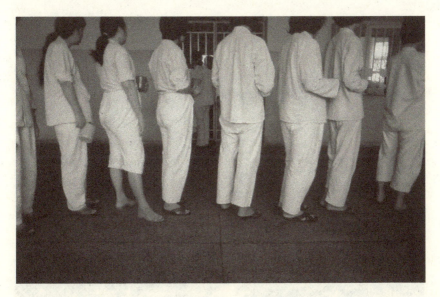

Figure 1.7 Female patients, Guangzhou Psychiatric Hospital, China.

mind. Between 1994 and 1995, I conducted field research in China's oldest psychiatric hospital. The administrative head granted me carte blanche to photograph everyday life in the hospital. During my time there, I saw up-close how the Chinese practiced psychiatry. Never did I see patients being abused or human rights violations. What I did see was a nurturing attitude toward patient care. I saw this same attitude between the patients as well. It was an impressive sight to see.

I worked for many years as a psychiatric aide in different American institutions in Philadelphia, Pennsylvania, and Grand Rapids, Michigan. On occasion, it was necessary to use leather restraints on patients for violent or harmful behavior. I learned to do this part of my job very well. In the Guangzhou hospital, I saw a much softer and gentler approach. I believe the Chinese were more humane. Reflexivity challenged me to honor and learn from others. For example, the staff used cloth strips to tenderly secure the patients' wrists onto the bed. The hospital beds were wood boards with a rattan mat—no mattresses like in America. I learned that the rattan mats and wood boards were standard in Chinese homes outside the hospital. The patients in cloth restraints all seemed safe and secure. In two of my mental health courses, I used Figure 1.8 to teach students about stigma. One of the assignments required students to view my online exhibit on mental health stigma and to select six photos for reflection. This particular photo was a student favorite because of the vivid colors, ambiguity about what they were looking at, and unfamiliarity with the cultural context. The photo's abstruseness actually turned out to be a pedagogical

Figure 1.8 Cloth restraints, Guangzhou Psychiatric Hospital, China.

advantage in allowing the students' imagination to roam and speculate about the use of restraints.

CONCLUSION

Goldstein (1990) challenged us to admit whether social work practice is really an art form that allows practitioners to express their imaginative selves. The role of art in social work education is an unfolding conversation. The hope here is to have added food for thought on how social work educators can help students *see* more clearly. We already do this through PowerPoints, online learning, YouTube videos, social media, clip art, and pie charts. In 2020, COVID-19 made Zoom nearly normative in allowing us to see and talk with one another from afar. The debates on art versus science should continue to further enrich our epistemological and ontological frames undergirding the mission of social work education. Photography is a viable tool of social research to make visible areas of social life social work students may not see without the visual evidence. Mel Gray and Stephen A. Webb (2008) argued that social work is art—that the binary tension between an aesthetic of creativity versus a necessity for concrete material evidence is a false dichotomy. They insist that social work is joining together the impulses of "art, truth and event" (p. 182). Howard Goldstein (1990) advocated for a humanizing social work. He viewed the arts as a way for social workers to embrace human

subjectivity, compassion, and empathy. For Goldstein, only the arts can do this. Tilting toward a positivist stance, John S. Brekke (2012) posited a science of social work framework. Brekke's hope was that social work's very identity becomes rooted exclusively in science. These varied perspectives each contribute a distinct view toward a more holistic and multiperspective approach. As presented here, photography bridges these different views since the medium is both a science and art.

Social work educators, like students, have much to learn from how photographs contribute to our ways of seeing. The photograph, akin to the pictograph, directly conjures within the mind information that the optical eye receives and transmits. Photographs stimulate the mind's visual imagination to surpass the mere descriptiveness of words. The photographic image is thus uncannily expansive in capturing and re-presenting reality. Its affinity toward realism, storytelling, and wholeness is why we gaze at the photo.

Practiced well, photographs and reflexivity serve to preserve personhood. A photograph of a grizzly homicide scene reminds us all too well how real a crime is and how dead are the dead. The crime scene photographs of Luc Sante (2006) are a striking example of the power of photography. In addition, photographs are instrumental in underscoring the policy adage that seeing social problems is requisite to solving them. Documentary photography vividly recorded the personal impact of the Great Depression on people. The group of Farm Security photographers helped American policymakers to see poverty in rural America (Stott, 1973; Szto, 2008). In 2020, living through the COVID-19 global pandemic has challenged preserving personhood difficult to practice due to required social distancing, mask wearing, and online instruction. Our traditional ways of relating to one another have become strained. This chapter has argued that the arts can refresh and rehumanize social work education with better ways of seeing persons as bio-cognitive-spiritual beings. We most certainly want to avoid depersonalization and to expose any loss of personhood that leads to oppression, abuse, discrimination, exploitation, sexism, or racism.

REFERENCES

Addams, J. (2003). To Ellen Gates Starr, Cedarville, Ill., August 11, 18979. In M. L. McCree Bryan, B. Bair, & M. de Angury (Eds.). *The selected papers of Jane Addams, Vol. 1: Preparing to lead, 1860–81* (p. 286). University of Illinois Press. (Original work published 1879)

Baigrie, B. S. (1996). *Picturing knowledge: Historical and philosophical problems concerning the use of art in science.* University of Toronto Press, Scholarly Publishing Division.

Bazin, A. (1960). The ontology of the photographic image. *Film Quarterly, 13*(4), 4–9.

Blevins, D. G. (2005). The practicing self: A theory of personhood. *Asbury Theological Journal, 60*(1), 23–41.

Bower, T. G. R. (1977). *The perceptual world of the child*. Harvard University Press.

Brekke, J. S. (2012). Shaping a science of social work. *Research on Social Work Practice, 22*(5), 455–464.

Bremner, R. (1956). Scientific philanthropy, 1873–93. *Social Service Review, 30*(2), 168–173.

Canda, E. R., & Furman, L. D. (2010). *Spiritual: The heart of helping*. Oxford University Press.

D'Cruz, H., Gillingham, P., & Melendez, S. (2007). Reflexivity, its meanings and relevance for social work: A critical review of the literature. *British Journal of Social Work, 37*, 73–90. https://doi.org/10.1093/bjsw/bcl001

Descartes, R. (1641). *Discourse on methods and the meditations*. Penguin Books.

Dunn, P. A. (Ed.). (2019). *Holistic healing: Theories, practices, and social change*. Canadian Scholars.

Fook, J. (2003). Critical social work. *Qualitative Social Work, 2*(2), 123–130.

Goldstein, H. (1990). The knowledge base of social work practice: Theory, wisdom, analogue, or art? *Families in Society: The Journal of Contemporary Human Services, 71*(1), 32–43.

Gray, M., & Webb, S. A. (2008). Social work as art revisited. *International Journal of Social Welfare, 17*, 182–193.

Gray, M., & Webb, S. A. (2013). *Social work theories and methods* (2nd ed.). Sage.

Green, J. W. (1978). The role of cultural anthropology in the education of social service personnel. *Journal of Sociology & Social Welfare, 5*(2), Article 5.

Griffiths, A. J. F., Miller, J. H., Suzuki, D. T., et al. (2000). *An introduction to genetic analysis* (7th ed.). W. H. Freeman.

Healy, L., & Link, R. J. (2012). *Handbook of international social work*. Oxford University Press.

Howard, C. (Ed.). (2007). *Contested individualization: Debates about contemporary personhood*. Palgrave Macmillan.

Janson, H. W. (1970). *History of art: A survey of the major visual arts from the dawn of history to the present day*. Prentice-Hall & Harry Abrams.

Kitwood, T. (1997). The concept of personhood and its relevance for a new culture of dementia care. In B. M. L. Miesen & G. M. Jones (Eds.), *Care-giving in dementia: Research and applications* (pp. 3–13). Routledge.

Klinke, H. (Ed.). (2014). *Art theory as visual epistemology*. Cambridge Scholars Publishing.

Leung, G. S. M., Lam, D., Chow, A., Wong, D., Chung, C., & Chan, B. (2011). Cultivating reflexivity in social work students: A course-based experience. *Journal of Practicing Teaching & Learning, 11*(1), 54–74.

Mapp, S., McPherson, J., Androff, D., & Gabel, S. G. (2019). Social work is a human rights profession. *Social Work, 64*(3), 259–269.

McLeod, S. (2018). Visual perception theory. Simply Psychology. www.simplypsychology.org/perception-theories.html

McTighe, J. (2015). Narratives of illness, difference, and personhood. In B. Probst (Ed.), *Critical thinking in clinical assessment and diagnosis* (pp. 171–188). Springer.

O'Loughlin, M., & O'Loughlin, S. (Eds.). (2015). *Effective observation in social work practice*. Sage.

Parker, J. (2001). Interrogating person-centered dementia care in social work and social care practice. *Journal of Social Work, 1*(3), 329–345.

Phillips, C., & Bellinger, A. (2010). Feeling the cut: Exploring the use of photography in social work education. *Qualitative Social Work, 10*(1), 86–105.

Profitt, N. J., & Baskin, C. (Eds.). (2019). *Spirituality and social justice: Spirit in the political quest for a just world*. Canadian Scholars.

Rauschenbusch, W. (1917). *Theology for the Social Gospel*. Macmillan Company.

Rones, N. (2013). Your baby's developing senses. *Parents*. https://www.parents.com/baby/development/physical/your-babys-developing-senses/

Saleebey, D. (1996). The strengths perspective in social work practice: Extensions and cautions. *Social Work, 41*(3), 296–305.

Sante, L. (2006). *Evidence: NYPD crime scene photographs: 1914–1918*. Barnes & Nobles.

Seltman, W. (2019). Vision basics: How does your eye work? *WebMD*. https://www.webmd.com/eye-health/amazing-human-eye

Senreich, E. (2013). An inclusive definition of spirituality for social work education and practice. *Journal of Social Work Education, 49*(4), 548–563.

Shepler, J. E. (1998–2020). Jane Addams, mother of social work: Her life of activism from Cedarville to Hull House. https://www.johnshepler.com/articles/janeaddams.html - copyright 1998-2023

Smebye, K. L., & Kirkevold, M. (2013). The influence of relationships on personhood in dementia care: A qualitative, hermeneutic study. *BMC Nursing, 12*(29). https://doi.org/10.1186/1472-6955-12-29

Stott, W. (1973). *Documentary expression and thirties America*. University of Chicago Press.

Szto, P. (2008). Documentary photography in American social welfare history: 1897–1943. *Journal of Sociology and Social Welfare, 35*(2), 91–110.

Szto, P. (2017). Doing research: Gathering visual evidence in China. In A. K., Butterfield & C. S. Cohen (Eds.), *Practicing as a social work educator in international collaboration* (pp. 230–254). CSWE Press.

Szto, P. (2020). Moral, spiritual and existential development. In J. Parker & S. A. Crabtree (Eds.), *Human growth and development in adults: Theoretical and practice perspectives* (Vol. 2, pp. 45–61). Policy Press University of Bristol.

Wenocur, S., & Reisch, M. (1989). *From charity to enterprise: The development of American social work in a market economy*. University of Illinois Press.

2
Art in Translation

Addressing Challenging Emotions From Classroom to Practice

SHELLEY COHEN KONRAD AND MICHAL SELA-AMIT

INTRODUCTION

Social workers assist clients in processing complex situations and powerful emotions, yet few academic courses explicitly target the essential skills of learning to handle uncertainties and suffering and their emotional impacts. This chapter explores using the arts to address this existing gap in social work education. Whether brought about by serious illness, traumatic events, death, injustice, or pervasive hopelessness, pain-filled stories challenge us with the ambiguity of circumstances we may or may not be able to affect. Kang and O'Neill (2018) explained that difficult conversations in the classroom raise internal and external tensions that instructors are ill prepared to manage. Pitner and Sakamoto (2016) pointed out that eliciting difficult emotions such as anxiety, shame, guilt, and frustration can be disruptive to learning, distracting students from needed cognitive and affective processing. The void created by not addressing fraught emotions, however, may inadvertently convey that intense feelings are better not evoked or explored. This message contradicts social work ethics devaluing the worker's critical role of being present *with* clients in their practice experiences, especially if painful.

We have observed that expressive arts and evidence-based practice together inform attitudes and skills that help social workers stay empathically

present with grievous circumstances and irresolvable quandaries. We propose that social work students need exposure to these skills in the safety of the classroom where they can reason and reflect on a range of assumptions, biases, and beliefs and be vulnerable in the face of difficult emotions. Application of cognitive and affective learning can then continue in field experiences where students work with supervisors and peers to implement and demonstrate advanced empathic and relational skills. This longitudinal model is consistent with social work's Educational Policy and Accreditation Standards (EPAS) that endorse applying "purposeful, intentional, and professional knowledge, values, and skills that best serve human and community well-being" in learning and practice (2015, p. 8).

To support our contentions, we offer single and integrating theories that underlie the use of arts-infused methods. These include Paulo Freire's (2000) pedagogy of the oppressed because it considers the big picture while time embracing ambiguity and refraining from judgment. Building on Freirean tenets, we then explore constructionism, which endorses bidirectional and multiperspectival meaning making (Miller & Stiver, 1997; Sharma, 2019), and feminist frameworks that identify disconnection (individual and societal) as critical to understanding human suffering. Interwoven across theories are principles of trauma-informed practice (Sanders, 2021) that recognize the omnipresence of adversity, trauma, and subsequent suffering across all strata and circumstances.

Our discussion then turns to knowledge transfer from arts-based classroom learning to social work practice. There's significant discourse about whether and how what is learned in the classroom is relevant to contemporary practice (Farber & Penney, 2020; Nixon & Murr, 2006). We maintain that expressive curricular activities improve cognitive/affective knowledge and foster empathy for complex circumstances students will encounter in their practice settings. We offer examples of integrated art-infused skills used with clients whose experiences have been silenced or for whom words could not adequately convey their distress.

From classroom to practice arts, activities align well with social work competencies emphasizing the importance of using "empathy, reflection, and interpersonal skills to effectively engage diverse clients and constituencies" (EPAS, 2015, p. 7). Altogether art and social work intentionally and with "rule and rigor" (Goldstein, cited in Damianakis, 2007, p. 527) bolster empathic and relational skills in practice with all clients and especially those whose stories tell of unfairness, injustice, and pain (Pitner & Sakamoto, 2016). According to Berzoff and colleagues (2016): "There is often no more profound experience than being heard, understood, and accepted" (p. 9).

THEORETICAL FOUNDATIONS AND SUPPORTING PLAYERS

Saoirse was adamant that "people simply don't change." This statement was particularly ironic for someone studying social work. It came in response to the instructor's art-based exercise assigned for a grief-and-loss elective. The assignment called for students to smash a terracotta pot then, using the shards, rearrange and decorate them producing a reconfigured entity. The exercise was designed to enact tenets of Robert Neimeyer's (2001) reconstruction of meaning after loss and Tedeschi and Calhoun's (2006) post-traumatic growth theories, both of which had been covered in class. Saoirse reluctantly went about placing her pot into a paper bag and smashing it with a hammer. All the while, she politely insisted on the irrelevance of the activity. "I don't see how this will help me understand grief," she said. "Death happens, a natural occurrence in life. I already understand how it works."

Freire (1972) recognized the silence endured by sufferers. His concept of liberating education was conceptualized to unfetter all voices, including those marginalized and dismissed by society. He promoted facilitated instruction to foster critical inquiry, a dynamic, relational process in which teachers together with learners cultivate intersubjective knowledge leading to both common and discordant discoveries. Facilitative educators refute the idea of a single story or one truth, appreciating the diversity of ways in which people experience and make sense of their lives.

Like Freirean concepts, constructivist epistemology explains knowledge as an interactive, iterative, and synthesized co-production of discovery (Hrynchak & Batty, 2012). Constructivism honors diverse perspectives and appreciates how factors of difference intersect and "shape the human experience" (EPAS, 2015, p. 7). As one social work student reflected: "Change happens in the space between us. It blends your perspective and mine" (personal communication, November 11, 2021). Constructivist processes are reflexive and reflective, urging critical examination from where knowledge is derived (experience, preferred facts, sociocultural systems) and naming deep-seated influential assumptions (beliefs, life experience, faith) (Fook & Askeland, 2007). Constructivist educational models mentor reflective skill applications explicitly preparing students for future engagement with diverse clients and circumstances. As Dean and Rhodes (1998) observed: "If students accept the notion that different theoretical approaches provide us with 'multiple truths,' they are more apt to question their assumptions and recognize the extent to which their values are implicated in the ways they understand their clients" (p. 257).

Relational theory weds constructivist concepts with feminist and relational-cultural practice theories (Berzoff et al., 2016; Farber & Penney, 2020; Miller & Stiver, 1997; Sharma, 2019). It underscores relational *connection* (individual and societal) as critical to human development and relational

disconnection (marginalization, exclusion, and discrimination) as a common factor in human suffering. Mutuality and empathy are the heart and soul of relational theory fostering energy, zest, and desire for increased relatedness (Farber & Penney, 2020). In the *classroom*, psychological safety allows learners to take chances knowing that judgment, dismissiveness, and racist/sexist or other discriminatory remarks will be addressed and mediated (Edmondson & Lei, 2014). In *practice*, relational and trusting connection underpins successful therapy regardless of and in conjunction with chosen evidence-based methodologies (Duncan et al., 2007; Graybeal, 2007).

Altogether, Freirean, constructivist, and feminist/relational pedagogies promote a critically conscious process that integrates science, reflectivity, context, and curiosity. When applied in education, this synthesis offers students the choice to engage with vulnerability when encountering difficult, oftentimes emotionally disruptive content. Personal insight, practice, and patience enable students to listen to hard stories without being overwhelmed. Capacity to engage in critical dialogue and active listening are prerequisites to field readiness and necessary preparation for professional practice.

Trauma-informed principles (TIPs) are interwoven throughout this theoretical and methodological fusion (Harris & Fallot, 2001). TIPs appreciate that adversity and trauma affect people's lives across different ages, races, genders, ethnicities, abilities, sexual orientation, classes, and faiths (Mackey Andrews et al., 2017). Further, workers meet clients at times of heightened vulnerability that inevitably activates places within themselves that are similarly vulnerable (Browning, 2003).

An integrated trauma-informed classroom sets the stage for developing attitudes and skills for encounters with suffering, making it safe to name, process, and mitigate emotional, physical, spiritual, and psychological impacts when in practice (Weiss et al., 2017). To be trauma informed prepares us to hear the painful vestiges of the past and not minimize or rush to fix their impacts in the present and to radically listen to the suffering of the moment and know that it will likely resurface. TIP further reinforces students' willingness to acknowledge personal frailties without self-blame or shame. It's important here to note that many students have experienced profound traumas and injustices themselves. Integrated TIP however is a pedagogical model, not a therapeutic intervention. In social work education, teachers are often also clinicians, and role drift can surreptitiously take place. Setting appropriate boundaries, creating trauma-informed classroom strategies, and identifying external supports help differentiate learning goals from therapeutic processes (Carello & Butler, 2015).

While we are promoting particular theories and methodologies in this chapter, at the same time, we are aware that instructors and practitioners may be dually discomforted dealing with challenging emotions in the classroom and doing so using unfamiliar art-based strategies. Most higher education

teachers do not receive formal instruction, operating in the classroom from deep knowledge of their unique subject area and not from a distinctive pedagogical theory. Yet, social work educators are increasingly tasked with imparting much more than knowledge to students. The Council on Social Work Education (CSWE, 2015) requires that students demonstrate cognitive *and* affective knowledge and skill to competently engage with clients' emotional and circumstantial stress. This requires that instructors have competency and comfort transferring affective/relational as well as cognitive knowledge in their teaching. Professional development and mentoring are ways to assist educators in these areas, helping them gain confidence in facilitative and reflective methods. Instructors may also benefit from tapping into their creativity and curiosity exploring novel methods, including the arts, to address uncertainties, suffering, and loss in their classrooms.

ART IN SOCIAL WORK EDUCATION: EMPATHY, NEUROLOGY, AND DISCOVERY

When I opened my laptop the morning after a class, there was an email from Saoirse. The subject line was: *Unexpectedly*. The email read:

> On my way home I experienced a cascade of unexpected emotion.
>
> I realized that in the process of putting the pot back together again thoughts of a miscarriage I had had in my teens, resurfaced. I had never allowed myself to feel that sorrow, it was an early loss after all. But there they were—emotions I hadn't allowed myself to feel from all those years ago. It made me woefully aware of how I might have missed such sadness and silenced such trauma in a client experiencing similar circumstances. I get it now. Thank you. I get that we never come back together quite the same after loss—but it doesn't necessarily mean that we are broken. It doesn't necessarily mean that we aren't beautiful.

Saoirse's story illustrates the transformative effect of arts-inspired affective learning. Would she have made the empathic connection between her own experience of miscarriage and those of future clients had she simply read about the psychological sequelae of early maternal loss? Did personal discoveries better prepare her to anticipate the silenced trauma of others she'll serve? Did the safety of the classroom permit navigation of a range of emotions, ones that she'll inevitably encounter in practice?

Saoirse's words—her translation of loss into empathic understanding—will undoubtedly influence her practice. "It made me woefully aware of how I might have missed such sadness and silenced such trauma in a client experiencing similar circumstances" is a comment that offers anecdotal yet potent

evidence of benefits gained when preparing social workers to recognize, manage, and gain comfort (and confidence) working with client suffering. Her conscious self-awareness ("I get that we never come back together quite the same after loss—but it doesn't necessarily mean that we are broken") opens an avenue for new considerations.

In the course of her studies, Saoirse learned to maintain permeable yet appropriate boundaries in the face of another's distress and to listen, witness, and yet not confuse her own experiences with those of her clients. Her learning process mirrors the sentiments of Foster (2007), who observed that willingness to reflect on what it might be like to be someone else is "the basis of all sympathy, empathy, and compassion" (p. 21). While reflection on one's own experience informs empathy, it simultaneously holds the potential to surface unexamined assumptions and presuppositions. Common experiences are not always commonly felt. Empathy must be accompanied by curiosity, and instructors must urge students to continuously ask, not preclude, how their clients are experiencing similar circumstances.

Reconstructing the terracotta pot and re-envisioning its beauty even with its broken pieces brought Saoirse to a new level of self-understanding and, by extension, increased sensitivity to the responses of her future clients. Art activities such as this engage learners on neurological and phenomenological levels that bypass traditional, primarily cognitive, methods of instruction (Huss & Sela-Amit, 2018). Neuroscience helps us understand how this happens. Arts-based activities stimulate beta brain waves, prompting conscious thought and logical thinking, both of which are essential to integrating new knowledge and insight (Belkofer & Konopka, 2008). Such processes simultaneously stimulate right and left brain hemispheres, leading to what Dan Siegal called "full creative discovery" (p. 2). Siegal further observed that such insights do not exist within cognitive awareness or physical space but come to light when one is *not* trying to *think* but rather when one is permitted to *feel*. Creative arts methods additionally appear to benefit internal and external regulation, helping people to maintain their ability to tolerate strong affect, a highly relevant capability given the traumatic and sorrowful content clients often have to share (Perryman et al., 2019).

Similarly, art in relationship influences how trauma and loss can be re-storied and reimagined. Neuroplasticity, the capacity of brain cells to transform in response to consistently positive feedback, prompts re-formation of neural pathways, resulting in physiological, phenomenological, and affective relearning (Carey, 2020; Shaffer, 2021; van der Kolk, 2014). As we wrote this chapter in 2022, such neural capacities seemed especially vital in the aftermath (enduring) realities of the 2020 pandemic. Glaude (2020) noted that collective grief and trauma will persist, affecting individual, relational, and political choices well into the future. "Those who survive this madness will have to figure out how to live together in the company of grief," which undermines

our capacities to make connections and bond (Glaude, 2020, Paragraph 1). Rerouting stories of trauma and re-informing the brain toward stories of agency, hope, and resilience gave us hope in light of COVID-19's tragedies (Shaffer, 2021).

The exigencies of suffering brought to bear by injustice and ignorance also linger in the pandemic's wake. Social injustice content in curriculum is well captured in lecture, readings, and service learning projects. These are excellent pedagogies to raise awareness and contribute to one's community. However, the impacts of injustice are rarely brought to reflective recognition through cognitive exercise alone. Freire (1970) referred to the "culture of silence" that muzzles sufferings such as poverty, shame, classism, deprivation, and loss. He viewed the arts as a cultural bridge that transcended language indelibly capturing lived experience, oppression, and perspectival diversity. Interestingly, Kübler-Ross (1969) used the same phrase—"culture of silence"—to describe the reluctance of practitioners, educators, and the greater society to speak of death and the consequences of grief.

Readers theater (Savitt, 2002) is used by educators to move learners from intellectual understanding to visceral appreciation of suffering instigated by injustice. One of the authors (S.C.K.) recalled a reader's theater exercise that brought together medical, social work, occupational therapy, and physician associate students to perform and be the audience for a rendition of "Imelda" by Richard Seltzer (cited in Savitt, 2002, p. 71). "Imelda" tells the story of a medical mission gone horribly wrong, ending with the death of a young girl in the aftermath of a missionary-supported corrective surgery. The script presents multiple perspectives and raises critical questions about the role of the privileged in the service of the poor. When the reader's theater activity was first described to the medical students, they audibly sighed. After the performance, they engaged in meaningful interdisciplinary discussion, recognizing as they did so the power of "feeling with" the story content rather than "learning about it" from a relatively neutral perspective.

Poetry also has a visceral impact when it addresses painful injustices. Maya Williams's public reading of their poem "Convince Us to Stay" (Chapter 13) at a university poetry slam spoke volumes to the duality that exists for those simultaneously experiencing suicidality and racism. Their imagery emphatically conveyed a message to those becoming practitioners:

> Make the knife a smoother cut
> of modeling, singing, and choreography
> by mostly
> Black women
> while the "It Gets Better"
> commercials display
> white male

> gays and allies
> tell us
> It gets better
> Suicide
> Prevention
> in a show
> is a commodity
> to inspire
> a specific demographic
> not cheering
> is proof we don't fit it.

As an artist-social worker/person with a history of mental illness, Maya uses their poetry to evoke the reality of suffering as a person of color in a system that buys into a monolithic, one-size-fits-all commodity of care. They stimulate artful insight that permits learners to view dual injustices through the eyes of one affected. Sharing their poetry is a gift as well as a condemnation of a terribly flawed and often unjust mental health paradigm. Maya's performance is also a visceral experience, one that engages observers' brains in a reappraisal of previous presumptions and gaps in their knowledge of racism, mental health, and gender misunderstanding.

APPLICATION AND TRANSFORMATION

So, how does art transform the learning experience? Sarah Gorham, an artist-educator (personal communication, November 11, 2020) uses the terminology of *contemplative observation* to describe how art engages learners in a process of slowing down, listening, and observing—taking in all that is being told. Contemplative observation requires one to become immersed in the present, to notice and be watchful. Such mindfulness and patience are not necessarily intuitive to those entering into the helping professions. Although equipped with the desire to help, they are often too quick to formulate solutions *for* the client without taking in *what* the client wants or the meaning they make of their circumstances. In using the arts in his classroom, Stephen Burt, also an artist-educator, remarked: "The more [students] create art the more [they] are able to access inner thoughts and express them clearly" (personal communication, November 11, 2020).

Art then can be seen as fostering cognitive and affective learning dimensions required in social work competency-based education. Thoughtful integration of the arts strengthens students' capacities to go beyond knowledge acquisition to include the development of skills and values for practice (CSWE, 2015). We understand these capacities to be those that integrate lived

experience (earned wisdom), memories (insight), and reflectivity with theoretical and evidence-based knowledge, and that facilitate empathy, compassion, and relational connection with clients whose lives and circumstances might otherwise be misunderstood, ignored, or minimized.

In the classroom, opportunities to achieve creative discovery are often set aside in preference for ever-expanding didactic knowledge in the field (Cohen Konrad, 2017). We appreciate (and have experienced) the pressures on instructors to cover relevant and emergent content. Yet, we contend that when critical affective skills are not intentionally taught, social workers may be less effective in serving clients and communities, especially those who are suffering and in pain as well as those experiencing social exclusion, injustice, and discrimination. As in Maya Williams's poem (above), workers are at risk of becoming "a specific demographic not cheering" for those who most need our understanding, presence, and support. To go beyond knowledge learners must have opportunities to integrate subjective and affective understanding, process its meaning, and explicitly transfer it to practice skills. Art-based teaching methods are used to enhance the integrative learning process. The following paragraphs offer examples of two arts-based pedagogical methods—viewing art and engaging in group work—that aid in cognitive and affective learning for social work practice.

When presenting content on the physical, emotional, and material challenges faced by refugees and immigrants, one of the authors (M.S.A.) was taken aback by the lack of engagement displayed by students. She quickly recognized that exposing students directly to such difficult content did not feel safe enough, especially for the first- and second-generation immigrant students who had lived experience with migration. How then could she balance reflection with vulnerability while exposing students to highly difficult and personal subject matter? A field trip to the University of Southern California Asian-Pacific Museum of Art displaying work by immigrants from China and Mexico proved illustrative. Students wandered through the exhibit, viewing the paintings and sculptures, carefully reading curators' notes, clearly engaged and deeply affected by the art. Some willingly reflected on their personal knowledge of migration, relocation, and discrimination; most empathized with the artists' struggles and were moved by their portrayals.

Viewing art and reflecting on an artist's vision is a potent tool for affective learning. Being surrounded by collective artistic vision and encountering the richness of stories rife with struggle deepens awareness whether viewers have lived exposure or not. In this case, students viewed the humanity and universal aspects of the immigrant experiences through artists' eyes while simultaneously revisiting their own or, alternatively, gaining new knowledge of experiences they had only learned about in texts.

For students with immigration histories, an exhibition like this offers potential to integrate embodied discovery, awakening personal knowledge,

encouraging voice, and enhancing deeper connection and empathy. This sense of "awakening" or recognition was shared by one student after viewing a painting of an older woman standing on a backdrop of painted flowers: "She's just like my grandma: her garden is a safe space." For students whose immigration histories were distant or rarely spoken, the exhibit elicited curiosity about their ancestors and a heightened realization of the complexities they also may have faced. Some students later reported having critical conversations with family members about their families' histories.

Here is a final note about the potency of *viewing* art. During the 2020 pandemic and since, museums have served as spaces for healing, connection, and discovery and as places to be less lonely in the company of others. It might be said that museums have spread beyond their walls, flowing into communities where murals and street art feature emergent artwork expressing hope and resilience/pain and suffering and providing a landscape for advocacy and rage and a site for solace when nothing else could soothe. According to Small (2020), curators are now looking into ways that exhibitions of all kinds can become trauma informed as well as more accessible to those seeking to reflect on shared experiences learning with and from each other should they choose. As Nissen (2019) noted, we are only constrained by the limits of customary practice. Viewing the arts in expected and unexpected spaces offers windows for creative discovery and unforeseen connection and change.

Group work also is a fertile environment for connected learning whereby interactive, or "working with," arts-based activities promote and enhance students' cognitive and affective learning. In some instances, opportunities arise that give voice to unspoken feelings and thoughts, making them accessible to group reflection, support, and meaningful exchange. During pandemic lockdown, classrooms were rife with unexpressed feelings and fears, many of which interrupted learning. Recognizing this, M.S.A. facilitated a group exercise instructing students to draw leaves, visualize them floating on a river, and then consider the duality of feelings that emerged for them e.g., sadness/joy; challenge/gratitude) as they engaged in the activity.

Initially, students focused exclusively on their creations. To encourage more dynamic interaction, M.S.A. invited two volunteers to begin reflecting on the drawing process and to prompt others to do the same. Conversations ensued about the beauty of nature that persisted despite the horrors of the pandemic. Some students decided to place words of gratitude on their leaves, for health, shelter, and the continuing ability to connect with family despite physical separation. As time went on, students spoke more intimately about the hardships of isolation and loneliness and its personal and professional impacts. In combination, group work and the arts gave students time to reflect on the pandemic and fostered powerful conversation

that was personally supportive while also elevating awareness of suffering and despair experienced by those living with similar strains and adversities.

TRANSLATING ART TO PRACTICE

It has been our experience, and that of many of our colleagues, that art-based methodologies complement a range of therapeutic modalities providing graphic, metaphoric, and other expressive means to raise that which has been silenced, forgotten, or misunderstood. Used within the context of mutuality and relationship, the arts strengthen empathy and relational connection and generate a sense of unconditional acceptance and belonging. Such acceptance has the potential to mitigate disconnecting barriers, deconstruct unhelpful assumptions, and achieve dynamic understanding (Escueta & Butterwick, 2012; Huss & Sela-Amit, 2018; Sakamoto & Cohen Konrad, 2022). According to Chong (2015), the "art dimension allows disassociated, unconscious emotions to emerge" and to be expressed in concrete external forms (p. 124). For people who have experienced trauma, expressive communication stimulates and reforms neural pathways in ways that open new possibilities for emotional and relational recovery.

An adolescent in one of the author's practices was in pursuit of such healing connection having experienced unrelenting bullying from peers and persistent criticism from parents who were baffled by their child's gender nonconformity. "Solace," Alex (pseudonym) said, was only to be found in music, so S.C.K. invited them to bring songs into our sessions. Alex's lyrics revealed much more than any assessment or conversation we had previously. Music created intersubjective space for Alex to feel safe and eventually share that they were gay. Genuine appreciation for their musical muse opened the door for authentic, trusting exchange and demonstrated that they mattered and belonged.

The felt experience of belonging is often tenuous for marginalized youth, particularly observed in African American males and gender nonconforming youngsters. According to Travis and Leech (2013), music conveys the rage, loss, and unspoken sadness that young people feel but cannot express without losing status within youth culture. According to Travis (2016), music (speaking specifically of hip-hop) has a "history of giving voice to the voiceless, allowing people a renewed freedom for cultural expression and giving people tools to liberate themselves from a belief that their external conditions define them" (p. xviii). Why not then bring hip-hop or other genres of music into the therapy office?

Achieving such exchange is not coincidental. It emerges thoughtfully and patiently through strategic engagement, managed so that the worker is

not overwhelmed by powerful emotions, including anger, grief, and shame. According to Freedberg (2007, p. 255):

> The idea is for the client to feel that she or he has moved you to know that she or he has made an impact on you. The worker may tap into her or his own memories and re-experience a similar life situation on a visceral level to intensify the affective arousal in empathic connection. . . . If the worker is successful, the empathic process is validated and strengthened.

Art and empathy allow a glimpse into others' unique worlds, ones often riddled with myriad manners of despair, hurt, and suffering. Art invites exploration into meaning making, especially when words can neither be spoken nor found. This is true for people across the life course, but it is especially poignant for children who experience trauma, loss, detachment, or themselves are ill or dying. Children's pain and suffering are often *spoken* through drawings, bookmaking, music, and other artful methods (Cohen Konrad, 2019) and has the additional benefit of helping adults understand children's worldviews through their eyes.

Dr. Elisabeth Kübler-Ross shared a moving account of a 5-year-old's progressive drawing, one that told the story of their awareness of impending death. The child divided a piece of paper into sections and in the lower right-hand side they drew a bouquet of seven flowers, each with a stem and flower head. As the child's illness progressed, they eliminated a single stem and flower until only a flowerless stem remained. It was their way of letting Kübler-Ross and the family know that there would soon be an empty page. They were gently illustrating/telling those they loved that death was near.

CONCLUSION

Describing his loneliness during the COVID-19 lockdown, 75-year-old Walter Enriquez remarked: "Art helps us capture the past and relive positive experiences to get through pain and sadness" (Small, 2020). Mr. Enriquez's comment affirms the potency of art as a method to process and manage loss and suffering. Unsettled times call for creative measures that prompt hopefulness and foster connection. During the pandemic, everything we thought to be true was shattered by co-occurring phenomena affecting health, safety, and moral and emotional well-being. Compassion fatigue and burnout accelerated, as providers, learners, patients, and families encountered illness, death, and dying; grief, fear, and violence; moral distress, exhaustion, anger, and, perhaps most toxic, hopelessness.

Mr. Enriquez reminds us, however that there is a pathway through: Art makes suffering tangible and in doing so it becomes something external, something we can address and ask others to help us confront and heal. Paraphrasing the words of Audre Lorde, the arts "give name to the nameless so it can be thought" (cited in Weingarten, 2000, p. 394).

This chapter has made the case for the value of weaving the arts into social work education and practice. We've been careful not to blindly advocate for a one-size-fits-all methodology but rather to offer theories and pedagogies that fit well with the use of the arts to aid in expressing, understanding, and being present with difficult circumstances and their telling. Along with many of our peers, we also view arts and the work of artists as powerful tools for both raising awareness of harms and instigating change. We have observed that the arts engage both heart and mind, and when intentionally integrated in both education and practice, their presence makes it less likely to "miss the sadness" that Saoirse learned to embrace and not fear. We hope that you, the reader, will find something useful to take away from our musings for your teaching, learning, practice, and personal edification.

REFERENCES

Belkofer, C. M., & Konopka, L. M. (2008). Conducting art therapy research using quantitative EEG measures. *Art Therapy*, 25(2), 56–63. https://doi.org/10.1080/07421656.2008.10129412

Berzoff, J., Flanagan, L. M., & Hertz, P. (2016). *Inside out and outside in: Psychodynamic clinical theory and psychopathology in contemporary multicultural contexts* (4th ed.). Rowan and Littlefield.

Browning, D. M. (2003). To show our humanness—Relational and communicative competence in pediatric practice. *Bioethics Forum*, 18(3/4), 23–28.

Carello, J., & Butler, L. D. (2015). Practicing what we teach: Trauma informed educational practice. *Journal of Teaching in Social Work*, 35(3), 262–278. https://doi.org/10.1080/08841233.2015.1030059

Chong, C. (2015). Why art psychotherapy? Through the lens of interpersonal neurobiology: The distinctive role of art psychotherapy intervention for clients with early relational trauma. *Journal of Art Therapy*, 20, 118–126.

Cohen Konrad, S. (2017). Art in social work: Equivocation, evidence, and ethical quandaries. *Research on Social Work Practice*, 29(6), 693–697. https://doi.org/10.1177/1049731517735898

Cohen Konrad, S. (2019). *Child and family practice: A relational perspective*. Oxford University Press.

Council on Social Work Education (CSWE). (2015). *Commission on Educational Policy and the CSWE Commission on Accreditation and Commission on Educational Policy. 2022 educational policy and accreditation standards for baccalaureate and master's social work programs*.

Damianakis, T. (2007). Social work's dialogue with the arts: Epistemological and practice intersections. *Families in Society*, 88(4), 525–533. https://doi.org/10.1606/1044-3894.3674

Dean, R. G., & Rhodes, M. L. (1998). Social constructionism: What makes a "better" story? *Families in Society, 79*, 254–263.

Duncan, B. L., Miller, S. D., & Sparks, J. (2007). Common factors and the uncommon heroism of youth. *Psychotherapy in Australia, 13*(2), 34–43.

Edmondson, A. C., & Lei, Z. (2014). Psychological safety: The history, renaissance, and future of an interpersonal construct. *Annual Review of Organizational Psychology and Organizational Behavior, 1*(1), 23–43.

Escueta, M., & Butterwick, S. (2012). The power of popular education and visual arts for trauma survivors' critical consciousness and collective action. *International Journal of Lifelong Education, 1*(1), 325–340. https://doi.org/10.1080/02601370.2012.683613

Farber, N., & Penney, P. (2020). Essential and neglected: Transforming classroom learning through relationship. *Journal of Teaching in Social Work, 40*(2), 95–113. https://doi.org/10.1080/08841233.2020.1726553

Fook, J., & Askeland, G. A. (2007). Challenges of critical reflection: "Nothing ventured, nothing gained." *Social Work Education, 26*(5), 520–533.

Foster, V. (2007). The art of empathy: Employing the arts in social inquiry with poor, working-class women. *Social Justice, 34*(1), 12–27.

Freedberg, S. (2007). Re-examining empathy: A relational–feminist point of view. *Social Work, 52*(3), 251–259. https://doi.org/10.1093/sw/52.3.251

Freire, P. (1970). *Pedagogy of the oppressed*. Seabury Press.

Freire, P. (1972). *Pedagogy of the oppressed*. Penguin.

Freire, P. (2000). *Pedagogy of the Oppressed, 50th Anniversary Edition*. Continuum International Publishing Group.

Glaude, E. S. Jr. (2020). *The pandemic will pass. Our grief will endure*. Washington Post, Opinions. https://www.washingtonpost.com/opinions/2020/04/06/pandemic-will-pass-our-grief-will-endure/

Graybeal, C. T. (2007). Evidence for the art of social work. *Families in Society, 88*(4), 513–523. https://doi.org/10.1606/1044-3894.3673

Harris, M., & Fallot, R. D. (Eds.). (2001). *Using trauma theory to design service systems*. Jossey-Bass/Wiley.

Hrynchak, P., & Batty, H. (2012). The educational theory basis of team-based learning. *Medical Teacher, 34*, 796–801.

Huss, E., & Sela-Amit, M. (2018). Art in social work: Do we really need it? *Research on Social Work Practice, 29*(6), 104973151774599. http://dx.doi.org/10.1177/1049731517745995

Kang, H., & O'Neill, P. (2018). Teaching note—Constructing critical conversations: A model for facilitating classroom dialogue for critical learning. *Journal of Social Work Education, 54*(1), 187–193. https://doi.org/10.1080/10437797.2017.1341857

Kübler-Ross, E. (1969). *On death and dying*. The Macmillan Company.

Mackey Andrews, S., Belisle, A., Hoffmann Frances, R., Cohen Konrad, S., Pérez, A., Redding, J., & Taglienti, R. (2017). Disseminating Trauma-informed Knowledge for Practice in Maine: The Blueprint. (unpublished).

Miller, J. B., & Stiver, I. P. (1997). *The healing connection: How women form relationships in therapy and in life*. Beacon Press.

Neimeyer, R. A. (Ed.). (2001). *Meaning reconstruction and the experience of loss*. American Psychological Association.

Nissen, L. B. (2019). Art and social work: History and collaborative possibilities of interdisciplinary synergy. *Research on Social Work Practice, 29*(6), 698–707.

Nixon, S., & Murr, A. (2006). Practice learning and the development of professional practice. *Social Work Education*, 25(8), 798–811. https://doi.org/10.1080/02615470600915852

Perryman, K., Blisard, P., & Moss, R. (2019). Using creative arts in trauma therapy: The neuroscience of healing. *Journal of Mental Health Counseling*, 41(1), 80–94. https://doi.org/10.17744/mehc.41.1.07

Pitner, R., & Sakamoto, I. (2016, August 05). Cultural competence and critical consciousness in social work pedagogy. In *Encyclopedia of social work* (20th ed.). Oxford University Press. http://socialwork.oxfordre.com/view/10.1093/acrefore/9780199975839.001.0001/acrefore-9780199975839-e-888

Sakamoto, I., & Cohen Konrad, S. (2022). Using reader's theater to enhance reflexive social work practice, research, and education. In E. Bos & E. Huss (Eds.), *Using art for social transformation* (pp. 179–191). Routledge.

Sanders, J. E. (2021). Teaching note—Trauma-informed teaching in social work education. *Journal of Social Work Education*, 57(1), 197–204. https://doi.org/10.1080/10437797.2019.1661923

Savitt, T. L. (Ed.). (2002). *Medical readers' theater: A guide and scripts*. University of Iowa Press.

Shaffer, J. (2021). Centenarians, supercentenarians: We must develop new measurements suitable for our oldest old. *Frontiers of Psychology*, 12, 655497. https://doi.org/10.3389/fpsyg.2021.655497

Sharma, M. (2019). Applying feminist theory to medical education. *The Lancet*, 393, 570–578.

Small, Z. (2020, June 15). Museums embrace art therapy techniques for unsettled times. *New York Times*. https://nyti.ms/2Y1ahRI

Travis, R. (2016). *The healing power of hip hop*. Praeger.

Travis, R., & Leech, T. (2013). Empowerment-based positive youth development: A new understanding of healthy development for African American youth. *Journal of Research on Adolescence*, 24(1), 93–116. https://doi.org/10.1111/jora.12062

van der Kolk, B. A. (2014). *The body keeps the score: Brain, mind, and body in the healing of trauma*. Viking.

Weingarten, K. (2000). Witnessing, wonder, and hope. *Family Process*, 39(4), 389–402.

Weiss, D., Kassam-Adams, N., Murray, C., Kohser, K. L., Fein, J. A., Winston, F. K., & Marsac, M. L. (2017). Application of a framework to implement trauma-informed care throughout a pediatric health care network. *Journal of Continuing Education in the Health Professions*, 37(1), 55–60. https://doi.org/10.1097/CEH.0000000000000140

3
Expressive Arts Within a Liberation Psychology Framework in Field Education

RAFAEL C. ANGULO

One of the greatest tragedies in social work practice has been the divorce of the social worker from the poet, the dancer, the musician, the painter, the dramatist, the hip-hop rapper, and the filmmaker. Treatment of choice was influenced by talk therapy using psychodynamic theory in the earlier part of the past century and is now significantly more cognitive behavioral (Mishna et al., 2013; Rasmussen, 2018). In many settings, the arts became a secondary consideration for the more significant social work profession. Today, talk therapy is the primary treatment method for individuals, couples, families, and groups. However, the use of the expressive arts as a method of treatment across diverse populations continues to grow due to its universal appeal (Degges-White, 2011).

In social work education, field seminar courses have yet to respond commensurately to rising interest in the expressive arts. With notable exceptions, Couous-Desyllas and Bromfield (2020) utilized arts-informed journaling to highlight the student's interior emotional and cognitive world regarding their practicum. They argued that field courses have traditionally utilized field experience papers, review of process recordings, and student journaling as assignments for reflection to exclude the arts. However, art is deeply receptive, healing, participatory, and embodied for it to be discarded and minimized. The expressive arts allow social work students who may be personally confronting issues of trauma, oppression, and privilege to give voice and expression

Rafael C. Angulo, *Expressive Arts Within a Liberation Psychology Framework in Field Education* In: *Social Work and the Arts*. Edited by: Shelley Cohen Konrad and Michal Sela-Amit, Oxford University Press. © Oxford University Press 2024.
DOI: 10.1093/oso/9780197579541.003.0004

through the creative medium. Thus, students work alongside their classmates to celebrate, mourn, and integrate their field experiences as they develop their professional selves.

In practicum, "talk therapy" evidence-based practice (EBP) is the backbone of clinical work, and the expressive arts are minimized as an intervention of choice by many field instructors who supervise bachelor of bachelor of social work/master of social work (BSW/MSW) students today. One of the consequences is the dismissal of the arts as an intervention on graduation. Practitioners supervising a new generation of MSW graduate students are challenged by the agency's expectations of incorporating manualized EBP interventions and neglecting the expressive arts in treating depression, anxiety, trauma, and other psychosocial problems.

Fortunately, there appears to be a gradual acceptance re-embracing the arts in social work practice. The literature suggests that creative methods in the expressive arts modalities, including the visual arts (Huss et al., 2012), music therapy (Trainin Blank, 2016), drama therapy (Regan, 1994), expressive writing (Lenette et al., 2015), and movement therapy (Roy & Manley, 2017) are being embraced by social work practitioners globally. In academic pedagogy, social work instructors use art to enhance learning. In one course, students learned about the importance of self-care by using photovoice to photograph wellness behaviors (Micsky & John-Danzell, 2021). In another, instructors leveraged a video assignment in teaching a social policy course to develop video skills for advocacy (Tetloff et al., 2014). The attempt in the last example to use visual equipment—the smartphone—for social justice work is a direction that other social work instructors are exploring. Moxley (2013) considered in a conceptual article the practice of art-making for purposes of resistance, development of knowledge about oppression, and its more democratized feature—art created not only by the elite or well-educated but also by all, including the marginalized in our communities who share the same creative impulse with all humanity. Foels and Bethel (2018) provided examples of three social work courses that included the use of the expressive and creative arts. They found that art created "aha" moments in the students that were transformative in critical thinking and commitment to justice work.

By the end of the semester, students saw themselves more clearly in the "here and now." Students also began thinking about essential changes they could make in their personal lives and their actions in the lives of others. The instructors found that most of the students' plans for action were practical and within their capabilities. For these courses, it was evident that the arts, via student assignments, served as a vehicle for social action.

This book chapter provides a conceptual and applied practice model known as liberation psychology situated within a field education course. Embracing the expressive arts, the final assignment's intended outcome is for developing critical consciousness, future engagement in liberation practices with self and

clients, honoring diversity, creating awareness of self-concerning social work practice, and exploring sensory ways of knowing.

LIBERATION PSYCHOLOGY

Key figures in the development of liberation psychology include W. E. B. Du Bois, Paulo Freire, Frantz Fanon, and Ignacio-Martin Baro (Afuape, 2011). Liberation psychology attempts to engage, assess, and intervene on behalf of oppressed and marginalized populations on an individual or group level (Martin-Baro, 1994). Social psychologist and Jesuit priest Ignacio Martin-Baro recognized the inherent contradiction of Western psychologies' ahistorical and apolitical lens. Although theories of human development and psychopathology are often constructed without connection to history and collective trauma memory, the treatment seemed devoid of community support, collective action, and the development of critical consciousness. Martin-Baro (1994) argued that human suffering originates in the social, political, and economic reality surrounding an individual. Social pathology creates individual pathology. Oppression is the seed that allows psychological distress to grow as an adaptive response to pathology. Before his murder in San Salvador in 1989 by government operatives, Martin-Baro developed a set of principles that laid the groundwork for liberation psychology.

First, the personal is political. The etiology of mental illness is not intrapsychic but rather a congruence of political, social, and economic factors that impact the human person and community. The origin of depression is not only negative self-talk but also external conditions of poverty, lack of agency created by cultural expectations or authoritarian governments, and social isolation that lead to increased levels of negative self-talk.

The second principle is recovery of historical memory. For many living in community conditions that are unbearable to the human spirit, the capacity to engage in social analysis to understand the history of the current situation is empowering (Afuape & Hughes, 2016). What major economic, political, social, and cultural structures support this situation? What are the critical values of the current oppressive social structures? This type of analysis is not done alone but rather in participation with others.

The third principle is denaturalization. All elements of society that are either personal or cultural have operating assumptions and beliefs. All people should be the providers in the home. Art is only for those born creative or the educated elite. Politics is personal. For many, these assumptions about gender, art, and politics are never questioned. Who defines these constructs? Whose interests are served when these assumptions are normalized as either facts or part of the status quo? Denaturalization requires a critical examination of societal assumptions or deideologizing everyday experiences (Rivera, 2020).

Fourth is the principle regarding the virtues of the people. The oppressor sees oppressed people worldwide as individuals or groups with deficits, dysfunctions, and disorders. Many are incarcerated, marginalized, and forced to live under conditions that do not allow them to thrive. However, social workers accompanying the oppressed on their journey recognize the virtues that have sustained the marginalized for generations. What is empowering is that these virtues are recognized by the disenfranchised themselves and become protective factors for the development of resiliency and instrumental in fighting for social change (Martin-Baro, 1994).

The fifth is conscientization, also known as the awakening of critical consciousness in an individual or group. The metaphor for this principle is the process of waking up from a sleep-walking state to a fuller understanding of one's social standing in the community, the forces of oppression that have been the determinants of alienation, and the critical awareness of action that must be taken in solidarity with others (Almeida, 2019).

Sixth is the principle of *acompanamiento*. Translated from Spanish, psychosocial accompaniment is an action verb (Watkins, 2019). This charge puts the social worker in "a process that unfolds and evolves from standing alongside communities, through building relationships, and everyday lived experiences of adaptation, assistance, compassion, and witnessing, acompanamiento implicates feelings of mutual vulnerability and struggle" (Fernandez, 2020, p. 93). In working with marginalized populations, this relational way of working with groups allows the social worker to release hierarchical notions of the educated versus the uneducated, leader versus follower, and helper versus helpee. The social worker walks alongside the other without being complicit in the hegemonic understanding of mental illness, psychological treatment, and the overpathologizing of the other. Instead, the social worker does not dictate liberation but provides a mutual encounter of struggle, vulnerability, collaboration, and radical hope.

LIBERATION ART PRACTICES

As individuals and communities come to terms with the accessibility of needs to thrive as integral human beings, liberation psychology affirms liberation practices that provide a means to an end. Martin-Baro (1994) approached the study of collective trauma through the lens of participatory action research (PAR), a collaborative community-informed type of research for purposes of social justice. PAR honors community voices as primary participants in developing research questions, analyzing data and narratives and leading initiatives for change (Fernandez, 2020). A research subset of PAR is photovoice, a method of documenting community issues with cameras with the premise that community members are experts in their day-to-day reality and assist

in promoting sociopolitical change (Wang, 2006). Practitioners working with communities are now using photovoice as a therapeutic healing intervention for sociopolitical trauma to process feelings related to chronic traumatic episodes (Gupta et al., 2019).

Thus, when art-based or expressive arts are utilized for self-empowerment and the development of critical consciousness, liberation art practice is utilized within a liberation psychology framework.

EXPRESSIVE ARTS-AS-REFLECTION ASSIGNMENT

I teach at a privately funded social work graduate school in Southern California. All students must take a field seminar course during their first year of the MSW program connected with their practicum during the academic year. The field seminar allows students to process their experiences in the field and learn new skill sets (critical reflections on dominant discourses, feedback-informed treatment, foundational understanding of the expressive arts), and dyadic and group dialogues in liberation psychology.

The final deliverable of the semester is the Expressive Arts-as-Reflection third (final) assignment, which provides an opportunity for students to create artwork that reflects their experiences in the field, insights about self-concerning client work, and honors their "growing edge" in the development of competencies and skills.

METHOD—TIMELINE FOR ASSIGNMENT

The spring semester is predicated on understanding the concepts and applications of liberation psychology. All students must read a week's chapter of the book *Power, Resistance and Liberation in Therapy With Survivors of Trauma: To Have Our Hearts Broken* (Afuape, 2011). Further, selected students each week hold a dialogue with a partner in front of the class to reflect on the chapter and explore its application to themselves, their community, and their current practicum. Prompts are utilized to assist the students in engaging in critical thinking and dialogue:

- Quotes: Make a note of the language that strikes or moves you.
- Inspirations: Write the inspirations that arise during the reading.
- Critical reflections: Examine, if any, which assumptions, values, and beliefs have been challenged in this chapter or that are daring to challenge and disagree with the author.
- Applications: Critically examine how to apply the knowledge in this chapter to the practicum.

Students begin to understand a new vocabulary during the book's examination—working with power, therapeutic approaches to resistance, stages of political consciousness, privilege, historical memory, coloniality, positionality, testimony, and more. They also connect these concepts to social work practice within their current practicum. They understand that psychological theories are context dependent and originate within a specific economic, cultural, and political settings. An aha moment occurs when they come to terms with the concept of neutrality in working with clients and that it can inevitably become an endorsement of the status quo related to poverty, racism, trauma, and more. They are challenged to consider disrupting the system by posing new questions related to their practicum:

- How is my current practice as a social worker promoting a status quo of dominance and privilege for those in power?
- Which specific institutions that utilize social workers are maintaining the dominant discourse?
- What specific therapeutic models dismiss the contextual factors impacting clients' mental health or problems in living? How does the *DSM-5-TR* (*Diagnostic and Statistical Manual of Mental Disorders, Fifth Edition, Text Revision*) dismiss dominant environmental influences?
- What cultural factors are practiced as a top-down process where the social worker is the expert providing solutions and the client is merely the recipient?
- In your MSW program at the present moment, how are you encouraged to engage in critical self-reflection and dialogue regarding your social location and that of others? In what ways do faculty demonstrate their ongoing engagement in critical self-reflection?
- How has the field instructor facilitated using voice, integrating social location, and bringing the whole self into your work as a social worker?
- How is my current practice in the internship dismantling systems of power and privilege?

Like the final assignment, the first two assignments of the semester, Decolonizing Dominant Discourses (Assignment 1) and Feedback-Informed Treatment (Assignment 2), have their foundation in liberation psychology. For example, Assignment 1 familiarizes students with a liberation psychology frame of analysis by examining the conditions of their personal development. White supremacy, predatory capitalism, heterosexism, nativism, and other systems of power and privilege are examined. Decolonization attempts to interrogate systems in a consistent forthright manner. The process of students sharing personal stories that illustrate the complexity of identity and its inherent positionality within the more extensive social system is a decisive and relational moment for students of different backgrounds related to class, race,

gender, sexual orientation, and more. Students also inquire about the profession of social work by calling into question the discipline's assumptions about power and hegemony (Tambburo, 2013). As experiences are courageously shared and supported through resonating listening by the group, students develop a critical consciousness as emerging social work professionals.

Assignment 2 utilizes an EBP intervention known as feedback-informed treatment (Miller et al., 2015; Prescott, 2017), which is an EBP treatment recognized by the Substance Abuse and Mental Health Services Administration (SAMHSA). SAMHSA leads public health efforts to advance the behavioral health of the United States. The pantheoretical approach attempts to evaluate and improve the quality and effectiveness of social work treatment using an Outcome and Session Rating Scale by routinely and formally soliciting client feedback regarding the therapeutic alliance and outcome of care. This antioppressive practice honors the "virtues of the people" by coming to terms with the reality that our perspective and approach in our case formulation and treatment are not working with our client, and that relational reflexivity—our ability to explore our attunement with our client—necessitates our capacity to dialogue about the therapeutic relationship with them. "I wonder, how are we doing together?" "Do you think I get you?" "Do you ever feel misunderstood by me?" "If so, what am I missing?"

To further enhance the Expressive Arts-as-Reflection assignment, students explore the fundamentals of the creative arts and make it reflect on their understanding of what an artist is, the creative process, and perhaps personal memories of shame associated with the creation of art. Throughout the semester, students explore how individuals, groups, and communities have utilized the arts for their conscientization and disrupting pathologies of power—theater of the oppressed, music, dance, altars and memorials, storytelling circles, visual arts, video, performance, and others.

SPECIFIC PROTOCOL OF ASSIGNMENT

The semester's final assignment also coincides with the practicum's completion. Students are purposely challenged to explore alternative creative ways of expressing and representing their experiences in the field. They are instructed 1 month before presenting their assignment to engage in reflexivity about what is different about them now as an emerging social worker compared to when they started their practicum and to explore an art form that will be an externalized representation of their interior development. Almost immediately, students become anxious: "I do not have a creative bone in my body." "I still draw stick figures of the human person." "I failed my art class in undergraduate school." Students are relieved when examples of creative work are explored, honoring the depth and breadth of creativity:

- Animation
- Altars
- Body art
- Calligraphy
- Cinema
- Collage
- Comic writing
- Dance
- Digital art
- Digital storytelling
- Drawing
- Engraving
- Fractal art
- Gastronomy
- Gold smithery, silver smithery, and jewelry
- Graffiti
- Hip-hop
- Mask-making
- Micro architecture
- Mixed media in visual art
- Murals
- Music
- Opera
- Painting
- Performance art
- Photography
- Photovoice
- Podcasting
- Poetry
- Pottery
- Print
- Quilt making
- Screenwriting
- Sculpture
- Shield
- Singing
- Theater
- T-shirt printing
- Woodworking
- Writing

In this assignment, it is suggested that during the process of self-reflection and creating artwork, students make a place for themselves and in their

schedule to both process the art experience and create the art piece. Further, it is essential to attempt to remove inhibition and judgment of themselves in the creation process. We suggest that students stay close to the art and pay attention to the act of creating. "What is happening to you emotionally?" "What insights are coming up?" "What are new ways of understanding yourself?"

On weeks 13 and 14 of a 15-week semester, students present their artwork in a nonjudgmental healing circle, which has been nurtured, it is hoped, through the semester using relational skills. Students share their expressive artworks by responding to and focusing on some of the prompts below for disclosure:

- Describe the work created—color, texture, material, design, and more.
- What inspired you?
- In the creation of your artwork, what worked, what didn't work, what surprised you, what frustrated you?
- What was the deeper reflection or insight that you developed in creating this artistic piece?
- Did the process of creating your artwork have a therapeutic/healing value? If so, how? If not, why did this experience not personally work for you?
- How may the expressive arts have a therapeutic/healing value for your future clients?

The moment is honored as students respond to the artwork, the creative act, and what it brings up for them. I attempt to refrain from using the word *beautiful* or *incredible* during the group sharing because it places an aesthetic value on the artwork. In the final analysis, the work focuses on process and insight, not content. See Table 3.1 for the three areas that are part of the assessment of this assignment.

IMPLICATIONS FOR FIELD EDUCATION

Social work students desire specific protocols and interventions they experience and utilize in practice settings. Besides attunement, respect, and presence, students share that they also want interventions for specific problems with particular populations. Expressive arts within a liberatory practice framework offer students both a conceptual model and a practical application. Students express gratitude and appreciation for the assignment and contemplate a future-oriented use of the arts in their practice. One example is offered by Mane, a student, who used a graphic convention through the use of speech balloons to explore the internal messages of her clients experiencing sociopolitical oppression along with her cognitive thoughts of empowerment (Figure 3.1).

Table 3.1 EXPRESSIVE ARTS-AS-REFLECTION GRADING RUBRIC

Category	Mastery	Partial mastery	Progressing
Creativity: 30%	Student has taken the artwork in a way that is totally his/her own. The student's personality/voice comes through in the artistic piece.	Student attempted to personalize the artwork but found it difficult to create an artwork that was uniquely his/her own.	Student appears to have put little creative energy into making this artwork a personal exploratory project about self.
Time and effort: 30%	Time was used wisely, and effort went into the planning and design of the artwork.	Student struggled in finding the time to plan and design the artwork, but a strong effort was made nonetheless.	Time was not used wisely in the planning and design of the artwork. Student described doing the artwork at the final moment.
Reflection/insight of self: 40%	Reflection or insight about the self, both personal and professional that is, developed in creating and finishing this artistic piece are honest, transparent, and described a personal striving about the student.	Student has the capacity to express a deeper understanding of self through the artwork, but insight into the development of personal and professional self is still a challenge.	There was little or no reflection or insight about the process of creating an artwork.

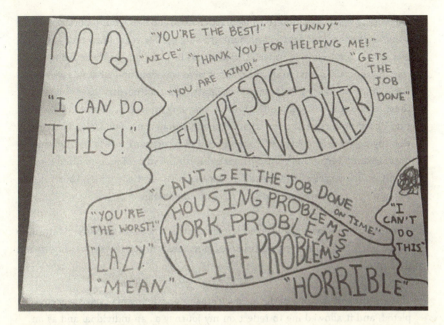

Figure 3.1 Graphic with speech balloons.

Mane reflected on the critical practice of self-care as she must be a container for the pain of the traumatic symptoms among marginalized communities.

> This assignment helped me rekindle my childhood love for art, and transform that past passion into a tool that can be incorporated in my present career as a social work student. This eye-opening experience pushed me to create a project that bridges the gap between my personal thoughts and experiences in life and in my career, and the thoughts, sayings, and actions of my clients. As a result, I've learned to understand that as we continue to help people at different and often tumultuous points in their lives, social workers need to actualize the concept of self-care so we can take care of ourselves while we're taking care of others.

Liberation practice honors the voices of those considered voiceless. Creativity is responsive. "As we breathe suffering out into our creative work more and more, we may also find ourselves becoming deeply compassionate—toward ourselves and others" (Quibel et al., 2019, p. 186). Student Jacqueline confronted the burdens of her own experiences—"You look prettier when you keep your mouth closed"—and recognized that many in the community where she resided hear the same message. Her poem, voice:

Calladita te ves mas bonita/You look prettier when you keep your mouth closed/ These were the words that followed me growing up/For years I saw many black and brown communities suffer in silence and in pain/One of those being my own/I was afraid/Afraid to speak up about what was right and what was wrong/ See/Silence was all I ever knew/Uncertainty, fear and poverty have followed these communities/Communities broken, yearning for help in silence/What can I do?/I am powerless/The questions that ran through my mind/Not knowing that my power is in my voice/Speaking up/Taking action/I slowly realized that my voice is powerful/The voice of those unheard/The voice of marginalized communities/The voices of those afraid to speak up/Tu voz tiene poder/Your voice has power/Tu voz crea cambio/Your voice creates change.

For Jacqueline, her poetry carried legitimacy as it was an artistic attempt to exorcize both her demons and those of her community through a liberation framework:

This assignment was one of the most eye-opening assignments I have ever completed, and it allowed me to reflect on my journey as an individual and as an emerging social worker. Through this assignment, I was able to understand the reasoning behind my passion for social work and how I can use my voice and knowledge to speak up for marginalized communities. Getting to use art as therapy provided me with a sense of comfort and gave me the space to reflect on the challenges/trauma I have endured and allowed me to begin my healing journey.

CONCLUSION

In an unjust world structured to promote complicity with our own oppression and the acceptance of pathologies of power, social work graduate programs must find a synergy that connects EBP protocols and affective-based learning as the ideal in the classroom. On occasion, concepts such as radical liberation, critical consciousness, solidarity, and liberatory arts become sidelined as "extras" only taught by those "radical professors." Liberation is a verb. The expressive arts integrate liberation psychology and action through the liberatory arts. Field education is the appropriate setting for professors and field instructors to embrace the creative for emancipatory personal and communal purposes.

REFERENCES

Afuape, T. (2011). *Power, resistance and liberation in therapy with survivors of trauma: To have our hearts broken*. Routledge.

Afuape, T., & Hughes, G. (2016). Historical development of liberation practices. In T. Afuape & G. Hughes (Eds.), *Liberation practices: Towards emotional wellbeing through dialogue* (pp. 27–36). Routledge.

Almeida, R. V. (2019). *Liberation based healing practices*. Institute for Family Services.

American Psychiatric Association. (2022). Diagnostic and statistical manual of mental disorders (5th ed., text rev.). https://doi.org/10.1176/appi.books.9780890425787

Capous-Desyllas, M., & Bromfield, N. F. (2020). Field note—Exploring the use of arts-informed journaling in social work field seminars. *Journal of Social Work Education, 56*(1), 201–209.

Degges-White, S. (2011). Introduction to the use of expressive arts in counseling. In S. Degges & N. L. Davis (Eds.), *Integrating the expressive arts into counseling practice* (pp. 1–6). Springer Publishing Company.

Fernandez, J. S. (2020). Liberation psychology of and for transformative justice. In L. Comas-Diaz & E. T. Rivera (Eds.), *Liberation psychology: Theory, method, practice, and social justice* (pp. 91–110). American Psychological Association.

Foels, L. E., & Bethel, J. C. (2018). Revitalizing social work education using the arts. *Social Work With Groups, 41*(1–2), 74–88.

Gupta, N., Simms, E., & Dougherty, A. (2019). *Eyes on the street*: Photovoice, liberation psychotherapy, and the emotional landscapes of urban children. *Emotion, Space, & Society, 33*, 100627. https://doi.org/10.1016/j.emospa.2019.100627

Huss, E., Elhozayel, E., & Marcus, E. (2012). Art in group work as an anchor for integrating the micro and macro levels of intervention with incest survivors. *Clinical Social Work Journal, 40*, 401–411.

Lenette, C., Cox, L., & Brough, M. (2015). Digital storytelling as a social work tool: Learning from ethnographic research with women from refugee backgrounds. *British Journal of Social Work, 45*(3), 988–1005.

Martin-Baro, I. (1994). *Writings for a liberation psychology: Ignacio Marin-Baro* (A. Aron & S. Corne, Trans., & Eds.). Harvard University Press.

Micsky, T., & John-Danzell, N. (2021). Practicing self-care: Integrating a photovoice self-care assignment into a social work course. *Journal of Baccalaureate Social Work, 26*, 55–67.

Miller, S. D., Hubble, M. A., Chow, D., & Seidel, J. (2015). Beyond measures and monitoring: Realizing the potential of feedback-informed treatment. *Psychotherapy, 52*(4), 449–457.

Mishna, F., Wert, M. V., & Asakura, K. (2013). The best kept secret in social work: Empirical support for contemporary psychodynamic social work practice. *Journal of Social Work Practice, 27*(3), 289–303.

Moxley, D. P. (2013). Incorporating art-making into the cultural practice of social work. *Journal of Ethnic & Cultural Diversity in Social Work, 22*(3–4), 235–255. https://doi.org/10.1080/15313204.2013.843136

Prescott, D. S. (2017). Feedback-informed treatment: An overview of the basics and core competencies. In D. S. Prescott, C. L. Maeschalck, & S. D. Miller (Eds.), *Feedback-informed treatment in clinical practice: Reaching for excellence* (pp. 37–52). American Psychological Association.

Rasmussen, B. (2018). A critical examination of CBT in clinical social work practice. *Clinical Social Work Journal, 46*, 165–173.

Regan, S. (1994). A mutual aid based group role play: Its use as an educational tool. *Social Work With Groups, 15*(4), 73–87.

Rivera, E. T. (2020). Concepts of liberation psychology. In L. Comas-Díaz & E. Torres Rivera (Eds.), *Liberation psychology: Theory, method, practice & social justice* (pp. 41–52). American Psychological Association. https://doi.org/10.1037/0000198-000

Roy, A., & Manley, J. (2017). Recovery and movement: Allegory and "journey" as a means of exploring recovery from substance misuse. *Journal of Social Work Practice, 31*(2), 191–204.

Tamburro, A. (2013). Including decolonization in social work education and practice. *Journal of Indigenous Social Development, 2*(1), 1–16.

Tetloff, M., Hitchcock, L., Battista, A., & Lowry, D. (2014). Multimodal composition and social justice: Videos as a tool of advocacy in social work pedagogy. *Journal of Technology in Human Services, 32*, 22–38.

Trainin Blank, B. (2016). Hip-hop social work. *The New Social Worker: The Social Work Careers Magazine.*

Wang, C. C. (2006). Youth participation in photovoice as a strategy for community change. *Journal of Community Practice, 14*(1–2), 147–161. https://doi.org/10.1300/J125v14n01_09

Watkins, M. (2019). *Mutual accompaniment and the creation of the commons.* Yale University Press.

4

Creative Arts in Social Work Education

"Good Ideas," Domains, and Activities

LORI POWER

DOMAINS OF ART IN SOCIAL WORK PEDAGOGY

This chapter explores the many benefits of using the arts in the social work classroom. Social work, from its very inception as a profession, incorporated the arts, starting with the settlement house movement and the work of Ellen Gates Starr and Jane Addams. Although its use has been questioned and waned in the intervening years (Cohen Konrad, 2019a), there seems to be a growing consciousness and a resurgence of interest, aided in part by the newer neuroscience research that demonstrates its efficacy (Perryman et al., 2019; Vaisvaser, 2021).

The arts are invaluable in assisting students gain access to the intricacies of building relationships, the benefits of reflectivity, and learning academic content. Creative experimentation enhances communication with ourselves; with close associates; and with the larger world, all of which are foundational skills in social work practice. The classroom is an ideal environment where students have opportunities to experiment with the arts as they explore the complexities of social work. They can then imagine and practice how they might utilize arts modalities with future clients. Experimentation with different modalities additionally helps students find their comfort with methods before formally incorporating the arts into their professional social work practice. In the following sections, I delve into specific examples of how and why I use the arts in social work pedagogy; explore the possibilities of each modality; and, I hope, inspire educators to try similar approaches with their students.

This chapter describes four specific domains of arts in the classroom: kinesthetic movement/dance, theater, music, and writing. We explore how each modality is applied; how students engage with it in the classroom; and the skills it provides to work with and advocate for clients at micro, mezzo, and macro levels. I illustrate experimentation from a specific graduate-level course, Use of Creative Arts in Social Work Practice, although the ideas introduced here can be (and have been) modified and applied to other courses in the social work curriculum. Activities and experiences utilized in the classroom align with the philosophy of the field of expressive arts writ large (i.e., that the arts can be used in conjunction with other therapies and pedagogies as a way to explore the self and as a means for growth and transformation, both personal and social) (International Expressive Arts Therapy Association, 2017) and with the revitalization of social work education (Foels & Bethel, 2018).

THEORY, PEDAGOGY, AND PREFERENCE

I embrace social constructivist learning theory (Vygotsky, 1978) and have written (Power & Sistare, 2019) about Paulo Freire's antioppressive education (1970) and the use of the arts, specifically creative writing, in social work education to enhance student learning. Social constructivism connects with the fundamental educational concept, attributed to linguist James Britton, that "being told is the opposite of finding out." Learning is social and requires experimentation. To learn something new, we must play with ideas and "try out" diverse interactions with others. This is the fundamental epistemology of social work education, including arts and social justice education.

According to Bloom (1965, cited in Huitt, 2011), American postsecondary education focuses disproportionately on the cognitive domain. In social work, however, emotion intersects with learning (Foster & Keane, 2019; Tyng et al., 2017), requiring that affective and psychomotor domains not be overlooked so that students effectively and variably process, incorporate, and integrate new information. Visceral and kinesthetic approaches are effective as well and are of particular value in connecting students with concepts of social determinants, social justice, and inclusivity throughout their educational experiences.

That said, not every arts modality resonates with every student. At the beginning of the Creative Arts in Social Work Practice course, I emphasize that we will be experimenting with many arts modalities, and not every experience is going to be comfortable, or one that they will choose to use in future practice. However, I suggest that students try out the different modalities and to be both open and vulnerable to new possibilities that may stretch their range of prior experience. I encourage openness and vulnerability to gently enact what it might be like for clients who are being asked to be vulnerable in our

presence. Modeling vulnerability is a way to prepare students to experience discomfort, tolerate mistakes, and learn from and respectfully share their reactions. To establish a safe enough space for taking chances, I share that although comfortable with physical movement and acting exercises, I feel insecure about drawing and the visual arts. Such self-knowledge is important and worthy of exploration, and together we will build an environment in which reflexivity and openness are welcome.

In the service of creating an optimal environment for experimenting with the arts, I offer educators these four "good" ideas: First, instructors must participate in arts activities with learners. Educators must be willing to be vulnerable and engage in every activity to lend credence and legitimacy. Second, students should be offered examples of how others have engaged with each activity, including my own, to make it acceptable to do art even if one is not artistically inclined.

The third good idea is to remind students that arts in the social work classroom (and with future clients) is about process, not product, and learning with and from each other through the process. Process orientation aligns with expressive arts philosophy (Gerber et al., 2018) and leads to the fourth good idea: One must never interpret someone else's art. Instead, the role of the instructor is to notice and be observant; to gently inquire about choices made (colors, shapes, subject matter, e.g.); and to show interest in the meaning the artwork has for the maker. The product or performance is an avenue for discussion and exploration, not an item that can be interpreted in ways the artist did not intend.

The next sections explore the four art domains described above and offer examples of their deployment in the social work classroom and therapeutic methodologies. An additional section looks at other methods educators might want to explore in their arts and social work curriculum.

KINESTHETIC/MOVEMENT DOMAIN

Much has been written about the overactive sympathetic nervous system (SNS). According to polyvagal theory (Porges, 2011), bodies exist within a certain level of activation due to the stresses of living and pressures of society. Conscious movement like dance and yoga send signals to the SNS to know we are safe, which in turn helps our bodies to relax and repair physiological damage affected by trauma, increasing serotonin uptake, and decreasing secretions of cortisol (the stress hormone). Simply speaking, the body interprets certain movements as "fun," which sends chemical signals to our brains telling us that all is well. Over time, as brains receive more positive messaging, our bodies learn to be less reactive and can more readily return to parasympathetic nervous system functioning, lowering hypervigilance and allowing the

body to be less activated ("rest and digest" or "tend and befriend") (Sullivan et al., 2018).

Yoga and trauma researchers have identified two concepts related to body activation: proprioception and interoception. Proprioception is defined as the overall sense of the body's position and location in space, often called "the sixth sense" (Walker, 2014). Interoception is described as awareness of sensations inside the body, such as breathing, hunger, and recognition of emotions related to autonomic nervous system functioning (Price & Hooven, 2018). People who have experienced trauma or prolonged toxic stress may have insufficient proprioception, meaning that they have decreased awareness of where their bodies are located in space and/or difficulties with interoception, unable to interpret how their bodies feel (Sullivan et al., 2018). According to researchers, kinesthetic experience aids in restoring these functions, leading people to become more centered and comfortable in their bodies (Koster, 2020; Weitz & Opre, 2020).

Movement and conscious embodiment exercises compliment cognitively oriented activities and therapies. Our bodies contain memories and energy that can be expressed physically (Koster, 2020). Cognitive/behavioral methods address logic, awareness, and conscious thought, and with practice, clients learn to navigate difficult emotions and overcome destructive behaviors. Together with kinesthetic activities, cognitive work expands the range of health and wellness to allow for the embodiment of change expressed in verbal and in nonverbal ways (Weitz & Opre, 2020).

Kinesthetics and movement can be experientially taught in the classroom in myriad ways. An introductory exercise I use to connect with students' nonverbal, nonlogical parts of themselves is juggling. Students are initially surprised when instead of beginning the course with a review of the syllabus, I open a large sack of potatoes and invite them to stand in a circle. Patiently and methodically, I teach them how to juggle using one potato at a time. The activity quickly engages an exchange of thought and movement, sometimes with nervousness, always with laughter. We then debrief the exercise, and like many concepts, what people think of as juggling—what they assume—is different from what juggling actually is. They recognize how assumptions are inhibiting, often causing people to repeat erroneous beliefs or behaviors and avoid change.

For example, a student might comment: "I can juggle two balls! But I can never get to three." When collectively examined, students discover that they are actually juggling the two balls incorrectly. They then technically recalibrate, and with practice, repetition, and growing confidence, they easily progress to juggling three balls. Following the juggling exercise, students are asked to consider their thoughts while juggling. Invariably students report that they were totally focused on juggling unengaged in typical mind chatter. Juggling is meditative. It is mindfulness in action.

Juggling is a useful metaphor for many things: learning new material, unlearning myths, or repairing misunderstandings; learning something step by step, scaffolding what we don't know on top of what we do; and building a foundation from a solid base (Vygotsky, 1978). From a social constructionist standpoint, juggling is used to co-construct what it means to be a juggler within a shared reality of learning. It also applies to the commitment to practice; to establishing a safe enough environment for making mistakes and not taking oneself too seriously. Scientifically, juggling illustrates the brain's neuroplasticity—that "neurons that wire together, fire together" (a phrase first coined by Donald Hebb, a Canadian neuropsychologist, in 1948). Trying something new changes and strengthens brain function, leading to enhanced coping and tolerance (Phillips, 2017).

From juggling, we transition to movement exercises, mirroring activities, and physical movement games like walking in rhythm with one another. Although dancing is a logical kinesthetic activity, many people become self-conscious; they do not identify as "dancers" and thus do not want to be observed dancing. Movement-only exercises provide nonperformative avenues for people of all abilities and inclinations to experience moving together, feeling safe, and feeling seen (van der Kolk, 2014). Students who care to experiment with dance can do so on their own or in group practices using ecstatic dance, yoga dance, 5Rhythms (https://www.hudsonvalley5rhythms.com/about5rhythms), all of which are part of the therapeutic unchoreographed movement to rhythm, inspired by Gabrielle Roth in the 1970s. Individuals might further explore the correlation between movement and emotion (Koch et al., 2019), or they may simply dance alone.

In the next section we move from individualized movement awareness or "me" to the more relational experience of "we." Theater-based learning and therapeutic methods are group based. The goals are improving communication, establishing connection, and learning with and from each other about ourselves, our communities, and the greater global society.

THEATER-BASED DOMAIN

Modern theater is thought to have begun with the ancient Greeks, created not merely for entertainment but as a tradition of honoring gods, passing on cultural history, creating community, and teaching ethical and civic lessons. Today, theater is used similarly: to speak to ethical and civic dilemmas, to highlight matters of known and unknown history, and to bring people together in community to learn about and with each other. Theater-based activities are also used to promote insight and empathy through affective and immersive learning.

Paolo Freire's (1970) concept of popular education, which informed Augusto Boal's theater of the oppressed (Boal, 1974/1993), is often cited as inspiration for social work education. Freire's popular education encouraged people to be actors/agents actively involved in knowledge cultivation. Active learning questions and analyzes the status quo, deconstructing it to make sense according to evolving perceptions and lived experience. Unlike traditional forms of education, popular education veers away from learners simply banking ideas deposited by privileged experts. Its goal is to foster learning that is transformative and aimed at creating a more equitable society (Freire, 1970).

Inspired by Freire's work, Boal used performance to formulate ideas for social activism, conflict resolution, and community organizing. Theatre of the oppressed highlighted mechanisms of oppression and exploitation, bringing both actors and spectators on the stage to examine inequities within their lives and communities. Social work educators using theater apply it to a range of modalities: the micro level of role playing (Fulton et al., 2019; Hargreaves & Hadlow, 1997); the mezzo level of group performance or psychodrama (Giacomucci, 2021; Konopik & Cheung, 2013); and the macro level, creating productions for social change (Shah & Thennakoon, 2019). Principles of theater-based activities promote group work, empathy, and affective learning and helping people explore their own and other's ideas.

Bessel van der Kolk (2014), psychiatrist and author, proposed that theater can be used therapeutically and educationally with nonactors, allowing for "confrontation of the painful realities of life and symbolic transformation through communal action" (p. 337). From a therapeutic standpoint, van der Kolk proposed that, after experiencing trauma, feeling anything can be emotionally overwhelming. Trauma survivors may not want to feel or be seen; they want to hide their emotions, even though in the end they become isolated and alone. Dissociation is not an uncommon coping device used by individuals to shield from pain. van der Kolk suggested that theater offers a safe place for people to process and tolerate their emotions. He posited that personal agency and self-control are critical to human connection, and theater provides a framework in which people can systematically gain confidence in relating to and being understood by others.

Theater in the classroom is meant to be illustrative, not therapeutic. A trauma-informed approach to theater-based activities recognizes that any given student may have a trauma history. Participation in theater must therefore be voluntary, structured, and cautiously approached, for example, working up to something as simple as eye contact, gently building trust within a group. Social work educators often use theater games as introductory icebreakers to generate such trust and foster group cohesion. Students participate in ethical decision-making by playing out scenarios

dramatizing quandaries and dilemmas. Role playing unique points of view (e.g., client, family member, social worker, other relevant players) makes the scenario more complex as students experience diverse and sometimes conflictual viewpoints and engage with critical thinking. The exercise concludes with students collectively determining a final, unequivocal, ethical decision, something they'll have to do in real-world practice. Such theater-based activities offer creative exploration of complicated and ambiguous situations that have no clear-cut solutions.

Creating human sculptures is another "we" classroom activity. One student takes on the role of sculptor, while the others are the sculptees. This activity requires a modicum of classroom trust and so should only be done well into the semester. Without words, and with consent from participants,* the sculptor silently moves the human sculptees to create shapes reflective of grand concepts (e.g., oppression, access to healthcare, and racism). Reflectivity and debrief are key to the sculpting exercise. It's not the sculpted product that matters; rather, it's about the felt expression of whatever topic is being depicted and also the reasons why students chose how to portray it.

The debrief is an opportunity for students to discuss impressions and observations. How might the subject be otherwise represented? What's missing? How might groups create different sculptures with the same title, and why? Instructor facilitation is critical to the success of the sculpting exercise, as is their responsibility to establish a safe enough environment for difficult conversations. Instructors encourage curiosity, challenge assumptions, and respectfully address microaggressions. Generative inquiry, awareness of self in relationship to others, and understanding the nuances and messages conveyed by the sculptor are goals of the exercise.

Reader's theater (Savitt, 2002) is another powerful theater-based classroom and community activity. It has been used in various forms since the ancient Greeks and is one of the strategies utilized in theater of the oppressed (Boal, 1993). In reader's theater, people are assigned roles from a predetermined script and then read their parts aloud, either for an audience or as a closed group. Reading rather than simply listening can be revelatory, which is what occurred when students read a play in my classroom about sex trafficking, which was authored by a person who had been trafficked and co-written by others who had also survived. When students read this play aloud, they learned about sex trafficking in an embodied, light-instigating visceral and empathic, nonjudgmental understanding for those being trafficked.

*. The assignment can be modified to include verbal instructions if participants prefer not to be touched (MacRae & Pardue, 2007; Savitt, 2002).

MUSIC-BASED DOMAIN

Music is visceral and embodied. When asked about a favorite song, people rarely describe the music. Rather they speak to how the music makes them feel or recall memories that the melody evokes. According to Papinczak et al. (2015), we are deeply connected to music throughout our lives. Studies with older adults living with dementia found that the music of their youth is a powerful tool for connection, reconnection, and finding meaning if only for a passing moment (Paolantonio et al., 2022). The 2014 film *Alive Inside* is one I use in class to illuminate the evocative quality of music, how it resurfaces previously unavailable emotions and memories for people living with dementia (http://www.aliveinside.us/#land). This neurological reawakening occurs because music stimulates dopamine, a type of neurotransmitter—a cell-to-cell messenger—associated with pleasure and learning.

Music also serves other physiological purposes. Music therapists find that singing can mitigate the debilitating impacts of speech and language disorders, helping people to gain confidence in using their voice. Music can also affect the heartbeats and stress levels of premature infants in neonatal intensive care units. According to Arnon and colleagues (2006), music therapy is a preferred nonpharmacological, nonintrusive approach to support premature infants recovering from necessary yet stressful or painful procedures.

Listening to music is one thing; making music is another. Most children sing freely and without reservation. Social learning, however, is highly influential, and as we grow, people become inhibited when they realize that their voices don't sound like popular singers or more "talented" peers. Cultural norms and gender also affect confidence in making music. For instance, Robson's study (2018) found that participants preferred male over female spoken voices, creating a gendered perception of what a "good enough" voice might be. Wilkin (2012) suggested that the idea of singer versus nonsinger is unique to Western cultures inhibiting people from freely engaging in vocal expression. Such reluctance is regretful as growing evidence suggests that making music has positive and healing properties (Fancourt et al., 2022; Williams et al., 2018).

Given cultural and maturational factors, educators can expect that social work students may enter the classroom reluctant about making music. To gently prepare them, I ask that in the privacy of a chosen place, they sing uninhibitedly, as loudly and as full-throated as possible. Encouraging students to boldly use their voices to test out the range of its power proves a potent experiment. Most report back that they experienced an unexpected and pleasurable release when they allowed themselves to vocalize without reservation. Learning the power of voice builds confidence, an attribute that is transferable from art to advocacy and other empowering skills needed for social justice practice with clients. Self-confidence can also be strengthened through music. Representatives from the Ukulele Kids' Club (https://theukc.org/) are

frequent guests, bringing enough ukuleles to my classroom so that everyone has a chance to play. Learning collectively is challenging, exposing everyone to the foibles inherent in change. Students are encouraged to learn with and from each other, gaining comfort in being publicly vulnerable, something that both they and their clients will experience at times in practice.

Music also opens windows to meaning making. This is true for people of all ages but especially for youth experiencing disconnection or struggling with conflicts around identity (see Chapter 2). To better understand the phenomenology of music, I ask students to share musical favorites with one another. What is it about the song or instrumentation that moves them? Is it the rhythm, lyrics, melody, or memories it surfaces? Another music-based classroom exercise, originated by a student, uses storytelling and musical teachback. Students are paired, and then one tells the other about a meaningful event. The listener then "tells" the story back, but without words, selecting two or three musical instruments (e.g., harmonicas, small drums, kazoos, recorders, tiny cymbals, a guitar) to convey the emotions of the story through sound. They then check back to see if the story's essence has been captured, embarking on meaningful exchange, telling and retelling to ensure that the student who conveyed the story feels heard and understood.

Willingness to listen has relationally significant properties. Producing and listening to music is a valuable tool for establishing mutuality and trust. It validates and conveys respect for what matters to that person and shows desire to get to know their world. Taking the time to listen together further conveys a sense of genuine caring, which can incentivize the healing process (Cohen Konrad, 2019b). Expressing curiosity promotes meaningful and co-constructed exchange that can be used as a strategy for learning about and connecting with clients.

Music is also a vehicle for establishing community connections and promoting social justice. It has been effectively utilized to advocate for racial and gender equity, raise awareness of environmental issues, protest war, and generate empathy for the plight of refugees and other marginalized populations. There are countless possibilities for harnessing music's potentialities at the macro level, one example being benefit concerts, which generate group cohesion and bring attention to pressing social problems and discriminatory practices. Songs like "We Shall Overcome" (https://www.youtube.com/watch?v=QhnPVP23rzo) generated in the 1960s endure as anthems for civil rights. The Estonian Singing Revolution of the late 1980s brought forth communal self-determination for Estonians escaping from a brutal Soviet regime.

One of my class assignments asks students to bring the versatility of music to a community-based project, one that is a collaboration with a program. One memorable activity orchestrated by students was a concert with a group called Listen Up!, an organization that supports people who have developmental uniqueness (https://listenupmusic.org/). This musical ensemble rarely

gets to perform publicly, so planners made certain that anyone who wanted to, had an opportunity to participate. The Listen Up! entourage didn't disappoint, sharing original compositions and getting the crowd to sing along. Students also benefitted from the performance and learned firsthand about the meaning music has for people often shunned by society.

WRITING DOMAIN

The written word is both received and given in the form of novels, poetry, or creative nonfiction that introduces people to new worlds and ideas, what psychoanalyst Donald Winnicott called "the third thing" (cited in Community Care, 2010). Fictional writing creates emotional distance between one's own life and those of storied characters. For example, a fantasy novel such as N. K. Jemison's *Broken Earth* trilogy (2015) offers a lens into White supremacy, environmental crises, and other realities of 21st-century America from a safe distance. Through her characters, the novelist Dorothy Allison (1992/2012) opened up channels for abuse survivors to read their story from another voice in *Bastard Out of Carolina*. And the great Nigerian writer Chimamanda Ngozi Adichie's narratives remind us that there is no one single story or truth, and that we must be willing to confront implicit and explicit biases.

Writing and journaling are potent techniques, even for people who consider themselves nonwriters. Much has been written about their therapeutic and analytical learning impacts (Foster & Keane, 2019; Godfrey-Isaacs, 2019; Tyng et al, 2017; Ulrich & Lutgendorf, 2002). So how do we explore the benefits of writing with students? One way for students to gain comfort with writing is to make it routine. In all my classes, arts or otherwise, I ask students to free write for 5 minutes after being exposed to a new concept or a particularly provocative activity. They are instructed not to worry about punctuation or spelling and are assured that their narratives are confidential. Free writing is designed to be uninhibited and gives students time to process new or challenging ideas prior to class discussion. Students also engage with writing in a number of other ways. We write poetry from prompts and formulas (e.g., "I am From"), which provides a structure so that students don't feel intimidated by the blank page. They also use word banks, shared storytelling games, or magnetic poetry. I offer a broad array of writing samples to introduce students to myriad ideas that can come from a single prompt.

Once students have experimented with writing exercises, they explore ways in which they can be used to work with clients. One particularly powerful example comes from a course I co-created with a former student on writing with jail residents. In the first half of the course, students learn about the exigencies of carceral life, its challenges and enforced limitations, along with trauma-informed theories and practices (https://ncsacw.samhsa.gov/

userfiles/files/SAMHSA_Trauma.pdf). Most students know very little about the lives and unique vulnerabilities of people who are incarcerated. For example, people lose the right to privacy when in jail. While students consider journaling as a means of personal expression, there could be danger for a jail resident if their private thoughts are revealed. Journals can be confiscated and used against them while in jail or when being sentenced. Students are also not aware of the residents' levels of literacy, thus activities must be carefully designed so they do not provoke shame or unintended harm. In our experience (see Power & Sistare, 2019), writing exercises in jail proved successful in promoting group cohesion, encouraging voice, and fostering self-discovery for residents and students alike.

STORY AND IMAGE

Two additional modalities, story and image, benefit arts-based social work education. Storytelling is multipurpose. It elaborates on ideas; enhances humility, compassion, and empathy; and allows the teller to take on alternate personas and configure alternative endings and future possibilities in their narratives. Storytelling aligns with constructs of narrative therapy (Madigan, 2019; White & Morgan, 2006), the primary premise of which is that stories make meaning of people's experience and open windows of understanding for therapeutic, healing, and social change. Storytelling sensitizes us to values, practices, and perspectives of other cultures and groups, breaking down assumptive barriers and building humble possibilities to get to know others outside of our familiar beliefs, experiences, and surroundings.

Representational images, such as murals, projections, photographs, sculpture, and other forms of public art, educate and connect people (see Chapter 1 by Peter Szto). Creating and viewing images, whether representative or abstract, lead to self-exploration of inner thoughts, ideas, and in some cases opinions about complex human and social issues. Carl Jung (1875–1961), founder of analytical psychology, explored the role of conscious and unconscious imagery in human psychology and neuroscience (Leigh, 2015). Jung posited that the collective unconscious, our deepest inner thoughts, is an aggregation of symbolic pieces of stories, experiences, interactions, and images, both individual and social, that accumulates over time (Leigh, 2015). The use of images such as mandalas and dream imagery, he suggested, can inform and enlighten the nuances of individual and collective identities. Jung's ideas have become well integrated into modern therapeutic practices.

Filmmaking is another powerful tool that combines stories and images to prompt inner and outer enlightenment. Movies bring us stories from underrepresented voices, depicting historical and contemporary characters living different values and sharing narratives that allow us to briefly enter their

worlds (see Chapter 5). Whether fiction or documentary, the filmmaker's goal is to generate curiosity, respect, understanding, and compassion for people, communities, and unfamiliar cultures. Beyond professional filmmakers, we live in a world where almost everyone has a phone that can produce and distribute video that captures visual stories. Such accessibility offers opportunities to share information and connect with people across the world and to raise previously unheard voices and provoke critical discussion. Although there are pitfalls to the ever-expanding digital culture, it has become a vital (and viral) form of communication (Shifman, 2013).

CONCLUDING THOUGHTS

Contemporary society is rife with endless, highly accessible possibilities for creative exploration. In social work education, activities using the expressive arts assist students to think critically, reflexively, and enhance affective learning skills commensurate with the values of the profession and identified in the National Association of Social Workers "Code of Ethics" (2017). Use of the arts urges students to see the world from multiple vantage points and to examine beliefs, assumptions, and biases that inhibit quality of life for all, inclusion, equity, and social justice.

There is one important caveat, however. Although arts-based social work education is primarily process oriented, it is important to ensure that it is achieving credible learning outcomes. Student learning must be continually evaluated so that assignments and activities are achieving core objectives aligned with the Educational Policy and Accreditation Standards, professional competencies, and the values of the field. It has been my observation that art-based activities and assignments offer evidence that students have integrated both cognitive and affective knowledge of social work constructs. An academic paper fulfills a final assignment, sharing new knowledge through production or performance illustrates coherency and resonance with the content studied. Such knowledge might be represented by a reader's theater production about food disorders; it may be a storytelling hour told by people struggling with addictions or a slam poetry event addressing experiences of racism. Presenting such projects to community audiences encourages experimentation and commitment. It also has the benefit of giving students with learning differences opportunities to express new knowledge through non-traditional academic platforms, for example, artworks, podcasts, and videos, among many other modes of expression.

It is my hope that this chapter inspires social work faculty to expand students' learning experiences—not to mention their own—by explicitly using the arts in both their pedagogy and educational assessment. This chapter can be a starting place, a toolbox full of reasons and strategies for working

in innovative and authentic ways that students can extend into their professional careers.

REFERENCES

Allison, D. (1992/2012). *Bastard out of Carolina: A Novel*. Penguin Book.

Arnon, S., Shapsa, A., Forman, L., Regev, R., Bauer, S., Litmanovitz, I., & Dolfin, T. (2006). Live music is beneficial to preterm infants in the neonatal intensive care unit environment. *Birth, 33*(2):131–136. https://doi.org/10.1111/j.0730-7659.2006.00090.x

Boal, A. (1993). *Theatre of the oppressed*. Theatre Communications Group.

Boal, A. (1993). *Games for actors and non-actors* (2nd ed.). CTO.

Cohen Konrad, S. (2019a). Art in social work: Equivocation, evidence, and ethical quandaries. *Research in Social Work Practice, 29*(6), 693–697.

Cohen Konrad, S. (2019b). *Child and family practice: A relational perspective* (2nd ed.). Oxford University Press.

Community Care. (2010). Play and creative arts help children in care explore their lives. *Personnel Today*. https://www.communitycare.co.uk/2010/04/22/play-and-creative-arts-help-children-in-care-explore-their-lives/

Fancourt, D., Finn, S., Warran, K., & Wiseman, T. (2022). Group singing in bereavement: Effects on mental health, self-efficacy, self-esteem and well-being. *BMJ Supportive and Palliative Care, 12*(4), e607–e615. https://doi.org/10.1136/bmjspcare-2018-001642

Foels, L. E., & Bethel, J. C. (2018). Revitalizing social work education using the arts. *Social Work With Groups, 41*(1-2), 74–88. doi:10.1080/01609513.2016.1258621

Foster, M. I., & Keane, M. T. (2019). The role of surprise in learning: Different surprising outcomes affect memorability differentially. *Topics in Cognitive Science, 11*(1), 75–87.

Freire, P. (1970). *Pedagogy of the oppressed*. Continuum.

Fulton, A. E., Dimitropoulos, G., Ayala, J., McLaughlin, A. M., Baynton, M, Blaug, C., Collins, T., Elliott, G., Judge-Stasiak, A., Letkemann, L., & Ragan, E. (2019). Role-playing: A strategy for practicum preparation for foundation year MSW students. *Journal of Teaching in Social Work, 39*(2), 163–180. https://doi.org/10.1080/08841233.2019.1576573

Gerber, N., Bryl, K., Potvin, N., & Blank, C. A. (2018). Arts-based research approaches to studying mechanisms of change in the creative arts therapies. *Frontiers in Psychology, 9*, 2076. https://doi.org/10.3389/fpsyg.2018.02076

Giacomucci, S. (2021). *Social work, sociometry, and psychodrama: Experiential approaches for group therapists, community leaders, and social workers*. Springer. https://library.oapen.org/handle/20.500.12657/47303

Godfrey-Isaacs, L. (2019). Maternal journal: How creative journaling can support pregnant women, new mothers, and those that birth, with a history of mild to moderate mental health problems. *Perspectives in Public Health, 139*(3), 119–120. https://doi.org/10.1177/1757913919838759

Hargreaves, R., & Hadlow, J. (1997). Role-play in social work education: Process and framework for a constructive and focused approach. *Social Work Education, 16*(3), 61–73. https://doi.org/10.1080/02615479711220241

Huitt, W. (2011). Bloom et al.'s taxonomy of the cognitive domain. *Educational Psychology Interactive*. Valdosta State University. http://www.edpsycinteractive.org/topics/cognition/bloom.html

International Expressive Arts Therapy Association. (2017). Home page. https://www.ieata.org/

Jemisin, N. K. (2015). *The broken Earth trilogy*. Hachette Book Group.

Koch, S. C., Riege, R. F. F., Tisborn, K., Biondo, J., Martin, L., & Beelmann, A. (2019). Effects of dance movement therapy and dance on health-related psychological outcomes. A meta-analysis update. *Frontiers in Psychology, 10*, 1806. https://doi.org/10.3389/fpsyg.2019.01806

Konopik, D., & Cheung, M. (2013). Psychodrama as a social work modality. *Social Work, 58*(1), 9–20. http://www.jstor.org/stable/23719587

Koster, A. (2020). Longing for concreteness: How body memory matters to continuing bonds. *Mortality, 25*(4,) 389–401. https://doi.org/10.1080/13576275.2019.1632277

Leigh, D. J. (2015). Carl Jung's archetypal psychology, literature, and ultimate meaning. *URAM, 34*(1–2), 95–112.

MacRae, N., & Pardue, K. T. (2007). Use of readers theater to enhance interdisciplinary geriatric education. *Educational Gerontology, 33*(6), 529–536. doi:10.1080/03601270701328920

Madigan, S. (2019). *Narrative therapy* (2nd edn). American Psychological Association. https://itachicago.org/musical-bridges-to-memory/?gclid=CjwKCAjw7c2pBhAZEiwA88pOFyW_1Agpj0iU6w4h43RB8NviC17KN26WpBcADx9s8BNPO7SHBF9z9xoCSFkQAvD_BwE

National Association of Social Workers. (2017). Code of ethics of the National Association of Social Workers. https://www.socialworkers.org/About/Ethics/Code-of-Ethics/Code-of-Ethics-English

Paolantonio, P., Pedrazzani, C., Cavalli, S., & Williamon, A. (2022). Music in the life of nursing home residents. *Arts & Health, 14*(3), 309–3235. https://doi.org/https://doi.org/10.1080/17533015.2021.1942938

Papinczak, Z., Dingle, G. A., Stoyanov, S., Hides, L., & Zelenko, O. (2015). Young people's uses of music for well-being. *Journal of Youth Studies, 18*(9), 1119–1134. https://doi.org/10.1080/13676261.2015.1020935

Perryman, K., Blisard, P., & Moss, R. (2019). Using creative arts in trauma therapy: The neuroscience of healing. *Journal of Mental Health Counseling, 41*(1), 80–94. https://doi.org/10.17744/mehc.41.1.07

Phillips, C. (2017). Lifestyle modulators of neuroplasticity: How physical activity, mental engagement, and diet promote cognitive health during aging. *Neural Plasticity, 2017*, Article 3589271. https://doi.org/10.1155/2017/3589271

Porges, S. (2011). *The polyvagal theory: Neurophysiological foundations of emotions, attachment, communication, and self-regulation*. W. W. Norton & Company.

Power, L. G., & Sistare, H. (2019). Writing in jail: A community-engaged, social work course model. *Journal of Social Work Education, 57*(2), 316–331. https://doi.org/10.1080/10437797.2019.1671259

Price, C. J., & Hooven, C. (2018). Interoceptive awareness skills for emotion regulation: Theory and approach of mindful awareness in body-oriented therapy (MABT). *Frontiers in Psychology, 9*, 798. https://doi.org/10.3389/fpsyg.2018.00798

Robson, D. (2018). The reasons why women's voices are deeper today. *BBC Worklife*. https://www.bbc.com/worklife/article/20180612-the-reasons-why-womens-voices-are-deeper-today

Savitt, T. (2002). *Medical readers' theatre: A guide and scripts*. University of Iowa Press.

Shah, A., & Thennakoon, K. (2019). Seven ways to create entertainment with impact. IDR. https://idronline.org/seven-ways-to-create-entertainment-with-impact/

Shifman, L. (2013). Memes in a digital world: Reconciling with a conceptual troublemaker. *Journal of Computer-Mediated Communication*, *18*(3), 362–377. https://doi.org/10.1111/jcc4.12013

Sullivan, M. B., Erb, M., Schmalzl, L., Moonaz, S., Jessica, N. T., & Porges, S. W. (2018). Yoga therapy and polyvagal theory: The convergence of traditional wisdom and contemporary neuroscience for self-regulation and resilience. *Frontiers in Human Neuroscience*, *12*, 67. doi:10.3389/fnhum.2018.00067. PMID: 29535617; PMCID: PMC5835127.

Tyng, C. M., Amin, H. U., Saad, M., & Malik, A. S. (2017). The influences of emotion on learning and memory. *Frontiers in Psychology*, *8*, 1454. https://doi.org/10.3389/fpsyg.2017.01454

Ulrich, P., & Lutgendorf, S. (2002). Journaling about stressful events: Effects of cognitive processing and emotional expression. *Annals of Behavioral Medicine*, *24*(3), 244–250.

Vaisvaser, S. (2021). The embodied-enactive-interactive brain: Bridging neuroscience and creative arts therapies. *Frontiers in Psychology*, *12*, 634079. doi:10.3389/fpsyg.2021.634079. PMID: 33995190; PMCID: PMC8121022.

van der Kolk, B. A. (2014). *The body keeps the score: Brain, mind, and body in the healing of trauma*. Viking.

Vygotsky, L. (1978). *Mind in society*. Harvard University Press.

Walker, E. (2014, October 27). Proprioception: Your sixth sense. Why movement and sensation are inextricably linked. *Northwestern University Science in Society: Helix Magazine*. https://helix.northwestern.edu/article/proprioception-your-sixth-sense

Weitz, N., & Opre, A. (2020). Therapists' attitudes towards the combined DMT and CBT treatment of children with anxiety disorders. *Cognition, Brain, Behavior. An Interdisciplinary Journal*, *24*(1), 35–56. https://doi.org/10.24193/cbb.2020.24.03

White, M., & Morgan, A. (2006). *Narrative therapy with children and their families*. Dulwich Centre Publication.

Wilkin, B. (2012). Three Northwest First Nations perspectives on the practice of drumming and singing: Expanding the dialogue on purpose and function. Retrieved from http://hdl.handle.net/1828/4309

Williams, E., Dingle, G. A., & Clift, S. (2018). A systematic review of mental health and wellbeing outcomes of group singing for adults with a mental health condition. *European Journal of Public Health*, *28*(6), 1035–1042. https://doi.org/10.1093/eurpub/cky115

5

Social Work and the Arts

Through the Student Lens

EMILY FRUMKIN, BRIANNA LEAR, JENNIFER SCHOCH,
SYDNEY SIEGEL, SHEFALI DUTT, AND MAX DEEB

STUDENT'S PERSPECTIVES ON THE ARTS AND SOCIAL WORK

In this chapter, we share as master of social work (MSW) students our experiences with art as a tool for reflection, growth, and empowerment and highlight the meaning of art in our personal and professional development. Kirkendall and Krishen (2015) suggested that within educational settings, professors often struggle with ways to infuse creativity within the context of the classroom. While we believe it is important to note the general absence of the arts in social work education, we also aim to identify the ways in which the arts were made accessible in our MSW program at the University of Southern California (USC) Suzanne Dworak-Peck School of Social Work. In this chapter, we describe how the arts were integrated into learning in and out of the classroom. These experiences enriched our understanding of art as a social work intervention, fostered personal insight, and supported healing. In our postgraduate lives, we continue to harness various art forms to engage with clients and practice self-care. It is our hope that sharing our personal narratives will offer a unique perspective on the discourse on social work and the arts.

ART IN THE SOCIAL WORK CLASSROOM: CREATIVITY IN PEDAGOGY AND CURRICULUM

Art moves people. It elicits complex neurophysiological, psychological, and social reactions that can have transformational effects on an individual's perceptions and actions in the world (Pelowski et al., 2016). The individual and communal biopsychosocial impact of art can be leveraged as a powerful learning tool, particularly in social work programs where students are called on to integrate complex societal problems with interpersonal experiences (Burton et al., 2000; Leonard et al., 2018). Incorporating arts-based mediums and creative self-expression into social work pedagogy enhances student learning, eliciting academic engagement, deeper memory formation, synthesis of micro and macro information, and invoking affective and relational experiences (Cramer et al., 2018; Franklin, 2010; Leonard et al., 2018; Linnenbrink-Garcia et al., 2016; Marshall, 2014). Art-making also aids in the development of valuable interpersonal skills necessary for successful and sustainable social work practice, including reflective thinking, self-expression, empathy, and perspective taking (Burton et al., 2000; Killian, 2008). We believe that these myriad benefits situate art as a uniquely transformative tool in social work education that enhances preparedness for the demands of professional life.

In the following case studies, Lear and Deeb, two authors of this chapter, describe the ways in which the arts were well integrated into their social work coursework. While their experiences were distinctive, each felt that the arts helped to sustain their commitment to social work practice during inevitable challenges and amidst professional and personal growth. Arts-based experiences further sparked confidence in their ability to work creatively with clients and advance social justice.

CASE STUDY 1: BRIANNA LEAR'S EXPERIENCE IN FIELD EDUCATION CLASS

During her first year in the MSW program, Lear participated in the required course, Applied Learning in Field Education, where students receive consultation and discuss professional development within the context of their varied field placements. The final assignment encouraged students to utilize the expressive arts to reflect on their growth over the year. This provided Lear with an opportunity to synthesize and process her experiences and emotions, some of which were painful, through music and singing. Such affective reframing reignited her passion and motivation to remain in the MSW program.

Lear felt a combination of hope, fear, and even a sense of emotional isolation while adjusting to graduate school and in her first-year field placement. She thought perhaps she was alone in her insecurities. For her final assignment presentation during class, she chose to perform a favorite song, one that articulated the growing pains of life and the decision to move toward the inevitable discomfort of growth. Learning and practicing this song was a cathartic experience. Performing and sharing her experiences with peers felt empowering and normalizing as others articulated similar struggles.

This experience transformed the learning space into a healing space and gave Lear a renewed sense of hope and confidence to continue into the second year of graduate school. In a field that requires emotional labor, a sense of connection and belongingness are vital to developing confidence and a sense of community that promotes resilience (Jordan, 2008; Levett-Jones & Lathlean, 2008; Moore et al., 2011). Lear observed that using art as a platform for emotional expression allowed students to vividly share stories. In turn, storytelling elicited a feedback loop of shared emotion, which enhanced a sense of camaraderie.

Though affective domains of social work practice are deemed vital, social work programs do not always effectively implement curricula to support development in these areas. Self-care is listed as a priority for the Council on Social Work Education (CSWE) (CSWE, 2020), and the process of affective awareness and regulation is one of four primary dimensions of learning within the nine core competencies of social work education (CSWE, 2015). However, in a survey of 786 MSW graduates from CSWE-accredited programs, Bloomquist et al. (2015) discovered that though many social work practitioners believed their MSW programs valued self-care, they reported that self-care practices were not effectively taught during their social work education (Bloomquist et al., 2015; Griffiths et al., 2019; Killian, 2008; Moore et al., 2011). The dissonance between the standards that prioritize self-care and affective learning and their implementation during MSW education is stark. Bloomquist et al.'s findings (2015) highlighted this gap and recommend intentionally creating and integrating art-based curricula like the one highlighted here into social work education.

Synchronizing values with pedagogy is critical to educating professional social workers. Through incorporating self-reflection, creative expression, and shared vulnerability into the curriculum, this first-year field class supported students in practicing affective and relational dimensions of social work practice in conjunction with gaining knowledge, skills, and values, setting a standard of pedagogy aligned with CSWE's holistic learning model. Ultimately, this experience inspired Lear, and she continues to use creative self-expression in her reflective healing and clinical work with children and youth.

CASE STUDY 2: MAX DEEB'S EXPERIENCE IN MEDIA IN SOCIAL WORK

As a first-year MSW student at USC, Deeb, a multimedia artist, selected to take the Media in Social Work course, taught by Professor Rafael C. Angulo (see Chapter 3). Angulo, a pioneer and advocate for integrated art and social work curriculum deeply influenced Deeb's understanding of the power of art as an invaluable tool for macro-level social work practice. Professor Angulo made clear the connection between artist and viewer and for Deeb, who co-chaired the SWAC; the course fit perfectly with the values and practices SWAC supported.

Course activities offered students a range of opportunities to demonstrate arts and social work integration. For example, as a required assignment, Deeb and his classmates were asked to conceptualize, construct, and publicly exhibit their artwork through filmmaking. Students produced short films and documentaries intended to raise awareness of challenging social justice issues. They studied films from diverse creators and collectives conceptualizing and framing the type of film they would ultimately produce for their final projects. Throughout the course, students engaged in writing, shooting, editing, directing, and screening short films, carefully circulating selected social justice topics relevant to the field of social work.

At the close of the academic year, the class hosted a student film screening for an audience of family, friends, faculty, the larger USC community, and members of local nonprofit organizations and charities (USHOULDSPEAK MUSIC, 2020). Deeb's film, *This Is Abel*, centered on the first-hand experiences of a young man from Los Angeles finding his way out from under the thumb of the juvenile justice system. In the film, Deeb highlighted the inefficacy of the juvenile justice system as well as the lived and long-term outcomes of inflicting such unnecessarily harsh, nonrestorative, and unjust treatment on youth.

The festival was a powerful culminating event, providing opportunities for students to witness the impact their art created in real time. Each film concluded with an audience question-and-answer forum, and attendees were invited to offer responses and feedback to each group of student creators. Deeb felt gratified to be regarded as both a social work student and an artist.

Deeb's commitment to using art as a lever to foster social justice was a critical outcome of Professor Angulo's course. Angulo had skillfully urged students to deliver their best work, allowing them opportunities to reimagine the ways in which they could enact societal change. This positive, generative outcome could not have been achieved without having felt valued as a learner and as a creator. Although no longer in the field, Deeb remains appreciative of his social work training. He believes that it opened new and innovative avenues to gain access to the complexities of person-centered work regardless of field of practice. Deeb continues to utilize art as a critical tool within his professional

life as an educator as well as in his personal life as a musician and visual artist. *This Is Abel* is accessible and may be viewed online: https://www.youtube.com/watch?v=kQ8q5qzXshU.

The next section describes student-led arts initiatives that took place outside of the classroom—in clubs and activities in the community. For us, these arts-based opportunities had both personal and professional impact, including enhanced empowerment, agency, and meaning through creating sustainable offerings for future students.

ART AND SOCIAL WORK OUTSIDE OF THE CLASSROOM: STUDENT-LED ENDEAVORS
The Social Work and the Arts Caucus

The SWAC at the USC Suzanne Dworak-Peck School of Social Work is a graduate student organization that provides opportunities for MSW students to connect their shared passion for bridging the profession with the expressive arts. SWAC organizes events that center on utilizing the arts for self-care and publishes the yearly *Soul Work Magazine*, a compilation of MSW student artwork ranging from visual arts to poetry. Under the mentorship of Professor Michal Sela-Amit, a faculty leader in USC's arts and healing community, SWAC leaders Dutt and Deeb reinvigorated the student organization through outreach to interested peers. SWAC became a pivotal part of the MSW program for Dutt, instilling in her an appreciation for arts-based self-care and offering her an outlet to connect with other students, connecting creativity with social work practice. For many students like Dutt, SWAC became a magnet for those with creative passions to build community and enhance well-being while enrolled in the rigorous and emotionally taxing MSW program.

Other experiential events such as the Free Museum Day excursion allowed students to practice self-care activities like playing with clay to release stress at the Los Angeles Craft Contemporary museum. Students also curated an event, "Healing Through Arts," during which MSW students performed spoken word and dance. During that event, Dutt showcased handcrafted collages and shared how the process of collage—sifting through images, gliding scissors on paper, and creating a whole from parts—was a personally powerful form of healing (Figure 5.1).

Diebold et al. (2018) wrote that social work students beginning their career path are particularly susceptible to the emotionally taxing work experienced in field placements and evoked by social justice issues discussed in the classroom. MSW students reported that exposure to distressing circumstances impacts their quality of life, for example, through indicators such as sleep disturbances, poor nutrition, and emotional burnout (Bonifas & Napoli,

Figure 5.1 Healing Through the Arts SWAC Event (2019).

2014). In addition to the secondary traumatic stress, an alarming rate of MSW students have experienced adverse childhood experiences themselves, exacerbating commonly occurring stressors experienced in social work internships. Thomas (2016) found that MSW students enrolled in a southwestern university in the United States were three times more likely than the general population to have experienced four or more adverse childhood events, including child maltreatment, exposure to parental substance abuse, and mental illness.

These findings suggest that MSW programs should provide opportunities for students to learn self-care strategies to successfully mitigate reactions to triggering experiences. Furthermore, faculty should be given time and access to relevant trauma-informed and self-care training. Intentional instruction could enhance these trainings by integrating expressive arts and other healing modalities that can be used in the classroom.

For Dutt, sharing her collages with a supportive community was healing (see Figure 5.2). Making collages and integrating contrasting elements of her identities offered a meditative respite from anxiety and grief and helped her process traumatic experiences. This practice also helped Dutt feel less affected by countertransference when working with clients within the child welfare system. Clark and Coleman (2003) wrote about the emotionally taxing transference and countertransference that occurs when working in the child welfare system. Workers often find themselves feeling overly responsible for a child's well-being or disproportionately angry at parents who

Figure 5.2 "Untitled" by Shefali Dutt (2020).

they may never know. Managing countertransference is a critical skill for child welfare workers, one for which they are not often prepared. Berlanda and colleagues (2017) suggested that knowing how to navigate emotional boundaries helps workers avert burnout and biases that commonly interrupt good practice in a field riddled with high caseloads, client mistrust, and lack of administrative support. Dutt's art practice as a form of self-care helped her manage countertransference and self-regulation and aided coping with vicarious traumatization that naturally [S.C.K.] emerged from daily work with children and families impacted by abuse, neglect, and family separation.

Dutt also used art interventions directly with clients as a method of rapport building and engagement with youth in foster care. While Dutt gained various leadership and program development skills that prepared her for a postgraduate social work career, she argues that the greatest benefit of SWAC was fostering and being part of a community of like-minded artists dedicated

to self-care. She felt gratified as well that she was able to create venues for classmates to integrate the arts into their professional and personal practices.

University of Southern California MSW alumna Jessica Peleaz, a contributor to SWAC's *Soul Work Magazine*, reflected on her experience of engaging in expressive arts as part of her MSW experience: "I believe that when I write poetry it helps me heal, stay grounded.
It helps me heal, stay grounded, and gives me a sense of peace and appreciation for my life. Poetry is a craft and a form of self-care where I can be creative with words, break language barriers, and use imagery to express how I feel. This is what I ask clients to do in my social work practice when they can't find the 'correct' words to express themselves" (Peleaz, 2020).

Art Rx

In addition to arts-focused classroom and caucus-based opportunities, the School of Social Work provided resources and support to assist students in forming new partnerships and developing new programs. Siegel, a former filmmaker, recognized the profound healing power of the arts and sought to form an interdisciplinary program to connect social work students with others across healthcare and arts disciplines. Frumkin similarly upheld the arts and mind-body modalities as powerful therapeutic tools after working in pediatric healthcare and as a yoga instructor before enrolling at USC. Joined by fellow student, artist, and chronic pain advocate Georgia Weston, they cofounded what became known as Art Rx.

During Siegel and Frumkin's tenure with Art Rx, they forged an enduring partnership between the USC Suzanne Dworak-Peck School of Social Work and the Keck School of Medicine at USC. There multiple and diverse cross-campus workshops are hosted promoting the healing power of art (see Figure 5.3). They also created a cross-campus USC fellowship program whereby healthcare students from various disciplines and fields supported the expansion of Art Rx through programming, marketing, development, and operations.

The first year of Art Rx culminated in an inaugural symposium (2018), which attracted over 250 guests. The educational forum was dedicated to the late actor Robin Williams, recognizing the creativity and laughter he brought to millions through his acting, comedy, and contagious zest for life. The Art Rx symposium showcased a range of performances by artists living with illness, followed by a multidisciplinary panel of physicians and social workers with artistic backgrounds discussing the therapeutic role that creativity plays in a medical setting.

The Art Rx team was moved by how a medical symposium focused on pain and illness could simultaneously bring an audience to laughter and tears. As the keynote speaker, Robin Williams's widow and brain health advocate,

Sueños sin Barreras ("Dreams Without Barriers")

Bred from a Guatemalan, immigrant broken family
The American dream is it a myth or a reality?
Mommy ran through the woods at only seventeen
Violence and poverty in Guatemala is what she had seen
Courage and passion within her genes
La migra within your sights
Mommy you had no rights
No education, low-income
Holding your fear like a loaded gun
La reina suffered, but persevered
Women like her are rare like the unicorn
Little did she know that her legacy would continue
A little girl was born
The little girl is a grown woman now
The crown was passed on
It came with a cost
Intergenerational trauma was passed on
This little girl suffered her mommy's pain since the womb
Blood and tears were in this little girl's destiny
But the little girl dreamed and persevered like her mommy
The mindset of sueños sin barreras
The grown woman continues to bloom
There are dark days in her locked room
Mental illness kept secret and locked away
Her God speaks to her soul when her mind goes astray
The growing pains of healing and generational memories that cannot be erased
Her voice is synchronized to the heartbeat of the oppressed
Al otro lado in the "land of the free" our feet will run towards justice
Her many missions on this earth ordered by her higher power are not complete
We are the roses that grew from concrete

Susan Schneider Williams, shared ways in which she painted alongside her late husband to foster creativity and hope in the midst of affliction and pain. The forum offered audience members an opportunity to reflect on what would strengthen their own healthcare or artistic practice. The Art Rx team received

Figure 5.3 Dancing Through Parkinson's Performance at Art Rx Symposium.

feedback for months after the forum detailing how audience members incorporated new types of artistic approaches with clients and patients in their distinct settings and shared about the long-term emotional impact of the event. The *Art Rx Symposium Trailer* can be viewed online: https://www.youtube.com/watch?v=pvvbjHigcnQ (Art Rx, 2020).

From its inception, cofounders Siegel and Frumkin had sustainability of Art Rx in mind. They mentored and prepared first-year MSW students Schoch and Lear to lead its second year. In 2019, Lear and Schoch hosted a luncheon in honor of Anthony Carbajal, an outspoken photographer and activist living with amyotrophic lateral sclerosis (ALS). Carbajal spoke to a cross-campus audience of interdisciplinary healthcare students and faculty, highlighting the healing import of his photography and its impacts as an equalizer that levels the field between people with disabilities and people who are nondisabled.

While the success of Art Rx was ultimately the result of a group of passionate MSW students who were willing to take on event planning, fundraising, and project planning outside of their academic curriculum and social work internships, it would not have been possible without the support of the university and various faculty members who were willing to provide mentorship and guidance. Art Rx demonstrates that social work schools without established arts programs can invest in both the arts and new generations of students by attracting prospective applicants with artistic and creative interests and providing them support to build out their own programmatic visions. Social workers, in particular, with their charge to "meet clients where they are

at" (Le Blanc, 2019), are uniquely positioned to use flexible and responsive approaches to working with clients. Art—because of its universal accessibility and limitless entry points—serves as a potent tool with which to equip student and professional social workers as they meet clients where they are in a way that transcends verbal assessment and traditional talk therapy-based interventions.

Art Rx programming constituted some of the first-ever events at USC in which social work, occupational therapy, physical therapy, and medical students convened and brainstormed about bettering their individual and collaborative practices. Interdisciplinary care is emphasized as an important aspect of social work education, according to the National Association of Social Workers code of ethics (2022). However, there are often few opportunities for social work students to intentionally collaborate with other fields. Studies have highlighted that the collaboration between analogous and different fields spurs innovation and novel ideas (Franke et al., 2013). Interprofessional education programs have utilized the arts and humanities to improve collaboration and quality of care among healthcare students (Langlois & Peterkin, 2019). Perhaps even more importantly, interdisciplinary work is suggested to increase social accountability (Jensen & Curtis, 2008; Rubin et al., 2017). Having providers from various disciplines collaborate in a single case allows for multiple lenses and ethical standards to offer more robust "checks and balances" in clinical assessment and treatment.

Collaborative work also counteracts hierarchical dynamics too often found in healthcare settings. Through Art Rx, USC students with diverse backgrounds, passions, and professional goals experienced how art can serve as grounding inspiration for rewarding interdisciplinary collaboration. For Frumkin and Siegel, who started their careers at hospitals after graduation, this type of interdisciplinary experience prepared them to bring a unique social work voice to their work settings.

Lessons learned by the inaugural Art Rx leaders were many. The essentialness of leadership and program development skills that would not have been cultivated in the classroom were underscored. They also learned about the unique role social workers can play by gathering healthcare disciplines to synergize and reform knowledge and practice. Not only that, they discovered the importance of expanding care to healthcare providers themselves to support empathy and sustainability in practice. Having honed program and event-planning skills through Art Rx, Siegel and Frumkin have gone on to create arts-based and healing programs that benefit clients and providers. They've embraced the arts as a tool for social work practice and as a method for self-replenishment and meaning making. Schoch also has integrated knowledge gained through involvement in Art Rx in her work life, experience that revived her belief that art can be medicine, even if that medicine isn't always curative.

A personal journey through art and healing

When Schoch applied to the MSW program at USC, she was transitioning from a career as an actress and writer to one that would effect change through direct relationships in the social services. From a young age, Schoch utilized theater and storytelling as a therapeutic outlet to help manage anxiety, instilling in her a belief in the healing power of art. Schoch valued the spiritual component of healing, a process she identified as reconnection to the "breath of life." She was curious to know what breathed life into patients' experiences. She wondered how clinicians could help patients find meaningfulness in light of their life-affecting illnesses.

Schoch got the opportunity to explore the interconnectedness between art, spirituality, and meaning when she was assigned to work with a patient who was passionate about the arts. Interweaving therapeutic interventions with opportunities for creative expression, Schoch guided her patient through a meaning-making process, unveiling a narrative that facilitated coping. Shortly after starting the therapeutic process together, however, Schoch's patient experienced a rapid decline in health. Schoch was present at the bedside when her patient drew their last breaths. In these moments, Schoch felt powerless, shattered by the loss of self-efficacy and idealism about the healing power of art.

There is little literature on how the death of a client during field placement impacts social work students. Evidence from other medical fields such as nursing demonstrates, however, that the effects of this loss can be disruptive, if not monumental (Edo-Gual et al., 2014). This was indeed the case with Schoch, and she entered a phase of internship characterized by disillusionment. M. A. King and Sweitzer (2014) recognized that disillusionment can occur during any of the developmental learning stages of an internship. It begins with a crisis that challenges educational expectations. Through supervision in field placement, Schoch was prompted to reflect on the limitations of art. In addition to feeling that art had done little to alleviate the suffering of her patient, Schoch's usual self-care tools, such as creative writing, felt inadequate in the midst of the death.

Art Rx guest speaker, photographer Anthony Carbajal's intangible message of hope was the catalyst that inspired Schoch's reconstruction of meaning as a social worker and artist (see Figure 5.4). In his presentation at the 2019 Art Rx luncheon, Carbajal modeled creative self-care and provided what M. A. King and Sweitzer (2014) would recognize as a new learning format that enables reflection and assists practitioners to transcend the constraints of disillusionment. Carbajal disclosed to the audience that he had not been in a good place when Art Rx invited him to speak about the healing power of art. Not only was he losing his ability to speak and eat, he was also losing his ability to use his hands and therefore his camera. Because of this, Carbajal found new ways to utilize his camera and

Figure 5.4 Breaking Boundaries (Carbajal, Anthony, 2019).

created a short film narrating his experience with illness and the meaning that photography brought him, which he presented at the luncheon. Carbajal's film humanized serious disease and put a face to the patient experience. By sharing the therapeutic benefits of the creative process, Carbajal reminded Schoch of how powerful art in healing can be, not only for patients, but also for herself.

Carbajal also reminded Schoch that healing, in many cases, was not the same as curing an illness. He shared: "I had forgotten how much my camera was so good for my spirit and it was so healing" (Carbajal, 2019). Healing, he proposed in his film, was a reconnection to the spirit, to the breath of life, a phenomenon possible in the midst of any life experience—even terminal illness. This inspired Schoch to reframe her experience into a narrative that enabled her to transcend her disillusionment. Schoch realized that as a social worker she would face loss throughout her career. Compassion fatigue would result without taking adequate measures, identified by Strom-Gottfried and Mowbray (2006) as "preparation, self-care, institutional support, review and debriefing, and mourning or memorial rituals" (p. 12).

To aid in her grieving process, Schoch wrote a quiet memorial narrative in her heart, one filled with empowering imagery and positive memories of her patient. Schoch's experience illustrates the unique power of art as a medium through which social workers can process grief and loss inevitable in any social work setting. Just as clinicians model behavior with their clients, social work faculty can model and educate their students about strategies to practice self-care (Konrad, 2010).

Carbajal transformed and expanded Schoch's vision of healing. She focused on staying present with her patient, exploring existential questions and listening to her creative dreams even while dying. Was her patient, like Carbajal, able to reconnect to her spirit through this process? Schoch now believes that her role as a social worker is to pose questions, deeply listen, and make space for what clients need. This meant opening up to the possibility that there will not always be tangible answers or results. Witnessing Carbajal's ability to heal and be healed by art "breathed life" into Schoch's educational journey and continues to shape her identity as a social worker and healer.

IMPLICATIONS

The utilization of the arts both inside and outside of a classroom setting has many practical implications for social work students. In the classroom, we experienced an increased sense of self-efficacy in a new field, as well as therapeutic benefits of self-reflection, meaning making, belonging, and shared vulnerability. Outside of the classroom, we gained leadership and program development skills, as well as a felt sense of gratification in enabling other students to experience the arts as part of their education. In both settings, we witnessed and designed new arts-based interventions to use with clients. We still have much to learn and plan to spend lifetimes exploring the power of arts-based healing modalities in the work ahead.

There are limitations worth noting for student-led extracurricular activities like SWAC and Art Rx. Often such endeavors are challenged by sustainability as they require a continuous rotation of highly motivated students to maintain program effectiveness. It is our hope that by describing these student-led programs, readers from universities and schools of social work will be inspired to co-construct interdisciplinary programming that incentivizes art-based collaborations, for example offering measurable benefits such as course or fieldwork credit, stipends, and/or scholarships. Until such benefits are readily available, we believe that mentorship will play the most critical role in nurturing artistically inclined future social workers. Additionally, given the myriad obligations of professorship, we believe that incentives, such as possibility for promotion or tenure, should be provided for faculty to mentor students and create innovative arts-based programming.

CONCLUSION

In art, is the masterpiece the final product or the creative process itself? It is a worthwhile question to contemplate. Do we focus on the final work? Or do we focus on what it was like to paint, create character, and delve into the

human experience? In social work, it is essential to focus on the process. Art reminds us of this. As Carbajal shared with the audience: "You are not looking for an image—you are looking for a process—a process of transformation, of healing" (Carbajal, 2019). Transformation is the foundation of learning. In this chapter, we argued that art enlivens and synthesizes learning and mitigates inevitable challenges and uncertainties experienced by MSW students. We believe that arts-based methods prepare social work students to enter the world as not only knowledgeable clinicians, but also reflective and integrated human beings. Taken together, we hope that our stories offer insight into the benefits we received from arts-based curricula, extracurricular involvement, and the need for continued incorporation and innovation of the arts in social work education.

REFERENCES

Art Rx. (2018). Art Rx *Symposium* trailer [Video]. YouTube. https://www.youtube.com/watch?v=pvvbjHigcnQ

Berlanda, S., Pedrazza, M., Trifiletti, E., & Fraizzoli, M. (2017). Dissatisfaction in child welfare and its role in predicting self-efficacy and satisfaction at work: A mixed-method research. BioMed Research International, *2017*, Article 5249619. https://doi.org/10.1155/2017/5249619

Bloomquist, K. R., Wood, L., Friedmeyer-Trainor, K., & Kim, H. W. (2015). Self-care and professional quality of life: Predictive factors among MSW practitioners. *Advances in Social Work, 16*(2), 292–311.

Bonifas, R. P., & Napoli, M. (2014). *Mindfully increasing quality of life: A promising* curriculum for MSW students. Social Work Education, *33*(4), 469–484.

Burton, J. M., Horowitz, R., & Abeles, H. (2000). Learning in and through the arts: The question of transfer. Studies in Art Education, *41*(3), 228–257.

Carbajal, A. (2019). Breaking boundaries [Photograph].

Carbajal, A. (2019, April 9). *Art Rx luncheon in honor of Anthony Carbajal* [Presentation YouTube video]. University of Southern California, Los Angeles, CA, United States. https://www.youtube.com/watch?v=MlfajyKW0r8&feature=youtu.be&ab_channel=Keck SchoolofMedicineHEALProgram

Clark, S., & Coleman, D. (2003). Preparing for child welfare practice. *Journal of Human Behavior in the Social Environment, 7*(1–2), 83–96. https://doi.org/10.1300/J137v07n01_07

Council on Social Work Education. (2015). Educational policy and accreditation standards for baccalaureate and master's social work programs. https://www.cswe.org/accreditation/policies-process/2015-epas-toolkit/

Council on Social Work Education. (2020, August 7). Ensuring all levels of social work self-care. https://www.cswe.org/news/newsroom/ensuring-all-levels-of-social-work-self-care/

Cramer, E. P., McLeod, D. A., Craft, M., & Agnelli, K. (2018). Using arts-based materials to explore the complexities of clinical decision-making in a social work methods course. Social Work Education, *37*(3), 342–360.

Diebold, J., Kim, W., & Elze, D. (2018). Perceptions of self-care among MSW students: Implications for social work education. *Journal of Social Work Education*, 54(4), 657–667.

Edo-Gual, M., Tomás-Sábado, J., Bardallo-Porras, D., & Monforte-Royo, C. (2014). The impact of death and dying on nursing students: an explanatory model. *Journal of Clinical Nursing*, 23(23–24), 3501–3512.

Franke, N., Poetz, M., & Schreier, M., (2013). Integrating problem solvers from analogous markets in new product ideation. *Management Science*, 60(4), iv–vii. https://doi.org/10.1287/mnsc.2013.1805

Franklin, M. (2010). Affect regulation, mirror neurons, and the third hand: Formulating mindful empathic art interventions. *Art Therapy*, 27(4), 160–167.

Griffiths, A., Royse, D., Murphy, A., & Starks, S. (2019). Self-care practice in social work education: A systematic review of interventions. *Journal of Social Work Education*, 55(1), 102–114.

Jordan, J. V. (2008). Valuing vulnerability: New definitions of courage. *Women & Therapy*, 31(2–4), 209–233.

Killian, K. D. (2008). Helping till it hurts? A multimethod study of compassion fatigue, burnout, and self-care in clinicians working with trauma survivors. *Traumatology*, 14(2), 32–44.

King, M. A., & Sweitzer, H. F. (2014). Towards a pedagogy of internships. *Journal of Applied Learning in Higher Education*, 6, 37–59.

Kirkendall, A., & Krishen, A. S. (2015). Encouraging creativity in the social work classroom: Insights from a qualitative exploration. *Social Work Education*, 34(3), 341–354.

Konrad, S. C. (2010). Relational learning in social work education: Transformative education for teaching a course on loss, grief and death. *Journal of Teaching in Social Work*, 30(1), 15–28. doi: 10.1080/08841230903479458

Langlois, S., & Peterkin, A. (2019). Promoting collaborative competencies through the arts and humanities: Lessons learned from an innovative IPE certificate program. *Journal of Interprofessional Education & Practice*, 16, 100267.

Le Blanc, J. D. (2019, March 1). What it means to be a social worker. The Guidance Center. https://www.tgclb.org/inside-tgc/what-it-means-to-be-a-social-worker/

Leonard, K., Hafford-Letchfield, T., & Couchman, W. (2018). The impact of the arts in social work education: A systematic review. *Qualitative Social Work*, 17(2), 286–304.

Levett-Jones, T., & Lathlean, J. (2008). Belongingness: A prerequisite for nursing students' clinical learning. *Nurse Education in Practice*, 8(2), 103–111.

Linnenbrink-Garcia, L., Patall, E. A., & Pekrun, R. (2016). Adaptive motivation and emotion in education: Research and principles for instructional design. *Policy Insights From the Behavioral and Brain Sciences*, 3(2), 228–236.

Marshall, J. (2014). Transdisciplinarity and art integration: Toward a new understanding of art-based learning across the curriculum. *Studies in Art Education*, 55(2), 104–127.

Moore, S. E., Bledsoe, L. K., Perry, A. R., & Robinson, M. A. (2011). Social work students and self-care: A model assignment for teaching. *Journal of Social Work Education*, 47(3), 545–553.

National Association of Social Workers. (2022). Code of ethics. Section 2.03. https://www.socialworkers.org/About/Ethics/Code-of-Ethics/Code-of-Ethics English

Peleaz, J. (2020). Sueños sin Barreras [Dreams without barriers] [Poem]. In *Soul Work*. University of Southern California.

Pelowski, M., Markey, P. S., Lauring, J. O., & Leder, H. (2016). Visualizing the impact of art: An update and comparison of current psychological models of art experience. *Frontiers in Human Neuroscience*, *10*, 160.

Rubin, M., Cohen Konrad, S., Nimmagadda, J., Scheyett, A., & Dunn, K. (2018). Social work and interprofessional education: Integration, intersectionality, and institutional leadership. *Social Work Education*, *37*(1), 17–33. https://doi.org/10.1080/02615479.2017.1363174

Strom-Gottfried, K., & Mowbray, N. D. (2006). Who heals the helper? Facilitating the social worker's grief. *Families in Society*, *87*(1), 9–15.

Thomas, J. T. (2016). Adverse childhood experiences among MSW students. *Journal of Teaching in Social Work*, *36*(3), 235–255. doi:10.1080/08841233.2016.1182609

USHOULDSPEAKMUSIC. (2020). This is Abel [Video]. YouTube. https://www.youtube.com/watch?v=kQ8q5qzXshU&ab_channel=USHOULDSPEAKM USIC

Walton, P. (2012). Beyond talk and text: An expressive visual arts method for social work education. *Social Work Education*, *31*(6), 724–741.

Walz, T., & Uematsu, M. (1997). Creativity in social work practice: A pedagogy. *Journal of Teaching in Social Work*, *15*(1–2), 17–31.

Zakaria, Z., Setyosari, P., Sulton, S., & Kuswandi, D. (2019). The effect of art-based learning to improve teaching effectiveness in pre-service teachers. *Journal for the Education of Gifted Young Scientists*, *7*(3), 531–545.

PART II
Arts and Research
Learning With and From Each Other

6
A Vision for Arts-Based Social Work Research

ROGÉRIO M. PINTO, EPHRAT HUSS,
AND MIMI V. CHAPMAN

INTRODUCTION

Acknowledging, understanding, and developing different research methods and modalities has been central to social work since the profession's beginnings in the late 19th century. In recent years, an arts-based research movement, among myriad professions, has emerged. Social work practitioners and academics, many of whom are also practitioners of the arts, have begun to define "research" and "art" in social work scholarship. Within arts-based research, art can be used to refer to artwork that is produced outside of the research frame but nonetheless is used as a part of the research process. Similarly, art-making can be a central activity for data collection and interpretation of findings. The process of art-making may be as important as its products and may itself be the subject of investigation. Thus, art can be situated in different roles within arts-based research, that of the subject method or outcome of the study. It goes beyond the research frame, for instance in a documentary, and can directly influence social relationships and society at large (Huss, 2012).

In this chapter, we assert that art reflects the subjective experience of the art creator as well as those that engage with works of art made by others. That phenomenological experience also reflects the experiences of other individuals with similar contexts or understandings of other groups that art creators may wish to represent. From this, visual and performance arts situate subjective experiences within a social context and become tools for opening

Rogério M. Pinto, Ephrat Huss, and Mimi V. Chapman, *A Vision for Arts-Based Social Work Research* In: *Social Work and the Arts*. Edited by: Shelley Cohen Konrad and Michal Sela-Amit, Oxford University Press.
© Oxford University Press 2024. DOI: 10.1093/oso/9780197579541.003.0007

up different ways of thinking about the connection between personal and social identity and society itself. Another characteristic of the arts as a research form is that it enables socially and psychologically taboo or silenced narratives of how the marginalized individual experiences his or her social context, or forms of oppression, expressed in indirect and metaphorical ways, which help to protect the creator.

Thus, arts-based research situates a pathway to socially engaged scholarship and community-engaged research frameworks—community-based participatory research, participatory action research, among others. Social work researchers often partner with members of disenfranchised populations to develop research questions, methods, and procedures. Wittingly or unwittingly, such partnerships may evoke the power dynamics found in the broader society. Community-engaged research, as a research paradigm, uses methodologies that aim to change power dynamics within the research context. Therefore, arts-based work can be a central component of community-engaged research as a decolonizing framework. It provides a space for silenced groups to express their understandings of and experiences of society and, by shifting language, disrupts the power dynamics of professional verbal discourses.

Herein, we argue that arts-based approaches can powerfully augment the existing social work research toolbox. Based on the literature, we provide a rationale for arts-based social work research, with emphasis on the use of participatory forms of research methods and procedures with the potential to disrupt power imbalances in society. Next, we explore how art-making and art forms might be incorporated into social work research and scholarship. Based on our experiences as social workers and art practitioners, we provide examples of how we have used arts-based methods to pursue research questions.

BACKGROUND

Central to social work is acknowledging, understanding, and developing diverse research methods and modalities. Hartman's (1990) pivotal editorial asserted: "Both the scientific and the artistic methods provide us with ways of knowing, highlights the need to integrate different ways of knowing and discovery" (p. 4). In recent years, an arts-based research movement, among multiple professions, has emerged and expanded beyond the bounds of clinically oriented art therapy and educational research with children (Huss et al., 2020).

In December 2012, more than 40 institutions across the United States joined in the Alliance for the Arts in Research Universities (a2ru) with a commitment to identify, fund, solidify, and support research that integrates the arts, sciences, and other disciplines (a2ru, 2020). In social work, beginning in 2013, hosted by the Pulitzer Foundation for the Arts and Washington

University in St. Louis, a group of national academic, arts, justice, and foundation leaders convened to explore an arts-based field of social work professional practice (Pulitzer Foundation for the Arts and the University of Michigan School of Social Work, 2013). In 2014, the University of Michigan's School of Social Work held the "Personal and Societal Transformation through Social Work and the Arts" conference (Gant, 2015). Faculty, students, and other participants worked to further the role of the arts in achieving social justice. More recently, in the summers of 2017–2019, the University of Southern California's School of Social Work convened an arts round table, an interdisciplinary group of social work scholars, practitioners, artists, philosophers, and directors of arts organizations from universities across the United States and abroad.

This group came together to study, debate, and imagine a social work agenda that could support the integration of the arts into social work research, education, and best practices, providing momentum for scholars who have experienced the power and usefulness of arts-based research. Over three summer meetings, this group worked together to define both research and art in the context of social work scholarship. In this chapter, we argue that arts-based research approaches can powerfully augment the existing social work research toolbox. We begin by providing a history of and rationale for arts-based social work research and highlight, in particular, the connection of arts-based methods to engaged and emancipatory scholarship approaches. We then examine ways art can be used in research and provide specific examples.

FINDING SOCIAL WORK'S VOICE IN ARTS-BASED RESEARCH

Pasztorzy (2005) defined art as "things to think with" (p. 11), and, although largely forgotten, social work in the United States has made use of things to think with since the profession's beginnings in the late 19th century. As social work emerged as a profession, new print reproduction technologies created the means for photographs to move from novelties to objects that had the power to transform personal attitudes and policy. Reform photography, in particular, was embraced by early social workers in the "scientific charity" movement (Hales, 1984; Stange, 1989) as a method for raising awareness about conditions in slums and immigrant quarters, and, later on, to address the scourge of child labor. By documenting inhumane conditions through carefully crafted images, reform photography sought to motivate the public to action. Edith Abbott (1876–1957), former dean of the University of Chicago's School of Social Service Administration, used photographs to document poor living conditions in immigrant enclaves. Abbott (1936) believed that images could spotlight problems and prompt action in ways that survey data alone could not. Her position promoted photography as an essential method in the

increasingly specialized discipline of social work. It was one of the first in social work to use art as a method of advocacy for social change.

Of course, images are not the only art-based means that can be used as things to think with. Theater and performance, musical performance, murals, paintings, among many other art forms, can be used for research purposes. Indeed, derived from interviews with 457 faculty, administrators, and students from institutions across the United States, the a2ru (2018) defined research as "systematic questioning and inquiry," "producing new knowledge," *and* "creative activity and scholarship." In a companion publication, the same organization defined arts research as highly compatible with engaged scholarship and community-based participatory approaches because of the "practice-led" and "human-centered" learning of arts-based methods (a2ru, 2018). Further, art is part of a large hermeneutic interpretive that promotes the coexistence of multiple meanings. These definitions echo social work's values and history. In the research context, the use of perspectives and techniques from architecture, visual arts, literature, music, performance, performing arts, and film allows researchers to expand how we conduct research. Individual and group art-based experiences with the arts—whether those are art-making or interacting with art created by others—have the potential to give agency and voice to those from whom social work researchers seek valuable information.

Within arts-based research, the word *art* can refer to the artwork produced outside of the research frame but, nonetheless, is used as a part of the research process. Similarly, art-making, the process by which we create objects, music, poetry, and other forms of artistic expression, can be a central process used for data collection and interpreting research findings. The method of art-making may be as important as the artistic product making the process itself the subject of investigation (Huss, 2018; Huss & Hafford-Letchfield, 2018; Knowles & Cole, 2008; Mason, 2002). The interplay between creating and creation; or between art as process, product; or as a trigger for discussion and meaning making, gives rise to a fruitful new way for research participants to give voice to their experiences and for researchers to engage deeply with research participants (Huss, 2018; Knowles & Cole, 2008).

Art reflects not only the subjective experience of the art creator, but also other individuals or groups whose life experiences might be reflected within the art that is created. Art can be defined as a meeting place between the personal and the social, and as such, it echoes social work's focus on person-in-environment (Emerson & Smith, 2000; Foster, 2007). In this way, images and other works of art such as dance and performances open up different ways of thinking about personal and social identities (Freire & Macedo, 1987; Harrington, 2004). From this social perspective, arts-based research, visual culture, visual anthropology, and community art suggest that using the arts in research enables socially and psychologically silenced narratives to be expressed in direct, indirect, and metaphorical ways. Eisner (1997) argued

that visual forms—and we add artforms more generally—integrate different facets of social experiences that can be difficult to encapsulate through either language-based analysis (i.e., qualitative research) or statistical techniques (i.e., quantitative research), meaning that arts-based research may be critical to proper community-engaged research.

ART AND COMMUNITY-ENGAGED RESEARCH

Hartman (1990) reminded us that social work researchers regularly blend theories and qualitative and quantitative methods to answer research questions. Indeed, arts-based research creates a powerful pathway to more emancipatory research methods, such as community-engaged scholarship, community-based participatory research, and participatory action research. Because social work scholarship focuses on underserved populations on which historical abuses have been inflicted when they were involved in research, complex feelings and power dynamics are at play when social workers attempt to join with communities for research purposes. Further, social work as a profession has perpetrated abuse toward marginalized communities (O'Brien, 2011). One notable example comes from North Carolina, in which social workers were deeply involved well into the 1970s with a statewide eugenics program that promoted "voluntary sterilization." Many states had such programs, although they were discontinued decades before the North Carolina program was halted (O'Brien, 2011). Although this example is extreme, it highlights the need for social workers and social work researchers to engage purposefully to understand the needs, values, and perspectives of those populations with whom they work. The North Carolina program was rooted in the idea that "professionals, including social workers," could make the best decisions about childbearing for populations marginalized by race, poverty, or disability status, again as defined by outsiders. The collaborative nature of arts-based research, particularly research that includes art-making, can prevent such abuses by building more vital bridges between researcher and research participants; by framing the questions to be asked, the methods to answer them, the approach to solving identified problems; and in analyses (Hafford-Letchfield & Huss, 2017; Sinding et al., 2012; Wang & Burris, 1994).

Because social workers are not immune to implicit and explicit prejudices or stigmatizing views about the individuals and groups they study, methods that allow for the co-creation of research can help social work researchers truly partner with communities. More often than not, social work researchers follow a linear/positivist or postpositivist research paradigm in which preexisting theory and practice experience inform research questions, data collection, and interpretation of findings. Yet, social work research often involves members of disenfranchised populations that have experienced complex

power relationships with a dominant society. Researchers often represent and re-create those same power dynamics, whether that is their intention or not. Using research paradigms and methods that explicitly challenge and change power dynamics within the research context is critical for social work research to live up to the values of the profession. Arts-based research can therefore be viewed as central to decolonizing research approaches. Research methods and designs that incorporate the arts in order to collect and interpret data and disseminate findings may be beneficial. Further, artists have often led the way in activism, advocacy, and social change, while social work, still reflecting a neoliberal paternalistic stance, has lagged.

Artists' leadership has demonstrated how art has the power to shift the public conversations, reveal injustices, and galvanize change efforts in a way that is much more powerful than academic discourse alone. The embodied nature of art, involving the senses, emotions, and imagination, produces that power. One famous example is the "SILENCE=DEATH" logo produced in 1987 that moved the conversation around HIV from a reductionistic formulation of questions that sought answers to biomedical questions while allowing the affected communities to remain highly stigmatized, to a cultural conversation that, over time, shifted both attitudes toward nonbinary people and forever changed public health interventions to be more embedded in community views and empowerment (Sember & Gere, 2006).

In the current moment, a time of multiple pandemics—COVID-19, anti-Black racism, anti-Asian violence and rhetoric, police brutality, mass incarceration, immigrant persecution, and extreme political partisanship—we can use arts-based approaches to address the impact of such societal difficulties on individuals, communities, and institutions. Social work scholars, artists, audiences, and activists call for systemic changes in society; see, for example, #OscarsSoWhite.

Moreover, the World Health Organization (WHO, 2019) published a report, "What Is the Evidence on the Role of the Arts in Improving Health and Well-being?" The findings of this review suggest that the best interventions to address public health issues, such as racism and White supremacy, are those whose foundations (theory and practice) involve interdisciplinary collaboration across the arts and disciplines like social work, whose main objective is to advance social justice. Incorporating arts-based methods into social work research allows our profession to learn from our artist colleagues and utilize an effective tool to structure and promote critical change efforts.

Indeed, a reinvigoration of critical social work to achieve social liberation has culminated in research designs, methods, and procedures that directly involve community members in arts-based activities at different stages of the research cycle. Because research participants often make sense of their experience and develop meaning using symbolic, narrative, and visual forms of expression (Foster, 2007; Malka, Huss et al., 2018), focusing on meaning

making and resilience through art practices gives research participants power, agency, and control. Through the use of the arts, participants become co-creators, art critics, interpreters, experts, and informants. Likewise, professionals (e.g., social work and health practitioners) and researchers engaged in arts-based research can reevaluate their attitudes and behaviors, as well as the oppressive systems and policies under which they operate (Chapman et al., 2018; Lightfoot et al., 2019; Malka et al., 2018; Windsor et al., 2018). Thus, arts-based research can help researchers center participants as active problem solvers and research designers that move researchers toward unbiased and respectful views of the communities they work with.

Although community-engaged research corresponds to the aims and sensibilities of social work, there is little literature on the use of the arts in social work research specifically (Hafford-Letchfield & Huss, 2017; Huss, 2012; Huss & Bos, 2022) as compared to books on art in social work practice. Indeed, within social work literature, the concept of "art" is most often used as a general metaphor for humanistic-oriented practice. Historically, social work literature has contained arguments and debates on the profession as an art versus a science (Chamberlayn & Smith, 2008; Huss & Bos, 2022). This is not the aim of this chapter. Rather, we assert that social work as a scientific field should more deeply incorporate both existing artistic objects and endeavors and art-making as the means for joining community members, for gathering more meaningful data, and for producing relevant research findings that promote positive social change. This chapter focuses on key arts-based approaches that can help to improve social work research: community engagement, problem definition, data collection, art as active ingredient, and art as dissemination and advocacy. Many aspects of these approaches have overlapping uses and values; therefore, some will be discussed together.

COMMUNITY ENGAGEMENT, PROBLEM DEFINITION, AND DATA COLLECTION

Using the arts in social work research enables the co-creation and transformation of meanings between groups and within the same groups or populations. Art making can promote engagement between researchers and the population of interest, may help the researcher more fully understand the point of view of the population under consideration, and help to equalize power differentials. Those traditionally considered "research subjects" can join with researchers to co-create a shared understanding of what the research will accomplish and delineate issues important to the community. Art making is often central to engagement, problem definition, and data collection elements. The process of creating art-based artifacts as a method allows research participants to self-express in ways no other method—qualitative or quantitative—can.

Participants' art allows them to define and redefine research questions and bring new meanings and perspectives into what is being studied. hooks (1992) described the difference between being objectified through others' gaze as compared with "seeing" and thereby self-defining issues for oneself. When traditional methods, such as surveys or focus group interviews, are used, the research agenda is already set because choices have been made about both procedures and measures. Psychosocial issues that are difficult for research participants to explore, such as incarceration, domestic violence, rape, or child abuse that might be "unspeakable" because of trauma or cultural taboo, can be expressed indirectly and symbolically through art, protecting both artists and viewers from secondary trauma (Ansdell & Pavlicevic, 2001; Huss, 2009).

Another rationale for using arts is differences in language and culture that make interviewing less effective. This could be cultural or language differences between social work researchers and research participants. It could also be due to difficulty with using language because of disability or to cognitive ability (Segal-Engelchin et al., 2019). A simple example of the ways that art helps to clarify research participants' experience of their cultural context can be demonstrated by asking them to depict a house. The house may be a tent, a village, or an apartment, and the person drawing it may feel safe, constrained, or homeless in this house. The background of the house might be a village, an unpopulated area, a city, a war zone, or a field—each expressing a social context for the house. The compositional decisions made when drawing the house (e.g., size, color, placement, contour) will also define how the drawer experiences that house. Thus, the image (or music or drama or dance) will portray a subjective experience of a person in context (Huss, 2018).

The process of art-making enables interactive experiences in the here and now that include research participants making videos, taking photographs, drawing, painting, composing music, and creating dance or performing theater. In each of these activities, participants' creations can potentially be analyzed as data. Here, the research participant is invited to engage in data collection by producing artifacts (producing data) that can be analyzed to describe behavioral patterns and/or social phenomena. This art-making process captures interactions, contents, and processes using senses, emotions, the body, and cognitions, which can then become the subject of research participants' interpretations rather than that of researchers alone. By engaging research participants in data collection, researchers are best positioned to obtain results that are relevant to the social contexts and phenomenological understanding of research participants, those who can most benefit from the research findings (Emerson & Smith, 2000; Huss, 2012; Malka et al., 2018).

For example, in photovoice, participants are asked to create the research questions they will answer in response to a specific prompt, such as "what I wish my doctor knew about my life" (Lightfoot et al., 2019). Through a series of photo assignments that participants design together with researchers,

participants share and talk about photographs they have taken and the reasons they chose to create those particular images. The transcripts of those conversations can be analyzed as qualitative data. Some researchers have extended analysis from photovoice beyond textual analysis to include analyzing the images themselves. Pictures can be coded for what is contained within them, what is missing, and then content analyzed for emerging themes. This type of analysis can be done with participants or member checked after a preliminary examination is done.

By way of example, Chapman et al. (2016) coded photographs using Atlas TI after going through a traditional photovoice process in which migrant mothers in China took pictures depicting their lives in a Shanghai migrant village. After analyzing transcripts, one author noticed that the pictures themselves contained other themes that had not been specifically discussed. In the same way that codes were applied when analyzing text, the researchers applied codes to the photographs and, using Atlas TI's visualization capabilities, explored which codes co-occurred most often. For instance, depictions of fathers were most often seen co-occurring with work or with children's education. Very few photographs, if any, showed fathers as husbands or involved in leisure activities with their wives, children, or elsewhere, thus suggesting and visually depicting the driving motivation of migrant fathers to provide a better life for their families (Chapman et al., 2016). Ideally, such coding would be done together with research participants. However, in this case, because of the physical distance involved, the coding was done first and then member checked with participants after the initial coding was completed.

ART AS ACTIVE INGREDIENT

In some instances, researchers have used art as the active ingredient in change efforts. Rogério Pinto is a co-investigator in a study, funded by the United States National Institute of Minority Health and Health Disparities (PIs: Windsor & Benoit; U01 MD010629), to develop and test *Community Wise* (CW), a behavioral intervention designed to decrease substance use and misuse by using strategies to raise critical consciousness and addressing internalized oppression. Community Wise uses thematic illustrations created for the intervention by Texas-based artist Christopher Alyosha Burkle (Windsor et al., 2018) in collaboration with the Newark Community Collaborative Board (Windsor et al., 2018). The illustrations were used to spark dialogue among participants to improve their self-understanding through reflection and questioning of deeply held assumptions and beliefs indicative of internalized oppression (Chronister & McWhirter, 2006). (Newark Community Collaborative Board. (2020) with Critical Consciousness Collaborative (2023): http://www.the3c.org/.)

Each image depicts different oppressive forces that participants recognize. Participants are encouraged to challenge the forces of oppression reflected in the illustrations and to find internal motivation to combat them by engaging in political advocacy and civic activities (e.g., writing letters to elected officials, volunteering at a community organization). This example shows how visual art can be used to spark motivation, cognitive change, and advocacy. The visual elements used in this research fostered social engagement, an outcome rarely achieved in typical cognitive behavioral interventions used to combat substance abuse. These artifacts are also examples of the engagement and problem definition functions referenced previously in this chapter.

Another investigation, *Yo Veo Salud/Envisioning Health*, funded by the National Institutes of Health (NIH/National Endowment for the Arts [NEA], National Institute for Biomedical Imaging and Bioengineering [NIBIB] #1R24EBO18620-01), also featured a series of photographs by photojournalist Janet Jarman, which featured a young girl's migration journey from Mexico to the United States. The photographs were used as part of an intervention designed to decrease both explicit and implicit bias toward new immigrant populations (Jarman, 2007). The research used traditional quantitative means to understand the impact of the photographs and the dialogue they prompted. Findings indicated that the use of the photographs, combined with a guided conversation, was effective in changing attitudes (Chapman et al., 2018). This method was earlier compared to more traditional "diversity training" methods and found to be superior (Chapman & Hall, 2014).

The performing arts have been used in a similar fashion to decrease anti-Islamic bias. In one such study, students were assigned to one of three conditions in which they viewed performances that were unrelated to understanding Islam, performances related to Islam, and performances related to Islam combined with a postperformance "talkback" experience. Students were tested pre-post on both implicit and explicit measures toward Islam and Muslim people. Although both types of measures showed a change in the hoped-for direction, the difference in the implicit measures was more significant (Chapman et al., n.d.).

ART AS A MEANS TO FACILITATE DISSEMINATION OF RESEARCH FINDINGS

Just as the research participant is invited to engage in data collection by producing artifacts that can be analyzed later for behavioral patterns and social phenomena, the artifacts created for these purposes can also be displayed or performed to disseminate new knowledge and to create public and political awareness around social issues. Using images, music, and other artifacts as a

means for marginalized populations to convey their issues of importance to their communities as well as their ideas and preferred solutions is a powerful method that can influence decision makers to make needed changes in policies and practices. Often, marginalized groups cannot directly reach powerbrokers, but through arts can convey to them their lived experiences of policies.

Art-based research that utilizes participants' arts as the end product of the research (e.g., plays, exhibitions, documentaries, etc.) is a powerful medium that utilizes aesthetic devices to engage people and can thus serve as vehicles to convey, to those outside of research contexts, issues concerning cultural identity and politics, creating a vehicle to influence public opinion and policy direction. Practices like these reflect social change social work values (Freire & Macedo, 1987; Huss, 2012; Narhi, 2002; Shank, 2005). Photovoice projects culminate in a forum in which participants choose target photographs to discuss with key decision makers. Such a forum, in which the data collected through photographs are presented and described by participants themselves, is a powerful means for advocacy and change. Performances can also be used as a means to engage decision-making audiences in understanding the views and desires of research participants.

Theater and performance, including self-referential theater/drama, have been described as advancing personal growth, healing, problem-solving, artistic, educational, and advocacy goals. Performance, used for dissemination of findings, has the potential to achieve community-level engagement and intervention. Funded by the University of Michigan's Office of Research, Rogério Pinto is developing a stage set that will accompany his award-winning *Marília*, a stage play, which falls under the umbrella of "personal performance" (Pinto, 2021). This form appears prominently in the theater as solo autobiographical and autoethnographic performances, often referred to as self-referential theater or self-referential drama (Pendzik et al., 2016). *Marília* is a form of self-referential theater. It includes both autobiographical (personal life) and autoethnographic positionalities and addresses issues including ethnicity, race, gender, and class, among others. (A script of the play can be found in DEEPBLUE at the University of Michigan Library.)

By writing and performing *Marília*, Pinto demonstrates self-healing while advocating for others who are similarly situated. The experience also spurs others to action, inviting audiences to engage in advocacy concerning child protective services, injury prevention, immigrant rights, and others. Although not yet formally evaluated for impact, preliminary responses to previous performances in Theatre Row (New York City) and Bloemfontein, Vrystaat, South Africa, indicate that themes such as grief and loss, gender identity, immigration identity, and status, among others, are engaged using this specific play and others like it.

DISCUSSION AND IMPLICATIONS

Social work research aims to be rigorous, informative, meaningful, helpful, and emancipatory. Both art-making and art-based artifacts can be used in different stages of the research cycle to help achieve these aims. As a *method*, art-making can be useful to obtain different types of data that will later be analyzed. Art-making can produce user-friendly knowledge with the potential to help unearth marginalized voices in ways that other methods often fail to do. As an *intervention*, it can help to change social norms and behaviors. As a *research dissemination device*, it can help research findings reach the populations that can most benefit from social work research. As an *outcome*, art-based artifacts can make research accessible to the broader society and not only to the academic community. It is essential to note that, in the research context, art-making and art-based artifacts are meant to reach people and change behavior and social phenomena rather than to impress art critics or influence the world of fine arts. Indeed, art in social research challenges the fine art parameters by shifting the criteria of quality to social-activist parameters rather than aesthetic and originality-based theories (Eisner, 1997; Emerson & Smith, 2000; Huss & Maor, 2015).

To fulfill social work's value for the importance of human relationships "social workers recognize the central importance of human relationships . . . [and thus] seek to strengthen relationships among people . . . to promote, restore, maintain, and enhance the well-being of individuals, families, social groups, organizations, and communities" (National Association of Social Workers, 2020). Therefore, to co-produce knowledge with disenfranchised populations, differences in power and culture and in forms of knowledge between social workers and those who can benefit from social work research need to be bridged. As this chapter has described, the integration of art-making into social work research can bridge power differences between researchers and research participants in ways other methodologies have failed to do.

One significant caution in integrating art-making and art-based artifacts into intervention research concerns the possibility that the intervention may not show "efficacy" and/or "effectiveness" or no change at all. For example, if we use an art form, say theater or film, as the intervention, do we assume that there is something wrong with the chosen art form (or the specific play or film) if the intervention turns out not to be effective? Social work researchers often use randomized controlled trials (RCTs) to test behavioral interventions. Nonetheless, RCTs are vulnerable to myriad problems, from unexpected challenges that are common in community-based studies, to small sample size, to intervention fidelity, to maintaining data integrity, to implementing human participant protocols, and others (Collins et al., 2009; Friedman et al., 2015; Wolff, 2000). Therefore, there is a need for researchers to account for all

potential methodological issues that might render art-making and art-based artifacts less or more helpful as interventions.

This possibility points to the need for carefully designed research that incorporates a variety of measurement types to capture the complete picture of how the arts-based intervention is or is not working. For instance, if scales are used, there should be a clear link between what the scale is designed to measure and why a particular arts-based object or an art-making activity would be hypothesized to produce a change in that particular metric. Pilot studies in which interviewing participants about how they experienced the intervention will allow for more careful tailoring in larger scale research designs. Just as we are promoting arts-based methods as a means to increase participants' voices and agency, we must do the same in evaluating those interventions. By allowing participants a voice in telling us whether and how arts-based interventions changed them, we escape the trap of choosing the wrong metrics by which to measure overall success.

Although we have attempted to provide an overview of why the use of the arts in social work research is powerful and have provided examples of arts-based work, we have elected not to provide specific guidelines for how to integrate the arts in research. Such guidelines, in our view, would be overly prescriptive, potentially stifling the imaginations of those that read this work. This field is still developing, and we hope that this chapter provides a jumping-off point that leads to the development of new methods and procedures. As scholars committed to arts-based scholarship, we hope to enlarge this community of researchers and work together both within social work and with other disciplines to develop working frameworks for building art integration capacity, including better communication and dissemination of information regarding arts-based research, which over time will yield best practices to train future social work researchers on how to integrate the arts in scientific research.

CONCLUSION

The a2ru promotes new perspectives, awareness, and social understanding. It promotes art-making and the use of artistic objects as a way for different disciplines to work together to create a unique way of knowing. We extend this analogy to advocate for arts-based work promoting a more authentic partnership between researchers and research participants. Given its interest and work toward this goal in the past several years, social work is poised to be a leader in creativity and innovative research methodologies. Herein, we laid out the foundation for integrating art-making into social work research, describing key ways social work researchers can use art-making and art-based artifacts as tools for both rigorous research and social emancipation.

We provided an account of the value of integrating the arts and for using community-engaged research as a paradigm that can be used to facilitate this endeavor. We hope that the examples we shared here will inspire others to develop and test other methods that will be needed for full integration of the arts in social work research.

REFERENCES

Abbott, E. (1936). *The Tenements of Chicago: 1908–1935*. University of Chicago Press.

Alliance for the Arts in Research Universities (a2ru). (2018). *What is research? Practices in the arts, research, and curricula*. (Version 2). University of Michigan.

Alliance for the Arts in Research in Universities. (2020). About the a2ru. https://a2ru.org/

Ansdell, G., & Pavlicevic, M. (2001). *Beginning research in the arts therapies*. Jessica Kingsley Publishers.

Chamberlayn, P., & Smith, M. (2008). *Art creativity and imagination in social work practice*. Routledge.

Chapman, M. V., Day, S. H., Rivens, A., Lee, K., & Shackelford, A. (unpublished manuscript). The performing arts and anti-Muslim attitudes: Can the arts change stereotypical thinking?

Chapman, M. V., & Hall, W. J. (2014). Outcome results from *Yo Veo*: A visual intervention for teachers working with immigrant Latino/Latina students. *Journal of Research on Social Work Practice*, 26(2), 180–188. https://doi.org/10.1177/1049731514545655

Chapman, M. V., Hall, W. J., Lee, K., Colby, R., Coyne-Beasley, T., Day, S., Eng, E., Lightfoot, A. F., Merino, Y., Siman, F. M., Thomas, T., Thatcher, K., & Payne, K. (2018). Making a difference in medical trainees' attitudes toward Latino patients: A pilot study of an intervention to modify implicit and explicit attitudes. *Social Science & Medicine*, 199, 202–208. https://doi.org/10.1016/j.socscimed.2017.05.013

Chapman, M. V., Wu, S., & Zhu, M. (2016). What is a picture worth? A primer for coding and interpreting photographic data. *Qualitative Social Work*, 16(6), 810–824. https://doi.org/10.1177/1473325016650513

Chronister, K. M., & McWhirter, E. H. (2006). An experimental examination of two career interventions for battered women. *Journal of Counseling Psychology*, 53(2), 151–164. https://doi.org/10.1037/0022-0167.53.2.151

Collins, L. M., Dziak, J. J., & Li, R. (2009). Design of experiments with multiple independent variables: A resource management perspective on complete and reduced factorial designs. *Psychological Methods*, 14(3), 202–224. https://doi.org/10.1037/a0015826

Eisner, E. (1997). The promises and perils of alternative forms of data representation. *Educational Researcher*, 26(6), 4–20.

Emerson, M., & Smith, P. (2000). *Researching the visual: Images, objects, contexts, and interactions in social research*. Sage Publications.

Foster, V. (2007). "Ways of knowing and showing": Imagination and representation in feminist participatory social research. *Journal of Social Work Practice*, 21(3), 361–376. https://doi.org/10.1080/02650530701553732

Freire, P., & Macedo, D. (1987). *Literacy, reading the word and the world*. Routledge.

Friedman, S. R., Perlman, D. C., & Ompad, D. C. (2015). The flawed reliance on randomized controlled trials in studies of HIV behavioral prevention interventions for people who inject drugs and other populations. *Substance Use & Misuse*, *50*(8–9), 1117–1124. https://doi.org/10.3109/10826084.2015.1007677

Gant, L. M. (2015). *Personal and societal transformation through social work and the arts* [Video]. University of Michigan, School of Social Work. YouTube. https://www.youtube.com/watch?v=4KqmwMoTQdA

Hafford-Letchfield, T., & Huss E. (2017). Putting you in the picture: The use of visual imagery in social work supervision. *European Journal of Social Work*, *21*(3), 441–453. https://doi.org/10.1080/13691457.2018.1423546

Hales, P. (1984). *Silver cities: The photography of American urbanization 1839–1915*. Temple University Press.

Harrington, A. (2004). *Art and social theory: Sociological arguments in aesthetics*. Polity Press Ltd.

Hartman, A. (1990). Many ways of knowing [Editorial]. *Social Work*, 35(1), 3–4.

hooks, b. (1992). *Black looks: Race and representation*. Turnaround Publishing.

Huss, E. (2009). "A coat of many colors": Towards an integrative multilayered model of art therapy. *The Arts in Psychotherapy*, *36*(3), 154–160. https://doi.org/10.1016/j.aip.2009.01.003

Huss, E. (2012). *What we see and what we say: Using images in research, therapy, empowerment, and social change*. Routledge.

Huss, E. (2018). Arts as a methodology for connecting between micro and macro knowledge in social work. *British Journal of Social Work*, *48*(1), 73–87. https://doi.org/10.1093/bjsw/bcx008

Huss, E., Ben Asher, S., Shahar, E., Walden, T., & Sagy, S. (2020). Creating places, relationships and education for refugee children in camps: Lessons learnt from the "The School of Peace" educational model. *Children & Society*, *35*(4), 481–502. https://doi.org/10.1111/chso.12412

Huss, E., & Bos, E. (Eds.). (2022). *Social work research using arts based methods*. Policy Press.

Huss, E., & Hafford-Letchfield, T. (2018). Using art to illuminate social workers' stress. *Journal of Social Work*, *19*(11), 1–18. https://doi.org/10.1177/1468017318792954

Huss, E., & Maor, H. (2015). Towards an integrative theory for understanding art discourses. *Visual Art Research*, *40*(2), 44–56.

Jarman, J. (2007). *Crossings; Dream of the rich north* [Photography documentary]. http://janetjarman.com/

Knowles, X., & Cole, X. (2008). *Handbook of the arts in qualitative research: Perspectives, methodologies, examples, and issues*. SAGE Publications.

Lightfoot, A., Thatcher, K., Simán, F., Eng, G., Merino, Y., Thomas, T., Coyne-Beasely, T., & Chapman, M. V. (2019). What I wish my doctor knew about my life: Using photovoice to explore barriers to health equity with immigrant Latino adolescents. *Qualitative Social Work*, *18*(1), 60–80. https://doi.org/10.1177/1473325017704034

Malka, M., Huss, E., Bendarker, L., & Musai, O. (2018). Using photovoice with children of addicted parents to integrate phenomenological and social reality. *Arts in Psychotherapy*, *60*, 82–90. https://doi.org/10.1016/j.aip.2017.11.001

Mason, J. (2002). *Qualitative use of visual method*. Sage Publications.

Narhi, K. (2002). Transferable and negotiated knowledge: Constructing knowledge for the future. *Journal of Social Work, 2*(3), 317–336. https://doi.org/10.1177/146801730200200304

National Association of Social Workers. (2020). Code of ethics. https://www.socialworkers.org/About/Ethics/Code-of-Ethics/Code-of-Ethics-English

O'Brien, G. V. (2011). Eugenics, genetics, and the minority group model of disabilities: Implications for social work advocacy. *Social Work, 56*(4), 347–354. https://doi.org/10.1093/sw/56.4.347

Pasztorzy, E. (2005). *Thinking with things: Toward a new vision of art*. University of Texas Press.

Pendzik, S., Emunah, R., & Johnson, R. R. (2016). The self in performance: Context, definitions, directions. In S. Pendzik, R. Emunah, & R. R. Johnson (Eds.), *The self in performance* (pp. 1–18). Palgrave Macmillan.

Pulitzer Foundation for the Arts and the University of Michigan School of Social Work. (2013). The integration and impact of art and social work. Pulitzer Symposium Meeting Summary. file:///C:/Users/pinto/Downloads/Pulitzer%20Symposium%20Meeting%20Summary%202013.pdf

Segal-Engelchin, D., Huss, E., & Massry, N. (2019). Arts-based methodology for knowledge co-production in social work. *British Journal of Social Work, 50*(4), 1277–1294. https://doi.org/10.1093/bjsw/bcz098

Sember, R., & Gere, D. (2006). "Let the record show . . . ": Art activism and the AIDS epidemic. *American Journal of Public Health, 96*(6), 967–969. https://doi.org/10.2105/AJPH.2006.089219

Shank, M. (2005). Transforming social justice: Redefining the movement: Art activism. *Seattle Journal for Social Justice, 3*(2005), 531–535.

Sinding, C., Warren, R., & Paton, C. (2012). Social work and the arts: Images at the intersection. *Qualitative Social Work, 32*(2), 187–202. https://doi.org/10.1177/1473325012464384

Stange, M. (1989). *Symbols of ideal life: Social documentary photography in America, 1890–1950*. Cambridge University Press.

Wang, C., & Burris, M. A. (1994). Empowerment through photo-novella: Portraits of participation. *Health Education Quarterly, 21*(2), 171–186. https://doi.org/10.1177/109019819402100204

Windsor, L. C., Benoit, E., Smith, D., Pinto, R. M., & Kugler, K. (2018). Optimizing a community-engaged multi-level group intervention to reduce substance use: An application of the multiphase optimization strategy. *Trials, 19*(1), 255. https://doi.org/10.1186/s13063-018-2624-5

Wolff, N. (2000). Using randomized controlled trials to evaluate socially complex services: Problems, challenges and recommendations. *The Journal of Mental Health Policy and Economics, 3*(2), 97–109.

World Health Organization (WHO). (2019). What is the evidence on the role of the arts in improving health and well-being? A scoping review. WHO Team. https://www.ncbi.nlm.nih.gov/books/NBK553773/

7
Affinity Between the Aims of Social Work and the Mechanisms of Arts-Based Research

EPHRAT HUSS

INTRODUCTION

The connection between arts and social work research is a rapidly developing area, as exemplified in this and other books and articles of late (Huss & Bos, 2020, 2021). This chapter will articulate the challenges and unique advantages of using arts-based research for social work, particularly in inquiry with marginalized and underrepresented populations. A primary challenge facing arts-based social work research is the presumption that artistic methods are less "scientific" than narratives or statistical numerical methods. Arts are considered supplemental, illustrative, or entertainment, not legitimate or objective representations of diverse perspectives or people's lived experiences. It is exactly this disenfranchisement, however, that makes the arts especially useful for social work research.

Social work is a predominantly female field, and thus its credibility and potency within the male-dominated arena of research is minimized. Social work further preponderantly serves women, children, and service users considered vulnerable. Voices of female and marginalized service users have historically been absent from traditional modes of research, and thus knowledge of their wants and needs have been misjudged or simply unknown. Unlike traditional inquiry, arts-based expressive modalities ensure that women's experience is authored, not assumed or filtered through the inherent biases of male perspectives and/or quantitative methodologies. Knowledge gained from arts-based,

participatory research prioritizes methods that bring to light more exact and elaborated understanding of service users' experiences and subsequent needs, information that is critical to social work education and practice. As Spivak and Guha (1988) stated:

> The place where female and marginalized "speech acts" can be heard is not in historical, academic, and political writings that are male dominated, but in the areas of symbolic self-expression where resistance is removed from reality, and thus does not threaten the central male discourse. (p. 207)

In this chapter, the theoretical, political, and social rationales for using arts-based methods are described and illustrated. Art as a research methodology belongs to the arena of "social art." Social art is differentiated from "fine art," which focuses more on aesthetics and techniques and is viewed mostly in confined sites such as museums, galleries, and buildings. Although some fine artists intend their work to convey social views, the views are secondary to their work. "Social art" belongs to the individual and to the community; its messages are meant to communicate affective and lived experiences and to bring awareness to unspoken and often painful narratives.

The chapter continues with detail on how to implement the arts in social inquiry. Social work researchers are invested in enabling service users and research participants to own their experiences rather than having them proscribed by outside investigators. Findings culled from arts methodologies better inform the field, providing insight into what service users want and need and also allow for more candid expression of their views on social service provision.

The final section speaks to translation. Phenomenological research seeks to understand the meaning of experience for participants. Thus, first and foremost, the creator or chooser of the art-based data is its interpreter, not the researcher. However, the art product is considered relational, situated in the context of the creator's world, and used as a method for knowledge expression and communication to the researcher.

SOCIAL ART—THEORY AND PURPOSE

It is worth further elaborating on the theoretical rationale for using arts-based methods in social work research to counteract its marginal status. Phenomenology is an area of philosophy that studies the realm of human experience, meaning, and awareness. Phenomenological inquiry aligns well with social work practice as its intent is to understand the world from the perspectives of service users -to meet them where they see themselves in

life's journey—and to aid them in ways that have utility and meaning to their circumstances.

It is from this phenomenological stance that social art distinguishes itself from fine art. Fine art is culturally contextualized embracing multiple roles and discourses in different countries, ethnicities, and sociogeographical contexts. Within Western culture, fine art is most often an elite form of expression that focuses on aesthetic innovations that are in dialogue with past fine art discourses. Success in the fine art world leads to the art product exiting the community and the context of its creation for a designated and privileged space, such as a museum (Hills, 2001; Shank, 2005). It can be said that fine art has relational qualities, but they are inhibited in scope, residing in the experience of the viewer who reacts to the work in their individualized way. The intent of fine art is not to elevate the experience and learn from it, but rather for the viewer to appreciate the work and the artist to benefit in some way from their appreciation.

Art is also used to influence. In political and financial arenas, art and design target peoples' understandings and perceptions, with the goal of manipulating their behaviors. In psychoanalytic terms, the desire is for the sensual elements of art to arouse and inspire people to buy certain products. In political campaigns, art is an effective vehicle to shift cognition and alter existing beliefs so that the public will vote for a specific candidate or referendum or put pressure on one party or another to act in their favor. The arts are similarly used within social change movements. Arts for social change embody aesthetic impact aimed at changing hearts and minds, political stands, and behaviors (Harrington, 2004; Huss, Braun-Lewensohn, Ganayiem, 2018). Art is also used as a psychological tool, as in art therapy, assessment, and diagnostic testing. From a therapeutic standpoint, art is understood as a projective representation of the inner unknown world of the drawer and the psychological expert, not the creator, judges its meaning and implications for treatment.

Phenomenological and humanistic discourses within Western culture focus on arts as an expression of the authentic self (Betinsky, 1995; Huss, 2015). The arts gain validity in light of the process that the artist undergoes and in terms of the meanings that only they can give it; the aesthetic quality of the product is not considered. Used in social work research, the arts allow for exploration of the conscious lived experience of shared phenomena, some of which has remained unspoken perhaps for generations or, in other instances, engenders feelings of the moment that may be taboo or contextually unacceptable. In social work, art enables service users to exteriorize particularly difficult emotions emanating from trauma, disaster, and/or disenfranchisement (Huss & Hafford-Letchfield, 2019). According to Sinding et al. (2014), art allows outsiders a glimpse into others' worlds and offers pathways to verbalize thoughts that have obstructed change.

Outside (and inside) of Western culture, within which social work research is situated, art is understood as a culturally constructed concept in itself: a visual culture that serves different roles and discourses in different contexts. The arts enable the creator to communicate through imagination, imparting their version of social realities uninhibited by the constraints of words or cultural misunderstanding (Friere & Macedo, 1987). The researcher and participants co-construct this visual culture to create objects and decorate them, a ritual for creative place making, understanding specific populations and groups, and gaining access to sociogeographical realities (Emmison & Smith, 2000; Harrington, 2004; Huss, 2015; Huss & Bos, 2019; Huss & Maor, 2015; Rose, 1988). Creating rituals for placement is critical to social art as research. Social work service users are from multiple, unfamiliar, and often marginalized cultures. They understand art as a means of conveyance more intimately than verbal self-expression. Arts-based research methods shift focus away from abstract verbal concepts to more culturally attuned, person- and community-centered contextualized descriptions (Huss, 2015; Huss, Braun-Lewensoh, & Hassan Ganayiem, 2018). Art is projective, expressive, didactic, participatory, anthropological, qualitative, or quantitative. It can focus on the process, its products, or interpretation. It can be a method for gathering data, the subject of the research, or its end product. Most importantly, art enables integration: It is a method to share, process, produce, and interpret in a participatory form. For example, art-making can begin as a reflective process of the group and conclude as an exhibition that goes beyond its generative source to influence others. Art is expressed through photovoice,[*] outsider art, arts for social change, community work (e.g., murals), arts and health, arts to humanize institutions, and arts to destigmatize minorities and give voice to silenced groups (Chamberlyne & Smith, 2008; Huss, 2012; Huss & Bos, 2019). We also see artists interested in working with and within communities, for example, in correctional and school settings. Methods of arts-based research enable non-Western participants to self-define central concepts and then to explain these culturally embedded visual elements rather than fitting into predefined concepts based in Western culture (Chilisa, 2011; Eisner, 1997; Huss, 2012, 2015, 2016; Knowles & Cole, 2008; Theron & Theron, 2010; Van de Vijver & Tanzer, 2004). Regardless of the modality or site, the process, product, and reactions to art production are all subjects of meaningful research (Huss & Bos, 2019, 2021). This explanation of what is meant by social art in arts-based research should help social work researchers or nonartists in overcoming hesitations. It is categorically different from fine art, therapeutic

[*]. Photovoice is a form of participatory action research whereby participants share their perspectives through photographs and accompanying narratives. Originating from public health, photovoice offers opportunities for marginalized and silenced populations to present their views and be acknowledged (Wang, 1999).

art, and art used to influence. Rather, social art is seen as a natural language across and among cultures, a best practice form of communication geared to a wide berth of individuals and populations rather than only dominant groups (Eisner, 1997; Huss, 2018). Next, the question of what constitutes the arts-based research process and how it connects to social work is discussed.

ARTS-BASED RESEARCH

How does arts-based research connect to social work values? First, social work is invested in enabling service users and research participants to self-define their experience. Yet too often traditional processes of communication do not permit such authorship or there is not sufficient trust or cultural understanding to support the openness needed for authentic sharing. The arts are a means to excavate and surface silenced facets of experience suppressed due to traumatic content, cultural taboos, fear of reprisal, or negative experiences with authority and/or as a consequence of pervasive social marginalization.

The first stage of arts-based research therefore is the participant's selection and creation of an expressive modality. This choice makes it possible for them to gather their own data, applying compositional sensory elements such as color, sound, and movement to express and author their experience. Emotions, cognitions, and embodied sensations are organized or controlled on the page, through music, or in whatever art form is chosen. Compositional aesthetic decisions are critical to self-definition. For example, choices about how to depict the content, the size and dimension of objects, the colors, texture, and placement on the page of the illustration or what type of tune, or stage, or movement in space is fully determined by the creator. Rather than fitting their experience into those of the researcher's preconceived words, interpretations, and conceptualizations, the art creator is fully in charge of delineating the parameters and scope of their production. As such, art expressions are in themselves a form of "re-searching." Silenced experiences become embodied expressive, representative, and reflective processes. To illustrate, a research participant was prompted to describe her experience of the 2020 pandemic. She did a drawing of herself alone in her home, thus exploring the experience for herself, choosing to depict it as being alone in a house and, from this, self-defining the experience of isolation and loneliness as the hardest part of dealing with the coronavirus.

Social workers also privilege human connection and thus aim to intensify the interconnection between subjective experience and social context. How does this interconnection enable the researcher? How does it guide the observer to reach a social and critical understanding of personal experience? Arts embody this quandary through the aesthetic tension created between the subject and the context within which they're situated, that is, the relationship

between actor and stage, dancer and space, tune and background music, and figure and background. The personal experience is always socially contextualized as it occurs within a specific background, helping to move away from decontextualized verbal abstractions. For example, when a poor Bedouin[†] woman draws confinement to a small tin house and then the systematic and illegal destruction of that house, she conveys her subjective experience or source of being "depressed" as a contextualized response to harsh reality rather than as an undefined pathological experience. Themes of fear and injustice are illustrated and can be used to inform action that is social and resource driven rather than purely clinical. The arts thus help maintain a broader "picture" of research participants' experiences, making apparent the connection between subjective experience, social determinants, and context for both participant and researcher (Foster, 2007; Freire & Macedo, 1987; Huss, 2015, 2016; Mernissi, 2003). Art also curates a culturally sensitive context, as the background includes the values and ways of seeing and understanding the world of the subject. It thus becomes informative as an ethnographic tool, showing the lived realities and perspectives of research participants; for example, when a Bedouin woman speaks of her home but draws a tent, we readily understand her cultural and situational reality (Amthor, 2017; Huss, 2012, 2017; Huss, Ganayiem, & Braun-Lewensohn, 2018; Mason, 2002).

Arts are also a natural and developmentally appropriate language for children, who have ideas, attitudes, and interests that are perceived and successfully understood through expressive interaction (Amthor, 2017; Bowler, 1997; Clark, 2011; de Kreek & Bos, 2017; Huss et al., 2020). The phenomenological rather than psychological-projective use of arts gives voice to especially vulnerable groups of children, seeing them as experts on how they experience their complicated and often unprotected worlds (Huss et al., 2020, 2021). The following research project illustrates the use of social arts to better understand the experience of refugee children.

Children in the study were asked to draw their experience of the schools in their camps. On one side of the page, they were to draw what they liked about school and on the other what they didn't like (Huss et al., 2020, 2021). Interestingly, one of the central things learned from the children's artwork was that they liked the process of dressing in good clothes for school and being taken there by bus so that they could see outside of the camp. Another element expressed was the hope that was instilled in their parents because they were going to school, which could give them a better future. Prescribed questions might not have revealed the subjective and distinctiveness of these children's

[†] The Bedouin are an Indigenous people of the Negev Desert in southern Israel who mostly live in settlements unrecognized by the Israeli government and with little to no access to public services. Israel's Bedouin are recognized as the most economically disadvantaged community in the country.

perspectives. Learning from their art brought forth important knowledge capable of informing important programming and/or change.

Third, social work aims to maintain an empowerment and strengths-based focus. The arts help to surface and consider participants' coping skills and resources (Antonovsky, 1987; Eriksson, 2017; Simon, 2005). Indeed, art-making itself can be understood as a strength-enhancing activity, as articulated in humanistic "art-as-therapy" approaches (Allen, 1993). Images are a construct through which people process and organize their inner experiences, integrate the past and re-story the present, and create new perceptions of the future. Culturally contextualized arts offer a space where people naturally make meaning of their lives, thus enhancing resilience, and gaining strength from personal and cultural symbols. Embodied relational aesthetic experience enables us to interact positively with the world, making spaces special, creating meaning, manageability, and comprehension of the world. Creative thinking augments problem-solving, agility, and capacity, which in turn enriches meaning making (Conway & Pleydell-Pearce, 2000; Huss & Sarid, 2014). This is an important point because it emphasizes how the arts are used to simultaneously describe stress and promote coping through engagement in expressive activities (Huss & Samson, 2018). The drawer of the previously mentioned coronavirus artwork added illustrative content to express the ways that she coped during the pandemic. She surrounded her initial image with drawings of joining Zoom meetings, talking on the phone, and writing to people. Engaging in an arts production enabled her to bring forth an internal experience and express it, to situate that experience within a specific social context, and to focus on the stress and the ways that she coped, within that context.

INTERPRETING AND EXPLAINING THE IMAGE

The second stage of arts-based research involves the interpretation or explanation that researchers apply to the data or artworks. Within the phenomenological tradition, data translation is relational and bidirectional; however, its meanings are first and foremost those of the art creator or chooser. It does not stand alone, however, and meaning interpretation is considered interactional, situated in the context of verbal interpretation and interaction with critical others. The phenomenological process can be exchanged and expanded in a group of those who have undergone the same or similar experiences. Within a shared reality group, the process of exchange produces a rich and collective body of knowledge culled by experts who have mutually shared, acknowledged, and expressed commonly lived experience. This process not only enriches understanding but also validates the participants' knowledge and perceptions, leading to a sense of empowerment. Like in traditional focus

groups, sharing fosters openness, allowing multiple perspectives or elements of experience to be heard that are enriching for the participants and enhance the research process undertaken.

To illustrate this process, I offer the following example: A group of Eritrean refugees in Israel created a collective mural of images of their individualized journeys and respective present situations (Huss et al., 2020). Themes that emerged included images of the ideal past before the war in their country, the traumatic journey, and the experience of confinement in the camps in Israel. Together, these brought forth a diverse and rich narrative of the whole experience, including good memories, trauma, anger, and hope for the future. The different group members connected through others to additional facets of the experience and significantly aided the researcher in the appreciation of the depth, breadth, and diversity of the central experiential themes.

Arts-based data are further used to decentralize power differences between researcher and research participant, influencing perceptions and interactions with those outside of the shared reality group. Research participants often do not have professional words or may not be from the same or similar cultures or share a common language or may not be comfortable or feel safe enough to verbally share their experiences or translate them into abstract social work terms. Thus, both research participant and researcher find themselves meeting in a new nondominant dialectic, which might be thought of as the crossroads of art and new knowledge. As Lippard (1990) stated:

> Educated Westerners use language as control, while poorer, less educated people, especially those from rural backgrounds, control language through expressive formulations. (p. 57)

Art as communication reduces inequitable power differentials as all concerned, researcher and participant, are learning a new language. Such a power shift, bridges differences in language and culture, building a space to truly co-produce knowledge. Rather than being defined by experts, or social workers, arts-based research is participatory and co-produced by participants and researchers (as nonartists) (Huss, 2012, 2016; Narhi, 2002; Segal-Englchin et al., 2019; Walton, 2012), surfacing broader possibilities for interpretation (Arnheim, 1996; Huss, 2016). As hooks (1992) described, such inquisitive exchange moves from being objectified through the researchers' gaze as compared with "seeing" and thereby self-defining issues for oneself (Abu Gazaleh & Bos, 2019). This can influence hegemonic knowledge or privileged knowledge that perpetuates social inequities and status. It also informs social work education in a way that includes lived experience as knowledge rather than relying on evidence-based, expert-only interpretations.

In another study, Huss and colleagues (2018) sought the views of marginalized Bedouin young women living in unrecognized shanty towns to better understand how they balance home/school demands (see Figure 7.1). The young women described how they internalize their feelings as a way to cope with the stress of extreme poverty, parental demands to help at home, along with school demands so they do not create more distress for their families. This example highlights the important connection between social work and Indigenous and feminist methodologies that situate research participants as experts, while emphasizing the need for multilingual texts (Pink & Kurti, 2004; Segal-Engelchin et al., 2019; Tuhawi-Smith, 1993; Wang & Burris, 1994). While from a Western standpoint this coping device might be interpreted as dysfunctional or negative, in the lives of these participants it is an effective management and surviving mechanism. The women's views challenge hegemonic psychological and privileged cultural values and standards of social work practice. Lack of cultural understanding is detrimental to effectively serving these young women or, at the least, alienates them from any benefits social workers could offer them.

One other illustration of arts-based research that informs culturally responsive social work is a long-term postdisaster project situated in Sri Lanka in which villagers following the civil war and tsunami self-defined their needs (Huss et al., 2016). Participants used art to create a small temple, making it clear that rebuilding the temple was the most important aspect of postdisaster recovery. This was in contrast to what researchers expected, for example,

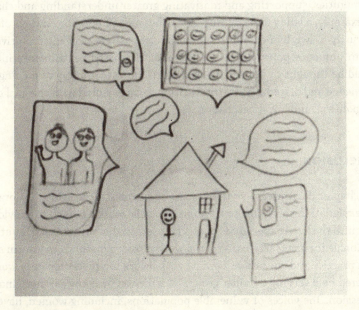

Figure 7.1 Bedouin Woman's Artwork.

having money for self-help or participating in therapy sessions. Understanding rather than assuming the needs of a community was a critical finding of this arts-based research study emphasizing the importance of participants' cultural/spiritual preferences to enhance problem-solving and provide needed resources after disaster.

Social change-oriented social work research is another mechanism used to disrupt existing power systems through amplifying marginalized voices, with the goal of changing the stands of those with power, such as policymakers. In this regard, artists try to destabilize hegemonic perspectives by engaging the senses, enabling projections, and projecting a broader interpretive base for social problems (Harrington, 2004). Artists use symbols and metaphors and nonviolent confrontation to make their points. These methods enable powerless groups to regulate the degree of direct or symbolic confrontation with one's social environment while challenging power holders (Eisner, 1997; Foster, 2007; Gauntlett & Holzwarth, 2006; Huss, 2012; Segal-Engelchin et al., 2019). The previously mentioned Eritrean refugees, for example, fashioned posters through which they called for empathy, acknowledgment of historical wrongs, and social justice.

Social work research aims to create as broad an impact as possible. Its intent is to catalyze change in not only academia, but also communities and through policy initiatives. The end products of the research, the report so to speak, may be an exhibition, film, performance, or music disseminated to influence and reach a broader audience than academic writing alone does. Knowledge gained from earned wisdom experts is also brought back to the originating communities, supporting and motivating greater understanding and change. For example, a study done by Huss and colleagues (2020) used images of food insecurity drawn by Bedouin children to raise awareness of their deprivation and to influence policymakers. In the end, arts-based participatory inquiry should be thought of not as an end in itself but rather a way of gaining new knowledge and disseminating information to be explored with the goal of social, political, and logistical change.

CONCLUSION

This chapter illustrated how the process of aesthetic expression, exploration, and explanation correlates to the aims of social work research to provide insight into the lived experiences of service users in their own terms. It outlined a rationale for using arts-based social work research methods to inform social work practice and education. Because social work is a predominantly woman-centered field serving outsider groups, it is viewed by many as a marginalized profession. The voices of vulnerable populations, including women, have historically been subdued or muted from traditional modes of research, which in

turn renders services designed based solely on evidence insufficient. The predominance of male-conducted, metrically driven research does not necessarily align with the realities of women and/or service users as well as with essential goals of social work. Although such methods are valid, they offer a sketch, not a full portrait, of lived experience.

Arts-based research is especially suitable when seeking deeper understanding of the perspectives and needs of any marginalized group because it deploys an array of expressive languages and modalities. In this chapter, arts-based research is defined as belonging to the area of social art, which is different from fine art and from psychological art and is manifested in different ways within diverse sociocultural contexts. This differentiation helps to demystify the use of expressive arts by social workers because it focuses on the relational and contextual value of art, not on its aesthetics. Arts-based research methods can be projective, expressive, didactic, participatory, anthropological, phenomenological, qualitative, or quantitative, depending on whether the arts-based element is intended to gather data or as an end product of the research.

The critical nature of arts-based research offers a process through which participants self-define, embody, and own their experience rather than having it interpreted by researchers alone. Such authorship intensifies the connection between subjective experience and social context through the aesthetic tension between subject and background within arts. As such, it highlights and socially contextualizes the ways that people live, suffer, survive, and cope.

The relational aspect of arts-based research is equally important to the process. Meaning is co-created by the participant in conjunction with mutual reality groups and alongside others with different levels of power. Thus, a critical characteristic of arts-based research is that it takes place in interaction with others, producing an enriched focus on the subject of the research while simultaneously situating participants as experts. This intersectionality has the potential to decentralize power differences between researcher and research participant and can be used to effectively raise awareness and advocate for changing stands of those who traditionally hold power, such as policymakers. In this regard, the arts enable disempowered groups to confront inequities and power differentials, disseminating their impact through plays, music, murals, films, and exhibitions, rather than by way of traditional research formats that only reach academicians and other researchers. All of these aims are central and aligned with the values of the social work profession.

This chapter has illustrated the deep connection and theoretical alignment between social work and arts-based research and the concepts of social arts. Examples of implementing the arts suggest a range of methods that social workers can utilize in their inquiries. My goal was to demystify the use of arts specifically in research as a way to learn with and from service users and marginalized populations to improve future services and resources, raise

awareness of injustices, and suggest methods to empower historically silenced voices to effect policy change.

REFERENCES

Abu Gazaleh, N., & Bos, E. (2019). *Social initiatives around Refugees*. HvA.

Allen, P. (1993). *Art is a way of knowing*. Shambhala Press.

Amthor, R. F. (2017). "If only I did not have that label attached to me": Foregrounding self-positioning and intersectionality in the experiences of immigrant and refugee youth. *Multicultural Perspectives, 19*(4), 193–206. https://doi.org/10.1080/15210960.2017.1366862

Antonovsky, A. (1987). *Unraveling the mystery of health: How people manage stress and stay well*. Jossey-Bass.

Arnheim, R. (1996). *The split and the structure: Twenty-eight essays*. University of California Press.

Betinsky, M. (1995). *What do you see? Phenomenology of therapeutic art experience*. Jessica Kingsley.

Bowler, M. (1997). Problems with interviewing: Experiences with service providers and clients. In G. Miller & R. Dingwall (Eds.), *Context and method in qualitative research* (pp. 66–77). Basic Books.

Chamberlayne, P., & Smith, M. (2008). *Art creativity and imagination in social work practice*. Routledge.

Chilisa, B. (2011). *Indigenous Research Methodologies (1st edn)*. Sage Publications Inc.

Clark, A. (2011). Breaking methodological boundaries? Exploring visual, participatory methods with adults and young children. *European Early Childhood Education Research Journal, 19*(3), 321–330.

Conway, M. A., & Pleydell-Pearce, C. W. (2000). The construction of autobiographical memories in the self-memory system. *Psychological Review, 107*(2), 261–288.

de Kreek, M., & Bos, E. (2017). Playfully towards new relations. In S. Majoor, M. Morel, A. Straathof, F. Suurenbroek, & W. van Winden (Eds.), *Lab Amsterdam: working, learning, reflections* (pp. 78–88). Thoth.

Eisner, E. (1997). The promises and perils of alternative forms of data representation. *Educational Researcher, 26*(6), 4–20.

Emmison, M., & Smith, P. D. (2000). *Researching the visual: Images, objects, contexts and interactions in social and cultural inquiry*. Sage.

Eriksson, M. (2017). The sense of coherence in the salutogenic model of health. In M. B. Mittelmark, S. Sagy, M. Eriksson, G. F. Bauer, J. M. Pelikan, B. Lindström, & G. A. Espnes (Eds.), *The handbook of salutogenesis* (pp. 91–96). Springer International. https://doi.org/10.1007/978-3-319-04600-6_11

Foster, V. (2007). Ways of knowing and showing: Imagination and representation in feminist participatory social research. *Journal of Social Work Practice, 21*(3), 361–376.

Freire, P., & Macedo, D. (1987). *Literacy, reading the word and the world*. Routledge.

Gauntlett, D., & Holzwarth, P. (2006). Creative and visual methods for exploring identities. *Visual Studies, 21*(1), 82–91.

Harrington, A. (2004). *Art and social theory: Sociological arguments in aesthetics*. Polity Press.

Hills, P. (2001). *Modern art in the USA: Issues and controversies of the 20th century*. Prentice-Hall.

hooks, b. (1992). *Black looks: Race and representation*. South End Press.

Huss, E. (2012). *What we see and what we say: Using images in research, therapy, empowerment, and social change*. Routledge.

Huss, E. (2015). *A theory-based approach to art therapy: Implications for teaching, research, and practice*. Routledge.

Huss, E. (2016). Arts as a methodology for connecting between micro and macro knowledge in social work. *British Journal of Social Work, 48*(1), 73–87.

Huss, E. (2017). Contribution of critical theories to art therapy. "Atol" British Association of Art Therapist's Journal. Routledge.

Huss, E., Bar Yosef, K., & Zaccai, M. (2018). Humans' relationship to flowers as an example of the multiple components of embodied aesthetics. *Behavioral Sciences (Basel, Switzerland), 8*(3), 32.

Huss, E., Ben Asher, S., Shahar, E., Walden, T., & Sagy, S. (2020). Creating places, relationships, and education for refugee children in camps: Lessons learnt from the "The School of Peace" educational model. *Children & Society, 35*(4), 481–502. https://doi.org/10.1111/chso.12412

Huss, E., & Bos, E. (Eds.). (2019). *Art is social work practice: Theory and practice: International perspectives*. Routledge.

Huss, E., & Bos, E. (2020). *Art in social work practice: Theory and practice: International perspectives. (Routledge Advances in Social Work) (1st edn)*. Routledge Press.

Huss, E., & Bos, E. (2021). *Using art for social transformation international perspective for social workers, community workers and art therapists*. Routledge Press.

Huss, E., Braun-Lewensohn, O., & Ganayiem, H. (2018). Using arts-based research to access sense of coherence in marginalized indigenous Bedouin youth. *International Journal of Psychology, 53*(S2), 64–71. https://doi.org/10.1002/ijop.12547

Huss, E., & Hafford-Letchfield, T. (2019). Using art to illuminate social workers' stress. *Journal of Social Work, 19*(6), 751–768. https://doi.org/10.1177/1468017318792954

Huss, E., Kaufman, R., Avgar, A., & Shuker, E. (2016). Arts as a vehicle for community building and post-disaster development. *Disasters, 40*(2), 284–303.

Huss, E., & Maor, H. (2015). Towards an integrative theory for understanding art discourses. *Visual Art Research, 40*(2), 44–56.

Huss, E., & Samson, T. (2018). Drawing on the arts to enhance salutogenic coping with health-related stress and loss. *Frontiers in Psychology, 9*, 1–9.

Huss, E., & Sarid, O. (2014). Visually transforming artwork and guided imagery as a way to reduce work related stress a quantitative pilot study. *The Arts in Psychotherapy, 41*(4), 409–412. (CI ISI 2; CI GS 8; IF 0.695; JR128/252; Q2 Clinical Psychology).

Knowles, J. G., & Cole, A. L. (2008). *Handbook of the arts in qualitative research perspectives, methodologies, examples, and issues*. Sage Publications Inc.

Lippard, L. (1990). *Mixed blessings: Art in a multicultural America*. Pantheon.

Mason, J. (2002). *Qualitative use of visual method*. Sage.

Mernissi, F. (2003). The meaning of spatial boundaries. In R. Lewis & S. Mills (Eds.), *Feminist postcolonial theory: A reader* (pp. 489–502). Edinburgh University Press.

Narhi, K. (2002). Transferable and negotiated knowledge: Constructing knowledge for the future. *Journal of Social Work, 2*(3), 317–336.

Pink, S., & Kurti, L. (2004). *Working images: Visual research and representation in ethnography*. Routledge.

Rose, G. (1988). *Visual methodologies*. Sage.

Segal-Engelchin, D., Huss, E., & Massry, N. (2019). Arts-based methodology for knowledge co-production in social work. *The British Journal of Social Work*, *50*(4), 1277–1294. https://doi.org/10.1093/bjsw/bcz098

Shank, M. (2005). Transforming social justice: Redefining the movement: Art activism. *Seattle Journal for Social Justice*, *3*, 531–559.

Simon, R. M. (2005). *Self-healing through visual and verbal art therapy* (S. A. Graham, Ed.). Jessica Kingsley.

Sinding C., Warren R., & Paton C. (2014). Social work and the arts: Images at the intersection. *Qualitative Social Work*, *13*, 187–202.

Spivak, G. C., & Guha, R. (Eds.). (1988). *Selected subaltern studies*. Oxford University Press.

Theron, L., & Theron, A. M. C. (2010). A critical review of studies of South African youth resilience, 1990–2008. *South African Journal of Science*, *106*(7-8). doi:10.4102/sajs.v106i7/8.252

Tuhuawi-Smith (1993). *Decolonizing methodologies: Research and indigenous people*. Zed Books Ltd.

Van de Vijver, F., & Tanzer, N. K. (2004). Bias and equivalence in cross-cultural assessment: An overview. *European Review of Applied Psychology*, *54*(2), 119–135.

Walton, P. (2012). Beyond talk and text: An expressive visual arts method for social work education. *Social Work Education*, *31*(6), 724–741.

Wang, C. C. (1999). Photovoice: A participatory action research strategy applied to women's health. *Journal of Women's Health*, *8*(2), 185. https://doi-org.une.idm.oclc.org/10.1089/jwh.1999.8.185

Wang, C., & Burris, M. (1994). Empowerment through Photo-Novella. *Health Education Quarterly*, *21*, 172–185.

8
Conducting Online Research in the Era of COVID

Theater-Based Methods to Study HIV Stigma

MARC ARTHUR AND ROGÉRIO M. PINTO

INTRODUCTION

In this chapter, we introduce a framework for theatrical social work research methods recommended for the study of HIV stigma among other types of stigma-related diseases and conditions, including COVID-19 and its long-haul effects. For those living with HIV or AIDS, stigma is a defining and ongoing phenomenon with enduring negative consequences. The 2020 COVID-19 pandemic caused significant disruptions in the HIV care continuum. Social distancing mandates forced providers to turn to telehealth and other virtual care modalities. Although precipitating an abrupt pivot from in-person to telecommunication clinical and support services, the exigencies of COVID-19 brought public attention to the potentialities of virtual connection.

In this chapter, we explore the use of virtual theater workshops, including forum theater and visualization exercises as research instruments and community-based methods to reduce HIV stigma and offer informal support. Virtual theater is rooted in the history of theater as a mechanism for raising awareness and for promoting social change. The methodology described in this chapter is currently being piloted with a group of HIV/AIDS service providers in southeast Michigan.

Marc Arthur and Rogério M. Pinto, *Conducting Online Research in the Era of COVID* In: *Social Work and the Arts*. Edited by: Shelley Cohen Konrad and Michal Sela-Amit, Oxford University Press. © Oxford University Press 2024.
DOI: 10.1093/oso/9780197579541.003.0009

BRIEF HISTORY OF HIV AND STIGMA: ORIGINS, MANIFESTATIONS, AND NEGATIVE HEALTH OUTCOMES

The COVID-19 pandemic wreaked havoc beginning in December 2019, and by November 2020, there were 48,196,862 confirmed cases of the disease globally, including 1,226,813 deaths (World Health Organization [WHO], 2020). For many of us, the spread of COVID resurfaced memories of the 1980s when acquired immune deficiency syndrome (AIDS) first emerged. The two pandemics trace infrastructural fault lines of racism, poverty, and disenfranchisement as related to access to prevention and care. Long-standing systemic health and social inequities put many people from racial and ethnic minority groups, particularly Black and Latinx populations, at increased risk of being infected by and dying from COVID-19 (Gold et al., 2020; Price-Haygood et al., 2020). Those already living with chronic conditions like HIV infection are also at higher risk of COVID-19 complications due to structural conditions that disrupted access to HIV treatment and prevention or that restrict human rights by increasing criminal penalties and expanding police powers to target underserved populations (Iversen et al., 2020; Pinto & Park, 2020).

Though we don't yet know how COVID-19 will affect populations over time, we do know that 38 million people across the globe are living with HIV and AIDS and its physical, economic, and psychosocial impacts (HIV.gov, 2020). Like COVID-19, in the United States, HIV/AIDS disproportionately impacts Black communities; in 2018, Blacks accounted for 13% of the U.S. population, yet they represent 42% of the 37,832 new HIV diagnoses (Centers for Disease Control and Prevention [CDC], 2020a). Dr. Anthony Fauci, director of the National Institute of Allergy and Infectious Diseases and chief counsel to the president during the 2020 pandemic observed that the coronavirus' disproportionate death toll among Black Americans was reminiscent of the early AIDS crisis, which largely impacted gay people (Nelson, 2020). Understanding the connection of these two pandemics helps us to see the importance of removing structural barriers at the foundation of the widespread historical transmission of two different viruses across already underserved communities.

Thirty years into the AIDS pandemic, stigma continues to produce adverse health and psychosocial outcomes for people living with HIV/AIDS (PLWHA), such as depressive symptoms, difficulties with medication adherence, and inconsistencies in and lower frequency of necessary medical visits (Bulent et al., 2017; Dubov et al., 2018). Stigma is a socially conferred prejudice or judgment identified as the outcome of negative cultural norms, values, and exclusionary practices that often operate on multiple social identities, for example, HIV serostatus and ethnic/racial identities (Pescosolido et al., 2008). Scholars from cross-disciplinary fields of inquiry have mapped out how stigma

lies at the interface of community, psychological, sociocultural, organizational, and societal factors (Lewis, 1998; Sontag, 1991).

Stigma has long been closely tied to HIV/AIDS. In 1983, during the confusion and chaos of the initial outbreak, the CDC published a study finding homosexuals, hemophiliacs, heroin users, and Haitians as the groups most impacted by HIV/AIDS. While the CDC's effort may have been to reduce transmission by identifying populations that had higher rates of HIV infection, their results prompted significant and widespread discriminatory attitudes toward these four populations. Dubbed in the media as the "4-H club" (Marx, 1982), the findings were reductionistic, translating the complexity of HIV transmission and blaming these communities for the vast majority of contagion. The consequence of this oversimplification was the false yet violent cultural fantasy that saw these populations as looming threats to White, middle-class families. The use of inflammatory and targeting language by social media and political leaders contributed to increasing the power of stigma (Villa et al., 2020).

During this time (1981 to 1984), when the AIDS epidemic was still relatively nascent, anthropologist Gayle Rubin (2011) argued that emerging AIDS discourses, like the 4-H club, represented an impending moral panic not dissimilar from other periods in history when disease was transformed from an illness into a political instrument to be used against certain, mostly marginalized, groups. Rubin argued that at times of outbreak, the social narrative incited moral panic, which invented victims based on existing biases and stereotypes that have had lasting social and legal ramifications. Rubin's paradigm could be seen as unfolding during the COVID-19 epidemic when, for example, then-President Donald Trump publicly used anti-Asian rhetoric when describing COVID-19 as the "Chinese virus" (Zia, 2020). Repeated terminology such as "Wuhan virus" and "Chinese virus pandemonium" had a quick and adverse impact on Asian groups, some of whom became victims of racist verbal and physical violence (Viladrich, 2021).

For PLWHA, the 4-H club and HIV-positive moral panic was irresponsibly associated with certain stigmatized groups in mainstream cultural understanding and remains to this day associated with sexual irresponsibility and is a powerful force in maintaining stigma that prevents effective care. The story of the HIV prevention regimen PrEP (pre-exposure prophylaxis) offers an example of such HIV stigma exigencies. Approved in 2012 by the Food and Drug Administration (FDA) for HIV-negative persons, PrEP is a daily pharmaceutical regime that is 96% effective at stopping HIV transmission (CDC, 2020b). Individuals known to use PrEP, however, are the targets of ill-informed judgment, negative stereotyping, and stigma because of HIV's association with irresponsible, frequent sexual behaviors (Calabrese

& Underhill, 2015; Pinto et al., 2018). Similarly, stigma is evidenced in the failure of service providers to use the term "undetectable = untransmittable" (U = U). U = U describes the evidence-based circumstances of those with HIV who achieve and maintain an undetectable viral load (the amount of HIV in the blood) by taking antiretroviral therapy and thus cannot transmit HIV sexually (Calabrese & Mayer, 2020). Despite these proactive and positive outcomes, both the use of PrEP and U = U status are unreasonably stigmatized.

HIV stigma is especially pronounced in the professional relationships between providers of medical, social, and public health services and toward users of such services. Provider HIV stigma manifests as mistreatment or negligence in interpersonal interactions fueled by attitudes based on historically negative ideas and stereotypes about persons vulnerable to HIV infection, such as drug users, transgender people, sex workers, the poor, and people having several sexual partners in their lifetime. Such stereotypes and misunderstandings cause providers to harbor fears of acquiring HIV through occupational exposure, an unfortunate and costly misconception (Geter et al., 2018). A global survey of healthcare providers to assess for HIV stigma conducted by the Joint United Nations Program on HIV and AIDS (UNAIDS) found significant fear leading to an unwillingness to care for PLWHA. The survey also found that people living with HIV or who require HIV preventive care were difficult to reach for testing, treatment, and prevention services (UNAIDS, 2017). Other studies have similarly found provider HIV stigma to be an obstacle to care, treatment, and prevention (Stringer et al., 2016). For African Americans in the United States, experiencing provider HIV stigma was found to be a major cause of drop-offs in care and a lack of trust in physicians (Fabian et al., 2019; Reif et al., 2019).

During the early years of the AIDS pandemic, social workers played a critical role in addressing the unknown and deadly emerging crisis. They built on skills central to the profession, including crisis management, medical compliance, and family conflict mediation to develop techniques for helping patients and clients adjust to the illness, make decisions about disclosure, engage in health education, and offer general support for vulnerabilities that were exacerbated by historically and structurally disadvantaged communities (Linsk, 2011). Social workers further addressed barriers to HIV care, including stigma. Activism was critical in the early years of the U.S. AIDS crisis. Social workers focused on organizing and facilitating support groups and providing crucial spaces to foster and support a sense of normality for otherwise isolated and stigmatized PLWHA (Weiner, 2003; Willinger, 2003).

The next section defines the concept of stigma and describes the integration of art-based, theatrical methods to assist social workers in addressing social works' role in working with PLWHAs.

THEATER PRACTICES TO ADDRESS STIGMA AND MARGINALIZED COMMUNITIES

We suggest that theatrical practices have the potential to build on and expand a social worker's toolkit to address and reduce HIV stigma in service provider and client interactions. To this end, the understanding of stigma in the field of theater is quite instructive. Performance studies scholar Erving Goffman (1986) identified stigma as the splitting of a whole person into a less-than-human person and proposed that stigma separates individuals from one another based on socially conferred judgments that taint them as "less than." Goffman further observed that stigma is enacted through social interaction, contending that stigmatized stereotypes are fueled and enacted "theatrically" as real attributes that often manifest in prejudice and intentional exclusions.

One way to combat stigma is to look closely at the conditions and norms of social interactions or the theatrical qualities that form the basis for the stigma to be enabled.

Theatrical interventions, which by their very nature are interpersonal, can help social workers identify and alter implicit stigmatization and expose systems of larger institutional stigma that propagate it. We further suggest that theatrical exercises be used to research the many ways stigma manifests in social exchanges and how it is embedded structurally in institutions providing HIV/AIDS services. The use of theatrical exercises as interventions can undo both institutionalized stigmatization and also stigmatization perpetrated in interpersonal relations (i.e., provider-consumer).

Theater and performance have long been used as tools to create positive change in civic life by bringing people together to engage in advocacy, to solve community issues, and to advance social justice (Taylor, 2020). Theater practices used as a method of community-based change are perhaps most notably deployed through the techniques created by Augusto Boal (Paterson, 1999), the Brazilian theater artist who developed "forum theater," in which audience members participate in a performance to explore solutions to situations of oppression. Boal argued for a theater where the spectators become "spec-actors" and offer solutions to their own problems by re-performing scenes of oppression. Boal's method is centered on community transformation and is connected to the broader movement of postwar political artists seeking to change society through theater, such as The Living Theater or the Bread and Puppet Theater.

Boal's method was created in conversation with the work of the Brazilian political theorist Paulo Freire (1970), who proposed critical dialogues as a method for communities to participate in developing a pedagogy of liberation. Boal's method has been so successful it is now used across the globe to combat oppression and empower marginalized communities in a vast array of contexts. The most well-known form of theater used for personal transformation

is playback theater (1981) developed by Jonathan Fox. Playback theater is improvisational and centers on the personal story or narrative. It is therapeutically oriented and typically takes place over several weeks or months.

Forms of theater such as those founded by Fox and Boal have been described as "applied theater." Applied theater has grown in prominence since the turn of the century. In higher education, some universities have adopted applied theater majors, though their disciplinary locations may vary across academic programming. This is perhaps due to the wide array of theatrical practices taught and the multiplicity of venues in which they are deployed, including across therapeutic and community-based settings. In the field of social work, the potential for applied theater is versatile, well aligned with the field's focus on community-based approaches to personal transformation and social justice. Applied theater as a social work practice is interactive, often public, and engages consumers in a collaborative problem-solving process aimed at serving the needs identified by participants (Snyder-Young, 2013).

Similarly, applied theater as a method of egalitarian participatory social work research holds great promise. However, like many arts-based approaches, the efficacy and viability of applied theater as social activism and/or research has historically been questioned and, in the case of the latter, perceived as less rigorous than traditional, data-driven social science approaches (Bundy et al., 2016; Neelands, 2009). We believe to the contrary that the potential for applied theater practices is highly relevant and concordant with the value base of social work research and practice. In the next section, we describe a developing project that employs virtual theater research workshops to address HIV stigma using methodologies informed by the integrated works of Boal, Fox, and Bausch's visualization exercises (Climenhaga, 2012). We suggest that such inclusive theatrical encounters impart empowerment, agency, and commitment to mutual participatory social change.

FRAMING HIV STIGMA FROM A THEATRICAL PERSPECTIVE

Our proposed use of theater and performance grew from a desire to create new approaches to address extant power inequities in consumer/provider perspectives through critical reflection and interactive relationship. HIV stigma and its impacts exist within structurally and socially unequal contexts where providers have power over how care is delivered and to whom (Lucas, 2020; Paterson, 1999; Thompson & Schechner, 2008). Building on the principles of applied theater as described in the previous section, we chose to concentrate on a community-focused approach, one that involves collaborative and playful techniques for opening up dialogue leading to social and cultural transformation (Diamond, 2007). We were especially interested in modes of Boal's forum theater and Freire's critical dialogues grounded in his pedagogy of liberation.

Both offer salient critique of the nature and precedence of stigma writ large that can be specifically applied to HIV stigma and to ways to combat it.

Forum theater and critical dialogue offer specific tools to facilitate collaborative narratives that permit participants to re-perform and re-story stigmatizing experiences with the goal of gaining new insights that relieve internalized and externalized self-judgment, initiating a chain of actions and reactions effecting positive emotional and behavioral change. Such performance methods create opportunities to challenge the social rules on which HIV stigma is understood and alter the power dynamics on which stigma survives. We propose that performance through virtual theater research workshops can dismantle HIV stigma and have potential to positively impact other forms of illness-related stigma, including the long COVID trends seen in some survivors of the coronavirus (Brown et al., 2020).

In addition to Boal's and Freire's work, we were also influenced by the innovations of choreographer Pina Bausch, including the use of visualization exercises designed by her company, the Tanztheater Wuppertal, to foster bodily agency, empathy, and empowerment (Climenhaga, 2012). Bausch's visualizations attend to strengthening and reinforcing empathy—the desire and capacity to understand different perspectives and feel with others. In combination, authentic and interactive dialogue and empathic visualizations aim to increase participants' sense of empowerment, reduce patient stigma, and increase provider compassion. In the next section, we discuss the impact of COVID-19 on HIV/AIDS service delivery and on the unintended growth of telehealth and virtual care.

TELEHEALTH, VIRTUAL CARE, AND ONLINE THEATER WORKSHOPS

In 2020 we watched in horror as COVID-19 spread across the globe* exposing existing structural inequalities and bringing to light myriad racial/ethnic/economic disparities affecting people's access to healthcare and overall quality of life (Karaca-Mandic et al., 2021; Matthew, 2020). Such disparities were widely spread in the United States, where long-standing systemic health and social inequities placed racial and ethnically underserved groups at increased risk of getting infected and dying from COVID-related complications (U.S. Department of Health and Human Services, 2020).

For individuals already suffering with or at high risk for other diseases and for those with preexisting conditions, including PLWHA populations, the coronavirus was another significant, frightening, and stigmatizing life challenge. PLWHA and individuals most vulnerable to HIV infection faced disruptions in the HIV health continuum, impacting prevention and care services, such as HIV testing, PrEP, and primary care. Community-based organizations

(CBOs) across the country had to close their facilities and were forced to develop virtual capacities and telecommunication online services to reach their clients. At the same time, consumers of social and public health services were required to socially isolate and to stop coming to CBOs (Pinto & Park, 2020).

The pandemic landscape also brought about unexpected challenges for researchers posed first by shelter-in-place mandates and then by requirements for mask wearing and social distancing making it nearly impossible to effectively conduct research with human participants (Wigginton et al., 2020). Social work research demands physical closeness to establish rapport with participants and to meaningfully engage in interviews. During the height of the pandemic, most universities halted in-person human research and instead turned to virtual online platforms and telecommunication strategies, which allowed studies to continue but presented new obstacles and steep learning curves.

The COVID-19 landscape, however, also produced opportunities to develop and test innovative research methods and strategies that otherwise might not have been developed. This included implementation of virtual community-based theater methodologies that allowed for conversations with a wide and diverse array of theater artists who were in the process of adapting to and creatively using the new digital reality. Theater artists have long used technology in their practices to create novel forms of connection (Cziboly & Bethlenfalvy, 2020). Companies like the Wooster Group, Elevator Repair Service, and Big Art Group, for example, used live feed video elements in their plays to perform scenes that are edited live and projected on screens for the audience to see (Giesekam, 2007). Prior to the 2020 pandemic, such digital innovations were rare given that the "live" quality of theater defines the form for most artists. During the pandemic, however, implementation of social distancing protocols mandated that gathering audiences in theaters cease, and theaters across the world shuttered their doors. To survive, theater companies big and small had to adapt, accessing their technology acumen to create fully online theater productions.

In the realm of community-based, educational, and applied theater, online practices similarly emerged to respond to the pandemic, creating spaces for digital connection and support. Perhaps even more than commercial online theater, community practices successfully established connective and collaborative digital spaces capable of establishing a sense of belonging, care for the environment, familiarity, even security during a period of unprecedented upheaval and change (Thompson & Mackey, 2020). Preliminary observations suggest that online applied theater methods of play, process, and experimentation can provide multipronged support that promotes personal well-being (Tam, 2020). Digital community theatrical practices have similarly been successful, fostering a positive online environment to explore urgent issues and

thus enhancing participants' resilience in a global crisis situation (Cziboly & Bethlenfalvy, 2020). A critical advantage of online theater is found in the ability to increase its access, particularly to those from low socioeconomic and ethnically diverse populations (Sullivan, 2020). The next section speaks to combining virtual theatrical strategies, with their lively and interactive approaches, and online social science research.

APPLYING LESSONS LEARNED FROM ONLINE THEATER TO SOCIAL SCIENCE RESEARCH

We've learned many lessons from the 2020 pandemic, including those related to virtual communication technologies and their timeless benefits for reaching broader populations and increasing access to services. As in-person events and gatherings are becoming common again, we believe that online workshops provide a template for consumers to get access to a space of creativity and connection from their phones and computers that was not otherwise previously available to them. The conversion from in-person to online theater-based strategies have synergistic implications for social science research and in particular to studies related to learning more from those living with HIV/AIDS and other stigmatized illnesses. Specifically, access to a safe virtual space offers opportunities for candid reflection, cross-cultural/geographic collaboration, and connection. For consumers who might have a tight schedule, experience motor limitations, or may not be able to travel to in-person workshops, online workshops are convenient and provide essential resources to combat the isolation that accompanies stigmatization beyond the COVID-19 pandemic.

We began with reaching out to collaborators, including HIV-informed community leaders and consultants as well as scholars of theater and performance to identify and develop virtual workshop themes to be explored by consumers. These collaborators have been essential in ensuring that themes are feasible, useful, and acceptable for online work and eventual data collection and analysis. A major concern for online research workshops, however, is how to engage participants in the absence of in-person interaction. The human connection can be lost in virtual settings; thus, the exercises and the facilitators who lead them must create a powerful sense of active connection across and among individuals' screens. Participants in our development meetings however responded positively to an array of experiential activities to facilitate virtual interpersonal connectivity. These included exercises involving wordplay games and breathing exercises that represented a clear departure from static webinars and other more common forms of online engagement.

To support recruitment and retention for the workshops, we had to address factors of online burnout. Even with incentives such as stipends, sustained attendance in virtual programs is a common struggle. To address this limitation, we consulted with community partners to devise retention strategies. We also chose to collaboratively "piggyback" on familiar events and meetings that took place at participants' service agencies. We found these strategies to improve participation.

Establishing and maintaining safe virtual space is, of course, essential for all encounters. Online meeting platforms where participants are contained by virtual boxes can feel solitary and impact how people experience their environments, behave, and connect. Forum theater-inspired exercises enlist interpersonal and psychological techniques that help participants break out of their siloed boxes and actively engage. Exercises further inspire a means to be self-reflective and generate empathy. For example, the exercises based on Bausch's dance form begin by asking consumers to visualize HIV stigma as abstract colors and shapes moving through and out of their bodies. Separating HIV stigma from their real-world experience helped participants gain new reflective models, experience compassion for their inner voices and emotions, and externalize stigma, all within a space of psychological safety. Psychological safety, defined by Edmundson and Mortensen (2021), is the belief that one can speak up without risk of punishment, judgment, or humiliation and is viewed as an essential aspect of building productive relationships, forming positive group dynamics, fostering shared decision-making, and increasing innovation.

In virtual spaces, technology contributes to a predictable environment. However, group ground rules clarify that participants may opt out or step away from an exercise without explanation. We ask, though, that participants do their best to stay consistently and reliably connected. Facilitators inform participants of safety issues prior to engagement, and they are continuously discussed as part of building a cohesive and open group dynamic.

Participation in virtual theater workshops invites dialogue not typical for online platforms. Participants are encouraged to actively observe and then be critically and emotionally involved in altering a stigmatizing scene that can affect interpersonal relations between providers and consumers. Witnessing and engaging critique is meant to be bidirectional, equitable, and collaborative, with the goal of leveling power dynamics between providers and consumers, a process that is at the heart of communicative justice. We propose that performance-based empowerment methods conducted in a safe and predictable environment offer opportunities for candid and open generation of information beneficial to address stigmatizing behaviors, particularly those of HIV/AIDS providers and systems. The next section speaks to how applied theatrical methods can be used to reduce HIV stigma.

THEATRICAL METHODS FOR STUDYING HIV STIGMA AND ADDRESSING IMPLICIT BIAS

Implicit bias refers to attitudes that unconsciously inform our actions and motivations and critically function like a habit that can be broken when raised to consciousness (Devine et al., 2012). HIV stigma manifests unconsciously as implicit bias (Penner et al., 2018) and can be viewed as a symptom of broader institutionalized oppression that contributes to economic instability, social discrimination, heterosexism, conservative religious bias, and racism (Bauermeister et al., 2015).

We propose that the use of applied theatrical or performance research methodologies illuminates implicit bias, providing a venue to learn about its influence on providers' views and actions and their impacts on consumers. Theatrical methodologies provoke discussions, enact nonverbal mannerisms, and bring forth language indicative of user/provider "performance" in healthcare encounters. Theatricalizing such encounters allows workshop participants (providers) to witness their behaviors transforming them from implicit to explicit. The performative nature of theatrical research emphasizes the importance of fair, destigmatizing communicative practices and the necessity for communicative justice (Neeson, 2019). Case scenarios developed by HIV service consumers are used to simulate fictitious yet common provider-consumer interactions (see the next section). Facilitators guide providers through the scenarios to identify assumptions and alter relational patterns that diminish service effectiveness and undermine compassion for consumers.

DEVELOPING HIV/AIDS CONSUMER/PROVIDER PROJECT

We are developing a series of trial performance-based research methods that offer novel strategies for understanding how HIV stigma emerges in interpersonal interactions between providers and consumers. Three workshops have been virtually offered on Zoom™ platforms to groups of service providers working in community-based organizations providing HIV prevention and care services. Service providers have worked with researchers to better understand how performance approaches may be particularly relevant to creating a space for dialogue and discovery about the following: (1) how HIV stigma is implicit in interpersonal relations; (2) how it is socially and structurally constructed; and (3) what theatrical exercises can do to help confront stigma and build resilience.

A primary goal of the theatrical workshops is to determine strategies that best support fruitful and affirmative discussions about what constitutes stigmatizing interpersonal encounters. A related and secondary goal is to identify which techniques reveal structural and social conditions and locate where the

experience of stigma manifests in one's body. This concern about the physicality of stigma was particularly relevant in the context of the COVID-19 pandemic, where social encounters were mostly experienced as out-of-body virtual exchanges as provider visits shifted from in-person to online or "telemedicine" exchanges (Mgbako et al., 2020).

We know that telemedicine will not disappear postpandemic, and in fact, trends indicate that telemedicine is here to stay, as are the problems associated with it (Bashshur et al., 2020). Within the formulaic nature of virtual and telemedicine some of the most pressing concerns raised by clinicians and service providers include the loss of personal connection, which can lead to a decline in patients' willingness to disclose sensitive information that may ultimately affect their healthcare outcomes (Gomez et al., 2021). Our research will contribute to better understanding HIV stigma and how to confront it using telecommunication. It is also hoped that new knowledge will promote a holistic environment for clients and providers to communicate effectively. For PLWHA clients, this means willingness and feeling empowered to disclose health concerns. For providers, it also potentially offers best practice strategies for telecommunication and engagement that actively reduce HIV stigmatization.

CONSUMERS AS INFORMANTS TO THEATRICAL RESEARCH METHODS AND DESIGN

A community-engaged research approach engages HIV service providers and researchers as co-designers of the theatrical workshops (Pinto et al., 2011, 2013). Community-engaged research capitalizes on the emergent group dynamic, values both scientific and experiential knowledge, and in the case of HIV stigma, enlists service users as informants to HIV research and its dissemination (Pinto et al., 2011). Exchange of information and mutual support mediates the power dynamic as consumers, providers, and researchers communicate across social and professional differences. Community-engaged research, like all participatory research, is designed to give voice to those with less social power. Instead of researching "about" people, consumers bring their earned wisdom to the research in a process of learning "from" and "with," a transformative process for both researchers and the populations with which they are engaged in the study. Giving voice to those genuinely involved in the research is viewed as a liberating and valid tool for advancing knowledge (Foster, 2007).

This community-engaged method is based on photovoice, a participatory research model (Sitter, 2017; Sutton-Brown, 2014). Photovoice views participants as experts and asks them to draw on personal experiences emphasizing the value of their life stories. Through open-ended questioning, photovoice

methodology encourages participants to address aspects of the research most relevant to them, resulting in emergent questions and greater insight into the topic studied. Knowledge gained is presented to researchers and others using consumer photographs and narratives that verbally and visually illustrate their findings.

Beyond photovoice, there's growing interest in developing ethical and inclusive research with consumers in the field of social work. The goal of ethically inclusive research is to form authentic, bidirectionally meaningful relationships between participants and professionals (Leigh, 2019). Inclusive and community-engaged research can, however, be challenging. Boundaries between "researcher" and "researched" can be blurry; anonymity and confidentiality, hallmarks of research ethical practice, as well as the "ownership" of research are complicated (Banks & Brydon-Miller, 2018).

For our purposes, recruitment of consumers as co-researchers expands knowledge about stigmatization, both implicit and explicit, experienced at HIV service organizations. The specific forms of stigma that consumer-generated interviews reveal (e.g., mannerisms, work choices, attitudes) speak to subtle, often unnoticed, innuendos and behaviors that help formulate theatrical methods. We encourage consumer-informants to discuss intersectional and assumptive issues affecting HIV-related stigma (e.g., racism, transphobia, homophobia, and compulsory heterosexuality). Data gathering takes place and is recorded on Zoom and is then used to develop fictitious provider-consumer interactional scenarios to engage service providers in the three 1-hour Zoom workshops.

DATA COLLECTION AND ANALYSIS

An inherent innovation in online theater-based methods is that performance becomes an instrument for data collection. During the performance space and time are provided for participants (service providers) to deeply reflect on their professional actions and behaviors related to HIV stigma. Trained facilitators guide participants as they analyze the images' content and discuss emerging themes and issues that surface around HIV stigma, bias, and other relevant and intersectional factors.

The analysis process is collaborative, engaging, and multiperspectival, with tacit understanding that each image may generate many meanings. The objective is not to produce consensus but rather to present and deeply explore the exigencies of HIV stigma in their practices. Themes that emerge from the analysis have multiple benefits. First, they will help identify common manifestations of HIV stigma found in provider and consumer interactions. From a research perspective, they will uncover how the use of theatrical methods are helpful in addressing HIV stigma specifically and service-based stigma writ

large. Last, insights gleaned from participants will elucidate which aspects of the performance workshops are effective and transformative in raising awareness of stigmatizing behaviors. Recommendations to improve the HIV/AIDS service culture and to improve provider/consumer relationships will be offered.

WORKSHOP EXERCISE EXEMPLAR: VISUALIZING STIGMA TO DEVELOP EMPATHY

A theater-based activity we recommend is one that builds on Bausch's theatrical visualization exercises that connect thoughts and feelings of stigmatization to the body (Climenhaga, 2012). In this exercise, the facilitator begins by asking participants to breathe deeply and close their eyes. They then are verbally guided to focus on the reactions of their body in the greatest detail possible as the facilitator describes a vignette. The vignette, or fictitious scenario informed by earlier interviews with service consumers, conveys the narrative of a consumer living with HIV who describes feeling stigmatized by a provider who assumptively suggests that they engage in "risky" or "excessive" sexual behavior. Participants are invited to pay attention to how the scenario impacts their breathing and where they are feeling it in their bodies. How have their sensations changed during the course of the exercise? At the conclusion of the scenario, participants are asked to "visualize the stigma" as an abstract shape or color that occupies their body. Participants are then gently brought back to full awareness, and after a brief intermission, a discussion and reflection debrief is facilitated.

The visualization exercise is followed by performances and discussions of a scenario co-created by HIV service users. The first performance enlists two volunteers and is performed without resolution of the provider's stigmatizing behaviors. It is followed by a discussion during which the facilitator asks participants what they observed as they watched the scene, encouraging them to think critically, noticing both overt and subtle forms of stigma that surface. Next, a new volunteer steps into a chosen role replacing one of the performers. The scenario is then re-performed with specific instructions to apply group critique and use it to take direct action in stopping the stigmatization. A second follow-up discussion asks participants to reflect on what they noticed about the performance after changes were implemented. Throughout this entire process, the facilitator asks the participants questions like "Was there any nonverbal or bodily stigma in this scene?" to elicit reflections specific to body awareness and empathy.

Bausch theorized that theatrical visualization exercises, especially those that bring body awareness, foster empathy for those affected by stigma. The

workshop objective is to viscerally raise awareness of HIV stigma impact encouraging service providers, without judgment, to become cognizant of their stigmatizing behaviors. Like Bausch, Sakamoto and Cohen Konrad (2023) saw the use of the arts in social service research and practice as an effective mechanism to strengthen affective learning and foster critical consciousness, particularly when working with vulnerable populations. They contended that arts and performance offer visionary lenses through which we can pay attention to suffering, challenge injustice, and facilitate social action and change.

IMPLICATIONS FOR ARTS-BASED RESEARCH

This chapter has made a case for the use of theater-based research as a method for design, data gathering, and data analysis when studying stigmatized groups, including PLWHA. Interactive and consumer-informed workshops offer opportunities for all involved (consumers, participants, and researchers) to gain insight into their behaviors, assumptions, and actions without judgment or blame (Foster, 2007). Further, theatrical processes enhance social connectedness and engagement, in this instance with HIV service providers, leading to greater affective learning, attitudinal change, and reduction in stigmatizing behaviors. Stigma is a serious and negative determinant of population health (Link & Hatzenbuehler, 2016), affecting mental health (Corrigan, 2004), obesity (Ratcliffe & Ellison, 2015), diabetes (Schabert et al., 2013), epilepsy (Jacoby & Austin, 2007), and race and gender identities (Logie et al., 2018). In this chapter we focused on HIV stigma, but its negative impacts affect a range of individuals, populations, and communities, and recent research has attempted to create models to reduce sigma from a generalizable perspective (Stangl et al., 2019).

The virtual methodology described in the chapter using theater and performance to study HIV stigma reduction may be applicable to other areas of stigma research. Virtual methodologies sidestep barriers such as transportation, cost, and time providing access to participants who otherwise would not be able to be involved in the research. These methods aim to create an environment in which participants are guided to deepen understanding of stigma's causes, foster empathy for those who are affected, and support human agency and resilience. Creating psychological safety in online environments is challenging, especially when participants are encouraged to be candid and open to critical reflection and change. This is where theatrical methods are essential: Their design is rooted in carefully constructed techniques that establish bonds of connection with other participants through self-expression and vulnerability. When transferred to the context of an online environment, theatrical methods transform an otherwise isolating and feeling less space into

a dynamic exchange of expression and bodily presence—that is, they create safety by making the online environment more like a real-world workshop where participants are engaged and vulnerable with one another.

The described theatrical research processes offer a framework to gain insight into how stigma manifests in interpersonal provider/user relations across a wide range of circumstances, conditions, and institutions. Our intent was to construct a transferable framework that bridges social work and the arts, particularly in the ways in which it provides a new model for community-based, consumer-informed research. As social work researchers seek more ethical approaches to working with communities, theatrical practices offer the potential to liberate the consumer by placing them at center stage as actors and advocates for authentic knowledge based on lived experience.

CONCLUSION

Theater-based research offers a unique, holistic methodology consistent with tenets of community-engaged research. It acknowledges service consumers as active agents who influence all aspects of the research process making critical choices about design, analysis, ownership, and outcomes. Theater practices, such as visualization workshops and forum theater techniques born from the work of Augusto Boal (Paterson, 1999) are methodologically compatible with the values of social work. These interactive performance approaches break down power dynamics and deconstruct barriers between providers and service users, offering possibilities for genuine improvements in healthcare systems.

We have described practical and theoretical models of online theatrical workshops to explore how HIV service providers can become key actors in the fight to decrease HIV stigma. We have argued that performance-based practices as research methods offer avenues for communicative justice leading to social change. The exigencies of COVID-19 made public the potentialities of virtual connection. Theatrical practices adapted for virtual settings, lessons learned during the 2020 pandemic, powerfully map new forms of social interaction and efficacy. Forum theater and Bausch's informed visualization simultaneously expose and invite change, in this example, from service providers about their bodily vernaculars, verbal choices, and the empowerment of those living with HIV who along with living with chronic illness also often experience subtle and overt discrimination. In all, our goals are to halt the spread of HIV stigma and to better equip healthcare providers to improve quality of life for the people they serve.

REFERENCES

Banks, S., & Brydon-Miller, M. (Eds.). (2018). *Ethics in participatory research for health and social well-being: Cases and commentaries*. Routledge.

Bashshur, R., Doarn, C., Frenk, J., Kvedar, J., & Woolliscroft, J. (2020). Telemedicine and the COVID-19 pandemic, lessons for the future. *Telemedicine and e-Health*, 26(5), 571–573.

Bauermeister, J. A., Eaton, L., Andrzejewski, J., Loveluck, J., VanHemert, W., & Pingel, E. S. (2015). Where you live matters: Structural correlates of HIV risk behavior among young men who have sex with men in Metro Detroit. *AIDS and Behavior*, 19(2015), 2358–2369. https://doi.org/10.1007/s10461-015-1180-1

Brown, D. A., O'Brien, K. K., Josh, J., Nixon, S. A., Hanass-Hancock, J., Galantino, M., Myezwa, H., Fillipas, S., Bergin, C., Baxter, L., Binette, M., Chetty, V., Cobbing, S., Corbett, C., Ibanez-Carrasco, F., Kietrys, D., Roos, R., Solomon, P., & Harding, R. (2020). Six lessons for COVID-19 rehabilitation from HIV rehabilitation. *Physical Therapy*, 100(11), 1906–1909. https://doi.org/10.1093/ptj/pzaa142

Bulent, T., Budhwani, B., Fazeli, L. P., Browning, W. R., Raper, J. L., Mugavero, M. J., & Turan, J. M. (2017). How does stigma affect people living with HIV? The mediating roles of internalized and anticipated HIV stigma in the effects of perceived community stigma on health and psychosocial outcomes. *AIDS and Behavior 21*, 283–291. https://doi.org/10.1007/s10461-016-1451-5

Bundy, P., Dunn, J., & Stinson, M. (2016). Exploring emotion in participatory drama about social justice: A case of Creon's decree. In K. Freebody & M. Finneran (Eds.), *Drama and social justice: Theory, research and practice in international contexts* (pp. 40–53). Routledge.

Calabrese, S. K., & Mayer, K. H. (2020). Stigma impedes HIV prevention by stifling patient-provider communication about U=U. *Journal of the International AIDS Society*, 23(7), 23:e25559. https://doi.org/10.1002/jia2.25559

Calabrese, S. K., & Underhill, K. (2015). How stigma surrounding the use of HIV preexposure prophylaxis undermines prevention and pleasure: A call to destigmatize "truvada whores." *American Journal of Public Health*, 105(10), 1960–1964.

Centers for Disease Control and Prevention. (2020a). Health equity considerations and racial and ethnic minority groups. https://stacks.cdc.gov/view/cdc/91049

Centers for Disease Control. (2020b). PrEP effectiveness. https://www.cdc.gov/hiv/basics/prep/prep-effectiveness.html

Climenhaga R. (2012). *The Pina Bausch sourcebook: The making of Tanztheater*. Routledge.

Corrigan P. (2004). How stigma interferes with mental health care. *American Psychologist*, 59(7), 614–625.

Cziboly, A., & Bethlenfalvy, A. (2020). Response to COVID-19 Zooming in on online process drama. *Research in Drama Education: The Journal of Applied Theatre and Performance*, 25(4), 645–651. https://doi.org/10.1080/13569783.2020.1816818

Devine, P. G., Forscher, P. S., Austin, A. J., & Cox, W. T. (2012). Long-term reduction in implicit race bias: A prejudice habit-breaking intervention. *The Journal of Experimental Social Psychology*, 48(6), 1267–1278. https://doi.org/10.1016/j.jesp.2012.06.003

Diamond, D. (2007). *Theatre for living: The art and science of community-based dialogue*. Trafford Publishing.

Dubov, A., Galbo, P., Jr., Altice, F. L., & Fraenkel, L. (2018). Stigma and shame experiences by MSM who take PrEP for HIV prevention: A qualitative study. *American Journal of Men's Health, 12*(6), 1843–1854.

Edmundson, A., & Mortensen, M. (2021, April 29).What psychological safety looks like in a hybrid workplace. *Harvard Business Review*. https://hbr.org/2021/04/what-psychological-safety-looks-like-in-a-hybrid-workplace

Fabian, K. E., Huh, D., Kemp, C. G., Nevin, P. E., Simoni, J. M., Andrasik, M., Turan, J. M., Cohn, S. E., Mugavero, M. J., & Rao, D. Moderating factors in an anti-stigma intervention for African American women with HIV in the United States: A secondary analysis of the UNITY trial. *AIDS and Behavior, 23*(2019), 2432–2442. https://doi.org/10.1007/s10461-019-02557-x

Foster, V. (2007). "Ways of knowing and showing": Imagination and representation in feminist participatory social research. *Journal of Social Work Practice, 21*(3), 361–376. doi:10.1080/02650530701553732

Friere, P. (1970). *Pedagogy of the oppressed*. Continuum.

Geter, A., Herron, A. R., & Sutton, M. Y. (2018). HIV-related stigma by healthcare providers in the United States: A systematic review. *AIDS Patient Care STDS, 32*(10), 418–424. doi:10.1089/apc.2018.0114. PMID: 30277814; PMCID: PMC6410696.

Giesekam, G. (2007). *Staging the screen: The use of film and video in theatre*. Palgrave.

Goffman, E. (1986). *Stigma: Notes on the management of spoiled identity*. Touchstone.

Gold, J. A., Wong, K. K., Szablewski, C. M., Patel, P. R., Rossow, J., da Silva, J., Natarajan, P., Morris, S. P., Fanfair, R. N., Rogers-Brown, J., Bruce, B. B., Browning, S. D., Hernandez-Romieu, A. C., Furukawa, N. W., Kang, M., Evans, M. E., Oosmanally, N., Tobin-D'Angelo, M., Drenzek, C., . . . Jackson, B. R. (2020). Characteristics and clinical outcomes of adult patients hospitalized with COVID-19—Georgia, March 2020. *The Morbidity and Mortality Weekly Report, 69*(18), 545–550. http://dx.doi.org/10.15585/mmwr.mm6918e1

Gomez, T., Anaya, Y., Shih, K., & Tarn, D. (2021). A qualitative study of primary care physicians' experiences with telemedicine during COVID-19. *The Journal of the American Board of Family Medicine, 34*, S61–S70.

HIV.gov. (2020).

Iversen, J., Sabin, K., Chang, J., Morgan, T. R., Prestage, G., Strathdee, S. A., & Maher, L. (2020). COVID-19, HIV and key populations: Cross-cutting issues and the need for population-specific responses. *Journal of the International AIDS Society, 23*(00), e25632.

Jacoby, A., & Austin, J. K. (2007). Social stigma for adults and children with epilepsy. *Epilepsia, 48*(Suppl. 9), 6–9.

Karaca-Mandic, P., Georgiou, A., & Sen, S. (2021). Assessment of COVID-19 hospitalizations by race/ethnicity in 12 states. *JAMA Internal Medicine, 181*(1), 131–134. https://doi.org/10.1001/jamainternmed.2020.3857

Leigh, J. (2019). Participatory models in practice. *Qualitative Social Work, 18*(5):886–893. https://doi.org/10.1177/1473325019867781

Lewis, M. (1998). Shame and stigma. In P. Gilbert & B. Andrews (Eds.), *Shame: Interpersonal behaviour, psychopathology, and culture* (pp. 126–140). Oxford University Press.

Link, B., & Hatzenbuehler, M. L. (2016). Stigma as an unrecognized determinant of population health: research and policy implications. *Journal of Health Politics, Policy and Law, 41*(4), 653–673. https://doi.org/10.1215/03616878-3620869

Linsk, N. L. (2011). Thirty years into the HIV epidemic: Social work perspectives and prospects. *Journal of HIV/AIDS & Social Services*, *10*(3), 218–229. https://doi.org/10.1080/15381501.2011.598714

Logie, C. H., Wang, Y., Lacombe-Duncan, A., Wagner, A. C., Kaida, A., Conway, T., Webster, K., de Pokomandy, A., & Loutfy, M. (2018). HIV-related stigma, racial discrimination, and gender discrimination: Pathways to physical and mental health-related quality of life among a national cohort of women living with HIV. *Preventive Medicine*, *107*(2018), 36–44. https://doi.org/10.1016/j.ypmed.2017.12.018

Lucas, A. (2020). *Prison theatre and the global crisis of incarceration: Performance and incarceration*. Methuen Drama, Critical Companions Series.

Marx, J. L. (1982). New disease baffles medical community. *Science*, *217*(4560), 618–621.

Matthew, D. B. (2020). Structural inequality: The real COVID-19 threat to America's health and how strengthening the Affordable Care Act can help. *Georgetown Law Journal*, *108*(1679), 1679–1716. https://www.law.georgetown.edu/georgetown-law-journal/wp-content/uploads/sites/26/2020/06/Matthew_Structural-Inequality-The-Real-COVID-19-Threat-to-America%E2%80%99s-Health-and-How-Strengthening-the-Affordable-Care-Act-Can-Help.pdf

Mgbako, O., Miller, E. H., Santoro, A. F., Remien, R. H., Shalev, N., Olender, S., Gordon, P., & Sobieszczyk, M. E. (2020). COVID-19, telemedicine, and patient empowerment in HIV care and research. *AIDS and Behavior*, *24*, 1990–1993. https://doi.org/10.1007/s10461-020-02926-x

Neelands, J. (2009). Acting together: Ensemble as a democratic process in art and life. *Research in Drama Education: The Journal of Applied Theatre and Performance*, *14*(2), 173–189.

Neeson, A. (2019). Communicative justice and reconciliation in Canada. *New England Journal of Public Policy*, *31*(2), Article 10. https://scholarworks.umb.edu/nejpp/vol31/iss2/10

Nelson, S. (2020, April 7). Anthony Fauci compares race disparities of coronavirus to AIDS epidemic. *New York Post*. https://nypost.com/2020/04/07/anthony-fauci-compares-race-disparities-of-coronavirus-to-aids-epidemic/

Paterson, D. (1999). *A brief introduction to Augusto Boal*. Community Arts Network.

Penner, L. A., Phelan, S. M., Earnshaw, V., Albrecht, T. L., & Dovidio, J. F. (2018). Patient stigma, medical interactions, and health care disparities: A selective review. In B. Major, J. F. Dovidio, & B. G. Link (Eds.), *The Oxford handbook of stigma, discrimination, and health* (pp. 183–201). Oxford University Press.

Pescosolido, B. A., Martin, J. K., Lang, A., & Olafsdottir, S. (2008). Rethinking theoretical approaches to stigma: A framework integrating normative influences on stigma (FINIS). *Social Science & Medicine*, *67*(3), 431–440. https://doi.org/10.1016/j.socscimed.2008.03.018

Pinto, R. M., Berringer, K. R., Melendez, R., & Mmeje, O. (2018). Improving PrEP implementation through multilevel interventions: A synthesis of the literature. *AIDS and Behavior*, *22*(11), 3681–3691. https://doi.org/10.1007/s10461-018-2184-4

Pinto, R. M., & Park, S. (2020). COVID-19 pandemic disrupts HIV continuum of care and prevention: Implications for research and practice concerning community-based organizations and frontline providers. *AIDS and Behavior*, 1–4. Advance online publication. https://doi.org/10.1007/s10461-020-02893-3

Pinto, R. M., Spector, S., Rahman, R., & Gastolomendo, J. D. (2013). Research advisory board members' contributions and expectations in the USA. *Health Promotion International*, *30*(2), 328–338. https://doi.org/10.1093/heapro/dat042

Pinto, R. M., Spector, A. Y., & Valera, P. A. (2011). Exploring group dynamics for integrating scientific and experiential knowledge in community advisory boards for HIV research. *AIDS Care*, *23*, 1006–1013.

Price-Haygood, E. G., Burton, J., Fort, D., & Seoane, L. (2020). Hospitalization and mortality among Black patients and White patients with COVID-19. *The New England Journal of Medicine*, *382*, 2534–2543. https://doi.org/10.1056/nejmsa2011686

Ratcliffe, D., & Ellison, N. (2015). Obesity and internalized weight stigma: A formulation model for an emerging psychological problem. *Behavioural and Cognitive Psychotherapy*, *43*(2), 239–252. https://doi.org/10.1017/s1352465813000763

Reif, S., Wilson, E., McAllaster, C., & Pence, B. (2019). The relationship of HIV-related stigma and health care outcomes in the U.S. Deep South. *AIDS and Behavior*, *23*(Suppl. 3), 242–250. https://doi.org/10.1007/s10461-019-02595-5

Rubin, G. (2011). *Deviations: A Gayle Rubin reader*. Duke University Press.

Sakamoto, I., & Cohen Konrad, S. (2023). Using reader's theater to enhance reflexive social work practice, research, and education. In E. Bos & E. Huss (Eds.), *Using Art for Social Transformation: International Perspective for Social Workers, Community Workers and Art Therapists* (pp. 179–191). Routledge.

Schabert, J., Browne, J. L., Mosely, K., & Speight, J. (2013). Social stigma in diabetes: A framework to understand a growing problem for an increasing epidemic. *The Patient*, *6*(1), 1–10. https://doi.org/10.1007/s40271-012-0001-0

Sitter, K. C. (2017). Taking a closer look at photovoice as a participatory action research method. *Journal of Progressive Human Services*, *28*(1), 36–48. https://doi.org/10.1080/10428232.2017.1249243

Snyder-Young, D. (2013). *Theatre of good intentions: Challenges and hopes for theatre and social change*. Palgrave Macmillan.

Sontag, S. (1991). *Illness as metaphor & Aids and its metaphors*. Penguin Modern Classics.

Stangl, A. L., Earnshaw, V. A., Logie, C. H., van Brakel, W., Simbayi, L. C., Barré, I., & Dovidio, J. F. (2019). The health stigma and discrimination framework: A global, crosscutting framework to inform research, intervention development, and policy on health-related stigmas. *BMC Medicine*, *17*(2019), 31. https://doi.org/10.1186/s12916-019-1271-3

Stringer, K. L., Turan, B., McCormick, L., Durojaiye, M., Nyblade, L., Kempf, M.-C., Lichtenstein, B., & Turan, J. M. (2016). HIV-related stigma among healthcare providers in the Deep South. *AIDS and Behavior*, *20*(1), 115–125. https://doi.org/10.1007/s10461-015-1256-y

Sullivan, E. (2020). Live to your living room: Streamed theatre, audience experience, and the Globe's A Midsummer Night's Dream. *Journal of Audience and Reception Studies*, *17*(1), 92–119.

Sutton-Brown, C. A. (2014). Photovoice: A methodological guide. *Photography and Culture*, *7*(2), 169–185. https://doi.org/10.2752/175145214X13999922103165

Tam, P. (2020). Response to COVID-19 "Now I send you the rays of the sun": A drama project to rebuild post-COVID-19 resilience for teachers and children in Hong Kong. *Research in Drama Education: The Journal of Applied Theatre and Performance*, *25*(4), 631–637. https://doi.org/10.1080/13569783.2020.1816816

Taylor, D. (2020). *¡Presente!: The politics of presence*. Duke University Press.

Thompson, J., & Mackey, S. (2020). Editorial. *Research in Drama Education: The Journal of Applied Theatre and Performance*, 25(4), 481–483. https://doi.org/10.1080/13569783.2020.1820196

Thompson, J., & Schechner, R. (2008). Why "social theatre"? *The Drama Review (New York University and the Massachusetts Institute of Technology)*, 48(3), 11–16. https://doi.org/10.1162/1054204041667767

UNAIDS. (2017). Confronting discrimination: Overcoming HIV-related stigma and discrimination in health care settings and beyond. Joint United Nations Programme on HIV/AIDS. https://reliefweb.int/sites/reliefweb.int/files/resources/confronting-discrimination_en.pdf

U.S. Department of Health and Human Services. (2020). Social determinants of health. https://www.healthypeople.gov/2020/topics-objectives/topic/social-determinants-of-health

Villa, S., Jaramillo, E., Mangioni, D., Bandera, A., Gori, A., & Raviglione, M. C. (2020). Stigma at the time of the COVID-19 pandemic. *Clinical Microbiology and Infection*, 26(11), 1450–1452. https://doi.org/10.1016/j.cmi.2020.08.001

Viladrich, A. (2021). Sinophobic stigma going viral: Addressing the social impact of COVID-19 in a globalized world. *American Journal of Public Health*, 111, 876–880. https://doi.org/10.2105/AJPH.2021.306201

Weiner, L. (2003). Group intervention in the early days of the GRID epidemic: A reflection of one social worker's personal experience. In B. I. Willinger & A. Rice (Eds.), *A history of AIDS social work in hospitals: A daring response to an epidemic* (pp. 143–154). Haworth Press.

Wigginton, N. S., Cunningham, R. M., Katz, R. H., Lidstrom, M. E., Moler, K. A., Wirtz, D., & Zuber, M. T. (2020). Moving academic research forward during COVID-19. *Science*, 368(6496), 1190–1192. https://doi.org/10.1126/science.abc5599

Willinger, B. I. (2003). The missing support: Group interventions with AIDS patients. In B. I. Willinger & A. Rice (Eds.), *A history of AIDS social work in hospitals: A daring response to an epidemic* (pp. 155–160). Haworth Press.

World Health Organization. (2020). Coronavirus disease (COVID-19) dashboard. https://covid19.who.int/

Zia, H. (2020, June 11). Trump rhetoric fuels anti-Asian harassment and violence. Women's Media Center. https://womensmediacenter.com/news-features/trump-rhetoric-fuels-anti-asian-harassment-and-violence

PART III
Practice in Community
The Arts and Social Work

9
Creating Comics on the Curb

KATY FINCH

PROLOGUE

Social workers are awash in stories. At times they are volunteered; at other times, stories emerge during a clinical assessment or when a person is simply attempting to access social services. As opposed to "diagnoses [which are] made using systems for mental illness based on a set of prescriptive criteria . . . assessments are made in a broader approach to understanding clients in the larger context of their relationships and environment" (Jordan & Franklin, 2020, p. 8). The purpose of assessment is to learn the client's view of the presenting problem by asking a series of questions, prompting elaboration, and augmenting answers with data collected from observation and collateral sources. This information aids in formulating a case theory, which is then used as a springboard for selected interventions. In traditional settings (e.g., behavioral health clinics; treatment facilities; residential treatment; and others), the social worker documents the assessment, creating a formal narrative. This narrative is told in third person, creating an identity without the voice of the person who is revealing deeply personal, and oftentimes traumatic, details of their life. The narrative that endures is a portrait of the person that they themselves have not authored.

Because "all narrative conversations story identity" (Ingamells, 2016, p. 61), some long-time users of social services adopt this constructed narrative as their own. Telling and retelling the storied narrative repeatedly to service providers reinforces the problem-saturated narrative. According to Ingamells and Epston (2012):

Repetition of this "problem-saturated" narrative reinforces a person's self-perception and identity, especially when they're longtime service users. Old narratives and diagnoses are often not removed but add to a pile-up of categorizations that influence others' perceptions and one's view of self. (p. 52)

The focus of assessment is typically on negative events in the person's life, with some exploring of "strengths" or "resiliency factors." Rarely does it capture the person's language and style of communication or inquire about what a person *likes* about themselves or positive memories in their life. By eliminating the person's language, aesthetic, values, sense of humor, and structure of their *storytelling*—an opportunity for connection and empowerment is lost. In addition, emphasis on a linear narrative and an end goal of boosting one's ability to cope and problem solve "often minimize[s] the significance of the unconscious and instinctual forces in personality, the defenses, the inner life, and the childhood past. They focus more on the rational and adaptive ego as it enters into life transactions" (Goldstein, 1995, p. XIV). Creating an opportunity to author one's life story permits a person to take control of their lived experience and gain confidence in moving forward toward chapters that remain to be written.

Opportunities for creative collaboration are ever present in social work, but it is a question of recognizing them, and taking advantage of the moment, preparation, plus opportunity. I believe that we have powerful opportunities to partner in assessment and to bring a person's authentic narrative to life with all its nuances and uniqueness. Through collaboration, we can find creative ways for the stories and the voices of those we work with to be valued and empowered. Bhada (2017) wrote about the "reciprocal relationship between listening and telling" (p. 131). When stories are brought to life by the act of giving and receiving, they observe: "The telling is a liquid poured into a bowl shaped by listening" (Bhada, 2017, p. 131). Collaborative assessment provides an opportunity to form such a reciprocal partnership and together create a shared narrative, one representative of individual distinctiveness, earned wisdom, and context. Perhaps it is not so much our role to discover and shape our clients "stories but rather to act as midwife to them, creating spaces of creativity to establish productive, collaborative relationships."

The first step in this realignment lies in the establishment of trust that the person is capable of competently telling their own story. In a society where people experiencing poverty and homelessness are more often spoken for, it is a radical act to provide an unrestricted public platform so that they may be in control of their own narrative. The more disenfranchised a group is, the more powerful it can be to hand them the pen, the microphone, the stage and invite them to tell their story the way they want.

A unique opportunity for creative collaboration presented itself while I was working at a local homeless shelter. Oftentimes terms such as "rough" and

"street smart" are used euphemistically to imply that a person experiencing homelessness is not educated and not interested in something as rarified as literary arts. I was interested in counteracting this belief and started a writing group for people accessing the shelter. One person who was a regular attendee was a man named Bob who I had met in the courtyard earlier and had discovered we share a mutual passion for books, music, and comic books. Bob was a self-identified "autodidact" who had found solace in his youth at his local library while trying to avoid going home to an abusive parent. Bob was a natural storyteller, and whenever I saw him, he would regale me with tales of his life on the streets and the crew he ran with, who he referred to as "The Pirates." As I listened, I began to engage in "active witnessing" by listening to his storytelling and doodling to process what he was telling me. While I drew, Bob started to make edits, point out the details I missed, and at times take the pen and add to the drawing. I would also write down quotes, which he would add to, and we would shape the sketches into narratives. He identified this process as similar to his experience in bands and the way songs would be created by the musicians together while they played their individual instruments.

Eventually, the pile of drawings and written passages grew, and we started to realize that the process was becoming a project, making it possible for Bob to speak for himself rather than be spoken for (Denborough, 2014, p. 10). Over time, we began to stitch the drawings and written passages together to create a comic "zine, emphasizing alternative events from the ones that typically defined his existence" (p.7). Using Bhada's metaphor, the comics "poured into a bowl" and were shaped by his telling, my listening, and our cooperative storytelling. What resulted was a nuanced and authentic assessment of what B's life looked like, the deep bonds among the "pirates," and where the successes and challenges lay, as determined by him, in conversation and collaboration with me.

By celebrating moments of humor in the lives of people living outside, emphasizing special knowledge such as secret places to sleep at night, and explaining the powerful social supports and moral code in Bob's life, the comic emerged as a tool to question normality and served as an escape from the portrait of Bob that had existed and from what society labeled as failure (Denborough, 2014, p. 149). In fact, the comic grew into a coauthored series and is now a source of income for Bob and a permanent and sustainable mechanism to reauthor events in his life. Over the years, we have begun to create fictional storylines together, but it is no accident that Bob continues to write about his life as well. What started out as a tool for a way to create an assessment of his life through his own lens, and in his words, has become less of a structured power dynamic and more fluid as our work together has become more collaborative. This is the function that art can play in the field of social work for it provides a creative space to find mutual ground fertile for collaboration, expression, and connection. Ultimately, by reimagining the dynamic

of the professional relationship, the creative process becomes a way for the individual to have tools for self-reflection, leading to a self-assessment, and finally serving as an intervention of sorts, but it is organic and self-determined, not applied by a provider. This shared experience and connection lowers barriers, allowing for authentic vulnerability to occur and a greater possibility of recovery.

The comic* in Figures 9.1 to 9.21 is the origin story of how "The Pirate Ship" was created on the curb of the streets.

EPILOGUE

Over the past 4 years, Bob and I have published six collections of comics and continue to produce a monthly strip for a local newspaper. Our comics permit a peek into an unknown world (of people who are unhoused) and a tangible record of forgotten and ignored aspects of human experience, acknowledging that joy and suffering can coexist. According to the National Association of Social Workers Code of Ethics (https://www.socialworkers.org/About/Ethics/Code-of-Ethics/Code-of-Ethics-English, 2021): "The primary mission of the social work profession is to enhance human well-being and help meet the basic human needs of all people, with particular attention to the needs and empowerment of people who are vulnerable, oppressed, and living in poverty." (n.p.)Alleviation of people's' struggles is the field's focus, and though noble in its determination to combat all forms of suffering, in the process, we miss the richness inherent in all lives.

Without their stories, the lives of people considered vulnerable and "at risk" are never fully known. Yet these stories are essential to those who seek to offer humanistic and person-centered service. Without stories, we risk not seeing beyond the stereotypes, of assuming normal has only one shape and size. According to Sophie Freud (1999): "Normality is a mere context-dependent social construct" (p. 333), and to deny stories is to deny the dignity of those who tell them. To assume that that normal only has one story is an injustice and socially exclusionary. And as Freud postulated, deviating from typical practice behaviors "may be required in the face of social injustices" (p. 333). These lives—Bob's life—are construed by some as insignificant, and their narratives stolen by well-meaning, but uninformed, people seeking to be of help. "The stereotypes of poor people in the United States are among the most negative prejudices that we have. And people basically view particularly homeless people as having no redeeming qualities—there's not the competence for

*. Cowritten with Robert Bergeron.

anything, not having good intentions and not being trustworthy" (Fiske, cited in Blow, 2013, n.p.).

This collaboration hasn't been without its challenges, especially in terms of how to bring our authentic selves as artists to the complicated dynamic of client and social worker. I was an intern at the shelter and was there to learn, not reinvent the wheel. And yet, I suddenly found myself with an opportunity that I did not want to give up. Thankfully, Bob was not my client. I intentionally chose to engage with Bob over a shared interest. He had been assigned dozens of caseworkers over the years, who had at times been "successful" getting him into detox and housing. But what he wanted to talk about were books and art and most of all comics. And that, to me, was clearly the portal and thread. We were both visual storytellers, and he had a very nonlinear story to tell that all lends itself beautifully to comics. Waldman (2014) saw the comic form as beneficial to understanding and working with mental health conditions. Comics, unlike the written word, challenge us to make sense of an often unrecognizable structure that brings the sharpness of life's dilemmas into focus.

Unlike the usual somber narratives provided to the public about the lives of people without an address, Bob chooses to tell tales of the mischief and debacles he and his crew get into, equating it proudly to the "Boys" in Steinbeck's *Cannery Row* (1945). The disarming use of humor creates an opening for empathy that can be cultivated in social work when collaborating with people on their preferred narrative (Green & Myers, 2010). By employing simple drawings and concise captions: "Comics excel at articulating subjective notions or layered equivocal meaning" (Williams, 2015, p. 133). By employing our collective passion for the punk aesthetic and the do-it-yourself approach of "zine making," the comics served as a relational device to find connection as fellow artists and storytellers and find equal ground to collaborate with each other and to eliminate the need for it to be presented "professionally." We were buoyed by the hope that our comic would present: "New truths [that] are often found in the rawest and visually unpolished of self-publications" (Williams, 2015, p. 133).

I would be remiss if I did not disclose that my coworkers and supervisor at the shelter were at first quite skeptical about our endeavor. Ethical boundaries are a cornerstone of social work practice, and I had waded into murky waters in regard to professional relationships and exploitation of vulnerability and power dynamics. Nonetheless, my supervisor was open to supporting the endeavor and consistently asked me to hold myself accountable for the responsibility I had taken on. She helped me to understand the mutuality of the project and the delicate balance of collaboration. I came to understand that creating this comic allowed me to explore and integrate my clinical training with my passion for art and visual storytelling

and also explore ethical practice outside of the usual template. For Bob, the comic is not only a source of income and structure to his otherwise untethered life, but also an amplification of his experience, which in turn validates his story as a whole person, not just a two-dimensional person defined by his housing status. Both of us embraced our inner creative selves, explored the professional boundaries of creative collaboration, and learned with and from each other about how to take control of narrative and lift up the voices that matter.

It's important to recognize that art, although not a luxury, is limited in what it can change and improve in the lives of people experiencing challenges. It is important to ask ourselves: "What is the real function of our art, our goals, our visions as creative cultural workers?" (Rowell & Lorde, 2000, p. 61). Reclaiming stories and creating aesthetic experiences to encourage empathy and connection is important, but then that cultivated empathy needs to translate into action. The more radical the disruption of existing modalities, the more unlikely it will be financed or publicized. This is the balancing act of any artist with an eye on social justice—we must remember that "practitioners influenced by the arts and humanities are not totally free and ephemeral spirits detached from an orderly, rational world" (Damianakis, 2007, p. 527). As we embark on creative endeavors to influence minds and change hearts, we must always keep an eye on the importance of the work being able to be distributed, received, and utilized as an effective tool of a greater vision of equity and compassionate listening.

AUTHOR'S NOTE ON THE PROCESS

The focus is collaboration—creating a piece of artwork that is not only the voice of one person or the other, but also a shared language and aesthetic. The authors employ techniques such as co-writing the text, alternating penciling and inking for different panels and characters, focusing on taboo topics, disrupting timelines and at times filling pages with text and single page panels. These approaches to comic making were adopted from shared influences and expanded while creating their comic. This is to ensure that there is a form for true collaboration—creating a piece of artwork that is not only the voice of one person or the other, but also a shared language and aesthetic. This technique is a natural extension of some of the authors' common influencers, including Pekar (Pekar et al., 2003); Crumb and Kominsky (2012); the Hernandez Brothers (Garcia, 2017); and Gloeckner (UMStamps, 2015).

Making Comics on the curb

Figure 9.1

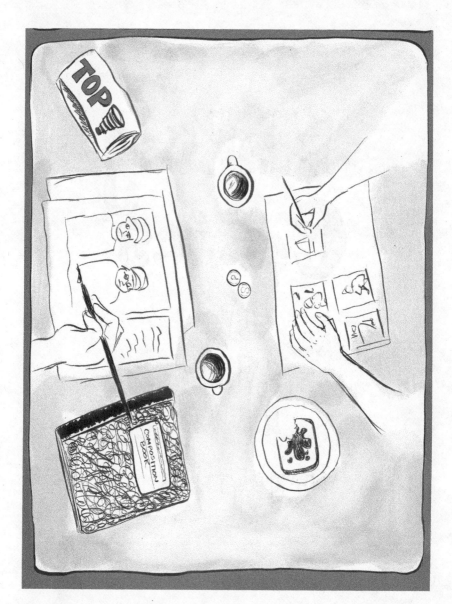

Figure 9.2

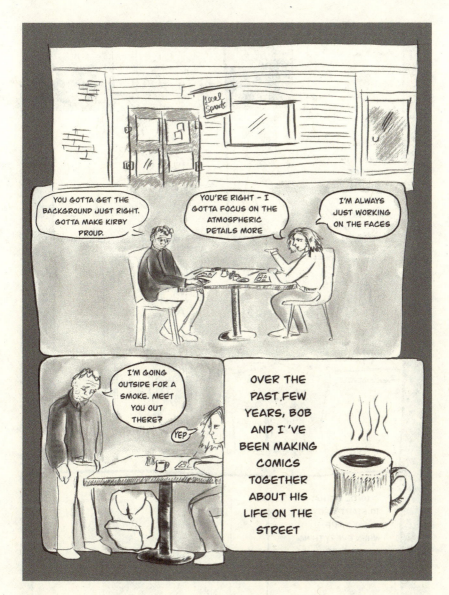

Figure 9.3

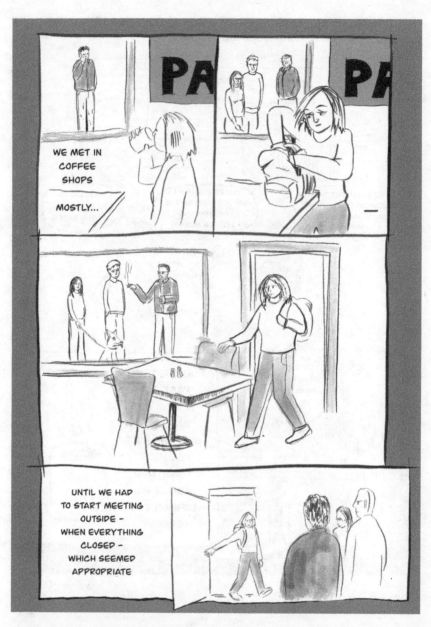

Figure 9.4

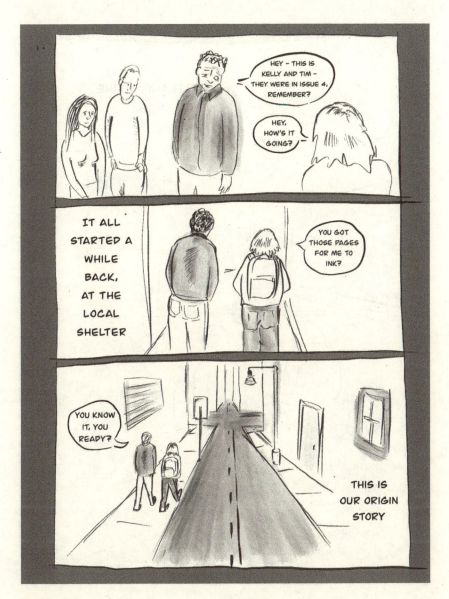

Figure 9.5

Figure 9.6

[156] *Katy Finch*

Figure 9.7

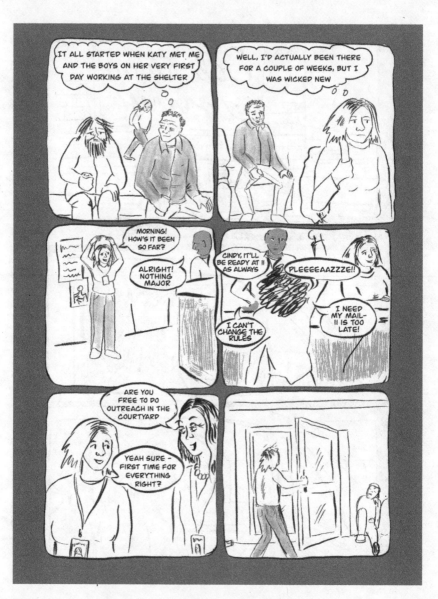

Figure 9.8

[158] *Katy Finch*

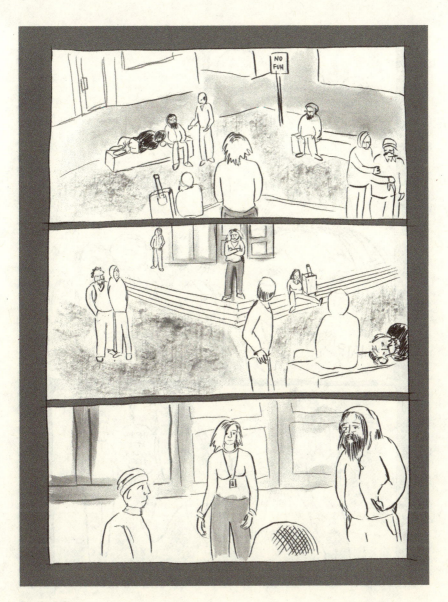

Figure 9.9

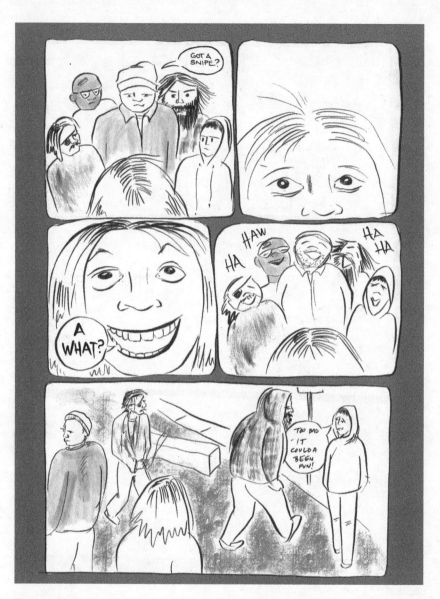

Figure 9.10

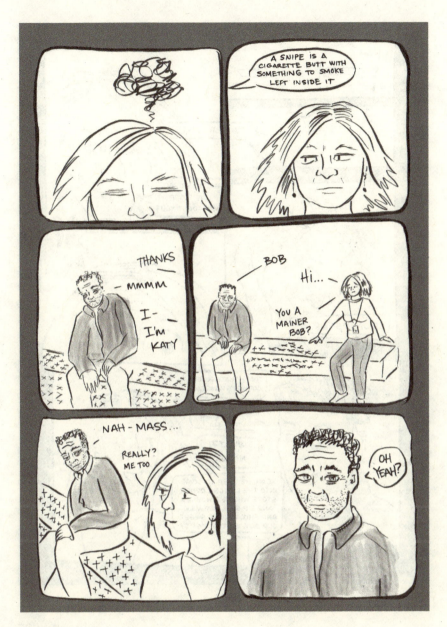

Figure 9.11

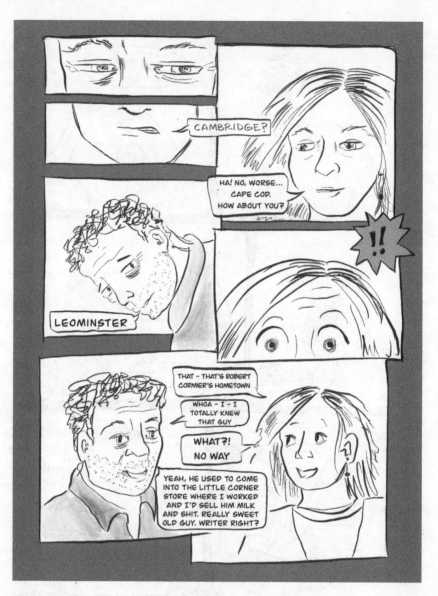

Figure 9.12

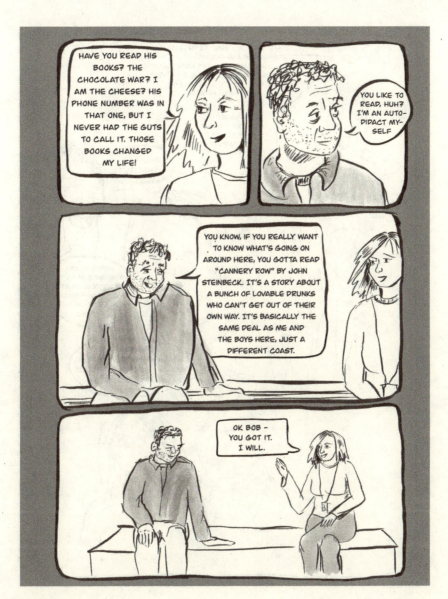

Figure 9.13

CREATING COMICS ON THE CURB [163]

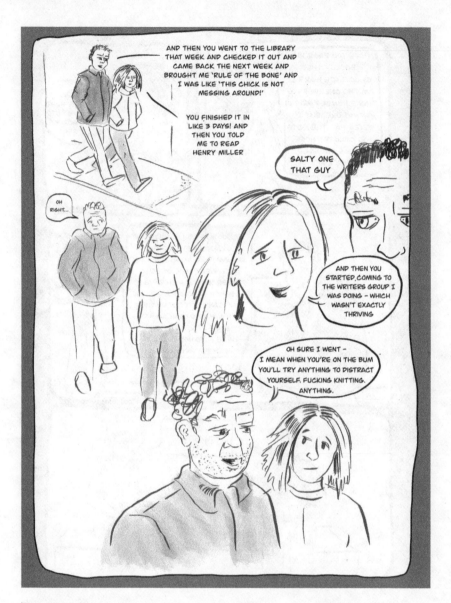

Figure 9.14

[164] *Katy Finch*

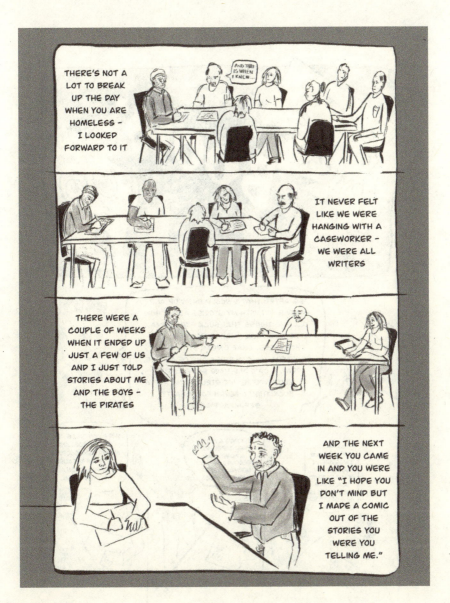

Figure 9.15

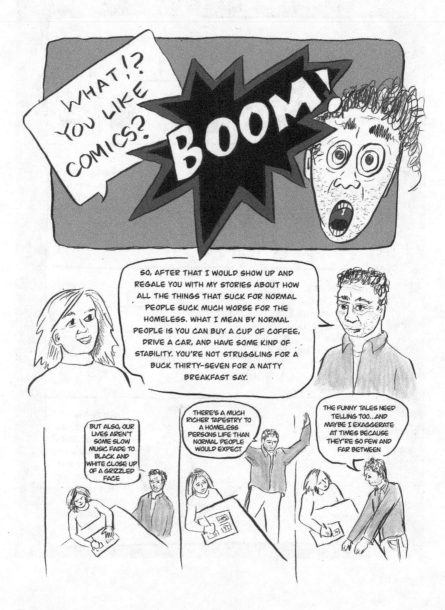

Figure 9.16

Katy Finch

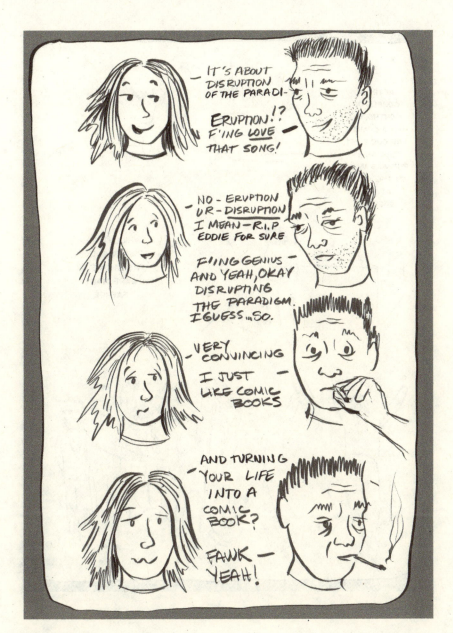

Figure 9.17

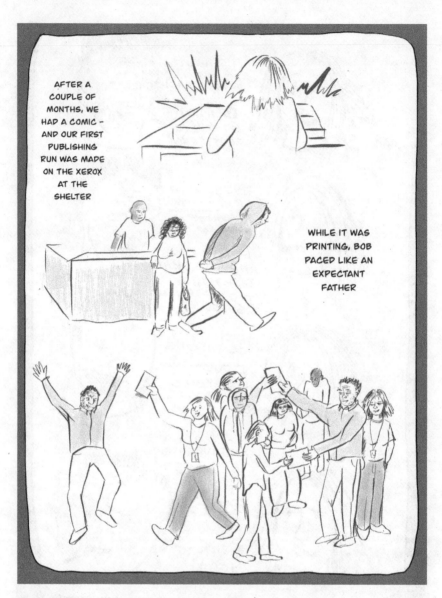

Figure 9.18

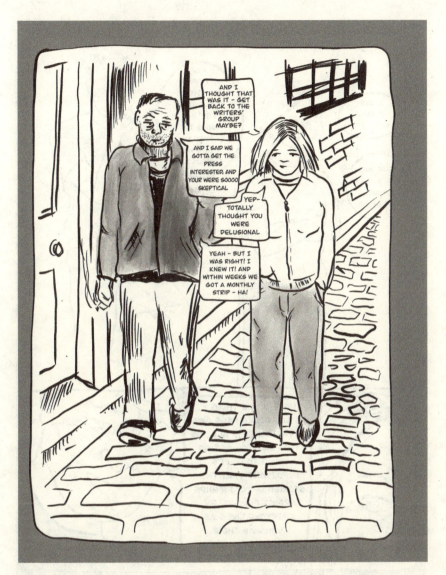

Figure 9.19

CREATING COMICS ON THE CURB [169]

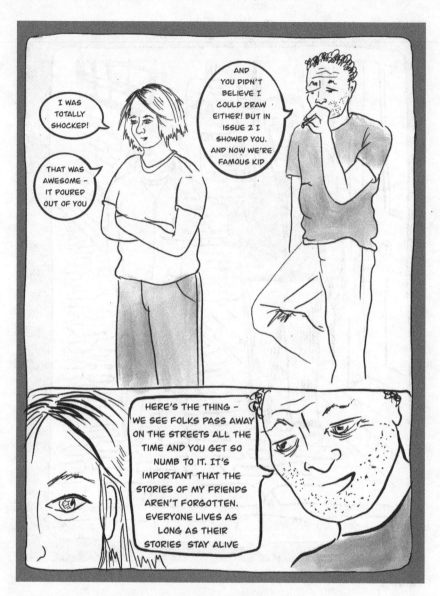

Figure 9.20

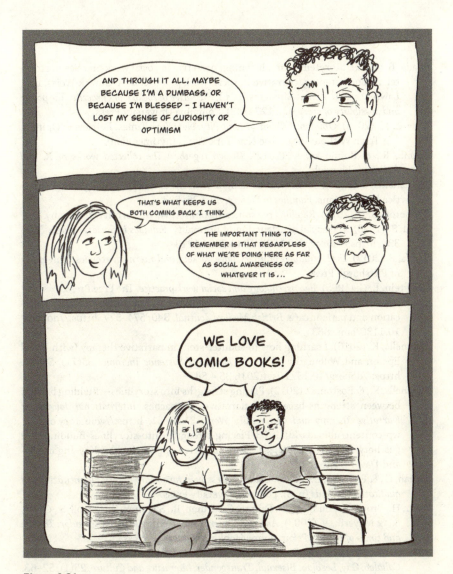

Figure 9.21

CREATING COMICS ON THE CURB [171]

REFERENCES

Bhada, B. (2017). Storytelling and listening, narrative in social work practice in storytelling and listening, narrative in social work practice. In A. Burack-Weiss, L. S. Lawrence, & L. Bamat Mijangos (Eds.), *Narrative in social work practice: The power and possibility of story* (pp. 127–143). Columbia University Press.

Blow, C. M. (2013). *Opinion: A Town without Pity*. New York Times. Retrieved: Opinion | 'A Town Without Pity' - The New York Times (nytimes.com).

Crumb, R., & Kominsky, A. (2012). *Drawn together: The collected works of R. and A. Crumb*. Liveright.

Damianakis, T. (2007). Social work's dialogue with the arts: Epistemological and practice intersections. *Families in Society, 88*, 525–533.

Denborough, D. (2014). *Retelling the stories of our lives*. W. W. Norton & Company.

Freud, S. (1999). The social construction of normality. *Families in Society, 80*(4), 333–339. https://doi.org/10.1606/1044-3894.1213

Garcia, E. (2017). *The Hernandez brothers: Love, rockets, and alternative comics*. University of Pittsburgh Press.

Goldstein, E. G. (1995). *Ego psychology and social work practice*. The Free Press.

Green, M. J., & Myers, K. R. (2010). Graphic medicine: Use of comics in medical education and patient care. *British Medical Journal, 340*, 574–577. https://doi.org/10.1136/bmj.c863

Ingamells, K. (2016). Learning how to counter-story in narrative therapy (with David Epston and Wilbur the Warrior). *Journal of Systemic Therapies 35*(71), 58–71. https://doi.org/10.1521/jsyt.2016.35.4.58

Ingamells, K., & Epston, D. (2012). Placing strengths into storylines—Building bridges between strengths-based and narrative approaches. *International Journal of Narrative Therapy and Community Work, 3*, 50–61. https://yourstory.org.nz/wp-content/uploads/2019/03/Placing-strengths-into-storylines-Building-bridges-between-strengths-based-and-narrative-approaches-by-Kay-Ingamells-and-David-Epston.pdf

Jordan, C., & Franklin, C. (2020). *Clinical assessment for social workers: Quantitative and qualitative methods* (p. 8). Oxford University Press.

Pekar, H., Brown, K., Budgett, G., Dumm, G., Crumb, R., Shamray, G., Carroll, S., Cavey, S., & Mayerik, V. (2003). *American splendor and more American splendor: The life and times of Harvey Pekar*. Johns Hopkins University Press.

Rowell, C. H., & Lorde, A. (2000). Above the wind: An interview with Audre Lorde. *Callaloo, Gay, Lesbian, Bisexual, Transgender. Literature and Culture, 23*(1), 52–63.

Steinbeck, J. (1945). *Cannery row*. Viking.

UM Stamps. (2015, January 22). Diary of a teenage girl: Phoebe Gloeckner on using both words and image to tell a story [Video]. YouTube. https://www.youtube.com/watch?v=a5xlKMRqvT4&feature=youtu.be

Waldman, Katy. (2014, October 8). Patterns and panels: How comics portray psychological illness. *Slate.com*. https://slate.com/culture/2014/10/comics-and-mental-illness-marbles-swallow-me-whole-and-hyperbole-and-a-half.html

Williams, I. (2015). *Graphic medicine manifesto*. Penn State Press.

10
Coming Fully Into the Present
How the Arts Have Shaped My Social Work Practice

CLAY GRAYBEAL

It was 1989, and I was in Chicago, attending my first Council on Social Work (CSWE) Education Annual Program Meeting. I'd come looking for a job, making the rounds of receptions, hoping to make an impression on someone. By the third night, I was exhausted from the effort, from so much time without anything approaching normal human interaction, so I headed out of the conference center and wandered down the street. I didn't have any casual clothes at the hotel, so I hit the town in my suit and tie and grabbed the nearest taxi. "I've had enough talking," I said to the driver, "I want music." "Got it," he replied. Fifteen minutes later, he dropped me off at a small club called Blue Chicago.

It was well worn and intimate. A tiny stage, just large enough to accommodate an ancient upright piano, acoustic bass, electric guitar, and traps was in the back corner. Customers were wandering in and seats were filling up, so I grabbed a stool at the bar. After a while, a tall, handsome African American man in a fedora with leopard print hatband stepped onto the tiny stage, picked up the mike, and said "Good evening" in a deep baritone. The other musicians followed, picked up their instruments, and proceeded to create a pulsing, emotionally charged atmosphere. It was clearly a home crowd, a neighborhood, and I was on the outside. But then something happened. The room was vibrating, the audience coalesced—moving in unison, and the sense of time dissolved around me. The bass was penetrating, I could feel it in my heart; I could feel it in my toes. As I stared at the row of empties in front of me I lost

Clay Graybeal, *Coming Fully Into the Present* In: *Social Work and the Arts*. Edited by: Shelley Cohen Konrad and Michal Sela-Amit, Oxford University Press. © Oxford University Press 2024. DOI: 10.1093/oso/9780197579541.003.0011

track of time, but then the sound of voices rose, and I realized the music had stopped. I turned just in time to see the singer working his way through the tables, greeting most everyone like old friends. To my surprise, he walked up beside me, ordered a whiskey, and slowly looked me up and down. No doubt I stood out—there were no other suits in the place.

"What's up, my man?" he said.

"Just spent three days at a conference," I replied.

He shook his head slowly from side to side, looked me over again, leaned over the bar, and cupped his glass in both hands. After a very long pause, he said: "Man, you gots to get out o' there."

I'd spent the previous 6 years working in a psychiatric hospital, dealing with every variety of human behavior, and several widely renowned mental health experts. But in all that time, no one had ever completed a more accurate diagnosis or rendered a more appropriate prescription than that. I removed my tie and stuffed it in my pocket, then raised my glass to him. He laughed, raised his as well, and we drank to liberation. He laughed again, adjusted his hat, and worked his way back to the stage. All I remember after that was that I didn't attend any of the morning sessions the next day.

Social work suffers from a strange and limited notion that sitting and talking is the most effective way to initiate social change and personal growth. We do this in classrooms, at conferences (in impossibly long straight rows), and in our work. We believe that relationships take hours, weeks, months, to develop and years to make a difference, while the rest of the world operates in seconds and minutes. In *How Doctors Think*, Jerome Groopman (2007) cited a study that suggested most physicians make their first diagnostic impressions just 17 seconds into the first encounter. On reading that, it occurred to me there is a parallel to social work. While we endeavor to focus on the individual, in many settings a diagnosis is a prerequisite to service. But it has also occurred to me that clients develop their first impressions of us in about the same amount of time, maybe even less. Yet, as those precious seconds tick by, we pull out our pages of forms, obliged in many settings to spend hours assessing the client from an expert perspective. Underlying is a tacit assumption that in 2 or 3 weeks trust will develop, and then the actual work will begin. Yet something incredibly meaningful occurs in those first few seconds of any human encounter, and if we blink we're liable to miss it. To discover that meaning requires our full presence, that elusive state of being where we can listen without distraction.

THE ARTIST'S WAY

The ultimate purpose of art is to illuminate the human condition. Casually or assertively, art demands our attention and enriches our lives, often deeply

and in unexpected ways. It evokes and provokes both emotion and intellect. It activates something in our beings that is otherwise hidden and often inaccessible; it engages us on multiple levels, conscious and unconscious, mental and physical, functional and spiritual (Cohen Konrad, 2019; Cornish, 2017; Huss et al., 2019). It can stir us out of our remote stations and into the present. It holds promise to enrich every encounter, to deepen every insight, and to facilitate human potential in every setting. Art can bring new insights, new perceptions, and perspectives. It can inspire and motivate.

Throughout my social work career, I've been privileged to collaborate with others through creative arts in numerous and diverse settings, including hospital practice, private practice, higher education, and community work. I've been able to witness and participate in a range of modalities, including poetry, movement, music, drama, art, drawing, landscape architecture, and theater. Through those experiences I've learned extraordinarily powerful lessons about listening, engagement, improvisation, commitment, preparation, rehearsal, development, movement, voice, action, and teamwork. I've come to believe that social work without art, like life without art, is limited, restrained, and incomplete.

This chapter is a chronicle of personal discoveries I've made regarding the arts over nearly 40 years in social work, the times I was able to break through my own restraints. Those restrictions, I've come to believe, were the legacy of a good Protestant upbringing, of being a privileged White male in a society that overly values emotional restraint, where decorum was meant to regulate passion. I now routinely ask every client: "What have you thought of trying, but haven't done yet?" This question gets right to the heart of where creativity is regularly stifled, and exploring the answer usually generates entirely new options and possibilities. In my experience, the great majority have thought of things they might do but have chosen not to out of social obligation or self-consciousness. We explore what it might be like to make a different choice. And when nothing comes immediately to mind, I encourage them to spend some time with the question and to return to it at our next encounter.

The stories we tell ourselves have great power and influence. The social role expectations, especially for a profession that centers on human relationships, can be very limiting. The pressure to be professional runs deep. And yet it is exactly that focus on relationships that suggests we would be wise to explore the incredibly rich diversity of ways to relate and the possibilities they engender. The experiences and discoveries I describe have made a lasting impact on how I practice and how I live. My hope is they will inspire others to get up from their chairs (literally or figuratively!), or get out of that conference, to stop talking and start moving, and to discover what happens when we start exploring those things we once knew but lost track of, or those things we never had the courage, inspiration, social permission, or professional sanction to try before.

FIRST EXPERIENCES

After I received my master of social work (MSW) from Fordham University, I was lucky enough to secure a position at the Carrier Foundation in Belle Mead, New Jersey. Carrier was a well-funded private teaching hospital that in the 1950s and 1960s was a pioneer in short-term psychiatric treatment (30–45 days—imagine that). In its first incarnation, it was the Belle Mead Farm Colony and Sanitarium. Its patients learned to garden and gained the benefits of physical activity and the outdoors. Such early notions of rehabilitation had long been abandoned by the 1980s, of course, but one of the legacies was the beautiful grounds, with extensive flower beds and shrubs maintained by a crew of groundskeepers sustained by an endowment. Another extraordinary aspect of the facility was the depth and breadth of the individuals working for the department of allied therapies. The early focus on the importance of physical activity had inspired the administration to maintain a complement of full-time therapists in movement, art, poetry, music, drama, writing, gardening, and physical activities. Collaborating with this group was one of the most meaningful experiences in my career. For example:

> Jeff was a 17-year-old, White, cis-gendered male diagnosed with schizophrenia. He'd been admitted following an incident at his school, where he was found standing on a desk and staring at the ceiling. Convinced that some creature was living above, he could not be dissuaded of that idea or convinced to get down. He'd been brought to the hospital, where on admission he was observed to be nonviolent, quiet, and unobtrusive, but clearly experiencing significant symptoms, including auditory, visual, and olfactory hallucinations.
>
> I was assigned to be his social worker. His psychiatrist was a charming and witty British man who enjoyed collaborating with social workers. We decided to invite Jeff's family for an interview together and had the inspiration to invite Sarah, an art therapist, to join us in an initial assessment. The family consisted of mother and father, Jeff, and his three younger siblings, ages 12, 9, and 7. After the usual introductions and pleasantries, the art therapist asked if the family would be willing and interested in working on a project together. She had brought with her a large roll of construction paper and a set of oversize colored crayons and suggested they draw a picture together. They agreed without hesitation, and soon she had pushed back the furniture and spread a sheet that was perhaps 3 feet wide and 4 or 5 feet long on the floor in the center of the room.
>
> Sarah then suggested that Jeff start the picture. He did so, drawing a large suspension bridge that filled the middle of the paper. It was impressive to watch how steady he was, the consistency of the scale and perspective. He was very intent and focused, and as he continued, Sarah asked if the parents would like to join in. What happened next created a vivid memory I can recall in full detail to this day, nearly 40 years later. Jeff's bridge, while appearing sturdy and well

designed, hovered in space, no anchor below or at either end. With no words, and only a couple of quick glances, the two parents moved to either side, and each drew a solid stone foundation pier for the two towers from which the roadway was suspended. Jeff evidenced a slight smile, and at that point he invited his younger siblings to add land to either end of the bridge. He helped them pick the colors they wanted to use, what they wanted to draw, and how to go about it. The treatment team had known Jeff for just a week or so, living those few days as an institutionalized person, wandering the halls, and speaking in incomplete and often incoherent sentences. But in those five minutes we could see that in his life, in his family, he was supported by two loving and communicative parents, that he could be purposeful and focused, that he had some artistic abilities, and finally, that he was a loving and thoughtful older brother. The metaphors were profound—he had transformed before our eyes, and his competencies became a new and productive focus of our conversations with him and his family.

One of my favorite colleagues at Carrier was a drama therapist, and one day we were musing about the previous weekend's episode of *Saturday Night Live* (SNL; hard to believe now, but it was just in its sixth or seventh season!). At that point in time, the SNL cast was still introduced as the "Not Ready for Prime Time Players." In an inspired moment, we decided to form the "Not Ready for Anytime Players," comprised of a small group of nurses, social workers, and allied therapists. We developed a series of one-act plays that portrayed some typical challenges for our patients: going off prescribed medications, taking a few days home over a holiday weekend, a stressful encounter with a family member, and so on. The unit where we worked comprised two long hallways, 16 bedrooms, and 32 patients. Every few weeks, we would stage a performance for the unit. There was a subtle but powerful shift in the atmosphere of the unit. Most interestingly, we learned that our performances led to a more humanized perception of the staff in the eyes of the patients. For example, one time I was playing the part of a man who had stopped taking his medication for bipolar disorder, and I began to cycle up into a manic phase. We always tried to inject some humor into the plays to avoid a sense of preaching or warning, so my behavior wasn't extreme, just disorganized. Afterward, a young man approached me in the hallway and offered: "I was never sure you really could see me; that you understood, until I saw you up there today." I thanked him for telling me that, and our relationship immediately became more open and effective from that day forward.

It is important to note that this took place more than 30 years ago. It was in the context of a unit where the average patient stay was 5–6 weeks, and the staff often had much more time to spend with patients and develop deep and lasting connections. And after each role play, we processed the experience with the group, asking how they felt, what seemed real. We asked if anything came across as inaccurate or offensive. Occasionally, we received criticism of

our acting abilities, and now and then a patient volunteered to join in and show us what it was "really like." We had an overwhelmingly positive response. However, for many reasons, it would likely be nearly impossible to re-create this context today. But this led me to think in other ways about how performance might be incorporated into practice.

PRIVATE PRACTICE

A few years later, after I had left the hospital and developed a private practice, I no longer had access to the extraordinary resources of that creative staff. And I was to learn over time that I had experienced something unique; the depth and diversity of creative talent at our disposal may not have existed anywhere else. On my own, I deeply missed those opportunities. But then one day when I was feeling somewhat stuck with a client, I had an inspiration:

Jessie was a newly divorced woman in her early 30s who had come for therapy to deal with a number of interrelated issues. Most prominent was the stress of the divorce, and she was concerned that she was becoming increasingly impatient with her two young daughters, aged 5 and 7. We explored many issues, and as we did so, it became clear that she was struggling to express and describe some events she had experienced earlier in her life. Talking, especially about her own experience, did not come naturally. So, one day I asked if she had any artistic outlets (singing, writing, drawing, dancing, etc.). "I used to, but not since I was a kid," she said, my first clue to this phenomenon. We discussed further, and as a child, she loved to draw. I gave her a sheet of paper and a pencil, and in seconds she had produced a drawing of a hand with exquisite detail and perspective.

We both smiled. It was near the end of the session, and I encouraged her to go get some supplies, perhaps an artist's drawing pad and colored pencils. She was hesitant, but clearly intrigued. "What do you want me to draw?" she asked. I replied: "What would you like to draw?" She shook her head, and said: "Okay, but I don't know." I smiled, shook my head, and said: "I don't know either." She also smiled and exited, still shaking her head, but with an expression of intrigue or expectation on her face.

One week later, she entered my office with a sizable artist's drawing pad under her arm. She sat, placed it in her lap, crossed her arms over it, and leaned forward, somewhat nervously. "How are things?" I asked. She rocked slightly: "It's been a very interesting week."

"Interesting is my favorite word," I said.
"Yeah."
"What would you like to talk about?"

She said nothing, but slowly uncrossed her arms, and handed me the pad. After a brief pause, she waved her hand, suggesting I should take a look. I reached out and took the pad from her and lifted the cover. I'm not sure anything could have prepared me for what I saw—before me was an extraordinarily beautiful composition. There was a field backed by a large and complex tree, vibrant with colors of early fall. In the foreground were two young girls. Each had long, straight, strawberry blond hair and the faces of angels. In their hands were flowers, clearly gleaned from the wildflowers dotting the field. I stared for a long time, and then looked up at Jessie.

"This is remarkable," I said, "It's beautiful."

"Thank you," she said quietly, then gestured for me to look at the next page. It was strikingly different from the prior one. In place of greens and blues and golden hues were black and reds that depicted a dramatically different reality. A small girl sat with her hands tied to the balusters of a staircase; she was peering through them to a decrepit Christmas tree, brown and withering. A figure was stoking the fire in a fireplace, his back to the child. It was desperate and lonely. I turned to Jessie, and she motioned for me to go on.

The next page echoed the last, a long, dark hallway ended in a door slightly ajar, dark orange and red leaked out around a black door. It was foreboding, even terrifying. She motioned me on. There were nearly a dozen pages, split evenly between the two themes.

"These are extraordinary," I said.

"Thank you," she replied.

"Can you tell me how you chose to do each one?"

"I didn't. They chose me."

"Ah. What was that like?"

"Like a wakeful dream. I wandered through them, and they came alive."

"That's such a powerful image."

"I think there are some things I need to talk about."

"Tell me."

Needless to say, our conversations became deeper, more resonant, and more powerful than before. She shared the secrets of her childhood. Every conversation began with an image. Some took us back and through those difficult times. But the others inspired our conversations about her imagined and desired future. I can call up each page in my mind as though they were sitting before me still. But most profoundly, I recall the image of her smiles as she described her children and her plans for her family.

THE ACADEMY

Not long after I received my MSW and started working in the hospital, I began contemplating a teaching career. I hadn't set out to do so, but perhaps I should have. My father, grandfather, and great-grandfather were all academics, and in some ways, it seemed preordained, at least it does in hindsight. Like everyone, I had favorite professors and some that tested the limits of my endurance. I'd always had a feeling that there might be more interesting and effective ways to teach, and that led me to enroll in a PhD (doctor of philosophy) program at Rutgers in 1984. I did my first teaching there in 1987 and moved to Maine in 1989 to take on a full-time academic position. I greatly valued my experience there, and while they asserted several times that we were going to learn about research and not practice, that the priority was the understanding of and discovery of new knowledge, I found that everything we studied had a profound effect on my practice. Most profound was the principle that true scientific method is based on the assumption and that *all knowledge is provisional* (Kerlinger, 1973). This idea ultimately inspired my exploration of the relationship and parallels between science and art in social work practice (Graybeal, 2007), but I hadn't fully made that connection yet.

In 1998, I was granted a sabbatical, and my purpose and intent were to write a couple of journal articles based on ideas from my dissertation. Many academics are familiar with the stultifying, mind-numbing standardization of language and format that control the lead-up to publication. At least, that's the way it felt to me at the time! As I settled in to contribute to this cultural phenomenon, I came across an article by Chet Raymo (2006) in *Science and Spirit*, a since defunct bimonthly magazine. His core theme was summarized by this sentence: "While knowledge vanquishes ignorance, mystery abides."

I reflected on this statement for several days as I sat immobile before the keyboard, staring out the window at the birds flocking to our snow-covered feeder. After a few days, my wife, Deb, who'd had a very successful career on the stage, entered my office and said: "Maybe you should think about writing a play." I sat in silence for some time. The year before she'd played the role of Annie Wilkes in the world premiere of the stage version of Stephen King's *Misery*. She frightened the audience every night, me included, with her capacity to inhabit a very dark, very scary personality, mining the depths of obsession, delusion, and violence.

Within hours, I began to visualize the story unfolding. A burned-out social worker in the middle of a long career (clearly not autobiographical!) would encounter an extraordinary survivor. Deb's performance inspired me in two ways. I knew that the survivor's story would have to be so compelling, so demanding of the social worker's attention, that it would cut through his defenses and resonate at some deep level of understanding. It would have to honor the lives of those clients I had served, those stories that seemed nearly

impossible to survive, and the ones that had demanded my full attention. And I knew that Deb would have the fortitude and capacity to inhabit that role on stage.

I went into my study and began to write. Over the course of 3 weeks, I did little else. I forgot my articles entirely, and at times felt I entered a fugue state—time seemed to stand still. After hours at the keyboard, I would have to get out, to do something entirely physical, to recover and return to the present. One day, Deb returned home from work, and I said, "There was a knock at the door."

"There was?" she said, looking toward our front door.

"No," I said, and pointed to my office. "There was a knock at the door."

I struggled to explain. In a surreal moment, my hands had written that line as I watched the words emerge on the page. This was to happen more frequently after that day. But at that moment, it was unique in my experience. I had stared in wonder as the words seemed to almost precede the keystrokes—as though my hands were working just to keep up. As the narrative emerged, a younger, naïve, but highly intuitive, social work student entered the play, arriving to cover the absence that day of her supervisor. In the pages that followed, her story became the third strand in a woven journey.

At the end of that month, I handed the script to Deb and went for a long walk while she read it. When I returned, she sat in silence, shaking her head. Somehow, I had done it. I had stayed out of my own way long enough for something essential to emerge. A few days later, she shared it with a good friend, a gifted director. We talked for hours. Over the following year, we had meetings with actors, directors, and designers and refined the play through workshops and readings. I gradually learned to cut words, to distill the language until it gave the actors room to grow. "Show it, don't say it" became my mantra.

On the evening of May 13, 1999, I sat in the back row at Oak Street Theater in Portland, Maine, as the seats filled and the room darkened. The Maine Department of Mental Health and Substance Abuse Services had bought the house; the 100 seats were filled with nearly 65 trauma survivors and the balance with social workers, friends, and colleagues. For a moment, I panicked. I contemplated exiting, sneaking out: "What on earth have I done?" I thought: "Why would I share the strange and twisted ruminations of my unconscious mind with the world? What a stupid thing to do!"

Two hours later, as the stage lights went down on the final scene, there was a brief silence, and then, as the lights came up again, the crowd surged to its feet, bursting into applause. It seemed to go on forever. I stumbled from my seat and out into the lobby, where we had planned a reception. I again considered escaping, but someone pointed to me and announced that I was the playwright. A young woman turned to me and approached slowly, her entire body was shaking. She looked up at me, opened her mouth, and slowly shook her head:

"I don't understand. How did you know my story?"

I was stunned. What to say?

"I didn't, but some very gracious and wise people told me theirs."

She nodded and took my hands between hers: "Thank you."

In my entire career, I've had no more powerful experience of seeing and being seen. Somehow, I'd transcended, through art, the chasm between us, the sheer impossibility of truly understanding the experience of another. I felt present in a way I couldn't describe. That moment has inspired and motivated my work ever since.

THE CLASSROOM

Luckily, we were able to secure funding to produce a videotape of *The Calling*, and subsequently it was shown at four national conferences. While video can't fully replicate the intimacy of a live performance, audiences continued to have profound reactions. Inspired by real events taking place in Portland, I wrote a second play, *Shadow Souls*, about the lives of five women over the course of one night in a women's shelter, during which they learn that the shelter would be closed in the coming weeks.

In contrast to the smooth, almost magical lead-up to *The Calling*, from the start *Shadow Souls* was hampered by a series of extraordinary challenges, nearly all of which occurred in the last 2 weeks before opening night. First, our stage manager kept blowing past light and music cues, throwing everyone off. Climbing to the balcony, I discovered that she was soundly asleep. It turned out that she suffered from narcolepsy and would routinely fall asleep during rehearsals. How she had managed this in previous productions remained a mystery, but she left, and a replacement was found. Next, our music designer had to bow out on learning that her husband had been diagnosed with terminal cancer. Luckily, the director had an inspiration for the musical theme, so we could move ahead. Finally, one of our actors was experiencing domestic abuse and needed safe harbor. Cast and crew came together to support her and create safe space. Faced with numerous external threats, the team coalesced, no complaints, no hesitation, and the curtain went up as scheduled at 8 pm on opening. As I peered across the expectant faces in the audience, it was clear that no one could possibly have suspected a thing. It was a seamless opening night. Throughout this ordeal turned mission, I learned something extraordinary: On opening night, the curtain will rise at the appointed time (Figure 10.1).

Figure 10.1 Scene from "The Calling".

While there are famous rivalries, squabbles, and feuds in theater history, there is also a remarkable, selfless commitment that can emerge around a creative production. It is an extraordinary thing to witness as individuals come together in the service of a higher purpose. Something unique happens when we are guided not by policies, procedures, and precedent, but rather by purpose, presence, and possibilities.

I also bore witness to the fact that actors have the great privilege of entering and experiencing alternate lives in a deep and meaningful way. There may be no more profound way to develop empathy and understanding for another than to spend time at least getting a glimpse of the world from their perspective. That year, we founded the Center for the Arts and Social Transformation at the university. It was a grand name for a small program. We hosted play readings, collaborated with community artists on various projects, and developed a new course: the Creative Arts in Social Work Practice. Over the next several years, students in the course wrote plays, recorded music, and incorporated drama, drawing, and other methods into their practice.

I and a group of colleagues met regularly to discuss ways to incorporate the arts. We were particularly intrigued by improvisation—the art of doing

something unplanned, unprepared, and spontaneous—behaviors that are known to emerge when actors are provided the opportunity to be unscripted. Even in scripted encounters, unexpected things happened, unimagined behaviors appeared. We began to explore and discuss the similarities between those skills and the core tenets of client-centered practice. To be fully client centered requires letting go of presumptions and prescriptions, not always an easy task for a profession based on the principles of assessment, diagnosis, and treatment. In my mind that triumvirate began to mutate into an alternative paradigm: *Assessment* was replaced with *dialogue*; the finite categories of *diagnosis* morphed into the limitless possibilities of *discovery*; and *treatment*, the ultimate validation of expertise, was abandoned entirely and replaced with *collaboration* (Graybeal, 2007; Walter, 2003).

Like improvisation, social work encounters are not scripted (Graybeal, 2014; Romanelli & Tishby, 2019). Working from a place of mutuality and empathy, social workers are "constantly tailoring their approach to the idiosyncratic strengths and needs of their clients" (Romanelli & Tishby, 2019, p. 797). They are the meeting of two or more individuals arriving in the same place but with entirely different agendas. To meet in the middle, come to mutual understanding, and co-develop shared goals and purpose is our ultimate aim. This demands remarkable focus and attention, flexibility, responsivity, and honesty, and like any improvisation is based on three key principles that I learned from my work with actors: The first is to *attend*. This means to listen carefully, to be fully present, and to be patient and engaged enough to get past the protective surface of clients' stories. Listening with your mind and body is not necessarily intuitive; it takes practice—we have to quiet our internal monologue, to still our restless bodies, and pay attention.

The second principle is to *accept*. We must suspend disbelief, stop looking for diagnostic clues, and begin to accept the other in full (Graybeal, 2001; Saleebey, 1992). To accept without judgment seems simple, but as we know, prejudice is layered through experience; it builds up over time and can harden with exposure to the external world. Without exception we all carry implicit bias (unconscious thoughts and feelings that influence how we see, understand, and judge others; Lai et al., 2014) and thus must actively practice self-reflection and "lucid awareness" of how experiences in our past and present affect how we attend to accept others (Wong & Vinsky, 2021, p. 191). Acceptance is the ultimate act of letting go, stepping free of those restrictions. Carl Rogers called it unconditional positive regard (Rogers, 1961).

Acceptance is not naïve. As noted previously, the scientific method emphasizes the provisional nature of knowledge (Kuhn, 2012). It encourages letting go in the presence of contradictory evidence. The actors' method is not dissimilar; it expects the same thing—something fundamental emerges and develops when we accept that which is before us, not what we anticipated, but rather that which we discover.

The third step, and the secret to all improvisation and to effective social work practice, is to *advance*. It is not enough to hear and accept, though in itself that may be a new experience for a client. As social workers, our ethical, moral, and professional obligation is to *advance* the narrative, to add something, to offer a way forward. This includes a sense of hope and possibility, of practical problem-solving and solution constructing, of finding the exceptions to problems and expanding them to create actionable alternatives.

This is where art meets science: These three principles are also at the heart of evidence-based practice. The original definition of evidence-based practice was founded on three pillars: the findings of research regarding technique or intervention, the wisdom and experience of the practitioner, and the values and preferences of clients or patients (Sackett et al., 2000.) We attend to the client or patient, we accept what they bring, and then we attempt to advance the narrative in a positive and healthy direction. But each moment is an opportunity to exhibit our capacity to live with our knowledge as provisional. The cumulative insights from such diverse sources as relational theory (Gilligan, 1982); narrative approaches (White & Epston, 1989); the strengths perspective (Graybeal, 2001; Saleebey, 1992); solution-oriented practice (Berg, 1994; de Shazer, 1985); and privileging the client's perspective (Duncan et al, 2004; Graybeal, 2014) all contribute to bringing us into the present and to help us advance our client's stories toward growth and connection.

EXPERIENTIAL LEARNING

As mentioned, no matter how erudite, how content rich, or how significant, academic writing at its best is thought provoking, but rarely memorable. Unfortunately, many classroom experiences replicate that culture and environment. We still tend to emphasize learning through traditional methods: read, discuss, write, evaluate, and grade. There is an inexorable pull toward what Freire called "the banking model" of education (Freire, 1970), in which information is deposited in the student so that it can be withdrawn for exams and assignments, only to subsequently disappear into the ether. We focus on CSWE mandates and competencies and develop complex rubrics and charts that convey little of the art, process, or science of real social work practice. We need those things, of course, but we also must learn to transcend them, to discover that which is truly meaningful and enduring. In contrast to the banking model, Belenky and colleagues (1986) offered the midwifery model, in which the task is to woo knowledge into expression and advance it through connection. In Latin, *educare* means to draw out or develop. This is the consequence of collaboration, of advancing the relationship.

Every year, I ask students what they found most meaningful in their educational experience. Inevitably, their answers focus on their field experience,

particularly if their field instructor provided a good role model as a practitioner and supervisor. They also describe the profound influence of challenging discussions about race, diversity, and privilege, and finally, the memorable examples and experiences shared by their professors and peers and, perhaps most importantly, the life experiences and challenges of their clients.

With each passing year, I have increased my efforts to *attend* more carefully to the words and experiences of my students, to *accept* the reality of how knowledge is developed and retained in each of their life contexts, and to explore the best ways to *advance* that process, as free as possible from the restrictions of tradition. We review the various methods of knowing, the contributions of authority, tenacity, a priori reasoning, and the scientific method. We also spend time on intuition and the value of dating your hypothesis before marriage.

With each passing year, I have expanded experiential learning in every class I teach. I've come to believe that focus on skill building through experiential exercise is a critical prerequisite to deconstruction and analysis. Theory is better understood as a descriptive exercise than a prescriptive one. We now know that the quality of the alliance formed between client and provider is substantially more predictive of outcome than the technique or model applied (Drisko, 2004; Wampold, 2001), and perhaps most importantly, that incorporating the client's perspective may be the most powerful predictor of outcome (Duncan, 2014). It is the same in the classroom. It makes pedagogical sense that we concentrate on that which will maximize the effectiveness of every encounter. When I incorporate role plays with real-time feedback from both the client and teacher, students routinely report that those experiences are the most profound and memorable in their learning.

CONCLUSION

I feel privileged to have worked in the settings I have and to have encountered such a diversity of individuals whose skills in the creative arts have enhanced my understanding of the richness there. I routinely ask students and workshop participants to indicate by a show of hands who among them, as an adult, no longer engages in some artistic endeavor central to their childhood. Inevitably, the majority raise their hands. The question is why would this be so? It is well worth exploring the answer to this question, as I believe it often holds the key to unlocked potential in their practice. That potential may lead to finding a technique to enrich the provision of therapy, or it may lead to an effort to raise social awareness of a critical issue. But the consequence may also be less direct. It may serve first to recall the freedom, the creativity, the joy we once had when play was not only permissible but expected.

The arts have a way of cutting through *all* the layers of defense and pretense, of intellectualization and isolation, and getting right to the heart of the matter. In 2001, my wife and I gave a presentation in Washington, D.C., on my play, *The Calling*, at the Annual Conference of the Society for Spirituality and Social Work. The presentation went well, but what I remember from that conference was the performance of the local gospel choir. From the very first note, I felt as though someone had reached in through my chest, grabbed me by the heart, and shook me loose from those leaden roots that keep us tangled in anyplace but the here and now. I will never forget it; the hair on my forearms tingles even as I write these words.

The promise and peril of the arts is their deep and broad diversity and the range of possibilities. For all of those who left an art behind, I encourage taking time to re-experience and rediscover, to explore what it represented, what it signified, and how it may have enriched your life. For those who have yet to experience artfulness, I recommend you consider finding an avenue of expression that works for you. You can also add some questions to your traditional assessment interviews: "What do you do to express creativity in your life?" "Is there something creative you used to do but have lost track of or miss in your life today?" "What would it be like if you could find the time to play as you once did as a child?"

The remarkable thing is that once you begin to incorporate the arts in your practice, each step leads not to one path but to many. "All the world's a stage," said Jacques in *As You Like It*, "and all the men and women, merely players" (Shakespeare, 1623). Not merely, I think, but fully, if we so choose.

REFERENCES

Belenky, M. F., Clinchy, B. M., Goldberger, N. R., & Tarule, J. M. (1986). *Women's ways of knowing: The development of self, voice, and mind*. Basic Books.
Berg, I. K. (1994). *Family based services: A solution-focused approach*. W. W. Norton.
Cohen Konrad, S. (2019). Art in social work: Equivocation, evidence, and ethical quandaries. *Research on Social Work Practice*, 29(6), 693–697.
Cornish, S. (2017). Social work and the two cultures: The art and science of practice. *Journal of Social Work*, 17(5), 544–559.
de Shazer, S. (1985). *Keys to solution in brief therapy*. W. W. Norton.
Drisko, J. W. (2004). Common factors in psychotherapy outcome: Meta-analytic findings and their implications for practice and research. *Families in Society*, 85(1), 81–90.
Duncan, B. L. (2014). *On becoming a better therapist: Evidence-based practice one client at a time*. American Psychological Association.
Duncan, B. L., Miller, S. D., & Sparks, J. A. (2004). *The heroic client: A revolutionary way to improve effectiveness through client-directed, outcome informed therapy*. Jossey-Bass.
Freire, P. (1970). *Pedagogy of the oppressed*. Herder and Herder.

Gilligan, C. (1982). *In a different voice: Psychological theory & women's development*. Harvard University Press.

Graybeal, C. (2001). Strengths-based social work assessment: Transforming the dominant paradigm. *Families in Society, 82*(2), 233–242.

Graybeal, C. (2007). Evidence for the art of social work. *Families in Society, 88*(4), 513–523.

Graybeal, C. (2014). The art of practicing with evidence. *Clinical Social Work Journal, 42*(2), 116–122.

Groopman, J. (2007). *How doctors think*. Houghton Mifflin Harcourt.

Huss, E., Sela-Amit, M., & Flynn, M. L. (2019). Art in social work: Do we really need it? *Research on Social Work Practice, 29*(6), 721–726.

Kerlinger, F. (1973). *Foundations of behavioral research* (2nd ed.). Holt, Rhinehart, and Winston.

Kuhn, T. S. (2012). *The structure of scientific revolutions: 50th anniversary edition*. The University of Chicago Press.

Lai, C. K., Marini, M., Lehr, S. A., Cerruti, C., Shin, J.-E. L., Joy-Gaba, J. A., Ho, A. K., Teachman, B. A., Wojcik, S. P., Koleva, S. P., Frazier, R. S., Heiphetz, L., Chen, E. E., Turner, R. N., Haidt, J., Kesebir, S., Hawkins, C. B., Schaefer, H. S., Rubichi, S., . . . Nosek, B. A. (2014). Reducing implicit racial preferences I: A comparative investigation of 17 interventions. *Journal of Experimental Psychology, 143*(4), 1765–1785. https://doi.org/10.1037/a0036260

Raymo, C. (2006). The end. *Science and Spirit, 17*, 66–67. https://doi.org/10.3200/SSPT.17.6.66-67

Rogers, C. (1961). *On becoming a person: A therapist's view of psychotherapy*. Houghton Mifflin.

Romanelli, A., & Tishby, O. (2019). "Just what is there now, that is what there is"—The effects of theater improvisation training on clinical social workers' perceptions and interventions. *Social Work Education, 38*(6), 797–814. https://doi.org/10.1080/02615479.2019.1566450

Sackett, D. L., Straus, S. E., Richardson, W. S., Rosenberg, W., & Haynes, R. B. (2000). *Evidence-based medicine: How to practice and teach EBM* (2nd ed.). Churchill Livingstone.

Saleebey, D. (1992). *The strengths perspective in social work practice*. Longman.

Walter, U. (2003). Toward a third space: Improvisation and professionalism in social work practice. *Families in Society, 84*(3), 317–322.

Wampold, B. E. (2001). *The great psychotherapy debate: Models, methods, and findings*. Erlbaum.

White, M., & Epston, D. (1989). *Collected papers*. Dulwich Centre Publications.

Wong, Y.-L. Renita & Vinsky, J. (2021). Beyond implicit bias: Embodied cognition, mindfulness, and critical reflective practice in social work. *Australian Social Work, 74*(2), 186–197. https://doi.org/10.1080/0312407X.2020.1850816

11
A Vision for Engaging the Arts in Social Work Practice

BRIAN L. KELLY, CARRIE LANZA,
RAPHAEL TRAVIS, AND TAYLOR ELLIS

INTRODUCTION AND OVERVIEW

In this chapter, we present a vision for engaging with art in social work practice that prioritizes two key concepts: (1) The arts offer important and vital ways of doing social work *with* rather than *for* people, and (2) the arts offer relevant and just means for cultivating a praxis that extends beyond cultural competence (Pon, 2009) and is grounded in cultural humility (Foronda, 2019; Foronda et al., 2016; Tervalon & Murray-Garcia, 1998).

We are writing this amid multiple crises: from a global health pandemic, accompanied by economic and vocational crises; to a global movement to stop police violence against Black and Brown bodies and dismantle the carceral state; to a global reckoning with systemic White supremacy and legacies of settler colonization that are unfolding across many continents. Further, multiple threats to electoral and representative democracy continue in the context of a rising neofascist agenda, while weather events and natural disasters highlight how the climate crisis is bearing down in every corner of the globe. For millennia, communities around the world have relied on the arts to improve and maintain wellness, express grief and rage, and mobilize for advocacy and mutual aid. This moment is no different. It is hard to imagine a more urgent time to consider how the profession of social work engages the arts to advance the mission of social justice, equity, and inclusion.

As this chapter will demonstrate, engaging with art in social work practice leads to a fuller realization of the broad potential for creative, client- and

Brian L. Kelly, Carrie Lanza, Raphael Travis, and Taylor Ellis, *A Vision for Engaging the Arts in Social Work Practice* In: *Social Work and the Arts*. Edited by: Shelley Cohen Konrad and Michal Sela-Amit, Oxford University Press.
© Oxford University Press 2024. DOI: 10.1093/oso/9780197579541.003.0012

community-centered practice. It demands practice that is attuned to the full spectrum of social work practice at the micro (i.e., individuals and families), mezzo (i.e., groups and communities), and macro (i.e., organizational, policies, and social action) levels. In addition, engaging with art prioritizes a broader range of epistemological and methodological approaches to understanding the relationship between the arts and social work, grounded in the understanding that the arts are critical sites of identity expression and well-honed tools for expressing grief and rage, as well as healing and liberation for many populations social workers serve and may also personally identify with, including ethnic and racial groups, youth, the LGBTQ+ (lesbian, gay, bisexual, transgender, and queer or questioning) community, placed-based communities, and many more.

In this spirit, throughout this chapter we examine social work, art, and the synergy of the two; what they offer each other and a vision of their potential. The chapter begins with intersectional positionality statements from the authors that serve to contextualize and ground our vision in our work. Following these statements, we provide a review of historical and current relationships between the arts and social work practice. Following this review, we examine the possibilities of arts-based approaches for social work practice, giving particular attention to what the arts and social work offer each other. With these considerations in mind, we then present a vision for engaging the arts in social work practice that harnesses the synergistic potential the arts and social work offer to each other. The chapter closes with a discussion of potential implications and barriers to our vision of engaging the arts in social work practice.

SYNERGISTIC PROFESSIONAL POSITIONALITIES

As authors, we first acknowledge the lands we inhabit in the South, Midwest, and Northwest of the United States. We acknowledge First Nations and the erasure of their cultural traditions. All of us live on Indigenous land (Tuck & Yang, 2012; Walters et al., 2010). Some of us descend from settler colonists, and some of us descend from people that were enslaved. All of us were raised in environments that encouraged acknowledging and embracing these complex identities to varying degrees. In addition, we bring years of practice as artists and social workers to this vision. We are poets and storytellers, dancers and musicians, producers and curators, DJs and scene makers. We are also counselors and clinicians, teachers and facilitators, researchers and scholars. We are continually negotiating and synthesizing our multiple identities as artists, social workers, and scholars. We experience these negotiations and synthetizations through multiple lenses. We reject the idea that these identities may be isolated and, rather, promote the reality that at any given time we are social

workers *and* artists, harnessing the synergized energy of these identities to the greatest benefit of those we collaborate with and serve (Travis, 2019).

We wish to adhere to the Indigenous methodological practice of relational accountability (Wilson, 2001), where as authors we consider how we are fulfilling our roles in our scholarly endeavors. Self-location statements provide an opportunity to address relational accountability (Windchief et al., 2018). These statements offer some of our backgrounds and positionality, as well as our theoretical sensitivity (Strauss & Corbin, 1998) with the phenomenon at hand. As a teacher-scholar-practitioner, Brian brings over three decades of experience as a musician, song writer, producer, DJ, label owner, and event curator to social work education, research, and scholarship. Rather than separating these identities, he has worked to develop a pedagogy and body of scholarship that explores the role of music-based services in strengths-based and socially just social work practice, particularly with young people experiencing homelessness (Kelly, 2015, 2017, 2019; Kelly & Hunter, 2016; Kelly & Neidorf, 2022).

Carrie's career in social work and scholarship has been integrated with a career in cultural production that has, over several decades, spanned film and digital media production; scholarship regarding visual research methods and socially conscious design (Lanza, 2016a, 2016b; Smolker & Lanza, 2011); museum curation; and event production and participatory music and dance with Seattle Fandango Project and Womxn Who Rock: Making Scenes, Building Communities (Lanza, 2016b). This work has been driven by questions about how communities of all kinds use cultural practices to build strong social bonds, pass on traditional knowledge, buffer the effects of historical and intergenerational trauma (Walters & Simoni, 2002), and heal and build foundations for resilience and political resistance. In her teaching, her body of work has also been realized in collaborative curriculum development with arts faculty, resulting in several multidisciplinary courses and mentoring students' work in arts-based practice.

As a born New Yorker, Raphael has engaged in all five elements of hip-hop culture (i.e., emceeing, b-boying, graffiti/writing, deejaying, and knowledge of self) as creative outlets, but more importantly as sources of empowerment and well-being throughout his lifetime. When the evidence became increasingly clear that cultural understandings of hip-hop were assets for not only for personal well-being, but also social work research and practice, he began a systematic integration of the personal and professional by empirically exploring the intersections of empowerment-based practice, positive youth development, and hip-hop culture (Travis & Deepak, 2011; Travis & Leech, 2014). While Raphael continues to experiment with beat making and turntable deejaying, his most public artistic presence has been curating blended mixtapes for over 15 years as part of the GriotStarters collective (Travis, 2021).

Taylor began writing and performing as a teenager through mediums of theater, hip-hop, and spoken-word poetry. However, he did not begin to blend his artistic and professional self until his graduate studies, where he was invited to perform original spoken-word poems at social work events (Ellis, 2021). Later, he began to integrate poetry written by youth with problematic sexual behaviors into his research practice, positioning the content as a method of exploring identity with vulnerable populations, developing empathy, and rehumanizing these stigmatized youth (Ellis, 2020; Ellis et al., 2020). Taylor has continued to blend these identities as a full-time professor, introducing music, documentaries, and graphic novels to explore the influence of policies on personal and group experiences.

It may seem that this visioning of social work(ers), art(ists), and the synthesized identities of the two is quite radical and "at odds" with 20th-century, modern conceptions of clinically and caseworker-oriented social work practice that support clear and linear boundaries in client relations and guidelines and standards for practice. But, as many community-oriented and relationally attuned scholars, educators, and practitioners have noted, social work as a discipline and a profession has much to gain from moving beyond these limiting frameworks for practice (Chambon, 2012; O'Leary et al., 2013). We also wish to stress that although we embody social worker and artist identities, the vision we are building toward does not require one to hold multiple professional identities. Rather, in the relational, ecological spirit of the vision, we ask practitioners to observe and include cultural and artistic practitioners as collaborators in all forms of social work practice. As the following historical review demonstrates, social worker–artists and artist–social workers have collaborated throughout the 19th and 20th centuries.

HISTORICAL AND CURRENT USES OF THE ARTS IN SOCIAL WORK PRACTICE

The methods and contexts that characterized the first three decades of the social work profession do not map readily onto contemporary definitions of what current social work practitioners are or do or where contemporary social work is most often currently practiced (Chambon, 2012; Lanza, 2016a). Prior to the bloom of agency and hospital-based clinical practice in the 1920s (Cabot, 1914, 1919; Richmond, 1917, 1922), the profession embraced methods that enthusiastically included photography and graphic arts and used them toward outcomes, such as reform of both urban residential areas and labor conditions faced by new immigrants arriving to live and work in American cities. Meanwhile, settlement house workers employed the arts to engage those same communities in prosocial activities that sought to build community

among the diverse residents they lived among in low-income neighborhoods (Addams, 1910; Kelly & Doherty, 2016, 2017).

In a 2012 essay, Canadian social work scholar Adrienne Chambon interrogated the "expansion and contraction" of social work's disciplinary "borders" and knowledge base over its history, noting that the arts are currently considered "outer limits" of the field. She commented, however, that during the Progressive Era:

> The arts did not dilute the specificity of social work. They were used instead as catalysts. The boundary activity of the early discipline served its interests and promoted social work to a central knowledge position, and its leaders as significant social agents. (2012, p. 10)

CANONICAL HISTORY OF ARTS-BASED PRACTICES

Social work emerged in the Progressive Era (1890–1920) as a profession deeply intertwined with the arts. And, indeed, as Chambon (2012) noted, this embrace did result in early social workers' much greater public notoriety as public reformers and social pundits. Of the original branches of practice that emerged in the late 19th century, both the charity organization societies (COSs) and settlement house movement took up arts-based methods, albeit to different ends. While they may have had different visions for how the arts might be used and their potential outcomes, each branch witnessed the emergence of collaborations among artists and social workers, as well as individuals and collectives practicing as artists and social workers.

Though commonly associated with the emergence of clinical practice via the evolution of "friendly visiting" into social casework (Richmond, 1917, 1922), the COSs in concert with the Russell Sage Foundation also developed and funded the use of documentary photography and graphic arts toward both large-scale urban reform and policy advocacy. Photography was also already prominent as a method for documentation, education, and publicity regarding health and welfare issues among Progressive reformers, who would later lead in the formation of the profession of social work (Lanza, 2016a; Szto, 2008). Lawrence Veiller of the New York Charity Organization Society developed the Tenement House Exhibit of 1900, which featured 1,100 images of the conditions among the low-income immigrant communities of New York City; these images became key evidence in bringing reform to housing conditions in the subsequent years (Stange, 1989).

In the wake of carrying out the Pittsburgh Survey, early social work leader Paul U. Kellogg declared the social survey movement as the third wave of early social work practice (Chambers, 1971; Lanza, 2016a). He and his colleague, social photographer Lewis Hine, explicitly called for social workers to

be trained in arts and media production tools for education, policy advocacy, and social action (Hine, 1980; Kellogg, 1912; Lanza, 2016b). Paul Kellogg also edited and published social work's first journal from 1902 until 1949: *The Survey*. Originally called *Charities & the Commons*, Kellogg renamed it after completing the Pittsburgh Survey in 1909. More significantly, Kellogg edited and published *Survey Graphic* from 1921 to 1952. *Survey Graphic* sought to offer a mainstream public concerned with social issues access to social justice–informed written content with art, documentary photography, and innovative graphic representations of complex information (Chambers, 1971; Chambon, 2012; Lanza, 2016a).

The methods of the settlement house movement also included a wide variety of arts-based practices facilitated by artist–social workers and social worker–artists, including theater, music, dance, visual arts, ceramics, and the preservation of traditional arts representing the many cultural groups they served (Lausevic, 2015; Ruiz, 2004). In her seminal work from 2000, *Lines of Activity: Performance, Historiography, Hull House Domesticity*, Shannon Jackson noted that the arts and social work were initially intertwined to create a vehicle for social reform by Jane Addams and the Hull House "settlers." Jackson posited that the arts and crafts, performing and visual arts, and sports and play were employed to cultivate social cohesion among an ethnically and racially diverse local community. Hull House's storied leader, Jane Addams, and frequent Hull House visitor, educator, and pragmatic philosopher John Dewey were very invested in both *communitas* and art as cultivators of a democratic culture.

The Hull House desired to elevate "art for the benefit of the masses" (Starr Family Papers, 1890, as cited by Stankiewicz, 1989, p. 35), hosting artists of all mediums as both teachers and residents (Payette, 2018). The campus in Chicago provided a pottery studio that generated a cottage industry for Mexican immigrants (Ruiz, 2004). It also provided dance, music, and theater performance and rehearsal spaces that cultivated jazz musicians such as Benny Goodman (Jackson, 2000), and educated thousands of children in the delights of folk dancing and producing theater (Jackson, 2000; Lausevic, 2015). While intended to build community in a diverse and sometimes conflicted multiethnic neighborhood, all the aforementioned authors noted that these practices also were shaped by a complex negotiation of cultural and ethnic/racial identity and structural inequities, as well as settlement house workers' emphasis on assimilation.

Underserved communities and arts and cultural practices

Meanwhile, in many underserved communities, if not outright ignored by social services (Carlton-LaNey et al., 2001; Reisch, 2008; Shepard, 2013),

ranging from Black and Indigenous to immigrant and refugee communities, the queer community and among youth, arts and cultural practices are life ways at the root of their identities. For instance, Indigenous social work scholars, such as Karina Walters (Choctaw) and Ramona Beltrán (Yaqui, Mexica), among others, have centered the significance of traditional cultural practices, including many art forms, such as storytelling, beading, carving, drumming, and dance as *cultural buffers* mitigating the impact of historical trauma as well as key factors in facilitating healing from depression, anxiety, suicidal ideation, and substance abuse among Indigenous communities (Beltrán & Begun, 2014; Lawrence, 2012; Walters & Simoni, 2002).

The practice of culturally specific art forms and *place making* (Sutton & Kemp, 2011) has always involved resistance, resilience, and deep intertwining with both the mutual aid systems communities developed to meet their own needs and culturally specific social services (Carlton-LaNey et al., 2001; Reisch, 2008; Shepard, 2004, 2013; Sutton & Kemp, 2011). For example, Seattle, Washington's, El Centro de la Raza: The Center for People of All Races, houses a variety of social service and health promotion programs as well as preschool, low-income housing, and a host of other services to the highly diverse community they serve. Founded in 1971 after a 2-month occupation of an empty former public school building, El Centro has served communities of south King County for 50 years. Murals fill the hallways and adorn the housing and events plaza. Annually, Dia de los Muertos celebrations feature altars built by other community-based organizations in the neighborhood. Gardens managed by local master gardeners, holiday celebrations, and dance and music classes all intertwine with social service provision in ways intended to offer a deep sense of belonging for all who visit, mutual respect for diversity and human dignity, and above all else, "building the beloved community" in the spirit of the Reverend Martin Luther King, Jr. (El Centro de la Raza, 2021; Johansen, 2020).

Current arts practices

The use of the arts in social work practice continues in many social work settings. At the micro level, art, dance, music, and play therapies, also known as expressive therapies, have developed into substantial fields of clinical and therapeutic practice used for self-discovery and the treatment of behavioral and medical health issues (Malchiodi, 2013, 2020). At the meso level, music-based services are also used therapeutically (DeCarlo & Hockman, 2003; Tyson, 2012) for indicated prevention and empowerment (Travis, 2020; Travis, Gann, et al., 2019; Travis, Rodwin, & Allcorn, 2019); skill building (Kelly, 2017; Kelly & Hunter, 2016); and creation of spaces for resistance for historically oppressed groups (Kelly & Neidorf, 2022). At the

macro level, interactive theater techniques are used to create socioculturally relevant intimate partner violence prevention (Yoshihama & Tolman, 2015), and traditional dance practices are used for community resilience, assessing community needs, and community-level interventions (Alliance for California Traditional Arts [ACTA], 2011, 2017). In addition, Beltrán and Begun (2014) described the process of Indigenous youth creating and sharing digital stories about their lived experiences as "a transformational tool for reclaiming knowledge and highlighting resiliencies despite legacies of colonization and ongoing discrimination" (p. 162). These ongoing practices support calls from practitioners, researchers, and scholars for the ongoing use of the arts in social work practice (Chamberlayne & Smith, 2019; Huss & Sela-Amit, 2019; Nissen, 2019).

ENGAGING THE ARTS IN SOCIAL WORK PRACTICE

As the prior review demonstrates, social worker–artists and artist–social workers have worked independently and collaboratively to engage the arts at all levels of practice since the origin of the profession. The profession, however, seems to lack a consistent and unifying vision for doing so. To be clear, individuals, groups, communities, and organizations likely have myriad means and methods for using the arts in their practice. It is the profession of social work that seems to lack a coherent vision for engaging the arts in practice. To develop such a vision, it is necessary to define what we mean by "social work" and "art." Before doing so, we would like to stress that we do not offer this vision as a kind of definitive statement of how, when, and/or why to engage the arts in social work practice. Rather, we offer this as a "jumping off point," a place to begin a dialogue within the profession with those interested parties. We hope that others will challenge, support, disrupt, and beautifully complicate this vision in the spirit of collaboration.

Defining social work practice

In defining social work practice, we see a range of approaches, where one end of the spectrum is defined by social work practitioners, educators, researchers, scholars, and top-down approaches to practice (i.e., approaches developed and implemented by professionals). The other end is defined by the individuals, groups, and communities social workers serve; bottom-up approaches to practice (i.e., approaches that are grounded in folks' lived experiences, needs, and wants). Given that we are particularly interested in developing a vision grounded in cultural humility that prioritizes social work *with* rather than *for* people, a bottom-up approach is most effective for realizing these goals.

Grounded in our synergistic experiences as social worker–artists and artist–social workers, a bottom-up approach allows for greater possibilities. These possibilities include the potential for client-centered, creative approaches that disrupt distinctions among micro, mezzo, and macro levels of practice and foster greater consideration and incorporation of all three levels. Bottom-up approaches also foster greater attention to issues of social justice, including advocacy, agitation, and resistance. In defining social work practice in this way, we explicitly lean toward community-oriented, participatory forms of practice. This does not, however, inherently exclude micro and mezzo forms of practice. Rather, it demands attention to ensuring individuals and groups are understood within their larger context of communities and environments.

Defining art

In defining art, we struggle to operationalize such a massive and multifaceted field. If we consider defining art in relation to its use in social work, drawing from our own practice, teaching, and research experiences as social worker–artists and artist–social workers, we have engaged in art production through participatory arts events and programs. We have curated arts events and products, including audio documentaries, mixtape camps, and talent shows. We have developed immersive art experiences, including exhibitions and performances. We have participated in place- and scene-making events and processes, including event planning and documentation. And, we have done this at individual, group, and community levels, with attention to dismantling distinctions among them. Like our definition of social work, our experiences of engaging the arts in social work practice suggest a bottom-up approach, in which individual, group, and community conceptualizations and experiences of the arts are centered. When considering a definition, then, of art in relation to social work practice, we envision a bottom-up approach as paramount. Rather than getting bogged down in lofty philosophical framings of what constitutes art, we prefer for individuals, groups, and communities to define art for themselves and support Graham's (2018) framing of *the aesthetics of everyday life*.

The vision

In presenting our vision for engaging the arts in social work practice, we would like to assert several points. The first is acknowledging that the profession of social work is vast, and that social workers play a wide variety of roles in organizations and institutions. The possibilities for engaging art in practice are literally innumerable. These could include facilitating arts engagement or production, fundraising for materials or spaces, curating exhibitions or events, or co-producing art with participants. Second, moving from a base

of key social work values, such as antioppressive practice, cultural humility is bedrock to approaching individuals, groups, and communities. Emphasizing client/community strengths, empowerment, and self-determination, we recommend collaborative, participatory approaches in which practitioners work *with* rather than *for* individuals, groups, and communities.

Third, art and cultural production are woven into the fabric of individual, group, and community lives. Keeping in the spirit of working with rather than for, as well as prioritizing Indigenous definitions and understandings of art, social workers may relieve themselves of preexisting conceptions of art and/or how to engage with individuals, groups, or communities in arts-based ways. Their attunement to existing cultural and artistic practices, practitioners, and resources will provide a guide for how to engage in culturally humble and meaningful ways. Fourth, from this collaborative and humble space the practitioner and participants are free to explore ideas and issues and develop creative approaches to address them, some of which may be arts based *if* the participants feel these are valid and useful approaches. We wish to underscore this last point by encouraging social workers to meet individuals, groups, and communities where they are and honor client/community self-determination. Rather than entering the relationship with the intention of engaging the arts, we encourage social workers to remain curious and open to the possibility of engaging Indigenous arts practices *if* folks wish to do so.

Finally, it is important to resist the external cultural curatorial forces that seek to define art and instead prioritize participants' definitions of arts and their arts practices. From this curious and open space, we envision a deep, mutually beneficial exchange, where the arts offer social work creative and powerful opportunities for social justice and change. In envisioning what social work offers the arts, we wish to be clear that we are not suggesting any deficiencies within the arts. Rather, from our synergistic positions as social worker–artists and artist–social workers, we have witnessed the power of engaging social work perspectives, models, and skills in our practice, teaching, and research. In the following sections, we present six conceptual spaces where we envision great potential for synergy when engaging the arts in social work practice. Figure 11.1 provides a visual representation of the spaces and the power that exists in bringing them all together.

Context and person-in-environment practice

Engagement with the arts provides opportunities for social workers to gain deeper contextual understandings of individuals, groups, and communities. This includes their histories, environments, cultural practices, and the policies that guide and shape the systems they exist within. From our own practice experiences, we have witnessed the power of dance, music, and poetry as methods of gaining deeper understandings of folks' lived experiences, as well

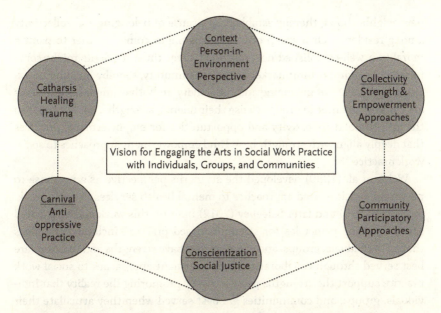

Figure 11.1 Vision for engaging the arts in social work practice with individuals, groups, and communities.

as their larger environments. From this space, we find resonance between the deeper context offered by tuning into Indigenous art practices and person-in-environment practice, which is a foundational social work perspective that centers the individual, group, or community in their environment and demands social work responses that are inclusive of micro, mezzo, and macro levels (Gitterman et al., 2021).

In keeping with the spirit of working with rather than for, it is important to caution social workers about making assumptions regarding context. We simply cannot assume we understand someone or something's context based on the finite and limited interactions social workers often have with individuals, groups, and communities. Establishing relationships and maintaining a position of cultural curiosity and humility, attending to artistic and cultural practices and products, and practicing from a person-in-environment perspective positions social workers to remain open to evolving contextual understandings of individuals, groups, and communities.

Collectivity, empowerment, and strength-based approaches

Individuals, groups, and communities often use the arts as a means of establishing and building on collectivity. For example, a group of individuals might come together to host a block party with DJ sets and live performances for a

new neighborhood, thereby establishing a sense of belonging and collectivity among residents. Or a group of individuals might come together to paint a mural in a well-established neighborhood. Over time, residents might come to see it as an important marker of their community, thereby building on existing sentiments of belonging and collectivity. In both examples, individuals are coming together in groups to use their talents, strengths, and interests in the arts to build collectivity and opportunities for empowerment, practices that deeply align with strength-based and empowerment approaches to social work practice.

Weick et al. (1989) developed the strengths perspective as a response to pervasive deficits-based approaches to mental health services in social work. Saleebey (1996) and later Saleebey (2012) built on this work and articulated several guiding principles for strengths-based practice, including the ideas that all individuals, groups, and communities have strengths and that they are best served through collaboration. Empowerment approaches to social work practice support the strengths perspective by promoting the reality that individuals, groups, and communities are best served when they articulate their needs and are provided with the resources and support to meet their goals. Two authors of this chapter have conducted research in using music and related cultural practice to foster empowerment through hip-hop culture (Levy & Travis, 2020) and strength building through music education and production (Kelly, 2015, 2017). In these instances, individual and group needs were collectively articulated and addressed. While engaging the arts in social work practice has the power to foster collectivity, strength, and empowerment, we would like to remind readers that collectivity may not always appear to be harmonious. At times, collectivity through arts engagement may manifest as resistance to oppressive practices, policies, and systems. Frankly, we could not imagine a better synergy between art and social work practice.

Community and participatory approaches

A review of sources cited throughout this chapter and additional sources from professional archives provide numerous examples of how social workers have engaged the arts in their practice to build relationships with and among community members. From settlement house workers using the arts in immigrant communities to foster citizenship and collaboration (Addams, 1910; Ruiz 2004); to COS workers using photography to advocate for social reforms with significant community impacts (Lanza, 2016a); to social group workers of the mid-20th century using arts and crafts in summer camps to build stronger connections among youth and their families (Kelly & Fleming, 2016); to the use of aural, performing, and visual arts to strengthen community bonds today (Ramirez & Jiminez-Silva, 2015), it is clear that social workers have

engaged their artistic practices and collaborated with artists and community members.

These collaborations have contributed to the relational qualities of communities by strengthening social bonds among residents and building social capital, as well as strengthening the structural qualities of communities through the establishment and support of arts-based programming and agencies. This last point particularly comes alive in the professional archive when reviewing the geographic footprints of settlement houses, with entire buildings dedicated to arts programming (Hull House Publishers, 1907, 1910, 1921) and the establishment of summer camps dedicated to the arts (Hull House Association, n.d.). With these incredible accomplishments in mind, we imagine building on these practices and using more explicit participatory, bottom-up approaches with communities to fully realize the potential of engaging the arts to build and strengthen community ties, social capital, and physical structures.

Conscientization and social justice

Conscientization or *critical consciousness raising* is a praxis grounded in the work of critical pedagogue Paulo Freire. As laid out in his seminal text, *Pedagogy of the Oppressed*, conscientization originally referred to a process in which a group experiencing oppression explore the sources and structures and possible tactics for dismantling it (Freire, 1970). As Carroll and Minkler (2008) pointed out, many elements of Freire's popular education model have deeply impacted social work education and participatory research and practice. A bedrock process of many social movements, the arts have been key vehicles for delivering consciousness-raising content. Activists are keenly aware of the power of visual symbols, music, dance, narratives, and film for the purposes of engaging stakeholders in their cause. Chicana feminist scholar and veteran musician Martha Gonzalez (2020) described the entwined work of artist–activists as *artivism*, theorizing about Chicanx and Mexican artivista communities of practice that have woven into a larger transnational movement that has mobilized to resist the oppressive forces of late capitalism and center the narratives of communities impacted by them.

Simultaneous with processes of resistance, artivista communities center an ethic of *convivencia*, a Spanish term that Gonzalez described as

> stemming from the words con and vivir, or "to live with" is the mindfulness of presence with others. Being present and engaging with others in mind, body, and spirit via participatory music and art practice, convivencia has become an invaluable code of ethics in artivista philosophy. (Gonzalez, 2020, p. 3)

Conscientization as a means of responding to oppressive systems is long established in social work. Meanwhile, convivencia and artivism offer new frameworks for this process, moving toward building communities that offer a sense of belonging through not only participatory arts practices but also the relationships and infrastructure to mobilize against identified forms of systemic oppression.

Carnival and antioppressive practice

Like conscientization, *carnival* is another potent aspect of participatory arts practice models for social work. In Barbara Ehrenreich's *Dancing in the Streets: A History of Collective Joy* (2006), she described carnival as characterized by not only festival and celebration, perhaps best recognized in Brazilian carnival or Mardi Gras in New Orleans, but also the emphasis on play with symbols of power as a means of grappling with and talking back to systems of oppression going back to antiquity. Social worker and activist scholar Benjamin Heim Shepard researched the significance of play, joy, and carnival in social movements (2005a, 2005b, 2008). Shepard explored the importance of experiencing positive forms of bonding as tools of activism and resistance in social movements as well as through the creative processes of performance, dance, and camp aesthetics. Shepard looked at the emergence of carnival in a variety of movements, ranging from Chicano guerilla theater in the 1970s to ACT UP's (AIDS Coalition to Unleash Power's) dramatic protests during the AIDS crisis in the 1980s to more recent antiglobalization movements.

While the role of carnival in social action may be quite clear, what does cultivating space for carnival offer social workers engaging arts-based practices in other contexts? There are several components of carnival. First, the creative process of performance for both the performers and their audience includes many possibilities for flow experiences of belonging and joy (Bos, 2018). Second, play and humor are critical coping skills in dealing with adversity at intra- and interpersonal levels, as well within groups and communities. Thus, laughter can be a powerful tool in processes of conscientization about systems of oppression. Third, carnival offers opportunities to experience *catharsis*.

Catharsis and healing trauma

In our final conceptual space where we envision great potential for synergy when engaging the arts in social work practice, we would like to discuss the cathartic power of the arts to address and heal trauma. Each of us, and we imagine you, the reader, has experienced the healing power of a poem, lyric, beat, melody, sculpture, painting, film, or television program. In these moments,

we experienced the emotive power of seeing a portion of our story presented and reflected back to us. We have been challenged and rewarded by these experiences, particularly when afforded the time and space to reflect on their meaning and relation to our lives. As social worker–artists and artist–social workers and as consumers and producers of art and social work, we find these moments provide invaluable opportunities for catharsis and growth.

While the field of expressive therapies has done much to address the potential of art to promote catharsis and heal trauma (Malchiodi, 2013, 2020), and several neuroscience scholars have noted the power and potential of the arts to address trauma-related symptoms (Perry & Szalavitz, 2017; van der Kolk, 2015), social work has yet to fully engage in this work. This seems at odds with the previously reviewed histories of settlement house, COS, and social group workers who engaged the arts throughout the history of the profession. Of particular note in these histories is how social workers engaged the arts at group and community levels. Current social worker–artists and artist–social workers might consider these practices and apply them to their thinking about the power of the arts to promote group and community catharsis and healing concerning trauma and related symptoms. Scaling up from the micro focus of most expressive therapies and neuroscientific work, social work has the capacity and the potential to harness the talents, strengths, and interests of social worker–artists and artist–social workers to engage the arts in their mezzo and macro practices. From this space, we imagine immense potential for healing trauma and its related symptoms at group, community, and organizational levels.

BARRIERS, RISKS, AND POSSIBILITIES

While we are confident and excited about our proposed vision that is based on years of practice, teaching, and research, we would be remiss not to address some potential barriers and risks to engaging the arts in social work practice. An author of this chapter, Travis (2019) described three major barriers that exist for integrating creative arts within the social work profession:

- Inconsistencies in how to operationalize core social work values and strategies.
- Obstacles within professional pathways and pipelines for education, research, and practice about the effective use of creative arts within all levels of social work practice.
- Challenges for the design, development, evaluation, and dissemination of the most promising creative art strategies (p. 710).

While these collective hurdles are indeed substantial, obstacles in education, research, and practice are especially profound. "Barriers remain within the existing professional pathways and pipelines of education, research, and practice for the effective use of creative arts within the social work profession" (Travis, 2019, p. 713). Informal gatekeeping processes exist, including the following:

> Funding opportunities; research support and dissemination within major social work conferences; journal expertise and cultural familiarity; course scheduling and field placement opportunities; and formal research and practice partnerships between social work, professional artists, and other disciplines that integrate creative arts with their other strategies. (p. 714)

Travis (2019) went on discuss the types of social work professionals that will help substantively move efforts forward to strengthen the creative arts infrastructure within social work, including "triple-threat" and "quadruple-threat" professionals. These social work professionals will at once be artist, practitioner, and researcher, and in some instances artist, practitioner, educator, and researcher. Utilizing these substantive skill sets within the profession will help overcome present barriers and usher in a new era of effective arts integration with social work strategies seeking "to enhance human well-being and help meet the basic human needs of all people, with particular attention to the needs and empowerment of people who are vulnerable, oppressed, and living in poverty" (National Association of Social Work [NASW], 2017).

We envision the triple-threat and quadruple-threat professionals, similar to our positions as social worker–artists and artist–social workers, as opportunities for realizing the full vision of social work, and more specifically an avenue to fully engage the arts in social work practice with individuals, groups, and communities. As we have previously detailed, there is a rich history of engaging the arts in social work practice, spanning more than 130 years. One of the greatest failings in social work in the past century has been the denial of this history and an ever-increasing move toward positivist and empirical approaches to practice, approaches that encourage separation from ourselves as poets, dancers, musicians, painters, dramatists, actors, and filmmakers.

Flexner's (1915/2001) perspective on social work, the ensuing race to professionalize, and all our efforts to keep up with medical and behavioral health fields over the last more than 100 years have reverberated throughout the profession, forcing practitioners, educators, and researchers to seek validation of our field solely from the scientific world and all but forgetting about the potential for and possibilities of the arts. This, in addition to a false dichotomy between art and science, has led practitioners to rarely consider art as a means of engagement, let alone consider their own talents, strengths, and interests

in the arts as applicable and/or appropriate to bring into their practice. Leavy (2015) and others have written extensively about the overlap between arts and science and the shared core desire of both groups to "discover, explore, and illuminate" (p. 302). It is time to include art in social work practice and align the profession to a more balanced space that respects art and science for their potential to inform social work practice.

CONCLUSION

While barriers and risks to engaging the arts in social work practice exist, we believe the opportunities and possibilities far outweigh them. There is much opportunity for substantive progress. Social work has intentionally set a course as a profession that is concerned with not only clients seeking to enhance individual and family well-being, but also communities and populations seeking to materially improve their social conditions. As we have discussed in this chapter, social worker–artists and artist–social workers have engaged the arts in practice with individuals, groups, and communities throughout the history of the profession. Now is the time to fully merge the two fields for the greater good of society. Social work professionals who are sensitive to these concerns use creative arts and are working to intervene on behalf of positive change at the micro, meso, and macro levels. Social work has the opportunity to seize on these pathways to substantiate change at every facet of practice, push back on existing barriers that inhibit arts integration to practice, and develop a new professional infrastructure that builds on the unique benefits of arts integration for individual and family well-being, a stronger social fabric, and a just society. Sam Cook released "A Change Is Gonna Come" in 1964. Today, we need change again as unjust social practices, a pandemic, and polarizing political systems disrupt these desired outcomes. Art has potential for the practitioner and the client to work within this unrest and bring us to a better society where art and social work are not separate but united in transforming society for the betterment of all.

REFERENCES

Addams, J. (1910). *Twenty years at Hull House*. Macmillan.
Alliance for California Traditional Arts (ACTA). (2011). Briefing: Weaving traditional arts into the fabric of community health. https://www.actaonline.org/wp-content/uploads/2019/06/Healthy-Study.pdf
Alliance for California Traditional Arts (ACTA). (2017). Building healthy communities: Approaching community health through heritage and culture in Boyle Heights. https://www.actaonline.org/wp-content/uploads/2019/06/BH-Cultural-Report-2017.pdf

Beltrán, R., & Begun, S. (2014). "It is medicine": Narratives of healing from the Aotearoa Digital Storytelling as Indigenous Media Project (ADSIMP). *Psychology and Developing Societies, 26*(2), 155–179. https://doi.org/10.1177%2F09713 33614549137

Bos. E. (2018). Why are arts-based interventions useful in social work practice? In E. Bos & E. Huss (Eds.), *Art in social work practice* (pp. 7–17). Taylor and Francis.

Cabot, R. (1914). *Social service and the art of healing*. Moffat, Yard and Company.

Cabot, R. (1919). *Social work: Essays on the meeting ground of doctor and social worker*. Houghton Mifflin.

Carlton-LaNey, I., Hamilton, J., Ruiz, D., & Alexander, S. (2001). "Sitting with the sick": African American women's philanthropy. *Affilia, 16*(1), 447–466. https://doi.org/10.1177%2F08861090122094361

Carroll, J., & Minkler, M. (2008). Freire's message for social workers. *Journal of Community Practice, 8*(1), 21–36. https://doi.org/10.1300/J125v08n01_02

Chamberlayne, P., & Smith, M. (Eds.). (2019). *Art, creativity and imagination in social work practices*. Routledge.

Chambers, C. A. (1971). *Paul U. Kellogg and the "Survey": Voices for social welfare and social justice*. University of Minnesota Press.

Chambon, A. (2012). Disciplinary borders and borrowings: Social work knowledge and its social reach, a historical perspective. *Social Work & Society, 10*(2), 1–12. https://ejournals.bib.uni-wuppertal.de/index.php/sws/article/view/348/700

DeCarlo, A., & Hockman, E. (2003). RAP therapy: A group work intervention method for urban adolescents. *Social Work With Groups, 26*(3), 45–59. https://doi.org/10.1300/J009v26n03_06

Ehrenreich, B. (2006). *Dancing in the streets: A history of collective joy*. Holt Paperbacks.

El Centro de la Raza. (2021). Home page. https://www.elcentrodelaraza.org/

Ellis, T. (2020). *Poetry and youth adjudicated for illegal sexual behaviors: A mixed methods study* (28153491) [Doctoral dissertation, University of Alabama]. ProQuest Dissertations Publishing. http://ir.ua.edu/handle/123456789/7645

Ellis, T. (2021, February 10). *Quilts from tattered rags: A story of resilience*. Live performance at the Dr. Ethel H. Hall African American Heritage Month Colloquium, Tuscaloosa, AL. https://www.youtube.com/watch?v=WLTs-lXooNk

Ellis, T., Li, Q., Bertram, J. M., Meadows, J. T., Ozturk, B., & Nelson-Gardell, D. (2020). Poetry authored by vulnerable populations as secondary data: Methodological approach and considerations. *The Journal of Poetry Therapy, 33*(4), 213–225. https://doi.org/10.1080/08893675.2020.1803614

Flexner, A. (1915/2001). Is social work a profession? In *National Conference of Charities and Corrections, Proceedings of the National Conference of Charities and Corrections at the Forty-second annual session held in Baltimore, Maryland, May 12–19, 1915*. Hildmann.

Foronda, C. (2019). A theory of cultural humility. *Journal of Transcultural Nursing, 31*(1), 7–12. https://doi.org/10.1177%2F1043659619875184

Foronda, C., Baptiste, D. L., Reinholdt, M. M., & Ousman, K. (2016). Cultural humility: A concept analysis. *Journal of Transcultural Nursing, 27*(3), 210–217. https://doi.org/10.1177%2F1043659615592677

Freire, P. (1970). *Pedagogy of the oppressed* (M. Ramos, Trans.). Bloomsbury Press.

Gitterman, A., Knight, C., & Germaine, C. B. (2021). *The life model of social work practice: Advances in theory and practice* (4th ed.). Columbia University Press.

Gonzalez, M. (2020). *Chican@ Artivistas: Music, community, and transborder tactics in East Los Angeles*. University of Texas Press.

Graham, G. (2018). Art, therapy, and design. *The Monist*, *101*(1), 59–70. https://doi.org/10.1093/monist/onx036

Hine, L. (1980). Social photography. How the camera may help in the social uplift. In A. Trachtenberg (Ed.) *Classic essays on photography* (2nd printing, pp. 125–132). Chicago, IL: Leete's Island Books. (Reprint from Hine, L. (1909). Social photography. How the camera may help in the social uplift. Proceedings, National Conference of Charities and Corrections.)

Hull House Association. (n.d). *Bowen Country Club* [Flyers, postcards, and other promotional materials]. Hull House Collection Records (Folder 321). University of Illinois at Chicago Daley Library Special Collections.

Hull House Publishers. (1907). *Hull-house yearbook: September 1, 1906–September 1, 1907* [Annual report]. Hull House Collection Records (Folder 434). University of Illinois at Chicago Daley Library Special Collections.

Hull House Publishers. (1910). *Hull-House yearbook: May 1, 1910* [Annual report]. Hull House Collection Records (Folder 435). University of Illinois at Chicago Daley Library Special Collections.

Hull House Publishers. (1921). *Hull-House yearbook: 1921* [Annual report]. Hull House Collection Records (Folder 438). University of Illinois at Chicago Daley Library Special Collections.

Huss, E., & Sela-Amit, M. (2019). Art in social work: Do we really need it? *Research on Social Work Practice*, *29*(6), 721–726. https://doi.org/10.1177%2F1049731517745995

Jackson, S. (2000). *Lines of activity: Performance, historiography, Hull House domesticity*. University of Michigan Press.

Johansen, B. E. (2020). *Seattle's El Centro De La Raza: Dr. King's living laboratory*. Lexington Books.

Kelly, B. L. (2015). Using audio documentary to engage young people experiencing homelessness in strengths-based group work. *Social Work With Groups*, *38*(1), 68–86. https://doi.org/10.1080/01609513.2014.931665

Kelly, B. L. (2017). Music-based services for young people experiencing homelessness: Engaging strengths and creating opportunities. *Families in Society*, *98*(1), 57–68. https://doi.org/10.1606%2F1044-3894.2017.9

Kelly, B. L. (2019). Positive youth development: Developing and sustaining music-based services for young people experiencing homelessness. *Emerging Adulthood*, *7*(5), 331–342. https://doi.org/10.1177%2F2167696818777347

Kelly, B. L., & Doherty, L. (2017). A historical overview of art and music-based activities in social work with groups: Nondeliberative practice and engaging young people's strengths. *Social Work With Groups*, *40*(3), 197–201. https://doi.org/10.1080/01609513.2015.1091700

Kelly, B. L., & Doherty, L. (2016). Exploring nondeliberative practice through recreational, art, and music-based activities in social work with groups. *Social Work With Groups*, *39*(2/3), 221–233. https://doi.org/10.1080/01609513.2015.1057681

Kelly, B. L., & Fleming, J. (Eds.). (2016). Group work camp: Reflections and learning [Special issue]. *Groupwork*, *26*(3), 3–10. Retrieved from Loyola eCommons, Social Work: School of Social Work Faculty Publications and Other Works, http://dx.doi.org/10.1921/gpwk.v26i3.1037

Kelly, B. L., & Hunter M. J. (2016). Exploring group dynamics in activity-based group work with young people experiencing homelessness. *Social Work With Groups*, *39*(4), 307–325. https://doi.org/10.1080/01609513.2015.1061962

Kelly, B. L., & Neidorf, J. (2022). Teaching artists' adaptability in group-based music education residencies. *Social Work With Groups*, 45(3–4), 228–243. https://doi.org/10.1080/01609513.2021.1896165

Kellogg, P. (1912). The spread of the survey idea. *Proceedings of the Academy of Political Science in the City of New York*, 2(4), 1–17.

Lanza, C. (2016a). "Truth plus publicity": Paul U. Kellogg and hybrid practice, 1902–1937. University of Washington.

Lanza, C. (2016b). carrielanza.net

Lausevic, M. (2015). *Balkan fascination: Creating an alternative music culture in America*. Oxford University Press.

Lawrence, R. L. (2012). Transformative learning through artistic expression. In E. Taylor & P. Cranton (Eds.), *The Handbook of Transformative Learning* (pp. 471–484). Jossey-Bass.

Leavy, P. (2015). *Method meets art: Arts-based research practice* (2nd ed.). Guilford Publications.

Levy, I., & Travis, R. (2020). The critical cycle of mixtape creation: Reducing stress via three different group counseling styles. *Journal for Specialists in Group Work*, 45(4), 307–330.

Malchiodi, C. A. (Ed.). (2013). *Expressive therapies*. Guilford Publications.

Malchiodi, C. A. (2020). *Trauma and expressive arts therapy: Brain, body, and imagination in the healing process*. Guilford Publications.

National Association of Social Workers (NASW). (2017). *Code of ethics of the National Association of Social Workers*.

Nissen, L. B. (2019). Art and social work: History and collaborative possibilities for interdisciplinary synergy. *Research on Social Work Practice*, 29(6), 698–707. https://doi.org/10.1177%2F1049731517733804

O'Leary, P., Tsui, M. S., & Ruch, G. (2013). The boundaries of the social work relationship revisited: Towards a connected, inclusive and dynamic conceptualisation. *British Journal of Social Work*, 43(1), 135–153. https://doi.org/10.1093/bjsw/bcr181

Payette, J. (2018). Eleanor Smith's operettas for children. In R. L. Schultz, G. Cassano, & J. Payette (Eds.), *Eleanor Smith's Hull-House songs: The music of protest and hope in Jane Addams's Chicago* (pp. 95–136). Brill.

Perry, B. D., & Szalavitz, M. (2017). *The boy who was raised as a dog: And other stories from a child psychiatrist's notebook* (2nd ed.). Basic Books.

Pon, G. (2009). Cultural competency as new racism: An ontology of forgetting. *Journal of Progressive Human Services*, 20(1), 59–71. https://doi.org/10.1080/10428230902871173

Ramirez, P. C., & Jimenez-Silva, M. (2015). The intersectionality of culturally responsive teaching and performance poetry: Validating secondary Latino youth and their community. *Multicultural Perspectives*, 17(2), 87–92. https://doi.org/10.1080/15210960.2015.1022448

Reisch, M. (2008). From melting pot to multiculturalism: The impact of racial and ethnic diversity on social work and social justice in the USA. *British Journal of Social Work*, 38(4), 788–804. https://doi.org/10.1093/bjsw/bcn001

Richmond, M. (1917). *Social diagnosis*. Russell Sage Foundation.

Richmond, M. (1922). *What is social case work?* Russell Sage Foundation.

Ruiz, V. L. (Ed.). (2004). *Pots of promise: Mexicans and pottery at Hull-House, 1920–40*. University of Illinois Press.

Saleebey, D. (1996). The strengths perspective in social work practice: Extensions and cautions. *Social Work, 41,* 296–305. https://doi.org/10.1093/sw/41.3.296

Saleebey, D. (2012). *The strengths perspective in social work practice* (6th ed.). Pearson Higher Ed.

Shepard, B. H. (2004). Sylvia and Sylvia's children: A battle for a queer public. In M. Bernstein Sycamore (Ed.), *That's revolting! Queer strategies for resisting assimilation* (pp. 97–111). Soft Skull Press.

Shepard, B. H. (2005a). Play, creativity, and the new community organizing. *Journal of Progessive Human Services, 16*(2), 47–69.

Shepard, B. H. (2005b). The use of joyfulness as a community organizing strategy. *Peace & Change, 30*(4), 435–468. https://doi.org/10.1111/j.1468-0130.2005.00328.x

Shepard, B. H. (2008). Skipping the life fantastic in a hard city. *The Journal of Sex Research, 45*(2), 194–197. doi:10.1080/00224490802012990

Shepard, B. H. (2013). From community organization to direct services: The Street Trans Action Revolutionaries to Sylvia Rivera Law Project. *Journal of Social Service Research, 39*(1), 95–114. https://doi.org/10.1080/01488376.2012.727669

Shepard, B. H., Bogad, L. M., & Duncombe, S. (2008). Performing vs. the insurmountable: Theatrics, activism, and social movements. *Liminalities: A Journal of Performance Studies, 4*(3), 1–30.

Smolker D. S., & Lanza C. (2011) Socially conscious design in the Information Age: The practice of an architecture for humanity. In S. E. Sutton & S. P. Kemp (Eds.), *The paradox of urban space: Inequality and transformation in marginalized communities* (pp. 241–257). Palgrave Macmillan.

Stange, M. (1989). *Symbols of ideal life: Social documentary photography in America 1890–1950.* Cambridge University Press.

Stankiewicz, M. A. (1989). Art at Hull House, 1889–1901: Jane Addams and Ellen GatesStarr. *Woman's Art Journal, 10*(1), 35–39. https://doi.org/10.2307/1358128

Strauss, A. and Corbin, J. (1998). *Basics of qualitative research techniques.* Sage Publications.

Sutton, S., & Kemp, S. P. (2011). Place: A site of individual and collective transformation. In S. E. Sutton & S. P. Kemp (Eds.), *The paradox of urban space: Inequality and transformation in marginalized communities* (pp. 13–28). Palgrave Macmillan.

Szto, P. (2008). Documentary photography in American social welfare history: 1897–1943. *Journal of Sociology & Social Welfare, 35*(2), 91–110. https://scholarworks.wmich.edu/jssw/vol35/iss2/6

Tervalon, M., & Murray-Garcia, J. (1998). Cultural humility versus cultural competence: A critical distinction in defining physician training outcomes in multicultural education. *Journal of Health Care for the Poor and Underserved, 9*(2), 117–125. https://doi.org/10.1353/hpu.2010.0233

Travis, R. (2019). All awareness and no action: Can social work leverage creative arts' potential? *Research on Social Work Practice, 29*(6), 708–720. https://doi.org/10.1177%2F1049731517735178

Travis, R. (2021). *FlowStoryATX.* Mixcloud. https://www.mixcloud.com/raphael-travis/

Travis, R., & Deepak, A. (2011) Empowerment in context: Lessons from hip hop culture for social work practice. *Journal of Ethnic & Cultural Diversity in Social Work, 20*(3), 203–222. https://doi.org/10.1080/15313204.2011.594993

Travis, R., Gann, E., Crooke, A. H., & Jenkins, S. M. (2021). Using therapeutic beat making and lyrics for empowerment. *Journal of Social Work, 21*(3), 551–574. https://doi.org/10.1177%2F1468017320911346

Travis, R., Gann, E., Crooke, A. H., & Jenkins, S. M. (2019). Hip Hop, empowerment, and therapeutic beat-making: Potential solutions for summer learning loss, depression, and anxiety in youth. *Journal of Human Behavior in the Social Environment*, 29(6), 744–765. https://doi.org/10.1080/10911359.2019.1607646

Travis, R., & Leech, T. G. J. (2014). Empowerment-based positive youth development: A new understanding of healthy development for African American youth. *Journal of Research on Adolescence*, 24(1), 93–116. https://doi.org/10.1111/jora.12062

Travis, R., Rodwin, A. H., & Allcorn, A. (2019). Hip hop, empowerment, and clinical practice for homeless adults with severe mental illness. *Social Work With Groups*, 42(2), 83–100. https://doi.org/10.1080/01609513.2018.1486776

Tuck, E., & Yang, K. W. (2012). Decolonization is not a metaphor. *Decolonization: Indigeneity, Education & Society*, 1(1), 1–40.

Tyson, E. H. (2012). Hip-hop healing: Rap music in grief therapy with an African American adolescent male. In S. Hadley & G. Yancy (Eds.), *Therapeutic uses of rap and hip-hop* (pp. 293–305). Routledge/Taylor & Francis Group.

van der Kolk, B. A. (2015). *The body keeps the score: Brain, mind, and body in the healing of trauma*. Penguin Books.

Walters, K. L., Beltran, R., Huh, D., & Evans-Campbell, T. (2010). Dis-placement and dis-ease: Land, place, and health among American Indians and Alaska Natives. In L. M. Burton, S. P. Kemp, S. A. Matthews, & D. T. Takeuchi (Eds.), *Communities, neighborhoods, and health (social disparities in health and health care)* (pp. 163–199). Springer New York.

Walters, K. L., & Simoni, J. M. (2002). Reconceptualizing Native women's health: An "indigenist" stress-coping model. *American Journal of Public Health*, 92(4), 520–524. https://doi.org/10.2105/AJPH.92.4.520

Weick, A., Rapp, C., Sullivan, W., & Kisthardt, W. (1989). A strengths perspective for social work practice. *Social Work*, 34(4), 350–354. https://www.jstor.org/stable/23715838

Wilson, S. (2001). What is an indigenous research methodology? *Canadian Journal of Native Education*, 25(2), 175–179.

Windchief, S., Polacek, C., Munson, M., Ulrich, M., & Cummins, J. D. (2018). In reciprocity: Responses to critiques of Indigenous methodologies. *Qualitative Inquiry*, 24(8), 532–542. https://doi.org/10.1177%2F1077800417743527

Yoshihama, M., & Tolman, R. M. (2015). Using interactive theater to create socioculturally relevant community-based intimate partner violence prevention. *American Journal of Community Psychology*, 55(1–2), 136–147. https://doi.org/10.1007/s10464-014-9700-0

12
Building and Repairing Through the Arts

NESRIEN ABU GHAZALEH, OSVALDO HEREDIA,
AND ELTJE BOS

POSITIVE PSYCHOLOGY AND THE ARTS

This chapter explores the interrelationship between the arts and the practice of positive psychology. Positive psychology, unlike traditional psychological deficit-based theories, seeks to uncover characterological strengths and foster meaningful behavioral change beyond mere survival toward resilience and thriving. We consider how traditional and positive psychology theories are intertwined; address the ambiguities that come with this synthesis; and illustrate how creative therapy is connected to both these practice perspectives.

We are particularly interested in the role of positive psychology and the arts as they relate to concepts of resilience and strength in the professions and everyday life. In social work and other health and helping professions, the self-care movement is flourishing because of growing awareness of the impacts of secondary trauma and compassion fatigue and, post-2020, to address the emotional exigencies of the coronavirus pandemic (Adams et al., 2006; J. Miller & Grise-Owens, 2020). Self-care and the pursuit of well-being have also become increasingly prominent in popular media and professional literature (Miller & Grise-Owens, 2020; Rashid & Baddar, 2019).

Traditional psychological theory reasons that people seek help when feeling bad, and treatment is sought when negative emotions and behaviors override functionality. Interventions by social workers, psychologists, and psychiatrists utilize a wide variety of theories to diagnose the problem and then apply techniques to help individuals adapt and change. The focus

is typically on repairing what is wrong, releasing the negative and replacing it with healthy coping skills. When treatment is successful, the disruption of negative emotions lessens and no longer interferes with people's functioning and/or individuals have acquired tools to better handle them.

We observe, however, that in current times, it is not only those at risk of experiencing diagnosable distress who can benefit from a positive psychology framework. We contend that many people actively seek happiness and want to increase their well-being, strengthen their resilience, and avert unnecessary distress.

We begin this chapter with describing tenets of positive psychology theory, its treatments, and research. We then elaborate on the role of art and how its implementation both therapeutically and as a mindful practice serve to decrease negative emotions and increase positive emotions, serving as methods of both intervention and prevention. Examples of the use of the arts in both these aspects are offered. The chapter concludes with a summary supporting the use of the arts from the perspective of positive psychology as a way of enhancing peoples' well-being or "happiness."

POSITIVE PSYCHOLOGY THEORY

Positive psychology is about studying positive emotions and positive characteristics as well as attributes of positive institutions and communities (Wilkinson & Chilton, 2013). It began as the study of how human beings harness inherent strengths and resilience to address life's adversities (Seligman & Csikszentmihalyi, 2000). Martin Seligman is often cited as a founding father of the field and introduced the theory of *learned helplessness* (Seligman, 1972). His idea was that if helplessness can be taught perhaps clients could also learn to be strong and resilient (Seligman & Csikszentmihalyi, 2000). Some years later, he challenged the field of psychology to shift from a deficit-focused model toward a strength-based one (Heiser, 2020).

Barbara Fredrickson, an author and researcher, contributed the *broaden-and-build theory* (1998, 2001), which proposes that positive emotions expand people's mindsets and extend their capacities to recognize and experience well-being and resilience. She further found that repeated experiences of positive emotions increase sociability and human and communal connection. Thus, people not only feel internally better but also are more open to others and more capable of positively influencing the circumstances they live in. The broaden-and-build theory further suggests that multiple, discrete positive emotions are essential for optimal functioning. As such, capacities to experience joy, interest, contentment, and love are viewed as fundamental human strengths that yield multiple interrelated benefits.

Positive emotions have intersecting impacts, including (a) broadening people's thought–action repertoires, (b) undoing lingering negative emotions, (c) fueling psychological resilience, and (d) building psychological resilience and triggering upward spirals toward enhanced emotional well-being. Furthermore, there is evidence to suggest that the experience of positive emotions affects physical health and motivation. For example, Fredrickson and colleagues' (2000) study found that positivity can undo anxiety-induced cardiovascular reactivity produced by negative emotions. Similarly, the work of Seligman and Lyubomirsky (cited in Haidt, 2006) observed that voluntary activities (e.g., sports, art projects, among others) can motivate and strengthen positive self-image, defined as the sense of being able to acquire something and the sense that one is worthy.

Like the emergence of the positive psychology movement in the late 1990s and early 21st century, the field of social work was also reconsidering its problem-saturated models of assessment and care. Dennis Saleebey (2009), among other social work thought leaders of the time, developed the strengths perspective, which placed the person/client at the center of care and resilience as the foundation of intervention. The strengths perspective emphasized agency, capacity, competency, possibility, and hope as key concepts contributing to personal empowerment, growth, and connection to society, groups, or community (Froh et al., 2014; Huss & Bos 2019; Saleebey, 2009). In the strengths perspective, empowerment is drawn from not only within the individual but also connection to the community and cultural and personal narratives, the art of storytelling, which supports human sustenance. Such empowerment encourages openness to others; people generally feel better and more capable to influence the circumstances they live in.

It is of course understandable that the fields of psychology and social work have concentrated on healing mental and moral distress and repairing the damage done in the lives of many people so that they are able to optimally function in society (Seligman & Csikszentmihalyi, 2000). However, in recent times interest in human well-being writ large has broadened. Aims of positive psychology are being viewed as not only beneficial to people who experience distress but also those who desire to improve the quality of their lives. This is in line with positive psychology's approach and its focus on augmenting human strengths (Seligman, 2011). Attention has shifted from focusing only on repairing what is wrong in life to also building on what is strong (positive qualities). This turn in perspective is consistent with Seligman and Csikszentmihalyi's (2000) reminder "that psychology is not just the study of pathology, weakness, and damage; it is also the study of strength and virtue" (p. 7). In the next section, we look at the intersection and mutual benefits of synthesizing positive psychology approaches with traditional psychological and social work practices.

POSITIVE PSYCHOLOGY AND TRADITIONAL PSYCHOLOGY: THE INTERSECTIONS

William James (1907) was among the first to introduce the concept of "positive psychology" and was considered by some to be America's first practicing positive psychologist with his writings on "healthy mindedness" (Gable & Haidt, 2005; Taylor, 2001). In his article, *The Energies of Men* (1907), James calls for the founding of a new field of psychology that would study the underlying principles of the success of mind cure. It wasn't until the 2000s that more and more psychologists began studying healthy mind themes. Many of them were part of the evolving new field of "positive psychology" (Gable & Haidt, 2005; Pawelski, 2003; Taylor, 2001).

In the 1980s, similar to James's work, Abraham Maslow focused attention on people's positive potential. Known for his theories of motivation, self-actualization, and categorization of essential human needs, Maslow questioned whether the field of psychology could have an accurate understanding of human potential without attention to what people can achieve when the focus is on their capabilities, virtues, achievable aspirations, and full psychological height (Maslow, 1987). The early 21st-century has seen growing support for the positive psychology movement. The shift from a deficit model to one emphasizing human resilience is captured in Gable and Haidt's (2005) comment: "Psychology was said to be learning how to bring people up from negative eight to zero but not as good at understanding how people rise from zero to positive eight" (p. 103).

Yet, a positive psychology approach does not deny the existence of emotional distress, individual and group trauma, and mental illness, it does not intend to erase the benefits of traditional psychology approaches to human suffering. Approaching negative emotions and trauma exclusively from a positive psychology perspective is insufficient and can inadvertently imply denial or dismissal of an individual's experience of pain and take away their opportunity to express that pain from their perspective and in their voice. Held (2004) wrote about the unintended consequences of positivity exclusivity:

> The tyranny of the positive attitude lies in its adding insult to injury: If people feel bad about life's many difficulties and they cannot manage to transcend their pain no matter how hard they try (to learn optimism), they could end up feeling even worse; they could feel guilty or defective for not having the right (positive) attitude, in addition to whatever was ailing them in the first place. (p. 12)

Held (2004) further noted that using positive or strengths perspectives alone may not have the desired outcomes of reducing depressive or other disruptive symptoms. Rather, she contended that people experiencing significant

psychological distress or illness "need to be freed from severe emotional distress symptoms" (Held, 2004, p. 12).

We argue that a synthesis of positive and traditional psychology lends to an enhanced understanding of how to address the exigencies of trauma and other mental health diagnoses and conditions. Repairing and healing from emotional pain and suffering and rebuilding strength and resilience are both needed: People who have experienced trauma, illness, or adverse circumstances deserve to both heal and flourish (Ghielen et al., 2018). People are more than their trauma, however, and focus on the possibilities (and thus peoples' well-being) that need to be taken into account: "Everyone wants to be happy, not just have less misery" (Ginwright, 2018, p. 26).

Building what is strong from a positive psychology perspective improves understanding of factors that build strengths; outlines the contexts of resilience, determines the role of positive experiences, and explains the function of positive relationships with others. According to Heiser (2020): "Positive psychology theories of meaning, post-traumatic growth, hope, and optimism, when integrated with trauma-informed (see Levenson, 2017) and cognitive behavioral art therapy approaches, offer a unique perspective of the potential for flourishing after trauma" (Rosal, 2018, p. 11).

The importance of healing what is wrong is critical. Working with and acknowledging the value of approaches in conjunction with positive psychology is essential. Interventions integrating character strengths, virtues, and personal empowerment can be used by traditional practitioners as part of the healing process, especially when treating trauma, depression, or other negative life circumstances (Gable & Haidt, 2005; Held, 2004). Such interventions expand the scope of care addressing suffering and balancing it with recognition of the potential to increase levels of happiness and civic engagement (Gable & Haidt, 2005). Barbara Held (2004) expressed the synthesis of positive and traditional psychology well, explaining that clients benefit when traditional psychologists study what is wrong with us, they do so in the positive hope of healing that person for overall better life and living circumstances.

So, what are some approaches that best synthesize positive and traditional psychological approaches? Examples of methodologies that explicitly combine repairing what is wrong and building what is strong are narrative exposure treatment (NET) and positive cognitive behavioral therapy (PCBT), both of which view case conceptualization as essential. The beauty of case conceptualization is its engagement with the client in defining and guiding the healing process. It begins from a position of mutuality and fosters empowerment. According to Kuyken et al. (2009):

> Case conceptualization is a process whereby therapist and client work collaboratively to describe and then to explain the issues a client presents in therapy. Its

primary function is to guide therapy in order to relieve client distress and build resilience. (p. 3)

Common therapeutic goals of NET and PCBT include alleviating problems and building resilience; both approaches illuminate clients' problems, while simultaneously identifying and promoting their strengths and virtues.

Narrative exposure treatment is a short-term, evidence-based therapy directed to the treatment of post-traumatic stress disorders (PTSDs) that originated in the treatment of refugees with multiple and severe traumas living in unstable conditions and war zones. NET is supported by two important therapeutic pillars: exposure and "testimony" therapies, both of which work with clients to reconstruct their lived stories. Particular attention is given to not minimizing the trauma but at the same time not neglecting or forgetting the pleasant, well-functioning parts of an individual's life. The testimonial aspect of NET ensures that the person can describe their whole life, both bad and good, and accept its complexities, uncertainties, and beauty.

Positive cognitive behavioral therapy is sometimes perceived as the reverse of traditional cognitive behavioral therapies (CBTs), which tends to be directed to identifying and remediating clients' problems, limitations, and shortcomings (Bannink, 2014). Sometimes referred to as the fourth generation of CBT, PCBT is competency based, bringing together the best elements of change- and meaning-oriented therapeutic currents. Therapeutic goals of PCBT similarly include not only problem alleviation but also a significant focus on building client resilience. Both NET and PCBT illuminate clients' problems while not losing sight of the import of identifying and emphasizing their strengths and virtue.

Other therapies that use elements of positive psychology are imagery (Beck, 1967), compassion-focused therapy (Gilbert, 2010); dialectical behavior therapy (Linehan et al., 1999); well-being therapy (Fava, 2016); motivational interviewing (W. R. Miller & Rollnick, 2012); acceptance and commitment therapy (Hayes & Strosahl, 2005); eye movement desensitization and reprocessing (Shapiro & Forrest, 2001); and schema-focused therapy (Young et al., 1994). It is beyond the scope of this chapter to describe each of these therapeutic approaches. We suggest, however, that these methodologies either alone or in combination address the symptomatic and behavioral aspects of trauma and mental illness while simultaneously embracing positivity and hope.

In the next sections, we elaborate on the role of the arts in positive and traditional psychology perspectives.

WHY THE ARTS
Impact on the brain

Over the last several decades, a growing body of research has investigated the interplay of arts activities and the brain, most notably the parts of the brain responsible for emotion and reactivity (e.g., brainstem, amygdala, and the prefrontal cortex) (Scherder, 2015; Sloboda & Juslin, 2010). According to Gabrielsson (2010), developments in neuroscience and brain research have been instrumental in advancing understanding of how the brain interprets and integrates music. We know that certain melodies and lyrics can evoke strong physical reactions, such as chills, goosebumps, shivers, as well as auditory, tactile, and visual perceptions and a changed experience of body–mind, time–space, and part–whole (Gabrielsson, 2010). Benefits cited when people engage in enjoyable arts activities include improvements in academic performance, creativity, and overall positivity, including a sense of well-being (Belfiore & Bennett, 2010; Matarasso, 1997; McCarthy et al., 2004; Scherder, 2015).

Juslin and Sloboda (2010) used a multidisciplinary approach to better understand the interrelationship specifically between music and the brain, seeking input from experts in neurobiology, (social) psychology, sociology, and political science and across settings and methods, for example in therapeutic contexts, community activities, political action, and marketing. They found that playing music and/or observing or performing art stimulates certain brainstem reflexes, and an interplay of brain parts that constitute the reward system, such as the amygdala, prefrontal cortex, hippocampus, and hypothalamus, providing pleasure and setting a pattern of input and reward that people want to re-experience (Berridge & Kringelbach, 2015; Juslin & Sloboda, 2010; Scherder, 2015). Also observed was the variability of people's reactions to music. As Gabrielsson (2011) noted, listening to music involves a complex interplay of individual and situational factors. Exactly how this is connected to brain functions is subject of further research (Kučikienė & Praninskienė 2018; Salimpoor et al., 2013).

Beyond the word

It is often assumed that cognition is grounded in symbols that are stored in separate centers in the brain. A contrasting view is the embodied view of cognition, which proposes that cognition is grounded in the body and its interaction with the environment. This means that, for example, creating certain simulations (concepts) might increase efficiencies of the desired output through sensory motor experiences. Thus, creating concepts through artforms that go beyond the spoken word enables the construction of symbols

for perceptual patterns (Springborg & Ladkin, 2018). They generate opportunities to perceive the nonmeasurable, the contradictory, and that which goes beyond one's identity and known structures (Chamberlayne & Smith, 2019). According to Springborg and Ladkin (2018): "Art objects can embody more complex sensory experiences and sensory experiences, which cannot be represented through any single word—or any simple combinations of words" (p. 536).

Various groups can benefit from using nonverbal art forms. For those who have lived through trauma, the arts can express what cannot be said. In addition, those who struggle with complex linear discursivity of verbal interaction, such as people with cognitive disabilities, psychiatric conditions, or dementias, can benefit from nonverbal expressive art options to convey feelings and opinions and foster their creativity (See Chapter 4 by Lori Power). Another group where nonverbal expression serves as a critical method of communication involves recently arrived migrants and refugees who do not have command of the language in the country of arrival. Of course, artforms of all kinds can be used by children to express what they cannot put into words. Cohen Konrad (2019) observed that children benefit from art expression because it permits them to be the authors of their own stories rather than having adults exclusively interpret their narratives.

Along with these specific populations, service users across settings may find it difficult to communicate effectively with their providers. Health literacy or the capacity for individuals to understand and process health information necessary to decision-making is an oft-ignored issue. This is especially true for those from other nations whose primary language is not of the country where healthcare is being delivered and who have differential concepts of health and healthcare. Language used by providers such as social workers or psychologists often consists of jargon and complex description. It can be intimidating and lead to miscommunication and misunderstanding. Visual art forms such as drawing and photography, among others, can positively bridge the communication gap between service users/clients and providers, leading to more effective care. Such nonverbal expression makes it possible for people to express feelings and ideas in multiple ways and opens the door for curiosity and conversation.

Art expression also allows space for contradictions. Perception is the process of how individuals perceive what they see and how they organize it to make sense of their environment. People can, for example, look at the same piece of art but interpret it differently. This means that when looking at an image, there is, of course, not one that represents the "truth" (Blackman & Fairey, 2007). The viewer is an active participant rather than a passive observer where perception comes to play (Duxbury, 2010). Human behavior is highly dependent on how individuals make sense of or understand reality and not of what reality itself represents (Robbins & Judge, 2015). So, for example,

subjective views of the world can be channeled through a photograph. Pictures stimulate conversation and can be used to encourage individuals to talk about their daily experiences and express their perspectives and values (Holm, 2008; Migliorini & Rania, 2017). Art provides a way of imagining and seeing the world without an objective conclusion (Duxbury, 2010).

Transitional, symbolic space

On a more abstract level, the arts offer a symbolic space that enables people and communities to retrieve and process memories and to express emotions and feelings in a nonlinear manner. It does so by disrupting automatic thinking, providing a canvas or stage for the many contradictions, ambiguities, secrets, fears, and enigmas of our lives, including those of body–mind, time–space, and part–whole. The dynamics of the safe and "as if" character of the symbolic space of play was well described in the work of Huizinga (1938/2010). He characterized play as freedom in a certain space. This space is apart from ordinary life in locality and duration and as such not laden with the difficulties of real life, a safe place to express oneself. Play asks for a certain order, and it is not connected to material interest. His ideas were used as a basis for creative and play therapy and are these days used at schools for the development and design of digital games.

In social practice, Huizinga's conceptualization is illustrated by our work in Amsterdam with participative theater (de Kreek et al., 2018) and that of Schubert and Grey (2019) with mosaics in the public space. In one situation, participative forum theater was used to help a neighborhood team of mental health and social workers find ways to manage their uneasiness with challenging clients and develop better methods for engagement. Scenes were intentionally constructed to aid workers play out difficult scenarios and imagine ways they could improve connection with their client population. The use of participative theater offered a symbolic space apart from the real world, one that allowed for unspoken or silenced issues to emerge. During the theatrical play, such an issue surfaced—workers felt unsupported by other team members, which led them to be demoralized and feel ineffective. Within the theater space, workers were able to identify better methods to address clients and ways in which they experienced a lack of support, especially in such a trying work environment. The team played out a second participatory forum theater to specifically confront how to be supportive of one another. For professional psychologists, social workers, and other helping professionals, the symbolic and transitional character of the arts serves as a relational bridge that permits them to gain a deeper understanding of their perspectives, feelings, and thoughts (Huss, 2012; Huss & Bos, 2019).

The role of the arts in "repairing what's wrong" and "building what is strong"

We've argued that engagement in the arts aids in the expression of ideas and feelings that bring about positive experiences that, when repeated over time, foster improved self-worth and more openness to one's environment writ large (Fredrickson, 1998, 2008; Haidt, 2006). Voluntary and frequent engagement in the arts also fosters positive self-image and empowers people to have a sense of control over their lives (Chemi, 2015; Darewych & Riedel Bowers, 2018; Wilkinson & Chilton, 2013). However, as noted previously, positive psychology alone may not be enough when addressing significant mental health conditions. Instead, it may be part of a multimodel and longitudinal treatment approach beginning with traditional cognitive, psychodynamic therapy among other therapies. Infusion of arts-based methods in the treatment process provides symbolic space for service users to express memories or silenced and painful experiences.

The application of a positive psychology theoretical framework in conjunction with directive and art-based therapeutic methods can be very effective in addressing adversity, negativity, and trauma. A positive outcome of intentional and scaffolded intervention enhances pride through empowerment—service users gain mastery over their healing. The use of the arts throughout the "healing" process shifts the meaning of therapeutic engagement from "repairing what's wrong" to "building what is strong."

In a pilot study with patients struggling with severe PTSD, Schouten and colleagues (2019) found that arts-based therapy benefitted participants for whom more traditional evidence-based trauma therapies were insufficient (Schouten et al., 2019). According to the researchers:

> Furthermore, patients mentioned that they were able to express their emotions and memories in art making and to share memories and emotions that they had never shared before. (p. 9)

In other instances, schema-focused group therapy, psychomotoric therapy, and/or creative therapy were combined with positive results. In another study, Farrell et al. (2014) used role-play and experiential techniques, which can also be seen as drama play, to help raise patients' awareness of basic needs they may have missed in their early lives. Using the arts integrated with other forms of therapy helped clients readjust their prior understandings and make new meaning of memories and accompanying emotions.

Arts also have a complementary role when used in conjunction with established therapies such as CBT, for example, in stress inoculation training, skills

training, role playing, imagery, and modeling. To illustrate, in activity-guided CBT, knitting is a known approach (Corkhill et al., 2014). This also holds true for positive PCBT and the NET approach mentioned previously. One could argue that these activities can help individuals to imagine the future and adjust the core beliefs of self, others, and the future and contribute to a more positive cycle of feelings, thoughts, and behavior.

Ambiguities: different worlds' paradigms and hierarchy

Nationally and internationally, the arts are used, but not yet widely accepted, in the realms of social work, psychology, and other therapeutic contexts. The more philosophical nature of the arts may to some extent explain the equivocation of its use, ignoring the scientific findings about how, for example, the brain and body react to the experience of drawing, painting, or other art activities (Malchiodi, 2003). Further, most social workers and behavioral health practitioners are not made aware of or schooled in the professional application of the arts and are not familiar with the work of creative therapists. This is despite the fact that the arts are historically connected to the roots of the social work profession, particularly in community-based participatory and group work practices. In the 21st century, social work clinicians, educators, and researchers continue to have to justify inclusion of art-focused methodologies (Cohen Konrad, 2019; Huss & Sela-Amit, 2019).

In the Netherlands, the use of art in social work practice is limited and could do with some attention, such as more focus in the curricula at the schools of social work and training for social practitioners. Some universities integrate the arts in social work practice and research curriculum, although the latter is rarely put into play. Lack of arts integration may in part be because in the majority of social work programs, teachers are unfamiliar with why and how the arts can be used (Huss & Sela-Amit, 2019). Similarly, the role of the arts in therapeutic contexts is neither integrated nor fully accepted in the world of psychotherapy and psychiatry. This also holds true for the practice and the knowledge of creative/arts therapists. The implication is that their practice and body of knowledge are not aligned with that of the psychotherapists. Thus, knowledge and practice of the arts is not used to its fullest by psychologists.

Like in social work, this is partly due to the relative unfamiliarity of arts-based methods and equivocation about its utility and ethic. This is reflected in the limited financial support for the arts in health and social care programs. It is hoped the SHAPER (Scaling-up Health Arts Programmes: Implementation and Effectiveness Research, https://www.kcl.ac.uk/research/shaper) project supported by Kings College London and Denmark Hill Campus will provide

data to show the importance of art interventions. The SHAPER interdisciplinary team is made up of clinicians, research scientists, charities, artists, patients, and healthcare professionals in the U.K.'s National Health Service (NHS) and the community. SHAPER consists of three studies: Melodies for Mums, Dance for Parkinson's, and Stroke Odysseys. Eight hundred participants will shed light on arts' benefits and provide data on clinical impact, implementation, and cost-effectiveness of these practices. The researchers hope the study will help the NHS and similar bodies in other countries validate the efficacy of art-based therapeutic practices and reimburse arts-based treatment interventions (Estevaho et al., 2021).

Another factor that nurtures ambiguity about the arts is professional hierarchy. In most cultures, psychologists hold more professional status than social workers and creative therapists, the former being perceived as having greater knowledge and skill than their counterparts. Fall et al. (2000) studied attitudes of favorability between psychologists, psychiatrists, and counselors. Counselors were consistently rated lower in professional status than psychiatrists and psychologists because they were perceived as not dealing with severe patient cases, but rather with those considered as having more less-complex issues (Fall et al., 2000). By default, this hierarchical imbalance affects how arts-based methods are understood. Because the arts are more commonly used by social workers, counselors, and creative therapists, they are often devalued or seen as unscientific and unproven.

In a field that prioritizes evidence-based methodologies, the value of arts-based approaches has historically been underrecognized as they do not conform to traditional instrumentation measurement and cannot always meet the requirements or scrutiny of a randomized controlled trial or institutional review board. However, the use of arts-based methods has in fact been substantively researched (van Campen et al., 2017), and in 2017 the Dutch Scientific Research Council urged the application of other research methods to assess the efficacy of art-based interventions. In the Netherlands, researchers are promoting the use of mixed-methods studies and participatory action research (PAR) methods, which engage consumers and communities in the research design and process. Within the broad range of PAR, several variations are possible (Migchelbrink, 2007; Reason & Bradbury, 2008), but what they all have in common is that the research process is not one of proving hypotheses or "objectively" measuring intervention outcomes. Rather, it is characterized by intentional and authentic involvement of service users and providers as active participants in the research processes determining the research objects, gathering "data," and reflecting on these data, interpreting their implications and relevance to interventions. Community participants also are involved in implementation processes and the evaluation of changes during and after the research process (Migchelbrink, 2007).

SUMMARY/CONCLUSION

In this chapter, we explored the connection between the arts and the practice of positive psychology in the context of social and mental health work. We highlighted the significance of arts in these contexts as their use and integration in clinical practice still is relatively unfamiliar. We focused on the impact of arts and expressive modalities on the brain, the free symbolic space, and the many nonlinear ways it provides healthful opportunities that have a direct and positive impact. Furthermore, we elaborated on the connection between the arts and the practice of positive psychology in social and mental health work, exploring the synergism and interrelationship between positive and traditional psychology.

Consequently, we recognized a deep intertwining between approaches that intend to heal what needs to be healed (belonging to the field of traditional psychology) and approaches that intend to build what is strong (an approach connected to positive psychology). We also highlighted how art-based interventions can be beneficial in both approaches. As a result, we feel the acceptance of an integrated and complementary view of traditional and positive psychology paradigms using art-based practices and how together they benefit a range of service users/clients for both healing from trauma and building resilience and hope.

To our knowledge, there is still a lack of use of the arts in social work curricula, as well as in the context of the training of mental health workers. We believe this is partly due to educators/trainers being unfamiliar with these methods and thus cautious about teaching art-based approaches. From a sociological standpoint, we suggest this might also be a consequence of ingrained hierarchies and differences in social statuses of psychiatrists, psychologists, social workers, and art therapists, which prove an impediment to adopting research findings generated by these fields. Last, lack of reimbursement or disparity of payment for art-based therapeutic approaches, in some countries, devalues their relevancy as compared to traditional and sanctioned evidence-based methods.

Consistent with our commitment to strengths, resilience, and hopefulness, we'd like to end the chapter on a positive note. We've observed a proliferation of literature throughout behavioral health and healthcare journals highlighting the benefits and, in some cases, necessity of arts-based methodologies. Equally apparent, especially since the 2020 pandemic, is renewed interest in resilience, in terms of not only inherent qualities but also in view of systemic support of infusing self-care and other supportive measures across a range of settings, including schools and health settings, among others. According to Strom-Gottfried and Mowbray (2006), crisis can galvanize creativity to the betterment of both ourselves and the health of the community. What does this tell us? Our hope is that growing appreciation for and validation of the

emotional benefits of the arts will lead to its acceptance and implementation across mental health fields of practice and a theoretical integration of tenets of positive psychology focused on resilience, healing, and improving lives across the spectrum of care.

REFERENCES

Adams, R. E., Boscarino, J. A., & Figley, C. R. (2006). Compassion fatigue and psychological distress among social workers: A validation study. *American Journal of Orthopsychiatry*, 76(1), 103–108. https://doi.org/10.1037/0002-9432.76.1.103

Bannink, F. P. (2014). Positive CBT: From reducing distress to building success. *Journal of Contemporary Psychotherapy*, 44(1), 1–8. https://doi.org/10.1007/s10879-013-9239-7

Beck, A. T. (1967). *Depression: Clinical, experimental, and theoretical aspects*. Harper & Row.

Belfiore, E., & Bennett, O. (2010). *The social impact of the arts*. Palgrave McMillan. https://doi.org/10.1057/9780230227774

Berridge, K. C., & Kringelbach, M. L. (2015). Pleasure systems in the brain. *Neuron*, 86(3), 646–664. https://doi.org/10.1016/j.neuron.2015.02.018

Blackman, A., & Fairey, T. (2007). *The photovoice manual: A guide to designing and running participatory photography projects*. Photo Voice Publications.

Chamberlayne, P., & Smith, M. (Eds.). (2019). *Art, creativity and imagination in social work practices*. Routledge.

Chemi, T. (2015). Learning through the arts in Denmark: A positive psychology qualitative approach. *Journal for Learning through the Arts*, 11(1), 1–15. https://doi.org/10.21977/D911115962

Cohen Konrad, S. (2019). *Child and family practice: A relational perspective* (2nd ed.). Oxford University Press.

Corkhill, B., Hemmings, J., Maddock, A., & Riley, J. (2014). Knitting and well-being. *Textile*, 12(1), 34–57. https://doi.org/10.2752/175183514x13916051793433

Darewych, O. H., & Riedel Bowers, N. (2018). Positive arts interventions: Creative clinical tools promoting psychological well-being. *International Journal of Art Therapy*, 23(2), 62–69. https://doi.org/10.1080/17454832.2017.1378241

De Kreek, M., von Salisch, M., & Bos, E. (2018). Transformatief leren via participatief theater. In P. van Heijst (Ed.), *Arts based research voor het sociaal domein* (pp. 91–110). Coutinho.

Duxbury, L. (2010). A change in the climate: New interpretations and perceptions of climate change through artistic interventions and representations. *Weather, Climate, and Society*, 2(4), 294–299. https://doi.org/10.1175/2010WCAS1053.1

Estevao, C., Fancourt, D., Dazzan, P., Chaudhuri, K. R., Sevdalis, N., Woods, A., Crane, N., Bind, R., Sawyer, K., Rebecchini, L., Hazelgrove, K., Manoharan, M., Burton, A., Dye, H., Osborn, T., Jarrett, L., Ward, N., Jones, F., Podlewska, ... Pariante, C. M. (2021). Scaling-up health-arts programmes: the largest study in the world bringing arts-based mental health interventions into a national health service. *BJPsych Bulletin*, 45(1), 32–39. https://doi.org/10.1192/bjb.2020.122

Fall, K. A., Levitov, J. E., Jennings, M., & Eberts, S. (2000). The public perception of mental health professions: An empirical examination. *Journal of Mental Health Counseling*, 22(2), 122–134.

Farrell, J, Reiss, N., & Shaw, A. (2014). *The schema therapy clinician's guide: A complete resource for building and delivering individual, group and integrated schema mode treatment programs*. Wiley-Blackwell. https://doi.org/10.1002/9781118510018

Fava, G. A. (2016). *Well-being therapy: Treatment manual and clinical applications*. Karger Medical and Scientific Publishers.

Fredrickson, B. L. (1998). What good are positive emotions? *Review of General Psychology, 2*, 300–319. https://doi.org/10.1037/1089-2680.2.3.300

Fredrickson, B. L. (2001). The role of positive emotions in positive psychology: The broaden-and-build theory of positive emotions. *American Psychologist, 56*(3), 218. https://doi.org/10.1037/0003-066X.56.3.218

Fredrickson, B. L. (2008). Promoting positive affect. In M. Eid & R. J. Larsen (Eds.), The science of subjective well-being pp. (449–468). Guilford Press.

Fredrickson, B. L., Mancuso, R. A., Branigan, C., & Tugade, M. M. (2000). The undoing effect of positive emotions. *Motivation and Emotion, 24*(4), 237–258. https://doi.org/10.1023/A:1010796329158

Froh, J., Bono, G., Emmons, R., Henderson, K., Harris, C., Leggio, H., & Wood A. (2014). Nice thinking! An educational intervention that teaches children to think gratefully. *School Psychology Review, 43*, 132–152. https://doi.org/10.1080/02796015.2014.12087440

Gable, S. L., & Haidt, J. (2005). What (and why) is positive psychology? *Review of General Psychology, 9*(2), 103–110. https://doi.org/10.1037/1089-2680.9.2.103

Gabrielsson, A. (2010). Strong experiences with music. In P. N. Juslin & J. A. Sloboda (Eds.), *Handbook of music and emotion* (pp. 547–574). Oxford University Press.

Ghielen, S. T. S., van Woerkom, M., & Christina Meyers, M. (2018). Promoting positive outcomes through strengths interventions: A literature review. *The Journal of Positive Psychology, 13*(6), 573–585. https://doi.org/10.1080/17439760.2017.1365164

Gilbert, P. (2010). An introduction to compassion focused therapy in cognitive behavior therapy. *International Journal of Cognitive Therapy, 3*(2), 97–112. https://doi.org/10.1521/ijct.2010.3.2.97

Ginwright, S. (2018). The future of healing: Shifting from trauma informed care to healing centered engagement. Medium. https://ginwright.medium.com/the-future-of-healing-shifting-from-trauma-informed-care-to-healing-centered-engagement-634f557ce69c

Haidt, J. (2006). *The happiness hypothesis*. Arrow Books.

Hayes, S. C., & Strosahl, K. D. (2005). *A practical guide to acceptance and commitment therapy*. Springer Science + Business Media.

Heiser, S. R. (2020). The art of flourishing: Integrating positive psychology with art therapy to promote growth from trauma. Master of Applied Positive Psychology (MAPP) Capstone Project: Scholarly Commons: University of Pennsylvania 2020-08-10 https://repository.upenn.edu/search?query=Heiser,%20S.%20R.%20(2020)

Held, B. S. (2004). The negative side of positive psychology. *Journal of humanistic psychology, 44*(1), 9–46. https://doi.org/10.1177/0022167803259645

Holm, G. (2008). Photography as a performance. *Forum Qualitative Sozialforschung/ Forum: Qualitative Social Research, 9*(2). https://doi.org/10.17169/fqs-9.2.394

Huizinga, J. (2010). *Homo ludens*. Amsterdam University Press. (Original work published 1938)

Huss, E. (2012). What we see and what we say: Combining visual and verbal information within social work research. *British Journal of Social Work, 42*(8), 1440–1459. https://doi.org/10.1093/bjsw/bcr155

Huss, E., & Bos, E. (2019). *Art in social work practice: Theory and practice: International perspectives*. Routledge.

Huss, E., & Sela-Amit, M. (2019). Art in social work: Do we really need it? *Research on Social Work Practice, 29*(6), 721–726. https://doi.org/10.1177/1049731517745995

James, W. (1907). The Energies of Men. *The Philosophical Review, 16*(1), 1–20

Juslin, P. N., & Sloboda, J. A. (Eds.) (2010). *Handbook of music and emotion*. Oxford University Press.

Kučikienė, D., & Praninskienė, R. (2018). The impact of music on the bioelectrical oscillations of the brain. *Acta Medica Lituanica, 25*(2), 101. https://doi.org/10.6001/actamedica.v25i2.3763

Kuyken, W., Padesky, C. A., & Dudley, R. (2009). *Collaborative case conceptualization: Working effectively with clients in cognitive-behavioral therapy*. Guilford Press.

Levenson, J. (2017). Trauma-informed social work practice. *Social Work, 62*(2), 105–113. https://doi.org/10.1093/sw/swx001

Linehan, M. M., Schmidt, H., Dimeff, L. A., Craft, J. C., Kanter, J., & Comtois, K. A. (1999). Dialectical behavior therapy for patients with borderline personality disorder and drug-dependence. *American Journal on Addictions, 8*(4), 279–292. https://doi.org/10.1080/105504999305686

Malchiodi, C. A. (2003). Art therapy and the brain. In C. A. Malchiodi (Ed.), *Handbook of art therapy* (pp. 16–24). Guilford Press.

Maslow, A. H. (1987). *Motivation and personality* (3rd ed.). Harper & Row.

Matarasso, F. (1997). Use or ornament. The social impact of participation in the arts. *Comedia, 4*(2), 1–97.

McCarthy, K. F., Ondaatje, E. H., Zakaras, L., & Brooks, A. (2004). *Gifts of the muse: Reframing the debate about the benefits of the arts*. RAND Corporation. https://doi.org/10.7249/MG218

Migchelbrink, F. (2007). *Actieonderzoek voor professionals in zorg en welzijn* [Action research for professionals in care and health sectors]. SWP.

Migliorini, L., & Rania, N. (2017). A qualitative method to "make visible" the world of intercultural relationships: The photovoice in social psychology. *Qualitative Research in Psychology, 14*(2), 131–145. https://doi.org/10.1080/14780887.2016.1263698

Miller, J., & Grise-Owens, E. (2020). Self-care: An imperative. *Social Work, 65*(1), 5–9. https://doi.org/10.1093/sw/swz049

Miller, W. R., & Rollnick, S. (2012). *Motivational interviewing: Helping people change* (2nd ed.). Guilford Press.

Pawelski, J. O. (2003). William James, positive psychology, and healthy-mindedness. *The Journal of Speculative Philosophy, 17*(1), 53–67. https://doi.org/10.1353/jsp.2003.0025

Rashid, T., & Baddar, M. K. A. H. (2019). Positive psychotherapy: Clinical and cross-cultural applications of positive psychology. In L. Lambert & N. Pasha-Zaidi (Eds.), *Positive psychology in the Middle East/North Africa* (pp. 333–362). Springer. https://doi.org/10.1007/978-3-030-13921-6_15

Reason, P., & Bradbury, H. (2008). Concluding reflections: whither action research. In L. Lambert & N. Pasha-Zaidi (Eds.), *Handbook of action research* (pp. 695–707). https://dx.doi.org/10.4135/9781848607934.n60

Robbins S. P., & Judge, A. (2015). *Organizational behavior*. Pearson.

Rosal, M. L. (2018). *Cognitive-behavioral art therapy: From behaviorism to the third wave*. Routledge.

Saleebey, D. (2009). The strengths approach to practice: Beginnings. In D. Saleebey (Ed.), *The Strengths Perspective in Social Work Practice* (5th ed., pp. 93–107). Pearson.

Saleebey, D. (2009). The strengths perspective: Possibilities and Problems. In D. Saleebey (Ed.), *The Strengths Perspective in Social Work Practice* (5th ed., pp. 281–304). Pearson.

Salimpoor, V. N., van den Bosch, I., Kovacevic, N., McIntosh, A. R., Dagher, A., & Zatorre, R. J. (2013). Interactions between the nucleus accumbens and auditory cortices predict music reward value. *Science, 340*(6129), 216–219. doi:10.1126/science.1231059. PMID: 23580531.

Scherder, E. (2015). Actieve en passieve kunstbeoefening goed voor de hersenen [Active and passive participation in the arts is beneficial for the brain]. *Boekman, 104,* 4–8. https://www.boekman.nl/wp-content/uploads/2021/08/bm104_scherder_actieve.pdf

Schouten, K. A., van Hooren, S., Knipscheer, J. W., Kleber, R. J., & Hutschemaekers, G. J. (2019). Trauma-focused art therapy in the treatment of posttraumatic stress disorder: A pilot study. *Journal of Trauma & Dissociation, 20*(1), 114–130. https://doi.org/10.1080/15299732.2018.1502712

Schubert, L., & Grey, M. (2019). Safe at home: an Australian example of arts-based community-focused practice. In E. Huss & E. Bos (Eds.), *Art in social work practice* (pp. 257–272). Routledge.

Seligman, M. E. P. (1972). Learned helplessness. *Annual Review of Medicine, 23,* 407–412.

Seligman, M. E. P. (2011). *Flourish: A visionary new understanding of happiness and well-being*. Free Press.

Seligman, M. E. P., & Csikszentmihalyi, M. (2000). Positive psychology: An introduction. *American Psychologist, 55*(1), 5–14. https://doi.org/10.1037/0003-066X.55.1.5

Shapiro, F., & Forrest, M. S. (2001). *EMDR: Eye movement desensitization and reprocessing* (2nd ed.). Guilford.

Sloboda, J. A., & Juslin, P. N. (2010). At the interface between the inner and outer world: Psychological perspectives. In P. N. Juslin & J. A. Sloboda (Eds.), *Handbook of music and emotion: Theory, research, applications* (pp. 73–97). Oxford University Press.

Springborg, C., & Ladkin, D. (2018). Realising the potential of art-based interventions in managerial learning: Embodied cognition as an explanatory theory. *Journal of Business Research, 85,* 532–539. https://doi.org/10.1016/j.jbusres.2017.10.032

Strom-Gottfried, K., & Mowbray, N. D. Who heals the helper? Facilitating the social worker's grief. *Families in Society*, 2006;87(1):9–15. https://doi.org/10.1606/1044-3894.3479

Taylor, E. (2001). Positive psychology and humanistic psychology: A reply to Seligman. *Journal of Humanistic Psychology, 41*(1), 13–29. https://doi.org/10.1177/0022167801411003

van Campen, C., Rosenboom, W., van Grinsven, S., & Smits, C. (2017). Kunst en positieve gezondheid: een overzichtsstudie van culturele interventies met mensen die langdurig zorg en ondersteuning ontvangen.

Wilkinson, R. A., & Chilton, G. (2013). Positive art therapy: Linking positive psychology to art therapy theory, practice, and research. *Art Therapy, 30*(1), 4–11. https://doi.org/10.1080/07421656.2013.757513

Young, J. E., Klosko, J. S., & Beck, A. T. (1994). *Reinventing your life: How to break free from negative life patterns and feel good again*. Penguin.

13
"When I Hold the Door for You"

MAYA WILLIAMS

INTRODUCTION

Social work invites us to work with people up close and personal instead of at a distance. The Applied Arts and Social Justice certificate offered by the University of New England social work program gave me the opportunity to use my art as a tool to have these brave conversations. The use of art, and specifically poetry, as a means to communicate aspects of social justice emphasizes my framework when sharing and writing about complex topics (Figure 13.1). For example, when sharing my poetry about survivor's guilt as a suicide survivor with the Yellow Tulip project, it led to a discussion of how many have felt the feeling of being alone and consider dying to no longer feel pain. It opened an even larger discussion about systemic changes needed to make mental health accessible for marginalized people and how access to other socioeconomic resources can lead to more positive mental health.

As I write this chapter (summer 2021), I'm in my third semester of a master of fine arts in creative writing with a focus in poetry. I'm exploring the intricacies and intersections of mental health and the ways in which systems (e.g., the prison industrial complex [PIC], racism, transphobia, classism, etc.) harm people's mental health. I am learning how you cannot separate these wider conversations from discussion of mental health; to frame it as an individualized issue is an act of victim blaming and erasure.

I truly hope folks take away a sense of honesty, vulnerability, and hope from these poems.

Maya Williams, *"When I Hold the Door for You"* In: *Social Work and the Arts*. Edited by: Shelley Cohen Konrad and Michal Sela-Amit, Oxford University Press. © Oxford University Press 2024. DOI: 10.1093/oso/9780197579541.003.0014

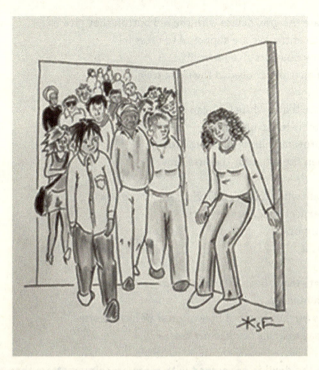

Figure 13.1 Drawing by Artist Katy Finch: When I Hold the Door Open.

VULNERABILITY AND COMMUNITY

I write about mental health and suicide because I find that writing specifically about my personal experiences builds community with others whether or not we have similar experiences. Building community happens by actively listening to vulnerability and being willing to share your own. I'm grateful to have learned this in my work with incarcerated and formerly incarcerated folks, in particular as a Black person with obsessive-compulsive disorder who is affected by the PIC even though I haven't been incarcerated. Prisons were built to fail people like me because they were built to legally continue the practices of enslaving Black people. Poetry has also helped me build community with incarcerated and formerly incarcerated people who are affected and people like me who haven't experienced incarceration but have been affected by the PIC due to a loved one being behind bars or being racially profiled by law enforcement.

>Spite
>I hate to go inside a building that was created to destroy me.
>At least I get to leave it.
>At least I get to return home.
>Not a guarantee I'll get home safely, but I still have the option.

I hate the gray device with the red button they give us
upon entry. We are supposed to press it
if any *residents* give us trouble.
We have never needed the extra weight.

I hate that a white C.O. can show up on
Bumble in his uniform.
I throw my phone across the room
when I see that for the first time.

I hate when a Black C.O. gives me eye contact
to expect solidarity from me.
I cannot
give it.

I hate that I have been mistaken
as a *resident*.
It is further proof of how often staff have desired
to say *welcome home* to my face.

I believe the devil is concerned with more pressing matters than my mental health issues

I won't deny. He sure has been the ghost writer of most of the DSM, American Psychiatric Association (2022). Transforming transness into evil corrupt contagion. Softening the blow of racism by labeling it as just an illness.

>I won't lie. A theologian once described Jesus as his favorite ex-boyfriend who checks in.

>I thought my least favorite as The Devil with his occasional unwelcome arrivals in spiritual realms.

>But he is way too busy to be the spirit that possesses my mind and body.
>The Devil has an apocalypse to plan. Filled with red-orange flames from the arrows of trusty horsemen. A supremacist army with desire for hell's manifest destiny eugenic colonial power.

>He has other curses to conjure that have zero correlation with mental illness.
>Emotions do not equate an ailment. An influence is not the same as final product.

There is a difference between the thoughts I can control and the thoughts I cannot.

Yes, continue to pray for me. If only you could pray the right one next time.

"Commit" in relation to suicide on trial

This poem is also forthcoming in *Maine Arts Journal*.

In Defense of "Commit" in Relation to Suicide

Exhibits A–F

It is a "commitment" to accountability.
It is a "commitment" to follow through.
It is a "condemnation" of one's own life.
It is a "condemnation" of the burden of breath.
It is a "call" to what those left behind do not want.
It is a "call" to an action those left behind cannot stop in time.

Verdict:
The plaintiff doesn't know the difference between criminalizing the act and criminalizing the person. To hate the sin and love the sinner.

In Offense of "Commit" in Relation to Suicide

Exhibits A–H

It compares "crime" to "truth."
It compares "doctor" to "patient."
It compares "seeking harm" to "seeking release."
It compares "contact abuser" to "contact protector."
It compares "a chance to suffocate" to "a chance to breathe."
It compares "seeking a form of hell" to "seeking a form of heaven."

Verdict
The defendant perpetuates making an insidious comparison between prison and mental illness.
Who judges to deliver the final etymology, the final lexicon, of the refusal to stay alive?

"Convince Us to Stay"*

What most people don't understand about suicidal ideation is how hella convinced we have to be to stay on this Earth. Some days, even, to *want* to stay. It's not enough to tell us that we'll burden someone if we leave, as often as we think how we'll burden someone if we stay. Ideation is the double-edged sword we never asked for. Then again, we never asked to be *alive* either.

Ideation is the pendulum that swings from one alternate universe of darkness to another. Convince us of an alternate universe of light that exists out there. With less clichés this time. With more clichés we can be proud of. With only natural prayers. With no empty prayers at all. Convince us of a better future ahead without the pressure of having to fucking think of one.

Convince us of possibilities without providing us *fucking barriers* in the same breath. Hear us. Commend us for our survival without us having to experience the threat of a disappearance in the first place. *Need us.* No, I mean, *really,* need us. Not because it'll make *you* feel better. Because it'll make *all of us* feel better. No, I mean, *really,* feel better. Like freedom of life without giving compensation for saving it after failed attempts. Like summer rains being the occasional cleanse, we desire with its liveliness within the gray. Like being so fucking present being a blessed gift in of itself; only no one has to wrap or re-wrap it for us. Mental illness unravels like a motherfucker. Convince us of the belief that we can wrap and re-wrap it *ourselves.*

> You mean to tell me we were supposed to applaud
> when *Glee* sang "What Doesn't Kill You Makes You
> Stronger"?
> When this aired
> my high school theater heart believed
>
> the act of survival was a performance
> worth applauding
>
> Who knew that to fail
> to kill yourself
>
> could be
> edgy?
>
> Make the knife a smoother cut
> of modeling, singing, and choreography

*. Originally published by the Trill Project. https://medium.com/weeklytrill/convince-us-to-stay-a-poem-5d0db614dd76

by mostly
Black women

while the "It Gets Better"
commercials display

white male
gays and allies

tell us
It gets better

Suicide
Prevention

in a show
is a commodity
to inspire
a specific demographic

not cheering
is proof we don't fit it
Judas & Suicide
So, Judas threw the silver coins into the temple and left. Then he
 went out and hanged himself.
—Matthew 27:5 NET

My grandmother thought
the women with mental illnesses in our family
were like Judas.

Judas.
Cowardly.
Betrayer of the disciples; Betrayer of Jesus.

Hanged himself not for being sorry,
but to escape blame.
Jesus died *for* our sins while Judas died *by* his.

Despite clear scripture of Judas' death
there are blurred lines in between where my grandmother
views his death as a sin, like his duplicity.

He killed Jesus
and himself.
Thou shalt not kill, right?

My cousin has bipolar disorder.
After her attempt,
my grandmother thought she was

Cowardly.
Betrayer of the family.
Betrayer of my grandmother.
Took
pills
as a way out.
I have obsessive compulsive disorder.
I mention my attempt,
my grandmother says I'm not like my cousin.

A problem child.
Always going through something;
craving her big escape.

I have it together.
Always keeping busy;
I stay away from making mistakes.

I ask,
"Are you
Sure?"

My grandmother
doesn't
understand.

She thought things were going well for me.
Why would I want to hurt
her by hurting myself like that?

We didn't think of our attempts
as a way to escape our grandmother
or our family.

We thought of our attempts
as a way for our family
to escape us.

We thought it was the most selfless gift we could give them.
Jesus taught us selflessness.
Not Judas.

ERASURES

An erasure poem is created when selected content is redacted from an original document (certain texts are blacked out or erased from the text), and the reader only reads the words left behind. I enjoy working with erasures in my poetry because it highlights for the reader the initial *intention* of a document versus the *impact* of the document. For example, the intent may be to bring joy, but the impact may be bringing sorrow to marginalized communities, such as my erasure of Janet Mills's proclamation over the holidays in 2020; the intent was to bring joy to young people, the impact was leaving out the young people who are incarcerated. Her impact is saying that there are specific youth who are not worthy of joy.

> An erasure of a proclamation exempting Santa Claus from Maine COVID travel restrictions by Maine Governor Janet T. Mills, 75th governor of Maine since January 2019

WHEREAS, the celebration of Christmas is a cherished tradition for many Maine families, anticipated with excitement and enjoyed in good years and not so good years; and

WHEREAS, as part of this tradition, St. Nicholas ("Santa Claus") annually visits the homes of Maine Children on Christmas Eve and, to the extent necessary, into the wee hours of Christmas morning, for the purpose of delivering gifts and good cheer to good little girls and boys; and

WHEREAS, the COVID-19 pandemic has caused worries among Maine children about whether Santa Claus will be able to travel this year to fulfill his jolly good duties to safely visit homes across Maine; and

WHEREAS, Dr. Anthony Fauci, Director of the National Institute of Allergy and Infectious Diseases, has traveled to the North Pole, personally vaccinated Santa Claus, and measured Santa Claus' level of immunity, determining that Santa is "good to go";

NOW, THEREFORE, I, Janet T. Mills, pursuant to the authority vested in me as Governor of the State of Maine, do hereby direct as follows:

I. **DIRECTIVE**

 A. **Travel Exemption:** Given his immunity, as confirmed by Dr. Fauci, and given the essential nature of his work to bring happiness and good cheer to children across Maine, Santa Claus is hereby declared exempt from Maine's COVID travel restrictions.

B. **Cookies and Milk; Carrots for Reindeer**: With Santa and his reindeers—Dasher, Dancer, Prancer, Vixen, Comet, Cupid, Donner, Blitzen, and Rudolph—expected to grow hungry during their long night's work, I encourage parents and children to prepare cookies and milk and carrots to sustain them during their extensive travel, being sure to wash their hands vigorously with warm water and soap prior to handling food.
C. **Social Distancing**: Even though Santa is vaccinated, it is important that all Maine children maintain appropriate physical distance so that Santa may safely go about his essential work. In this case, maintaining appropriate physical distance means children should be nestled all snug in their beds as Santa visits home to deliver the gifts.

Dated this 23rd day December 2020
Janet T. Mills
Governor

Olaf would make an excellent therapist or an erasure of the last 37 seconds of *Frozen 2*

Show yourself, right now!
be who you are.
I will Mama, I will!
Elsa's dead.
Olaf's dead.
Anna cries.
And then a bunch of important things happened that I forgot, but all that matters is I was right, and water has memory, and thus . . . I live . . . and so do you.

An erasure of the art critique essay "The Show Is Not Over" by Sinziana Ravini

I A M
 still alive
 fluid
 free
trans people
transcend
 the
eternal

An erasure of a job opening at Long Creek Youth Development Center on Indeed[†]

† Originally published in *Misery Tourism*.

Job description
This is paraprofessional support work involving the interaction, care, security, treatment, and rehabilitation of juveniles committed to a correctional facility. Responsibilities including providing direct care; modeling appropriate behavior and implementing rehabilitative, protective, treatment and behavioral health programs and services. Employee maintains security, coordinates and supervises residents daily living activities, and enforces facility rules. This classification is distinguished from traditional correctional officers in that a primary focus of this work involves the treatment, rehabilitation, and behavior modification of troubled youth. Work is performed under general supervision. This position requires exposure to chemical agent (OC Spray).

Knowledge, skills, & abilities required to perform the job successfully

> Knowledge of adolescent development and behavior.
> Knowledge of methods of providing care, custody, and control of juvenile detainees.
> Knowledge of counseling techniques.
> Knowledge of modern security principles and practices.
> Ability to communicate effectively.
> Ability to write clearly and effectively.
> Ability to prepare reports of activities.
> Ability to establish and maintain effective working relationships.
> Ability to understand and follow oral and written instructions.
> Ability to exercise independent judgment and discretion.
> Ability to observe and communicate situations and behavior in detail.
> Ability to maintain order and control juveniles individually and in groups.
> Ability to provide guidance and leadership to juveniles.
> Ability to in a negative and hostile environment.

CONTRADICTIONS AND FORGIVENESS

The National Social Work Code of Ethics (COE) discourages social workers from self-disclosure or sharing personal information with clients. It assumes that to connect with those we're serving we must be empty/neutral—present only for the client without bias or assumptions; without need or perspective. The COE invective not to share is also a means of preventing social workers from sharing something that may be viewed as "inappropriate."

Although I agree that we shouldn't disclose everything under the sun, not sharing anything is a disservice to the people we're serving. It creates an unhealthy power dynamic that shouldn't be there in the first place.

I want my poems to be an act of service.
This is what I thought when I got to paint with my feet
In the opening of the first episode of the first season of *Ramy*, an elder at the mosque
 reminds Ramy of cleaning his feet in between the toes in order to feel closer
 to the divine. Closer to the presents of worship. I felt more present cleaning the paint between my toes just now than I have ever felt cleaning them in
 the bathtub or shower. My feet mushed and gushed in Tempura. Swished in
 my own specific rhythm. There was no rush.
I couldn't cease to think about how often we feel rushed out of politeness to speed up
 to a building when someone opens the door for us out of *common courtesy*. I
 can't speak for when others open the door for me; I only know that I am still
 learning how to take my own time in a world where Time is way too linear to
 the point of forcing the body to their will. What I can speak for is when I open
 the door for others.
When I hold the door open wide for you, I beg of you: do not rush yourself. I don't know
 if you're in a hurry. Just know that I am not. If I was, I would have continued my
 path forward. I am working more towards kindness in this life than politeness. I
 open the door for you out of kindness.
Maintain the initial pace you have before you look up to see me. You may nod and
 articulate a thank you. No need to prove your gratefulness by high stepping,
 jogging, or running. I need you to enjoy the stroll you are holding in your body.
 I don't want you to drop it.
I don't want you to release it because of the overwhelming narrative of *common*
 courtesy. I want you to swish in the mush and gush of the journey to your destination. Yes, even entering the building to pick up a missing item, or
 to use the trip for a restroom break counts as a journey.

I don't know if your journey is out of obligation more so than desire, but I do hope
 desire outweighs your list of obligations for once. Today, I want this interaction
 to be an opportunity of pause. Maybe even reflection. This poem is a little out
 of selfishness. I need to remind myself of the kindness I want to give to you.
Maya, when someone holds the door open wide for you, I beg of you: do not rush yourself.
I don't know if the person is only being polite. Just know that you are not. If you were, you would have taken a much longer walk that inconvenienced yourself. You are
working more towards kindness in this life than politeness. Believe they open the door
for you out of kindness.
Maintain the initial pace you have before you look up to see them. You may nod and
 articulate a thank you. No need to prove your gratefulness by high stepping,
 jogging, or running. I need you to enjoy the stroll you are holding in your body.
 I don't want you to drop it.
I don't want you to release it because of the overwhelming narrative of *common*
 courtesy. I want you to swish in the mush and gush of the journey to your destination. Yes, even entering the building to pick up a missing item, or to use the trip for a restroom break counts as a journey.
I know sometimes your journey is out of obligation more than desire, but I do hope
 desire outweighs your list of obligations for once. Today, I want this interaction
 to be an opportunity of pause. Maybe even reflection. It is okay that this poem
 is a little out of selfishness. You need to remind yourself of the kindness you want
 to give.

Ekphrasis[‡] of David Driskell's *Pines at Night, II* **and more[§]**

[‡]. *Ekphrasis* is the use of a written, detailed description of a work of visual art; *ekphrastic poetry* is defined as poems written about works of art.
[§]. This poem was commissioned by Maine Writers and Publishers Alliance, the Portland Museum of Art, and Maine Audubon, August 25, 2021.

My partner and I once strolled along a trail in Freeport and came across a tree split down its middle, most likely from previous lightning, leaning against another tree. The other tree, with its sturdy roots gripping *the* depths of the soil for dear life, I thought, provided a daily mantra to its sibling.

—

"I got you.
If you go down,
I go down with you."

—

David Driskell developed
a specific fascination
for pine trees.

Organisms
with more faces
than any human

can ever amount to.
As David processed the pines'
jagged leaves

blowing air
kisses to the blue-black
night sky, staring

at the slight
bright moon,
how often

did he get to see
them hold each other?
How many faces

through their bark
in each transitional
season made him think

to explore
the two faces
he was capable of?

Did he ever tell
the archangel, Gabriel,
to tell the pines

his thankfulness
for their service
so he can provide

his service
to fellow humans?
The humans

left behind
driving, biking, strolling
past plethora of trees?

Have I forgiven you?

My capacity to forgive you fluctuates.
There are days I don't even think about you,
although the strongest memory of harm recapitulates

Now when my mind is triggered, my body no longer frustrates.
At least not all the time, I can't completely erase you.
My capacity to erase you fluctuates.

It is a calmer day when I can feel great.
When I feel honest enough to pray for you.
Honestly, it's hard when the strongest memory of harm recapitulates.

I am learning how to only pray in a honest state
of mind. It gives me comfort to not know how you
are doing or living as life consistently/non-linearly fluctuates.

I am still reconditioning how mechanized memory invalidates
me while making sure to validate you.
It surprises me when legitimately kind memories of you recapitulates

Living a life without you is one I don't believe complicates
my necessity for affirmation; and I believe I will slowly forgive you.
My capacity to forgive you fluctuates
because of all memories of you that recapitulate.

Contradictions of my mother

Don't judge other people. Do judge your father
 because you now have more
 permission and agency than I ever will.

Don't talk to strangers. Do contact stranger through a taxi number
 because I can't pick you up
 right away.

Don't hit other people. Do hit people back if they hit you first;
 I might question
 your level of self-esteem
 if you won't defend yourself.

Don't tell lies. Do remember
 that when we arrive at CiCi's you are twelve.
 I know you just turned fourteen,
 but today you are twelve.

Don't tell me
about therapy.

Don't allow Do allow this new man
men to hurt you in our lives to say the things he does
 because it's not as bad
 as we're making it out to be.
 Do communicate with me your problems.

Don't communicate your problems
when he's around,
he'll use them against you.

Don't tell me Do take words seriously.
about therapy.

Don't take his words,
his attitude,
or his hands seriously.

Don't tell me about therapy.

Don't tell me about therapy.

Don't tell me about therapy.

Maya Williams

> Do tell me about therapy.
> You seem to be doing better.

Don't remind me of my mistakes.

Don't remind me of my mistakes.

Don't remind me of my mistakes.

> Do remind me of my mistakes;
> we move out and leave him on the 4th.

Don't use swear words in public.

> Do use swear words to express yourself;
> you write so damn much,
> I trust you to use words
> with me.

Don't tell me it wasn't my fault.

Don't tell me it was your fault either.

> Do forgive him.

Don't forget what he's done;
I know I won't.

Don't tell me I'm the best
or that you love me.

> Do tell me you love me,
> because it lets me know
> I'm doing something right, that we're getting better,
> and that I love you too.

FINAL COMMENTS

Thank you, Shelley Cohen Konrad and Michal Sela-Amit for reaching out to me and letting me share my work. Thank you for your gracious edits. Thank you to the organizations Maine Inside Out, MaineTransNet, The

Yellow Tulip Project, EqualityMaine, and many more who have allowed me to combine social work with the arts. Thank you, reader for reading, take precious care.

REFERENCE

American Psychiatric Association. (2022). *Diagnostic and statistical manual of mental disorders* (5th ed., text rev.). https://doi.org/10.1176/appi.books.9780890425787

PART IV
Foresightful Epilogue

14
Four Ways the Arts Can Help Social Work Be More Future Ready and Future Engaged

LAURA NISSEN

INTRODUCTION

In so many ways, social work is implicitly a "future-oriented" profession. Activities, values, and ethics all point to co-creating a better world in the future than is present right now. But on a day-to-day basis, social workers are busy people, and the profession itself is dealing with a generation's worth of neoliberal trimming and compression (Fenton, 2019; Hyslop, 2018; Weinberg & Banks, 2019) that makes the average "scope of work" intense, urgent, and focused on responding (and sometimes reacting) to crisis after crisis, with little energy, expertise, or bandwidth for either planning or imagining. Social work's focus on equity, human rights, and well-being confronts a world of complexities and nonlinear change that the profession could scarcely have imagined at its inception. Social work needs new tools, frameworks, and imaginaries to find its place in a rapidly changing world—where strengths and opportunities, as well as existential threats, are evolving at unprecedented speeds. What is missing is a "futures lens" to help social workers navigate turbulence, uncertainty, and change—and to do our work in rapidly changing contexts. For the purposes of this chapter, a *futures lens for social work* is defined as a set of ideas, tools, and methods that help make sense of the emergent future in creative ways. This is in equal parts (maintaining the ethical, justice-oriented and strength-based aspects of social work) while simultaneously using utopias and

dystopias, discontinuity, and imagination to better anticipate what is ahead—and what our role should be in new unfolding worlds.

This chapter invites social workers and social work scholars to explore two intersecting and interdisciplinary frames: (1) "futures thinking-foresight practice" as a new knowledge system and toolkit to help the profession feel less reactive and more responsive and intentional about navigating the complexity of the times (now and ahead) and (2) how a futures lens specifically intersects with the power of imagination and the arts as central aspects of becoming future engaged to accelerate more meaningful engagement, learning, and impact. This exploration utilizes primarily a meso/macro perspective—but that has huge implications for the future of micro social work as well. It inherently involves a commitment to co-creating futures with communities with whom we identify and ally with.

NEW WAYS TO "DWELL IN POSSIBILITY"

The human family has always been interested in the future—and by a variety of mechanisms, has sought out perspectives and voices to inform "what might happen next." Indigenous wisdom brought forth the idea of the "principle of the seventh generation" or a commitment to think ahead seven generations to inform the impact of the decisions made today (Williams, 2018). And of course, there have been less reliable "soothsayers" along the way offering "what people wanted to hear" as opposed to a carefully informed perspective. The truth is that the future is unknown, and yet in the past 100 years, the concept of "foresight science and practice" has evolved from a transdisciplinary tool and framework of elites within governments, military actors, and corporate leaders to a more democratized and accessible set of principles, tools, and frameworks to help individuals, communities, and even nation states to be more informed, agile, and "ready" for various futures—even as they are leaning in to co-create those that are most preferable (Gidley, 2017).

Foresight is not a tool to "predict" the future; however, it is an emerging transdisciplinary social science that seeks to intentionally anticipate the next chapters of social issues, social structures, and community well-being. Intentional use of foresight helps individuals, organizations, governments, and communities to simultaneously prepare for various futures (some positive, some not so positive) and focus their own resources on co-creating the futures they most want. It is, in an evolutionary sense, the heir to and expansion of "strategy planning" when strategies of prior generations could enjoy a kind of stability that is not reliably apparent in the current and future world. Foresight assumes a kind of VUCA (volatile, uncertain, complex, and ambiguous) sensibility about the operating ecosystem—demonstrated undeniably by the COVID-19 experience in the last few years. Conceptualizing and then

cultivating agility and momentum through the increasingly complex, non-linear, and unexpected futures ahead is the goal of foresight. Foresight is used in cross-disciplinary contexts in both public and private settings all over the world, with a 50-year scholarly foundation and a global community of practitioners and scholars (Slaughter & Hines, 2020).

In the historical family tree of foresight work, there have been many uses, applications, and actors engaged in foresight in previous eras. Not all of these (business and/or military lenses, e.g.) would attract or find common ground or natural affinity with social work. There is, however, one particular branch most closely aligned with the values and ethics of social work—known as "critical" futurisms. Critical futurisms focus intently on issues of power in considering matters of the future and involves a "participatory futures" lens to encourage larger scale engagement in future building (rather than future as designed in hierarchical fashion) (Ramos et al., 2019). This lens is commonly used in matters of social change and the amplification of community voice. The issue of "who decides" what the future should be—global elites or democratic actors and processes (including non-Western)—is paramount (Bhagat, 2020; Inayatullah, 1990; Krishnan, 2019; Slaughter, 1984). Critical futurisms extends into a variety of creative frameworks featuring diverse voices, theories, and models to include postnormal futurisms (Mayo, 2020; Sardar, 2010, 2015); mutant futures (Ramos, 2020); Afrofuturisms (Anderson, 2016); Indigenous futurisms (Dillon, 2012); queer futurisms (Yekani et al., 2016); feminist futurisms (Kember, 2012); and others, including efforts to decolonize the future (Bisht, 2017, 2020) or increase focus on futures cultural studies in general (Powers, 2020). All have in common a thread of asserting identities, intersectionalities, and perspectives that differ from the "official futures" so often asserted by the powerful and reasserted as more diverse, disruptive, and often more equity-centered aspirations

> The overarching goal of critical futurisms is to serve a future that is concerned with human liberation, human rights, and global survival rather than economically centered, military, or other forms of futures decided, conceptualized, and formed by elites.

(collective, participatory, and/or liberatory futures). The overarching goal of critical futurisms is to serve a future that is concerned with human liberation, human rights, and global survival rather than economically centered, military, or other forms of futures decided, conceptualized, and formed by elites.

Increasingly, the global community of foresight scholars and practitioners considers not only the "future of" such things as the impact of new technologies on the human and natural world (particularly artificial intelligences), the future of climate change, and the future of equity in its many forms, but also the intersection of these things with one another and such issues as the future

of government and democracy; the future of disinformation, of health, and of many other factors that comprise the future of life on planet Earth.

The arts and the role of artists are commonly present in pursuit of full execution of foresight processes. The reasons for this are multifold. Davies and Sarpong (2013) described the role of the arts as one with deep epistemological relevance to foresight—and that artists often bring an "anticipatory consciousness" to matters of social and hard science. They are able to discern, sometimes unconsciously, currents of change and emergence in society that are not yet observable—and they often "usher in" new eras. Artists help accelerate and amplify imaginative possibilities that many had not yet even thought of. Artists are watched, enjoyed, disruptive, and engaging for this very reason—and deserve respect for not only their creative achievements but also their disciplinary contributions to co-creating new worlds. And although they live and operate in their own economic system that frequently undervalues and resources all but the most elite of them, artists are also workers and everyday contributors and transformation specialists—and they inspire and help to build the future in whatever space they inhabit. Increasingly, futures and the arts are converging in more spaces of both activism and research—highlighting both the need and power of the arts to communicate, engage in world building, fuel sense-making and change and resist where needed (Duncombe & Lambert, 2021).

SOCIAL WORK AND THE ARTS—COMING INTO FOCUS

The role of the arts has been deeply connected to the history of the social work profession. From its earliest days in Chicago, the arts were viewed as a space where individuals and communities could simultaneously heal, grow, contribute, and build agency against harmful social conditions. Over many years, there has been a rich variety of ways that the arts have been woven into social work scholarship and practice—though in many respects it has not had wide uptake throughout the field (Flynn, 2019; Huss & Bos, 2019; Huss & Sela-Amit, 2018; Nissen, 2017).

Everything from art therapies (Chamberlayne & Smith, 2009), to use of arts in community contexts toward justice (Kim, 2017; Sakamoto, 2014), to arts as part of disaster response (Huss et al., 2016), and the arts in culturally specific and responsive contexts (Huss & Bos, 2018), the arts evolve and show promise as social workers around the world continue to experiment with, practice using, and study in this space.

During numerous years between 2015 and 2020, a community of arts and social work scholars and practitioners have gathered at annual retreats in Washington State at the Islandwood Conference Center to explore how to best prepare ideas of the role of the arts to expand more broadly in the profession.

These retreats included social work educators, students, and practitioners—as well as artists, philosophers, and other people dedicated to the arts for the public good as we collectively sought to deepen and strengthen social work's capacity to engage more fully in the arts in the years to come. In our 2018 gathering, we explored the issue of the ways in which a futures lens might intersect with our social work and the arts exploration—and the result is this chapter.

The power, beauty, and centrality of the arts as a life-giving force areclear in human history. Art gives meaning, power, and momentum to realizing value in human experience, strengthens people, provides avenues for awareness and integration—and often provides critique in ways that are not possible in other forms. The need to build professional channels to grow social work's capacity (profession-wide) to learn about and utilize these tools and perspectives has never been more needed.

SOCIAL WORK AND FUTURES PRACTICE

> Social work itself remains a primarily progressive era profession with a deep commitment to equity, well-being, and justice, yet concerns itself primarily with issues and challenges of today and not tomorrow.

Though social work has for some time given thought to what the future might bring to the profession (Council on Social Work Education, 2018; Reisch, 2013), it still remains at the beginning stages of figuring out what this means not as a time-limited consideration, but with deeper and dedicated focus over time at both top leadership and front-line engagement. Given the rapid acceleration of changes regarding the role of professions in society (Susskind & Susskind, 2015), there is a need for the social work field writ large to consider the dramatically changing landscape of drivers, impacts and potential social problems, contradictions, and ethical concerns of the future. Social work itself remains a primarily Progressive Era profession with a deep commitment to equity, well-being, and justice, yet concerns itself primarily with issues and challenges of today and not tomorrow. In this sense, use of rigorous and disciplined foresight frameworks and methods could accelerate the breadth and depth of the professions' readiness for an uncertain future (Nissen, 2020).

The very essence of the core concepts of "human behavior in the social environment" is shifting in the current world. New forms of human behavior and new forms of social environments are stretching classical social work boundaries and concepts (including new forms of art as in virtual or extended realities and the "metaverse"). As mentioned above, technology, climate change, and racism (in old and new forms)—as well as other concerns such as the future of health, the future of communications and information (as well as

disinformation), the future of government, the future of work and more—all demonstrate that the "world of practice ahead" may look very different from the past. Social work, it would seem, is at an inflection point to meaningfully and rigorously prepare as a profession for what comes next. Deep profession-wide rethinking, self-critique, and anticipatory shaping of the professions' next steps are already happening in law, medicine (Exponential Medicine, 2021; Regev, 2019), and journalism (Marconi, 2020), to name a few other professions actively and substantively engaging in imagining and planning for the future of their shared work. A foresight lens and methods mean going far beyond merely initial explorations of what the future of our profession might look like, to intentionally anticipate in creative ways and build readiness for agility accordingly and deeply. Additionally, issues of the future of social movements (outside of and within the profession), the future of social welfare, and the future of social issues/problems themselves all play a role in how social work will evolve moving forward.

Part of understanding how a profession prepares itself for the future is by seeking the story of how it has evolved in the past. Social work *has* evolved over its existence, though there is argument about how adequate the speed of that evolution has been. Social work has a history of gradual and incremental changes in a world that is becoming increasingly nonlinear and exponential (Baines, 2021). There have been increasing calls to make dramatic changes to disengage from "traditional" social work sites of practice away from carceral and toward abolitionist and overtly antiracist approaches (Haymarket Books, 2021). There has been concern about increasing and pervasive neoliberal forces continuing to deform/erode the clarity of purpose of the social work profession (Spolander et al., 2014; Strier, 2019), and there have even been calls to end the social work profession as a whole (Maylea, 2021).

New calls for skills such as "transition design" (Carnegie Mellon University, 2021; Zaidi, 2017) to specifically focus on moving extended parts of human infrastructure (economies, governments, and all forms of social arrangements) from one state of being (White supremacist, extractive, carceral) to another (ecosustainable, antiracist, liberatory) have potential to grow and intersect with social work principles and values. There is also an emerging literature about designing institutions for future generations that has strong potential to accelerate social work's view of its role in the years to come (Gonzalez-Ricoy & Gosseries, 2016; Mackenzie, 2016). There will undoubtedly be both new and emerging forms of old social movements that continue to shape the world in ways that social workers care about and are committed to (Brescia, 2020; Engler & Engler, 2016; Garza, 2020; Tufekci, 2017), as well as, predictably, likely efforts to curtail or inhibit them.

However, the point and promise of a foresight lens activated in social work are to accelerate the degree to which "anticipating" becomes an ethical imperative for the profession, along with other key ethical commitments. This

includes anticipating what will happen not only in various existing fields of practice (the future of therapy, the future of child welfare, the future of disaster social work, the future of school social work or medical social work, and beyond) but also the future of the things that drive and regulate these fields of practice. All of this happens in a context that is dynamically changing—described elsewhere in this piece. Social work will always be a blend of reacting to changes even as we always endeavor to co-create and guide, if not directly build, more humane, equitable, and human-rights-centered futures. But in many respects, the future of social work is much bigger than social work—and that commitment—to learn, to stay abreast of, and to stay informed and engaged in larger issues of the day (climate justice, tech justice, health justice, etc.) are imperative for the future vibrancy and relevance of our profession.

THE ARTS, SOCIAL WORK, AND A FUTURES LENS—HOW THEY WORK TOGETHER TO ACCELERATE A BETTER FUTURE FOR ALL

Having explored the "parts"—how do the arts, social work, and a futures lens all fit together? For the purposes of this chapter, there are four primary ways to consider the power and utility of a future-informed, arts-based lens for the profession: (1) a commitment to "imaginaries" and imagination to get to the future; (2) the role of arts and artists in revealing emergent futures; (3) the use of scenarios and other speculative futures frames to help people co-create and pre-experience different futures; and (4) the emergence of art as social practice itself.

Commitment to imaginaries and imagination to get to the future

Among their other characteristics, artists of all kinds (poets, novelists, actors, sculptors, graffiti artists, and others) are imagination specialists. They exercise their imaginations in rare and particular ways that stimulate social interactions with the world around them. It is without question that artists have played an important role in the history of the world, but from a futures perspective, they might play an especially important role at this time in history. Futurist Ziaddun Sardar refers to the current era as "postnormal times"—a kind of global liminal period between significant eras for which increasing destabilization and disorientation are becoming increasing norms in the world around us. *Imaginaries*, so the ethics theorists suggest, are shared notions of an ideal society, including such features as what is good, bad, valuable, and more (O'Neil, 2016). In a time when much is shifting and imaginaries themselves are becoming more fragmented through the transitions of the times we live within—artists, those people for whom imagination, interpretation, and

communication of these is a series of skills and gifts, become increasingly important and powerful.

For futurists and for social workers, there is much to be learned by simply paying attention to and learning from what artists are thinking, producing, describing, representing, and committing to. Artists are troubling and complicating and provide commentary and insights on our shared notions of the elements of preexisting but rapidly changing shared imaginaries—and this, among other strengths, is among their greatest contributions. Brown (2017) described the times we live in as set in "an imagination battle" (p. 14), and that use of imagination is among our most important (and most stressed) resources to change ourselves and to change the world. Those who "hold" the role of artist in society engage and participate in modern life in ways that are very likely to prefigure aspects of the world that are not as apparent to the masses. It is not meant to imply "clairvoyance," but rather artists have a way of inventing in ways that tap into or reflect underlying yet potentially as yet unspoken shifts that are occurring in the world around them. They communicate artistically and, in many ways, amplify and co-create changes in the world.

Role of the arts within social change movements

The arts are often part of or deeply connected to social movements or other powerful social experiences in the world. Whether it is the art reflecting and amplifying (e.g.) the Black Lives Matter movement (van Veen & Anderson, 2018), calls for abolition of carceral systems (Hotchkiss, 2020), art that reflects the COVID-19 disaster (Byck, 2020), artists leading dialogue about the future of shared public monuments (Thomas, 2020), or art that reflects concerns for climate change (Lescaze, 2018), or other economic justice issues (Thompson & Sholette, 2004)—the art that is produced, shared, and positioned plays a large part in engaging community in a process of becoming mobilized, energized, and focused on important issues for whom traditional institutional leadership has failed the collective. Social movements are engaging in collective imagination by envisioning a better world that it intends to create—and the art that emerges from these spaces amplifies this phenomenon. This is related to forms of activism directly related to a term called *prefigurative politics* or the act of creating worlds, experiences, and opportunities that reflect the world that is desired, not necessarily the world we have (Jeffrey & Dyson, 2021; Tornberg, 2021).

Similar to above, there is also much to learn for both social workers and futurists by more carefully observing the contributions of artists specifically oriented to social movements and social change agendas to get glimpses of both how movements will unfold and the future of movements themselves (as new artists use new media to accelerate their messages/impact in new spaces)

(Mina, 2019). Art that is happening in social movement arenas is stretching the moral imaginary in particular ways to challenge, disrupt, and expand, if not transform all together, what a "good and valuable" society might be—from exclusionary and extractive, to justice-based and sustainable (e.g.).

Use of scenarios, stories, and other creative tools to take imagination to a simultaneously visionary and practical level

Futures practice and foresight embrace stories as a primary vehicle for building conceptual bridges from the past and present to some abstract future time. Sometimes this leans into direct use of science fiction (in literature and film) (Middleton, 2015; Raven, 2017), and sometimes it includes a less explicitly arts-based but intensely creativity-based method of developing "scenarios" (Bezold, 2019; Ringland, 2010).

The most well known of the scenario formats comes from Jim Dator's work with the "four archetypes," which guide people to consider four explicit and different futures: (1) a future of growth (where things continue to grow, expand, and progress); (2) a future of constraint (where compromises must be made in order to survive; (3) a future of collapse (where something ends in a substantial way; and finally (4) a future where a transformation occurs (where something happens that requires the engagement of the outer reaches of our imaginations) (Dator, 2009). Increasingly, use of an intersection of design sensibilities is also becoming part of the use of scenario-based and science-fiction-linked approaches—to literally engage in "futures design and worldbuilding" (Zaidi, 2019), including emerging frames such as speculative futures design—including what has been called "social dreaming" (Dunne & Raby, 2013) and experiential futures (Candy & Dunagan, 2017; Candy & Kornet Weber, 2019; Kelliher & Byrne, 2015; Lederwasch, 2012; Selin, 2015). In these approaches, activities move from narrative, visual, and/or game-based approaches to literally intersecting with an almost theatrical concept of experience building in which people are asked to pre-experience some kind of carefully constructed and curated future to consider its full ramifications and impact. Reflection on these purposefully created experiences becomes rich material to assist individuals and groups to discern preferred and undesirable futures more fully and to use these to map forward paths toward a future that is wanted.

Art as social practice itself

Finally, in the last 20 years, a new type of art practice has emerged that further blends the intersection of the arts and social change (often with a lens toward more just social futures). Its point is not to make art about social problems but

rather "employ the varied forms offered by the expanded field of contemporary art as a collaborative, collective and participatory social method for bringing real-world instances of progressive justice, community building and transformation," (Sholette et al., 2018, p. i). Rather than making art to hang on walls or in museums, this type of art practice encourages engagement, expression, and social change from community members themselves as its primary contribution with identity, local concerns, and political realities centered, amplified, and elevated. These forms seek to elevate awareness and discourse about art, activism, and power. They also complicate the commodification of the arts and the exploitation of artists (Thompson, 2015). They engage community arts and other leaders as change agents via the arts (Erenrich & Wergin, 2017) as well as seek to reveal and challenge the increasingly industrialized and hostile economic forces of the art world itself and how the mission of art and artists to challenge power, oppressive economic and political systems, and support the imagination of just worlds must be reclaimed (Sholette & Charnley, 2017).

CONCLUSION AND CALL TO ENGAGEMENT

The arts are an enduring resource for humanity's past and present—and likely will continue to provide inspiration, momentum and world-changing influence for many generations to come. Increasingly, social work is finding numerous ways to increase the range of ways that the arts can inform, enhance and accelerate practice—but this chapter has sought to show that the arts

> Social work cannot and should not "wait" for the future to happen. . . . We should engage actively with those whom we align with . . . to support the building of new futures in which equity, justice, and human thriving are possible.

are also a vehicle for encouraging and extending the field's ability to be "foresightful." The world is changing dynamically—with volatility and ambiguity persistently a part of the modern human experience. Futures and foresight work provides tools and structures to support individuals and collectives to use imagination and a disciplined sense of anticipation—often aided if not organized through and around creative approaches involving the arts—as a way to help effectively navigate the complexity of the times in which we live, to give voice to diverse communities, and to expose dynamics of power in order to reorder them. All of these will heavily impact the future of the world and have unique impacts on vulnerable populations. Social work cannot and should not wait for the future to happen. We should engage actively with those whom we align to support the building of new futures in which equity, justice, and human thriving are possible. Neither the arts nor foresight need exclusively be a tool of the few. What is needed are ways to maximize collective imagination

and creativity—as well as ways to intentionally co-create the futures we want. Social workers in all fields and all levels are urged to explore and embrace the possibilities of enhanced practice that both creatively engages with artists and the arts, as well as with futures thinking and foresight practice. There is no more important time.

REFERENCES

Anderson, R. (2016). Afrofuturism 2.0 and the Black speculative arts movement: Notes on a manifesto. *Raleigh, 42*(1/2), 228–236.

Baines, D. (2021). Soft cops or social justice activists: Social work's relationship to the state in the context of BLM and neoliberalism. *British Journal of Social Work, 52*(5), 2984–3002.

Bezold, C. (2019). The history and future of anticipatory democracy and foresight. *World Futures Review, 11*(3), 273–282.

Bhagat, A. (2020). Minimizing shock: Reimagining a more equitable future. In J. Schoeter (Ed.), *Aftershock: The world's foremost futurists reflect on 50 years of Future Shock and look ahead to the next 50* (pp. 1–79). Abundant World Institute. https://openresearch.ocadu.ca/id/eprint/2129/1/Bisht_Pupul_2017_MDES_SFI_MRP.pdf

Bisht, P. (2017). *Decolonizing futures: Exploring storytelling as a tool for inclusion in foresight*. [Master's thesis]. OCAD Design. http://openresearch.ocadu.ca/id/eprint/2129/1/Bisht_Pupul_2017_MDES_SFI_MRP.pdf

Bisht, P. (2020). Decolonizing futures: Finding voice, and making room for non-Western ways of knowing, being and doing. In R. Slaughter & A. Hines (Eds.), *The knowledge base of futures studies 2020* (pp. 216–230). Association of Professional Futurists.

Brescia, R. (2020). *The future of change: How technology shapes social revolutions*. Cornell University Press.

brown, a. m. (2017). *Emergent strategy: Shaping change, changing worlds*. AK Press.

Byck, D. (2020). An artist is projecting giant memorials to covid-19 victims on walls all over DC. *Washingtonian*. https://www.washingtonian.com/2020/04/17/this-dc-artists-projections-are-a-huge-poignant-memorial-to-the-citys-covid-19-victims/

Candy, S., & Dunagan, J. (2017, April 17). Designing and experiential scenario: The people who vanished. *Futures, 86*, 136–153.

Candy, S., & Kornet Weber, K. (2019). Turning foresight inside out: An introduction to ethnographic experiential futures. *Journal of Futures Studies, 23*(3), 3–22. doi:10.6531/JFS.201903_23(3).0002

Carnegie Mellon University. (2021). Transition design seminar 2021. https://design.cmu.edu/tags/transition-design

Chamberlayne, P., & Smith, M. (2009). Art, creativity and imagination in social work: Introduction. In P. Chamberlayne & M. Smith (Eds.), *Art, Creativity and Imagination in Social Work Practice* (pp. 1–12). Oxfordshire, England. doi:10.4324/9781315876504-10

Council on Social Work Education. (2018). *Envisioning the future of social work: Report of the CSWE Futures Task Force*. Council on Social Work Education.

Dator, J. (2009). Alternative futures at the Manoa School. *Journal of Futures Studies*, 14(2), 1018.

Davies, C., & Sarpong, D. (2013). The epistemological relevance of the arts in foresight and futures studies. *Futures*, 47, 1–8.

Dillon, G. (Ed.). (2012). *Walking the clouds: An anthology of Indigenous science fiction*. University of Arizona Press.

Duncombe, S., & Lambert, S. (2021). *The art of activism: Your all purpose guide to making the impossible possible*. OR Books.

Dunne, A., & Raby, F. (2013). *Speculative everything: Design, fiction and social dreaming*. MIT Press.

Engler, M., & Engler, P. (2016). *This is an uprising: How nonviolent revolt is shaping the 21st century*. Nation Books.

Erenrich, S. J., & Wergin, J. F. (2017). *Grassroots leadership and the arts for social change*. Emerald Publishing.

Exponential Medicine (2021). Archive of exponential medicine gatherings and updates.

Fenton, J. (2019). "Four's a crowd"? Making sense of neoliberalism, ethical stress, moral courage and resistance. *Ethics and Social Welfare*, 1, 6–20.

Flynn, M. (2019). Art and the social work profession: Shall ever the twain meet? *Research on Social Work Practice*, 29(6), 687–692.

Garza, A. (2020). *The purpose of power: How we come together when we fall apart*. One World.

Gidley, J. (2017). *The future: A very short introduction*. Oxford.

Gonzalez-Ricoy, I., & Gosseries, A. (Eds.) (2016). *Institutions for future generations*. Oxford University Press.

Haymarket Books. (2021). Abolitionist social work: Possibilities, paradox and praxis. Online webinar. https://www.haymarketbooks.org/blogs/284-abolitionist-social-work-possibilities-paradox-and-praxis

Hotchkiss, S. (2020). Artists team up with critical resistance to make prison abolition irresistible. KQED. https://www.kqed.org/arts/13886700/artists-team-up-with-critical-resistance-to-make-prison-abolition-irresistible

Huss, E., & Bos, B. (Eds.). (2018). *Art in social work Practice: Theory and practice: International perspectives* (Routledge Advances in Social Work), 1st Edition. Oxfordshire, England

Huss, E., & Bos, B. (Eds.). (2019). *Art in social work practice: Theory and practice—International perspectives*. Routledge.

Huss, E., Kaufman, R., Avgar, A., & Shuker, E. (2016). Arts as a vehicle for community building and post-disaster development. *Disasters*, 40(2), 284–303.

Huss, E., & Sela-Amit, M. (2018). Art in social work: Do we really need it? *Research on Social Work Practice*, 29(6), 721–726.

Hyslop, I. (2018). Neoliberalism and social work identity. *European Journal of Social Work*, 21(1), 20–31.

Inayatullah, S. (1990). Deconstructing and reconstructing the future: Predictive, cultural and critical epistemologies. *Futures*, 22(2), 115–141.

Jeffrey, C., & Dyson, J. (2021). Geographies of the future: Prefigurative politics. *Progress in Human Geography*, 45(4), 641–658. https://doi.org/10.1177/0309132520926569

Lederwasch, A. (2012). Scenario art: A new futures method that uses art to support decision-making for sustainable development. *Journal of Futures Studies*, 17(1), 25–40.

Kelliher, A., & Byrne, D. (2015). Design futures in action: Documenting experiential futures for participatory audiences. *Futures*, 70, 36–47.

Kember, S. (2012). Notes towards a feminist future manifesto. *Ada: Journal of Gender, New Media and Technology*, *1*(1), 1–9.

Kim, H. C. (2017). A challenge to the social work profession? The rise of socially engaged art and a call to radical social work. *Social Work*, *62*(4), 305–311.

Krishnan, A. (2019, June 21). Futures, power and privilege. *Medium*. https://aarathi-krishnan.medium.com/futures-power-and-privilege-14fa9096bf6

Lescaze, Z. (2018, August 22). 12 artists on climate change. *New York Times Style Magazine*. https://www.nytimes.com/2018/08/22/t-magazine/climate-change-art.html

MacKenzie, M. K. (2016). Institutional design and sources of short-termism. In I. Gonzalez-Ricoy & A. Gosseries (Eds.), *Institutions for future generations* (pp. 24–47). Oxford University Press.

Marconi, F. (2020). *Newsmakerss: Artificial intelligence and the future of journalism*. Columbia University Press.

Maylea, C. (2021). The end of social work. *The British Journal of Social Work*, *51*(2), 772–789.

Mayo, L. (2020). The postnormal condition. *Journal of Futures Studies*, *24*(4), 61–72.

Middleton, S. (2015). Decolonizzing the future: Biopolitics, ethics and foresight through the lens of science fiction. In P. Stapleton & A. Byers (Eds.), *Biopolitics and utopia: An interdisciplinary reader* (pp. 119–138). Palgrave.

Mina, A. X. (2019). *Memes to movements: How the world's most viral media is changing social protest and power*. Beacon Press.

Nissen, L. B. (2017). Art and social work: History and collaborative possibilities for interdisciplinary synergy. *Research on Social Work Practice*, *29*(6), 698–707.

Nissen, L. B. (2020). Social work and the future in post-COVID 19 world: A foresight lens and a call to action for the profession. *Journal of Technology in Human Services*, *38*(4), 309–330.

O'Neill, O. (2016). *Justice across boundaries: Whose obligations?* Cambridge University Press.

Powers, D. (2020). Towards a futurist cultural studies. *International Journal of Cultural Studies*, *23*(4), 451–457.

Ramos, J. (2020). Messy grace: The mutant futures program. In M. Bussey & C. Mozzini-Alister (Eds.), *Phenomenologies of grace: The body, embodiment and transformative futures* (pp. 41–63). Springer Nature Switzerland A G.

Ramos, J., Sweeney, J. A., Peach, K., & Smith, L. (2019). *Our futures: By the people for the people—How mass involvement in the future can solve complex problems*. Nesta.

Raven, P. G. (2017). Telling tomorrows: Science fiction as an energy futures research tool. *Energy Research & Social Science*, *31*, 164–169.

Regev, A. (2019). Looking forward 25 years: The future of medicine. *Nature Medicine*, *25*, 1804–1807.

Reisch, M. (2013). What is the future of social work?. *Critical and Radical Social Work*, *1*(1), 67–85. Retrieved Oct 22, 2023, from https://doi.org/10.1332/204986013X665974

Ringland, G. (2010). The role of scenarios in strategic foresight. *Technological Forecasting & Social Change*, *77*, 1493–1498.

Sakamoto, I. (2014). The use of the arts in promoting social justice. In M. Reisch (Ed.), *Routledge international handbook of social justice* (pp. 463–479). Routledge.

Sardar, Z. (2010). Welcome to postnormal times. *Futures*, *42*(5), 435–444.

Sardar, Z. (2015). Postnormal times revisited. *Futures*, *67*, 26–39.

Selin, C. (2015). Merging art and design in foresight: Making sense of Emerge. *Futures*, *70*, 25–35.

Sholette, G., Bass, C., & Social Practice Queens. (2018). *Art as social action: An introduction to the principles and practices of teaching social practice art*. Allworth Press.

Sholette, G., & Charnley, K. (Eds.). (2017). *Delirium and resistance: Activist art and the crisis of capitalism*. Pluto Press.

Slaughter R. (1984). Towards a critical futurism: An outline of critical futurism. *World Future Society Bulletin, 18*(5), 17–21.

Slaughter, R., & Hines, A. (Eds.). (2020). *The knowledge base of futures studies 2020*. Association of Professional Futurists.

Spolander, G., Englebrect, L., Martin, L., Strydom, M., Pervova, I., Marjanen, Paivi, Tani, P., Sicora, A., & Adaikalam, F. (2014). The implications of neoliberalism for social work: Reflections from a six-country international research collaboration. *International Social Work, 57*(4), 301–312.

Strier, R. (2019). Resisting neoliberal social work fragmentation: The wall-to-wall alliance. *Social Work, 64*(4), 339–345.

Susskind, R., & Susskind, D. (2015). *The future of the professions: How technology will transform the work of human experts*. Oxford University Press.

Thomas, H. W. (2020, June 17). What should our monuments of the future look like? *CNN*. https://www.cnn.com/style/article/what-should-our-monuments-of-the-future-look-like-hank-willis-thomas/index.html

Thompson, N. (2015). *Seeing power: Art and activism in the 21st century*. Melville House Publishing.

Thompson, N., & Sholette, G. (2004). *The interventionists user manual for the creative disruption of everyday life*. MIT Press.

Törnberg, A. (2021). Prefigurative politics and social change: A typology drawing on transition studies. *Distinktion: Journal of Social Theory, 22*(1), 83–107. doi:10.1080/1600910X.2020.1856161

Tufekci, A. (2017). *Twitter and tear gas. The power and fragility of networked protest*. Yale University Press.

Van Veen, T., & Anderson, R. (2018). Future movements: Black lives, Black politics, Black futures—An introduction. *Topia: Canadian Journal of Cultural Studies, 39*, 5–21. https://doi.org/10.3138/topia.39.00

Weinberg, M., & Banks, S. (2019). Practicing ethically in unethical times: Everyday resistance in social work. *Ethics and Social Welfare, 13*(4), 361–376.

Williams, K. P. (2018). *Kayanerenkó:wa. The great law of peace*. University of Manitoba Press.

Yekani, E. H., Killian, E., & Michaelis, B. (2016). *Queer futures: Reconsidering ethics, activism and the political*. Routledge.

Zaidi, L. (2017). *Building brave new worlds: Science fiction and transition design* [Master's thesis]. OCAD Design.

Zaidi, L. (2019). Worldbuilding in science fiction, foresight and design. *Journal of Futures Studies, 23*(4), 15–26.

Continuing the Conversation

An Epilogue

SHELLEY COHEN KONRAD AND MICHAL SELA-AMIT

BACKSTORY

Our time spent at Islandwood was magical. It brought together the collective imaginations, talents, and passions of a small cadre of social workers, socially engaged artists, philosophers, and those whose identities intersected across these boundaries to consider the role of the arts in social work. Surrounded by ocean sounds and spied on by curious deer, we indulged in uninterrupted, often challenging, dialogue about where the arts belonged in our field of practice. Though the makeup of the group shifted slightly over the 3 years, some folks leaving and others bringing new perspectives to the round tables, there was overarching consensus that the arts were undeniably rooted in social work's history and should be integrated into all aspects of social work practice. The workshops ended in 2019, and we left with shared understanding that the arts were finely woven into the fabric of social work, but their presence needed to be elevated, made stronger, and be inclusive of more diverse voices.

This book was inspired by our Islandwood experiences. So much has happened since being on Bainbridge, and even more has transpired from the time we conceived the idea for this compilation of chapters. As such, we wanted to check in with our authors as a way of continuing the conversation we had begun. To be fully transparent, I (S.C.K.) was dogged about including an epilogue, but credit has to go to Michal for the idea to recontact our authors. As she put it: "I didn't want the book to conclude with an ending. I wanted it

to continue the conversation. So, bringing the authors together made good sense."

In fall 2022, we sent an open Zoom™ invitation to the book's authors asking them to convene and share what they were currently doing with the arts and to consider its future in social work. Like the rest of the world during the pandemic, we'd become accustomed to virtual communication, so the medium wasn't a deterrent. We were, however, worried that the topic may have lost its luster, been affected by COVID strains, or was put aside in favor of other pursuits. We were therefore delighted that so many authors responded enthusiastically to our invite.

The virtual gatherings were reunions for some, first-time meeting for others. Participants' ongoing fervor for arts and social work was palpable, and they let us know how much they appreciated that we had convened these chats. Evident as well was frustration with social work leadership, schools, and agencies' seeming reluctance to embrace the arts as a meaningful practice tool. Several authors mentioned the risk of falling behind other professions in using the arts for community-based research and practice. Laura thoughtfully observed: "Social work holds on to its traditions . . . but we need to evolve faster."

Yet there were others who shared advancements in integrating the arts in their personal and professional journeys. For example, Raphael Travis converted his office to look and feel like a music studio where students are inspired to create. Rogério Pinto announced that his school, a trailblazer in social work, was searching for two tenure-line faculty specifically engaged with social work with the arts. Despite barriers and challenges, folks were finding ways to bring the arts to social work students, faculty, and the community.

What follows are themes culled from two virtual conversations with the editors and authors where sentiments, successes, frustrations, and dreams were freely expressed. You'll note that some of the themes overlap. We've done our best to capture them in a way that honors the authors' voices and intentions. The overarching takeaways from these conversations were that the arts are good for social work and align with the roots of the profession; that adherence to traditional social work methods has not served vulnerable populations well; and that regardless of the arts importance and relevancy, advocating for the arts in social work can be a lonely endeavor. And, finally, the social work profession must be ready for inevitable transformation inclusive of integrated art-based practices.

"Everything about the arts was in my head."

Peter Szto

Loneliness and invalidation. For many, Islandwood was the first encounter with others passionate about using the arts in social work practice. "I thought

I had been carving a path not knowing social work and the arts was already happening" (Taylor) reflected a sentiment of many authors. Immersion in the arts was described as "isolating," unacknowledged, and minimized. Such feelings were couched as fighting for legitimacy in a field increasingly reliant on a constricted definition of evidence-based practice. Some thought too much time was spent on competition among faculty rather than on creative collaboration. Taylor summarized this perspective when he said: "Traditional sciences fight the war of ideas [whereas] the arts bring people together." People agreed that embracing "the synergy between art and science" (Brian) was the path to take if the arts were to be viewed as integral to social work. Several participants observed that no scientific methodology has yet to adequately measure human relationships—the heart of social work practice (Perlman, 1979). Art—we agreed, comes closer than surveys to revealing critical insights about people's lived experience than advanced practice knowledge. Though undeterred by feeling "othered" by colleagues, lack of recognition and minimization of the arts nonetheless added to participants' loneliness. Raising awareness of the arts and working toward expanding its presence in social work and beyond was understood as the antidote.

"Hearing the voices of People"

Nesrien Abu Ghazaleh

Commitment to our roots. Critical exploration of the arts led many authors back to Hull House, where the field of social work began. For Raphael T., going back into the earliest days of social work opened his eyes to art's prominence. It gave him "permission" and "authority" to promote his hip-hop work with youth in the field. Similarly for Brian, studying Hull House records was revelatory, helping him to revise his perspective on social inclusion for future work with marginalized queer and BIPOC (Black, Indigenous, and people of color) communities.

Taylor and Raphael T. talked about how they use the arts to bridge disconnection and miscommunication, especially with stigmatized youth who, they believed, "find themselves in the arts." Taylor's use of the arts opened doors for young sex offenders to dream, to feel fully human, and to know that change was possible. Raphael T. similarly focused on ways that disenfranchised African American young people could access the expressive arts to invest in their personal and community well-being. Katy, who formerly worked in the film industry, enlightened us about how art is often hijacked by the media to make a story dramatic and thus more compelling to the public. As a visual storyteller, she's committed to telling truthful stories, ones that are most meaningful to the teller.

Participants agreed that the arts is a universal language understood across cultures, ages, genders, abilities, and circumstances. It promises a more

diverse bandwidth for communication. Peter, who learned firsthand while in Singapore as a non-Mandarin speaker, commented: "If you don't have the words the best thing is to go visual" (Peter). For Rogério and Marc, performance was a preferred expressive method to improve care and to raise awareness of marginalized voices. Storytelling was another oft-used expressive device deployed by authors, particularly with refugees and minority groups. Narrative offers a mechanism to hear the voices of people who are typically invisible, muted by societal norms and power. Nesrien and Osvaldo witnessed how stories create an equitable means for clients and social workers to communicate and build a relationship.

Participants reflected on how social work has moved away from its settlement house roots because of medical corporatization, healthcare payment models, and the drive to be accepted as a "legitimate" health profession. There was some joking about going "back to the future," but it was underscored with strong sentiment that regaining traction in the arts would bring us closer to social work's mission and values.

"Faster, Together, and On Purpose."

Laura Burney Nissen

Musings and next steps. The cross-generational nature of our virtual discussions was fascinating. The student voice was especially meaningful to our discussions since they had experienced the synergistic benefits of art and social work in their social work education. Now in practice, they're un-self-consciously applying the arts with clients and communities. Katy, who describes herself as stepping into the field of social work "sideways" was baffled by the controversy of social work and the arts. "Artists say I'm also doing social work. Why don't social workers do the same?"

Maya spoke about how in their practice art offers a reprieve to reflect on what's happening. They noted that this was especially important for marginalized populations, for example transgender people and those who've experienced violence. "Arts can bring forth an awakening" making it possible to connect when connection seems impossible." Bree cautioned that the use of arts in social work must be organic: It can't be forced but should inspire. Like all methodologies there's no one size fits all.

While many authors spoke to the importance of reconnecting with social work's relational and expressive roots, others looked more toward future possibilities. Laura, a social work futurist, noted that artists bring "anticipatory consciousness" to the change process, and social workers should do the same. In many respects, she reflected, the field has an ethical obligation to stay abreast of future concerns and of the trends that will drive changes in how and with whom we practice. Observing and doing art further helps identify where change is taking place. "The way the arts are moving in social work is very

much where we need to be going" to keep pace with what future clients and communities will want and will need. Lori added that public art is a barometer of cultural shifts. Taking down statues of confederate icons and painting broad antiracist murals are indicators of change.

Some authors were notably worried about the prioritization of micro over macro practice in schools of social work. Brian observed that "the arts are better activated in interaction," and many agreed that groupwork should be taught as an optimal expressive, action-oriented, community-informed method in social work curriculum. Participants further asserted that social work hasn't done due diligence in activating the arts to build community. Solving problems in today's world takes creativity and willingness to take chances—something that isn't happening. There were also those who were quite vocal in declaring social work's failure to deliver meaningful services to underrepresented populations and those with the most need. As Brian passionately observed: "From my view I don't see science building community in the same ways the arts build community."

The fusion of arts in social work was strongly promoted as a versatile tool to reach underrepresented groups, lift the voices of those with lived experience, and engage in community building. Most of the authors were already actively engaged in blending social justice and the arts in their practices and in social work education. They agreed with Rogério: "The performing arts, the literary arts could be very helpful in delivering better social work services." Arts global relevance was highlighted by Eltje and Marc: "Drama is just one example of the way arts are used in all parts of the world to support people's solution-building." Carrie, whose arts-based teaching abroad is used to study inclusion, exclusion, and historical trauma, told us about how Mexican musical traditions and fandango enhanced her students' knowledge about religious and gender oppression.

We shied away from explicitly asking the authors for recommendations to move social work and the arts forward, but some were offered. These included recruiting faculty who are social workers and artists or at least comfortable with teaching arts as a viable methodology; creating dual degrees with social work schools and arts departments; amplifying community-based social work and the role of the arts in advocacy; developing a distinctive role for social work and the arts recognized by national and accrediting bodies; and collaborating with arts in medicine and public health programs.

As an editor and author of *Social Work and the Arts: Expanding Horizons*, I (S.C.K.) was heartened by our colleagues continuing passion and innovation in using the arts in their respective practices. In the end, I believe that what's most needed is to get brave as a field. To remind ourselves of our ethical obligation to "meet the client where they are," and the arts may be just the thing to determine where that might be. Art brings us closer to the lived experience of those we serve; it requires us to be humble and not assume; art connects

us to the beauty, strengths, and struggles of people and communities in a way that simply talking, or surveying, cannot possibly achieve. And I agree wholeheartedly with bell hooks, whose words introduced our chapters: "The function of art is to do more than tell it like it is—it's to imagine what is possible." And imagine we must with hopefulness, creative passion, and inventiveness as we make our way into the future.

I (M.S.A.) have been involved with the movement to reintegrate the arts in social work since its inception at the University of Southern California Dworak-Peck School of Social Work. Our work on this book provides building blocks for the rationale, theory, research, education, and practice of this field. There is no going back to a social work profession devoid of the arts. Yet, our work must continue. In our teaching we must foster students' creativity and innovation so that their exciting ideas are directed toward developing art-based knowledge and skills. In turn, this advances their capabilities to fully listen to their clients, learn from them, and respond to their needs in ways that awaken self-agency and promote well-being.

Moreover, by collaborating with allies, such as socially engaged artists, we advance the practice of social workers in communities and further cultivate social justice. These connections with students and artists, as well as with one another and clients, propel and transform our creativity as we work for a better world.

We're grateful to all of you who participated in the epilogue conversations and to those of you who are reading this now.

Shelley and Michal

ACKNOWLEDGMENTS

Many thanks to our collaborators and friends for bringing Social Work and the Arts full circle and into the present. We appreciate the contributions of our international authors: Marc Arthur, Eltje Bos, Taylor Ellis, Katy Finch, Nesrien Abu Ghazaleh, Osvaldo Heredia, Brian Kelly, Carrie Lanza, Brie Lear, Laura Burney Nissen, Rogério Pinto, Lori Power, Peter Szto, Raphael Travis, Maya Williams. And to other dear colleagues and students who inspired this work.

REFERENCE

Perlman, H. H. (1979). *Relationship: The heart of helping people*. University of Chicago Press.

ADDENDUM 1
Expressive Work: Realm of the Dead: An Installation Performance

ROGÉRIO M. PINTO

BLENDING PERSONAL PERFORMANCE AND VISUAL ART

The *Realm of the Dead* (https://www.pintorealmdead.com/) is a performance installation that falls under the umbrella of "personal performance." This form appears prominently in the theater as solo autobiographical and auto-ethnographic performances, often referred to as self-referential theater or self-referential drama. In *Realm of the Dead*, I used psychological excavation and "assemblage" techniques to produce artifacts—sculptures inside vintage suitcases and trunks—that incorporate everyday objects and others created by me. My sculptures have aesthetic and symbolic meanings within the context of the installation performance.

The "Mother" suitcase (see Figure A1) offers an example of a symbolic structure. It is a large metal trunk that was painted white with a touch of green. We reinforced the entire trunk with plywood and lined it with velvety dark green fabric representing the trees and grass my mother loved. At the bottom of the trunk, I placed the clothes and jewelry to represent what she wore for her funeral and the urn that would have her ashes.

I placed the image of Brazil's patroness *Aparecida*, meaning "Apparition," which is also my mother's name. My grandmother was a devout Catholic, and she named my mother *Aparecida de Jesus*, which means "Apparition of Jesus." When she retired, my mother painted a picture of a bull for me. I think of it as her self-portrait. So, her trunk includes that painting plus a picture of her

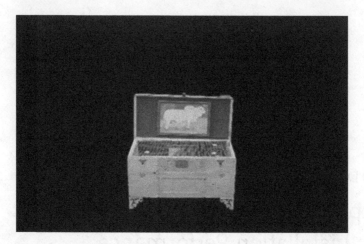

Figure A1 The "Mother" suitcase from Realm of the Dead (by Rogério M. Pinto).

separated by a net indicating the space between life and the afterlife, the place she is reunited with my deceased sister, the inspiration for the entire exhibit, *Realm of the Dead*.

ADDENDUM 2
The Calling Commentary and Script
CLAY GRAYBEAL

In 1998, I was on sabbatical, doing my best to settle down and write an article for publication in a peer-reviewed journal. Anyone who has undertaken this effort is familiar with the process of systematically making the content as dull as possible in order to enhance the possibility of publication. It is an important, but, for many, a spiritually demoralizing process. With few exceptions, each article ends with some variation on the following sentence: "These findings are limited and must be confirmed by additional study."

One morning I was sitting at the keyboard and staring off into the distance when my wife, Deb, passed the door of my study. She looked at me and said: "Perhaps you should write a play," and went on about her business. I don't know to this day exactly what led me to believe I could do such a thing, other than that simple suggestion. But, sensing some door about to be opened, I turned to my computer and began to write. I knew just two things as I began. First, I wanted to honor the lives of those survivors of trauma I had worked with over the years. And second, I wanted to explore and challenge the concept of expertise. The intellect and presence of the client would need to break through the burnout and professional distance of the social worker.

Six weeks later, the first draft of *The Calling* was complete. Soon thereafter, Deb gathered her friends and colleagues, all actors, directors, and designers, and we read the play at our dining room table. It was for me a strange, out-of-body experience to hear the words spring off the pages. And on opening night, a theater filled with 65 trauma survivors and 35 social workers burst into applause at the curtain, and my life and career were changed forever.

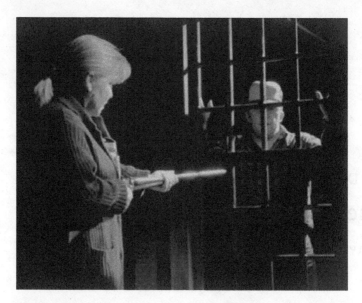

Figure A2 Scene from "The Calling."

What follows are a few lines of dialogue from the opening of the play. My hope is that readers will be not only intrigued but also inspired to explore the power and importance of integrating art into social work.

CLAY GRAYBEAL

Act One

Scene One

(JENNIFER sits in a large stuffed chair, reading a book. On a small table at her side is a teacup and a reading lamp that shines over her shoulder and onto the book. The phone begins to ring. After a couple of rings, SHE looks at it, and then looks back to her book. It continues to ring several times and then falls silent. When it does, SHE looks up again, and then goes back to reading. SHE sips her tea, leans back in the chair. The stage goes dark.)

Scene Two

(JENNIFER is sitting on a hassock in front of the fireplace, reading. GARRET enters, carrying a briefcase, approaches the front door, and knocks. There's no

response, so HE knocks again. Reluctantly and with difficulty, SHE crosses to the door and opens it.)

JENNIFER: Yes?
GARRET: Are you Ms. Jennifer Casey?
JENNIFER: Who wants to know?
GARRET: Sorry, I should have introduced myself. My name is Hughes, Garret Hughes. I work with Outreach Services for the county.
JENNIFER: What are you out . . . reaching . . . for, Mr. Hughes?
GARRET: Uh . . . good question. It is my job to let people know if they are eligible for any services that they might not be taking advantage of.
JENNIFER: It's been a lifelong policy of mine, Mr. Hughes, to avoid taking advantage of others. Especially ones who invite me to do so. (JENNIFER closes the door, locks it, and turns away. Garret knocks again, then calls through the door.)
GARRET: Perhaps, Ms. Casey, I didn't state that in the best way. There are some services that you're entitled to, and it's my job to provide you with this information.
JENNIFER: By any chance, Mr. Hughes, is this something you could slide under the door?
GARRET: I don't think so, Ms. Casey. I do apologize for stopping by unexpectedly, but I have called a number of times, and there was never any answer.
JENNIFER: (SHE opens the door partway.) Oh, there was an answer. Not sure you were listening. Anyway, I expected you, or someone like you. I could tell by the way the phone rang the same time each day. I knew you didn't have a degree in telemarketing. You were predictable, Mr. Hughes. I just didn't know what you would look like. For some reason, I expected someone younger, more earnest looking somehow.
GARRET: I had an earnest look in the early years.
JENNIFER: Well, it's gone. What exactly is it, Mr. Hughes, that you believe I should be taking advantage of that I have apparently missed?
GARRET: May I come in?
JENNIFER: I have two questions for you, Mr. Hughes. One, why didn't you answer my question? And two, why should I let you into my home?
GARRET: Once again, I apologize. I just . . .
JENNIFER: That's a bad habit, you know, apologizing all the time. I hate that. Stand your ground. What are you selling?
GARRET: I'm not selling anything.
(JENNIFER slams the door in GARRET'S face. The stage goes dark.)

THE CALLING COMMENTARY AND SCRIPT [271]

Scene Three

(JENNIFER is sitting in her chair, reading. GARRET appears on the walk outside the door, dialing on a cell phone. The phone beside her rings. SHE looks up, shakes her head, and goes back to reading. The phone falls silent, and after a short pause, there's a knock at the door. SHE looks up again, then stands and goes to the door.)

JENNIFER: Who is it?
GARRET: It's Garret Hughes.
(SHE opens the door partway.)
JENNIFER: So, who made that call for you?
(GARRET raises his hand, revealing a cell phone.)
JENNIFER: I'll give you credit for that one, Mr. Hughes. Perhaps I underestimated you. So you do have some sales experience in your background after all?
GARRET: Can we try again?
JENNIFER: Try what? Did it ever occur to you that I don't want anything from you?
GARRET: I find most people don't want things they don't know about.
JENNIFER: I imagine there are a number of communicable diseases in that category. You don't have any, do you?
GARRET: None that I'm aware of.
JENNIFER: No? I trust you've been tested. Wait a minute. (Searches her pockets and pulls out a crumpled brochure.) I got this in the mail. They're having a free test. It's for depression. (Hands it to him.) They call it a national screening day. Holidays sure have changed since I was girl. Look, little smiley faces. Maybe you should go there. I don't know for certain if depression is communicable, but I suspect I could catch it from you. (Shuts the door in his face.)
GARRET: Ms. Casey, before you leave me standing here again, I'd just like to say that you are quite possibly the most ornery person I've ever met.
JENNIFER: (Opening the door.) You don't get out much, do you, Mr. Hughes? And by the way, was it really that hard? To speak like a real person.
GARRET: I'm not sure I know what you mean.
JENNIFER: Well, that's the only honest thing you've said to me. But there's something else, did you notice that I just offered you a service? You know, one that you might have been unaware of? But you didn't seem to like that very much, did you?
GARRET: Well, I uh . . .

JENNIFER: Come on, don't fall apart now! Not after you've come so far. You had a brief moment there you were almost human. I can see it's gone now.

GARRET: Wait a minute. Now you're being unfair! You're too fast for me. I'm just trying to be helpful. Maybe that's not what you want. Maybe you don't need anything. I don't know. I'll just leave my card, and if you ever think there might be something you'd like help with, you can give me a call. Otherwise, I won't bother you anymore.

JENNIFER: Ah, poor Mr. Hughes. Would you like to come in?

GARRET: Is this a trick question?

JENNIFER: You are a slow learner, Mr. Hughes. I'm not devious. It is a simple question. Would you like to come in? Perhaps you are concerned, uncomfortable, you can't figure me out, but then, I haven't asked you for anything, and you've asked me for a lot. It's a simple question. Would you like to come in?

GARRET: You are a complex person, Ms. Casey.

JENNIFER: And you expected something quite different, didn't you? Perhaps you hoped to bring light into the darkness of my life. Do you start with the assumption, Mr. Hughes, that you will encounter simple minds? That would explain a lot. You must be surprised quite often. What are you waiting for?

GARRET: I don't understand why you've invited me into your house.

JENNIFER: Mmm. And I don't know why you insist on bothering me, so we're even. I imagine you're not used to that, either. Being even, I mean.

GARRET: You seem to have a pretty clear idea about who you think I am.

JENNIFER: Not really, I'm just guessing out loud. I learn a lot that way.

GARRET: I thought you said you weren't devious.

JENNIFER: I'm not. See, I've just revealed my strategy. If I were devious, I wouldn't have told you that I guess out loud.

GARRET: Well . . . I don't believe that I'm devious either.

JENNIFER: I'm sure you don't, but then, how do you explain the phone trick? You should practice your honesty, if such a thing is possible. I can see it comes hard to you.

GARRET: I've become strangely tired.

JENNIFER: Another moment! Would you like to come in before it passes? (Jennifer beckons him in. Garret enters, shaking his head.)

INDEX

For the benefit of digital users, indexed terms that span two pages (e.g., 52–53) may, on occasion, appear on only one of those pages.

Tables and figures are indicated by *t* and *f* following the page number

Addams, Jane, 13–14, 194
Afuape, T., 47
Alive Inside, 64
Alliance for the Arts in Research Universities (a2ru), 92–93
antioppressive practice, 202
archetypes, 255
art
 classroom applications of viewing, 36–37
 translating to practice, 38–39
art, definition of, 197
Art Rx, 78*f*, 79–82, 81*f*
arts-based practices, canonical history of, 193–96
assessment, and opportunities for storytelling, 145*f*–72*f*, 145–50

Bausch, Pina, 127, 134–35
Bazin, André, 11
Bergeron, Bob, life stories in comics, 145*f*–72*f*, 145–50
bias, addressing implicit, 131
bio-cognitive-spiritual framework, 9–10, 24–25
 gender relations and, 22*f*, 22
 mental health and, 22–24, 23*f*, 24*f*
 observation and perception, 18–19
 personhood, preserving, 16–18
 photography and social work, 15–16, 16*f*, 24–25
 race relations and, 20–21
 reflexive photography, 19–20
 science and the progressive era, 13
 from spiritual to secular, 13–15
 words and images, 10–12
Boal, Augusto, 62, 125–27
brain, impact of arts activity on, 217
broaden-and-build theory, 212

Calling, The (Graybeal), 182–83, 183*f*, 270*f*
 script of, 270–73
 writing of, 269–70
Carbajal, Anthony, 83–85, 84*f*
carnival, and participatory practice models, 202
cartography, 12
catharsis, and healing trauma, 202–3
Chambon, Adrienne, 193
Charitable Organization Societies (COS), 14
Charities Review, 14
Charities & the Commons, 193–94
China
 Guangzhout, gender relations in, 22*f*, 22
 Guangzhout, race relations in, 19–21, 20*f*, 21*f*
 how navigators imagined, 12*f*
 mental health in, 22–24, 23*f*, 24*f*
comics, and opportunities for storytelling, 145*f*–72*f*, 145–50
community approaches, 200–1

community engagement, and arts-based research, 95–97
Community Wise, 99
conscientization, and arts in social work practice, 201–2
constructivism, and addressing challenging emotions, 30, 31
contemplative observation, 35
COVID-19, online research in era of, 121, 127–29
creative arts, domains and activities in, 57–58, 68–69
 filmmaking, 67–68
 movement domain, 59–61
 music-based domain, 64–66
 storytelling, 67
 theater-based domain, 61–63
 theory, pedagogy, and student preferences, 58–59
 writing domain, 66–67
creativity, in pedagogy and curriculum, 73
curriculum, creativity in, 73

Descartes, Rene, 16–17
Devine, Edward T., 14
domains, in creative arts, 57–58, 68–69
 filmmaking, 67–68
 movement domain, 59–61
 music-based domain, 64–66
 storytelling, 67
 theater-based domain, 61–63
 theory, pedagogy, and student preferences, 58–59
 writing domain, 66–67

emotions, addressing challenging, 28–29, 39–40
 classroom applications, 35–38
 contemplative observation, 35
 empathy, 32–33
 group work, 37–38
 neuroplasticity, 33–34
 poetry, 34–35
 readers theater, 34
 social injustice, awareness of, 34–35
 theoretical foundations, 30–32
 translating art to practice, 38–39
 and viewing art, 36–37

empathy
 and addressing challenging emotions, 32–33
 visualizing stigma to develop, 134–35
"Energies of Men, The" (James), 214
Envisioning Health, 100
Epston, D., 145–46
erasure poems, 235–37
experiential learning, 185–86
extracurricular activities, student-led, 76–85
 art and healing, case study in, 83–85, 84*f*
 Art Rx, 78*f*, 79–82, 81*f*
 social work arts caucus, 76–79, 77*f*

field education, case study in, 73–74
field education, liberation psychology framework in, 43–45, 54
 assignment protocols, 49–51
 classroom exercises, 47–49
 grading rubric, 52*t*
 implications for field education, 51–54, 53*f*
 practices of liberation art, 46–47
 tenets of liberation psychology, 45–46
filmmaking, 67–68
Finch, Katy, life stories in comics, 145*f*–72*f*, 145–50, 229*f*
Fredrickson, Barbara, 212
Freedberg, S., 38–39
Freire, Paulo, 29, 30, 31, 125–27
 concept of popular education, 62
 conscienitization, 201
future orientation of social work, 247–48, 256–57
 archetypes, 255
 art as social practice, 255–56
 and the arts, 250–51
 dwelling in possibility, 248–50
 imaginaries and imagination, 253–54
 scenarios and stories, 255
 and social change movements, 254–55

gender relations, and international social work education, 22*f*, 22
Gonzalez, Martha, 201
Gorham, Sarah, 35
grading rubric, for arts as reflection, 52*t*

Graybeal, Clay
 The Calling, 182–83, 183*f*, 270*f*
 The Calling, script of, 270–73
 The Calling, writing of, 269–70
Great Depression, and photography in social work, 15–16, 16*f*
group work, and addressing challenging emotions, 37–38
Guha, R., 107–8

"Healing through the Arts," 76, 77*f*
healthcare and art, interdisciplinary programs, 79–82
Held, Barbara S., 214–15
HIV stigma, theater-based methods to study, 121, 136
 consumers as informants, 132–33
 data collection and analysis, 133–34
 and developing empathy, 134–35
 history of HIV stigma, 122–24
 implications for arts-based research, 135–36
 and implicit bias, 131
 and marginalized communities, 125–26
 providers and consumers, interactions between, 131–32
 stigma from theatrical perspective, 126–27
 telemedicine, patient connections and, 132
homelessness, storytelling and, 145*f*–72*f*, 145–50
Hoovervilles, in Great Depression, 16*f*
Hull House, 194
human sculptures, 63

images, words and, 10–12
 and efforts at change, 99–100
 interpreting and explaining images, 113–16, 115*f*
Ingamells, K., 145–46
interdisciplinary programs, in healthcare and art, 79–82
international social work education, 19
intersectionality, of social work and art, 228, 229*f*
 erasure poems, 235–37
 mental health and suicide, writings about, 229–35
 and self-disclosure, 237–43

James, William, 214
Jarman, Janet, 100
journaling, and writing domain of creative arts, 66–67
juggling, and kinesthetic domain of creative arts, 60–61

Kellogg, Paul and Arthur, 14
Kellogg, Paul U., 193–94
kinesthetic domain of creative arts, 59–61
Klinke, Harald, 10
Kübler-Ross, Elizabeth, 39
Kuyken, W., 215–16

languages, and learning, 10–11
learned helplessness, theory of, 212
learning, languages and, 10–11
liberation art, practices of, 46–47
liberation psychology framework, 43–45, 54
 assignment protocols, 49–51
 classroom exercises, 47–49
 grading rubric, 52*t*
 implications for field education, 51–54, 53*f*
 practices of liberation art, 46–47
 tenets of liberation psychology, 45–46
Lines of Activity (Jackson), 194
Lippard, L., 114

maps, 12
marginalized communities, theater practices to address stigma in, 125–26
Martin-Baro, I, 46–47
Maslow, Abraham, 214
media in social work, case study in, 75–76
mental health, and international social work education, 22–24, 23*f*, 24*f*
mental health, writings about, 229–35
movement domain of creative arts, 59–61
music, relationship with brain, 217
music-based domain of creative arts, 64–66

narrative exposure treatment (NET), 215–16

National Social Work Code of Ethics, 237
neuroplasticity, and addressing challenging emotions, 33–34
nonverbal art forms, 217–19

observation, and arts in social work education, 9–12, 18–19

participatory action research (PAR), 46–47
participatory approaches, 200–1, 202
pedagogy, creativity in, 73
Pedagogy of the Oppressed (Freire), 201
Peleaz, Jessica, 79
perception, and arts in social work education, 18–19
performing arts
 and disseminating research findings, 101
 and efforts at change, 100
personal performance, and visual art, 267–68, 268f
personhood, preserving, 16–18
person-in-environment practice, 198–99
phenomenology, and social work practice, 108–9
photography
 and arts in social work education, 9, 10, 15–16, 16f, 24–25
 reflexive photography, 19–20
 reform photography, 93–94
photovoice, 46–47, 98–99
 and consumers as informants, 132–33
 and disseminating research findings, 101
poetry
 about mental health and suicide, 229–35
 about self-disclosure, 237–43
poetry, and addressing challenging emotions, 34–35
positive cognitive behavioral therapy (PCBT), 215–16
positive psychology, arts and, 211–12, 223–24
 ambiguities, living with, 221–22
 intersections with traditional psychology, 214–16
 music, relationship with brain, 217
 narrative exposure treatment (NET), 215–16

nonverbal art forms, 217–19
positive cognitive behavioral therapy (PCBT), 215–16
repairing and building, role of arts in, 220–21
symbolic space, 219
theory of positive psychology, 212–13
Power, Resistance and Liberation in Therapy with Survivors of Trauma (Afuape), 47
progressive era, and emergence of social work, 13
psychology. *See* positive psychology, arts and

race relations, and international social work education, 20–21
readers theater
 and addressing challenging emotions, 34
 and theater-based domain of creative arts, 63
reflexive photography, 19–20
relational theory, and addressing challenging emotions, 30–31
research, arts-based, 91–92, 103–4, 107–8, 116–18
 art and efforts at change, 99–100
 background of, 92–93
 Bedouin women's artwork, 115f
 and community engagement, 95–97
 implications of, 102–3
 interpreting images, 113–16
 and measuring efficacy, 102–3
 online theater workshops, 129–30
 phenomenology, and social work practice, 108–9
 problem definition and data collection, 97–99
 relational aspect of, 117
 research findings, using art to disseminate, 100–1
 social art, theory and practice, 108–11
 stages of, 111–13
 varieties of art, 93–95
 See also COVID-19, online research in era of
research findings, using art to disseminate, 100–1
Roosevelt, Frankin D., 15–16
Rubin, Gayle, 123

[278] Index

Saleebey, Dennis, 213
Schouten, K. A., 220
science, and emergence of social work, 13
self-disclosure, 237–43
Seligman, Martin, 212
settlement house movement, 194
Shadow Souls (Graybeal), 182–83
sight, sense of, 18
singing, and music-based domain of creative arts, 64–65
social art, theory and practice, 108–11
social constructivist learning theory, 58
social injustice, and addressing challenging emotions, 34–35
social justice, and arts in social work practice, 201–2
social practice, art as, 255–56
social science research, and online theater workshops, 129–30
social work, emergence of, 13
social work, future orientation of, 247–48, 256–57
 archetypes, 255
 art as social practice, 255–56
 and the arts, 250–51
 dwelling in possibility, 248–50
 imaginaries and imagination, 253–54
 scenarios and stories, 255
 and social change movements, 254–55
social work arts caucus, 76–79, 77f
social work education, bio-cognitive-spiritual framework, 9–10, 24–25
 gender relations and, 22f, 22
 mental health and, 22–24, 23f, 24f
 observation and perception, 18–19
 personhood, preserving, 16–18
 photography and social work, 15–16, 16f, 24–25
 race relations and, 20–21
 reflexive photography, 19–20
 science and the progressive era, 13
 from spiritual to secular, 13–15
 words and images, 10–12
social work practice, defining, 196–97
social work practice, engaging the arts in, 189–90, 196, 205
 antioppressive practice, 202
 arts-based practices, canonical history of, 193–96
 barriers and risks, 203–5
 carnival, and participatory approach, 202
 community approaches, 200–1
 and conscientization, 201–2
 context and, 198–99
 defining art, 197
 defining social work practice, 196–97
 historical and current uses of arts, 192–93, 195–96
 participatory approaches, 200–1, 202
 person-in-environment practice, 198–99
 and social justice, 201–2
 strength-based approaches, 199–200
 synergistic professional positionalities, 190–92
 trauma, catharsis and healing, 202–3
 underserved communities, 194–95
 vision for, 197–98, 199f
social work practice, how arts have shaped, 173–75, 186–87
 academic career, 180–82
 classroom teaching, 182–85
 early experiences, 176–78
 experiential learning, 185–86
 private practice, 178–79
social work practice, phenomenology and, 108–9
social work research, arts-based, 91–92, 103–4, 107–8, 116–18
 art and efforts at change, 99–100
 background of, 92–93
 Bedouin women's artwork, 115f
 and community engagement, 95–97
 implications of, 102–3
 interpreting images, 113–16
 and measuring efficacy, 102–3
 online theater workshops, 129–30
 phenomenology, and social work practice, 108–9
 problem definition and data collection, 97–99
 relational aspect of, 117
 research findings, using art to disseminate, 100–1
 social art, theory and practice, 108–11
 stages of, 111–13
 varieties of art, 93–95
 See also COVID-19, online research in era of

Index [279]

Soul Work Magazine, 76
Spivak, G. C., 107–8
stigma. *See* HIV stigma, theater-based methods to study
storytelling, 67
 opportunities for, 145f–72f, 145–50
strength-based approaches, 199–200
strengths perspective, positive psychology and, 213
student perspectives, 72
 art and healing, case study in, 83–85, 84f
 Art Rx, 78f, 79–82, 81f
 and creativity in pedagogy and curriculum, 73
 extracurricular activities, 76–85
 field education, case study in, 73–74
 media in social work, case study in, 75–76
 practical implications of art and healing, 85–86
 social work arts caucus, 76–79, 77f
student preferences, and pedagogy in creative arts, 58–59
suicidal ideation, 232
suicide, writings about, 229–35
Survey Graphic, 14–15, 193–94
sympathetic nervous system, and conscious movement, 59–60

telemedicine, patient connections and, 132
Terracotta Warrior statues, 11f, 11
theater-based domain of creative arts, 61–63
theater-based methods, to study HIV stigma, 121, 136
 consumers as informants, 132–33
 data collection and analysis, 133–34
 and developing empathy, 134–35
 history of HIV stigma, 122–24
 implications for arts-based research, 135–36
 and implicit bias, 131
 and marginalized communities, 125–26
 online theater workshops, 127–29
 providers and consumers, interactions between, 131–32
 stigma from theatrical perspective, 126–27
 telemedicine, patient connections and, 132
theater performances, and disseminating research findings, 101
theory, and pedagogy in creative arts, 58–59
trauma, catharsis and healing, 202–3
trauma-informed principles, and addressing challenging emotions, 31
Travis, Raphael, 203–4

van der Kolk, Bessel, 62
visual art, personal performance and, 267–68, 268f

"What Is the Evidence on the Role of the Arts in Improving Health and Well-being?" (WHO), 96
words, images and, 10–12
World Health Organization (WHO), role of arts in healthcare, 96
writing
 about mental health and suicide, 229–35
 about self-disclosure, 237–43
writing domain of creative arts, 66–67

yoga, and kinesthetic domain of creative arts, 59–60
Yo Veo Salud, 100